French Bronze Clocks
1700-1830

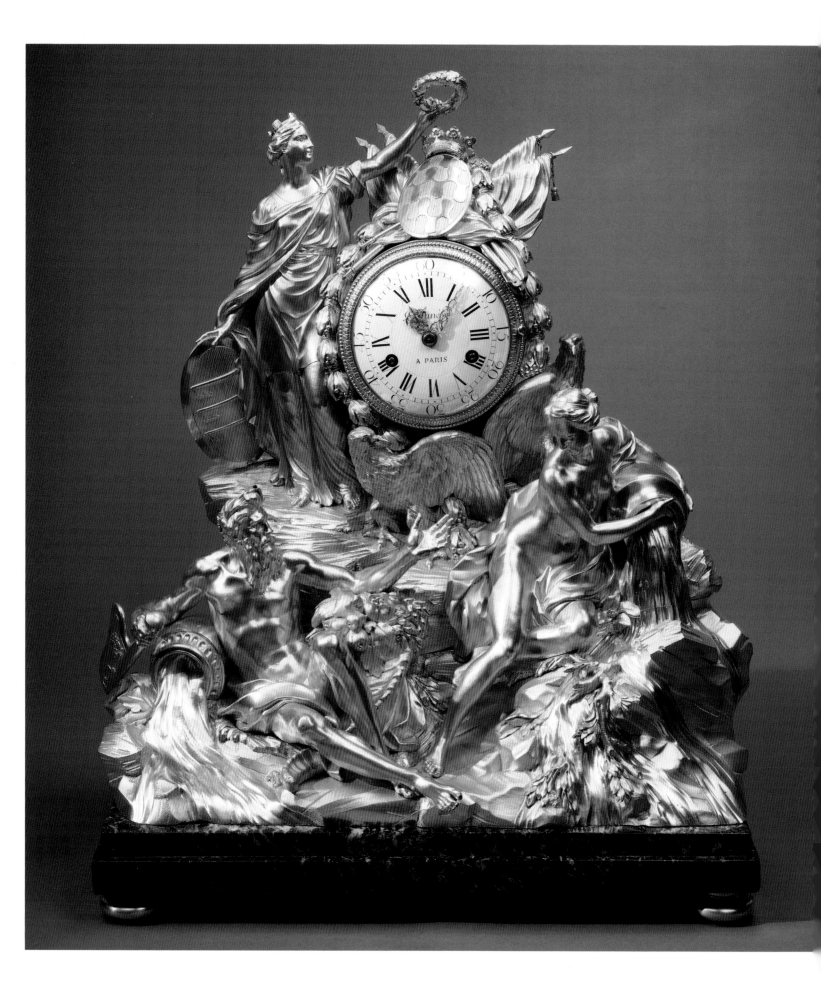

Elke Niehüser

French Bronze Clocks, 1700-1830

A Study of the Figural Images

With a Directory of 1365 Documented
Bronze Table Clocks
collected by Clemens von Halem

4880 Lower Valley Road, Atglen, PA 19310 USA

Illustration on page 2:

1 The Avignon Pendulum Clock – Allegory to the governor of the city of Avignon

The pyramid shaped composition shows in the lower section a rock formation on which the male personification of the Rhone river and the female personification of the Durance river are grouped. The two rivers merge to the west of Avignon. Personifications, heraldic emblems and attributes are employed to hail the governor in the style of a baroque allegory to the ruler. The honor is aimed at the Marquis de Rochechouart (1717 – 76), who received this spectacular pendulum clock from the senate of the city. As field marshall under Louis XV, the Marquis conquered the city, which had been under papa rule since the middle ages, and goverend it from 1768 to 1774 to the fullest satisfaction of the population. The personification of the city of Avignon with its characteristic walls and the armorial crest of the city with its three papal keys is at the top of the composition. Representing the people of Avignon, it pays tribute to the coat of arms of the Marquis de Rochechouart, by decorating it with a wreath of oak leaves, the corona civica. The dominant location of the coat of arms within the composition shows its military, political and social importance. It is triumphant over time, symbolized by the clock. Like a monument the bronze memorializes the achievements of the honoree for eternity. Initially a gift of 100 gold pieces to the governor had been contemplated. Then a commission to create the pendulum clock was given to the sculptor Louis-Simon Boizot (1743 – 1809), who created the model, to Pierre Gouthiere (1732 – 1812), who did the gilding and chasing and the clock maker Nicolas-Pierre Guichon de Delunesy (Maitre 1764). The dial was made by Joseph Couteau (1740 – 1812). Remarkable and significant for the different importance of the various crafts is the distribution of the costs: The sculptor received 1500 livres, the gilder and chaser 9200, and the clock maker 360 livres. The production was coordinated by the goldsmith Ange-Joseph Aubert. Sculptor and gilder signed the back of the armorial shield: BOIZOT FILS/ET/EXECUTE/PAR GOUTHIERE/CISELEUR ET DOREUR/DU ROY/A PARIS/QUAI PELLETIER/A LA BOUCLE D'OR/1771"

Louis XVI, circa 1771, fire gilded bronze, Pavento-rosso-marble. The Wallace Collection, London, F258.

Acknowledgments

Whenever one undertakes the task to write a book, one depends on cooperation. Of the many, who were on my side, I would like to especially thank Michael Nolte, Muenster. He has opened the door to his "treasures" and generously shared his knowledge with me. Through my work in his gallery, I met many collectors of 18th century pendulum clocks. In numerous conversations I received many suggestions. And I was always met with friendliness. The fruits of this close exchange of thoughts will hopefully be beneficial for everybody. Mr. Christian Pfeiffer-Belli initiated and took care of this book project and I would like to thank for his helpful and cheerful support. Monsieur Francois Duesberg, who has put together an exceptional collection of French pendulum clocks thanks to his profound knowledge, was willing to share his enormous expertise. His museum in Mons, Belgium is the base for the central aspect of the historical concept of this book and the iconographic tradition of clocks. The photographs were made by Gabriele Bracht. They are instrumental to not only showing the beauty of three dimensional objects in a two-dimensional fashion, but providing the reader with a sensual experience.

This work was originally published in German as *Die französische Bronzeuhr: Eine Typologie der figürlichen Darstellungen.* by Verlag Georg D.W. Callwey GmbH & Co., Munich

Copyright © 1999 Schiffer Publishing
Library of Congress Catalog Card Number: 99-63980

Layout by Ian Robertson
Typeset in Times

ISBN: 0-7643-0943-9
Printed in China

Published by Schiffer Publishing Ltd.
4880 Lower Valley Road
Atglen, PA 19310
Phone: (610) 593-1777; Fax: (610) 593-2002
E-mail: Schifferbk@aol.com

In Europe, Schiffer books are distributed by Bushwood Books
6 Marksbury Rd. Kew Gardens
Surrey TW9 4JF England
Phone: 44 (0)181 392-8585; Fax: 44 (0)181 392-9876
E-mail: Bushwd@aol.com

Please write for a free catalog. This book may be purchased from the publisher. Please include $3.95 for shipping. Please try your bookstore first. We are interested in hearing from authors with book ideas on related subjects.

Contents

Introduction

A Pendulum Clock is more than a Clock

For the longest time, French pendulum clocks of the 18th and early 19th century have been examined only in their function as timepieces. Part of the reason might be that the dial usually carried the name of the clockmaker while the artists responsible for the design remained anonymous. Pendulum clocks were therefore considered as cultural history, which has been rarely consulted by art historians. The most visible parts – the artistically executed bronze sculpture – remained unnoticed and unresearched. This book has as its goal to see these clocks as bronze sculptures, intertwined with the art and cultural history of the applied arts of the period. They are neither mere handicrafts nor technical rarities, very oftenbeing designed and executed by the most gifted artists of the period. Famous sculptors such as Falconet, Coustou and Clodion created models for them which have all the characteristics of fine art.

This approach opens a new perspective for their evaluation. The cases are not merely seen as ornaments or decorations of the clock movement, but rather as small sculptures with their own iconographic program, which is interpreted according to European tradition. Instead of an analyses which groups the pendulum clocks within crafts, this book tries to define the connection to the applied arts.

The contemporary viewer often has difficulty interpreting thesculptural images because the figural group has lost its meaning. Apparently tales are shown, but which one, by whom and why remain a mystery.

Most pendulum clocks refer to myths and stories which are not well known to us today– however people of the 18th and 19th centuries were very familiar with them. These stories continue to be worth knowing and are interesting also in our

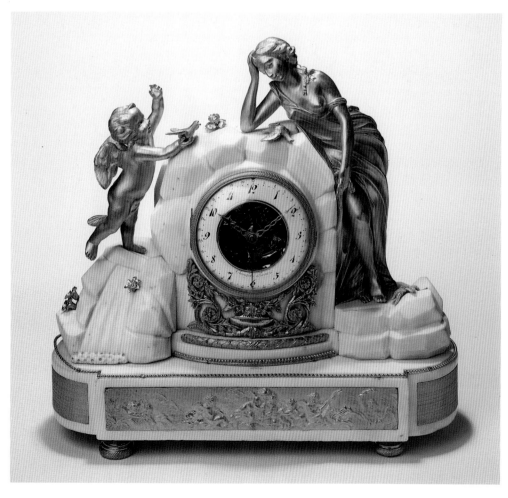

times. Ever since the beginning of mankind, myths have helped us to explain the world, to structure it and to analyze and strengthen our understanding. Myths are an entertaining weapon against chaos and the diversity of the creation, which is hard to understand intellectually. Myths tell about love, war, and faith; about heroes and gods; about sacrifices and the victory of good. They tell about human feelings and bring the listener to sympathy or antipathy. As recipient and narrator of the myth,the listener becomes part of the story.

Knowledge of the mythological background of the theme was an important factor in choosing a certain motif. Every pendulum clock has its own theme, which creates a certain mood and was chosen in order to achieve a particular purpose. Pendulum clocks were made for libraries, for representative salons, and for boudoirs – rooms which had roots in the refinement of the 18th century. Pendulum clocks were made for people of melancholic temperament, for free masons, for collectors of antiquity, for monarchists, republicans, adventurers and epicures, and especially for lovers. The majority of the themes are taken from mythology around Amor and Venus.

Despite the diversity of themes, the context to the phenomenon of "time" is the junction between all of them. Sometimes very obvious – such as when the winged god of time, Chronos pulls the timepiece along – and sometimes very indirect, such as when a young girl cries over a dead bird and mourns the irreversibility of the past. In these pendulum clocks, symbolic representation and function meld to a perfect unity.

Pendulum clocks are remarkable objects: they give time, they are witnesses of their times and they symbolize the multiple aspects of the phenomenon of time.

The vast array of subjects can be grouped into four main categories, which are also the titles of the following chapters: 1) Above all is the presentation of antique gods and heroes, primarily used during the French Classical period and the Louis-seize period of Neo-classicism and Empire. 2) The second group is dedicated to the Amor and Venus theme, which has an especially strong tie to time and vanity. 3) The chapter on the "Noble Savage" reflects on the fascination with exotic places and the desire to go there, which are so typical for the period. Accordingly, the pendulum clocks of the late 18th century are full of Africans, Indians and exotic animals. 4) The last chapter is dedicated to pendulum clocks with genre scenes. They are furthest removed from time and capture life in a certain moment – as timeless time.

3 Chronos – tempus fugit
The god of time, shown here as an old man with long beard with an athletic muscular body , represents several elements: Chronos, the Greek term for "time", Kronos, who is the powerful father of the gods and human beings in Greek mythology, and his Roman counterpart, Saturn, the old, bearded god of agriculture who has the scythe as attribute. As a result, Chronos, the God of Time, has very diverse characteristics: he is the "Father of all things" (Pindar, Olymp., II, 32) and he is the cruel Kronos, who devoured his own children – time destroys everything it initially created (Therefor the idiom" the ravages of time"). He terminates life with his scythe and therefor is also the god of death. The baroque appearance of the figure remembers of two drawings by Gianlorenzo Bernini, which also shows two obelisks (as sun dials). Demeanor and composition are very similar and were used as models (illustr. See Panovsky, Studies to Iconology, 1980, illustr. A and B). The base relief shows the boat of Chronos, steered by Amor, a theme which can be found as a pendulum clock (see illustr. 51).
Empire, circa 1815, Dial signed: Ledure/Bronzier a Paris?Hemon Hr, fire gilded bronze, see Ottomeyer/Proschel, I, p. 351, another casr is signed by the bronzier Ravrio.

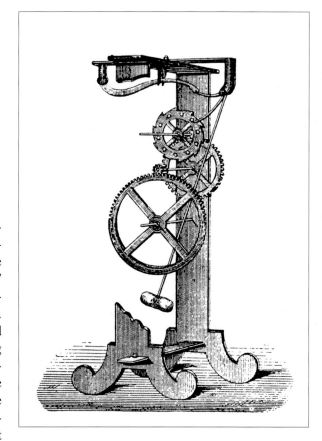

History of Pendulum Clocks

The terms "time" and "clock" are almost synonymous for modern man. All our life we are surrounded by clocks, which influence our life rhythm, our actions, thinking and feeling. "Time" which is created by clocks is not a natural phenomenon, but a product of man-made technology. In the past as well as present various cultures and epochs were solely based on the rising and setting of the sun. The seasons with their changes in vegetation were the framework. asr timekeepers date back to the Middle Ages, but initially they were very rare and did not play a role in the social structure. It was several centuries before they had that influence.

The astronomical research conducted by Galileo (1564 – 1642) revolutionized not only the view of the world for mankind, but also moved man's self-image away from being God's center of creation. In connection with his research, Galileo also conducted studies of the pendulum and its characteristics. He was the first to understand the theoretical ideas behind the concept of a pendulum, even though he never built one. The first construction of a pendulum was done in 1656 by the Dutchman Christiaan Huygens (1629 – 1695) who developed the first pendulum clock and introduced it to the world in his book Horologium in 1658. This paved the way for modern time keeping. How important the development of the pendulum was for the clock movement can be seen in the change of terminology for clocks from " horloges" to "pendule."

What seems normal today was indeed a revolutionary development at the time. The partition of a day into equal units suddenly was possible.

At a fast pace, the following decades brought new technical discoveries and the precision of the pendulum was improved. The speed behind all these developments gives reason to believe that after the old world order was lost, Western man urgently was looking for a new man-made order based on scientific instruments. Western man was also looking for new land across the oceans. Precise time keeping is essential for accurate navigation. It is easy to understand the great interest European kingdoms had in the development of the chronometer. From a political point of view, they were the basis for colonial power and overseas trade.

Timekeeping devices gradually were constructed more frequently after these models and eventually became part of everyday life. Originally clocks on church steeples gave the hour only, and precision timekeepers were reserved for scientists and aristocratic treasure rooms. With the invention of the pendulum clocks were suddenly part of all different parts of life. Large dials made it pos-

4 **Model of a Pendulum escapement after Galileo Galilei**

sible to read hours and minutes from a greater distance, which had not been possible with earlier models. Hour and half hour chimes were introduced, which made time also acoustically ever-present. It is also interesting to point out that after about 1700, everybody with the necessary means increased the number of clocks in their houses. Originally there was only one clock in every household, which was placed on a table, but eventually there was a clock in almost every room. Visible at the chimney mantle, it became the visual and social centerpiece of a room.

The pendulum clock, which opened a new world view for the upper and middle classes, and which rang in a new world vision, suddenly was omni present.

For technically interested collectors who would like to know more about the inner-workings of their pendulum clock, access to the clock movement itself is not always easy. However, several features visible from the outside give hints about the type of movement inside. All pendulum clocks illustrated in this book have spring driven movements with a running duration of at least eight days. Most of them will strike the full and half hour on a bell.

Movements of the Louis-quinze and Louis-seize periods (see the section Short Guide to French Art History on page 19) have a glass door at the back for dust protection. Most Empire clocks (1804 – 1814) have metal doors or screwed on covers. Some Empire clocks, however are open at the back, allowing an open view of the interior. The purpose of these small doors and covers at the back was primarily for protection and aesthetics. Many of these pendulum clocks were placed in front of mirrors and were seen as sculptures from front and back.

Upon closer look at the movement of a clock, the characteristics of French pendulum clocks of the 18th century are obvious. First one sees the brass back plate, with the bell, hammer and pendulum with suspension. In order to open the view, the bell has to be removed. Sometimes the back plate bears the clock maker's signature.

The Clock Movement

The Pendulum

The parts of a pendulum are: the pendulum bob, the pendulum rod, with increased diameter in the upper one third and the hook at the end, which is hung on the string. The string suspension – always with a silk string – is another characteristic of French pendulum clocks. By increasing or shortening the string the clock movement can be regulated. Clocks of the Louis-quinze and Louis seize

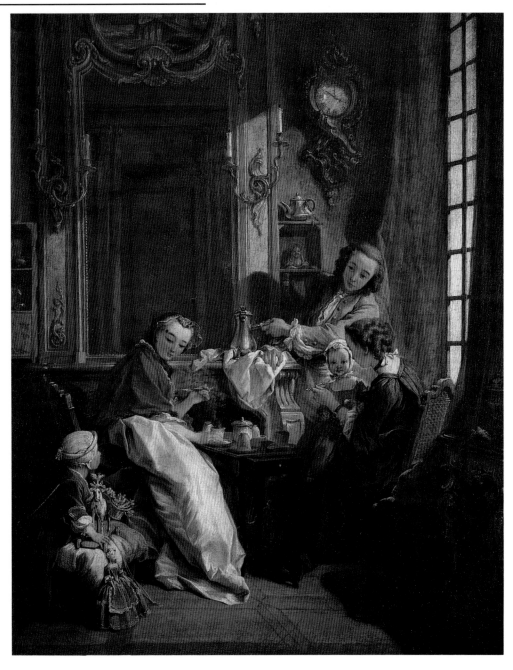

5 Francois Boucher (1703 – 1770), The Breakfast
1739, Oil on canvas, Musee du Louvre, Paris (R.F. 926)
The genre painting lets us participate in an intimate family scene. It gives the viewer the opportunity to see a detailed and lively impression of a modern Parisian Rococco houshold. Above the scene, the cartell clock is hangs the wall, a type of clock which started around 1730 and which is characterised by its independent ornamentation and the lack of a console is a typical example of the "gout pittoresque" which developped around 1725.

period can be regulated from the front. Usually close to 12 o'clock a small opening allows a regulating key to be inserted, which by turning right or left will shorten or lengthen the silk string. Later clocks from the Empire period do not have this feature on the dial, they are regulated directly at the suspension with a small wheel which fulfills the same function.

Despite all its strength, a silk threat does have several disadvantages: temperature and humidity changes will affect its length, which influences the precision of a clock. For everyday use a variance of approximately 5 minutes per week is accept-

able, however, for scientific purposes, a higher rate of precision is necessary. Therefore the silk thread was later replaced by a metal strip, which reacted much less to these outside changes. This so-called spring suspension had been developed for precision clocks and can be found in some figural clocks. Frequently suspension had been converted in the 19th century. Temperature changes also have an effect on the pendulum rod, which is made of metal. In order to minimize the effect, the compensation pendulum had been developed, which instead of one pendulum rod has several (usually five or seven) metal rods running parallel from the pendulum bob. The idea behind it is to make use

of different metals and their different reactions to temperature changes, which in the end should offset each other. Other pendulums contain metal or glass compartments filled with mercury, which reacts minimally to temperature changes. These types are only rarely found in figural pendulum clocks.

Striking and Countwheel

The back plate houses another important part of the clock movement, the count wheel. Usually it is a four- or six-arm wheel. Its name describes its form and function well. The function of the count wheel is to coordinate the hour with the clocking mechanism. The rim of the wheel has grooves at different positions, which will catch a pin, which stops the turning of the wheel. In order to activate the striking, the pin is lifted and the count wheel turns until the pin is stopped by the next groove. The length of the striking depends on the distance between the grooves.

Almost all pendulum clocks have a two-train movement and therefore two winding holes on the dial: one train for the movement and the other for the striking mechanism. Most clocks have a running duration of eight days. It sometimes happens that the moving train runs longer than the striking train. This means that the running and striking are not coordinated-a problem which can be solved by the layman. One only has to lift the pin and allow the count wheel to run to the next groove. This has to be repeated until hour and striking are coordinated.

The sound of a clock is just as characteristic as the sound of a human voice. The type of metal alloy has the biggest influence on the sound. Older clocks are made of bronze, sometimes mixed with silver which results in the "silvery" tone, which is very fine and long-lasting.

Movement and Escapement

The movement is primarily housed behind the back plate. The main feature of the movement is the escapement. The power, which is stored inside the metal springs, is

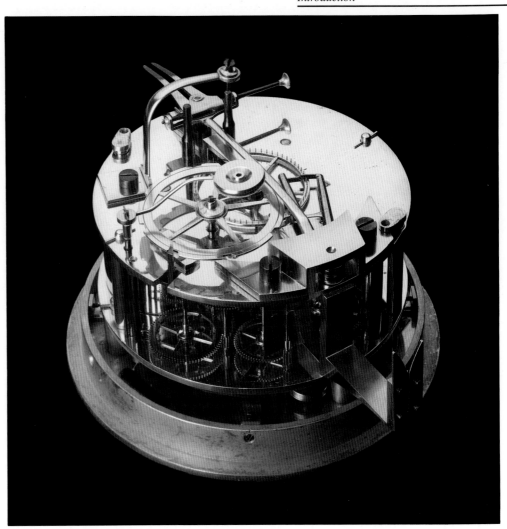

divided by the escapement in small, equal portions and then released.

Depending on its technical construction, the following types of escapements can be differentiated: 1) the verge escapement, 2) the anchor escapement, 3) the bar pin escapement or pin escapement. The escapement is the heart of the clock, its proper function is instrumental.

The earliest type of escapement is the verge, which dates back to the 13th century. It is very sturdy, not very precise, but can handle uneven positions. The first *dead beat escapement*, invented by the London clock maker Thomas Tompion, which quickly found its way into French pendulum clocks, provides for a much higher precision. However, it also requires a leveled plane to sit on. This requirement might be the reason that during the 18th century the verge escapement remained very popular despite the much better precision of the anchor escapement.

Even higher precision was offered by the so-called Graham es*capement*, invented in 1715 by

6 Unusual movement of a pendulum clock
With sweeps seconds, date and planetary date. View of the count wheel, pin wheel escapement and the arched pendulum rod and pendulum spring.

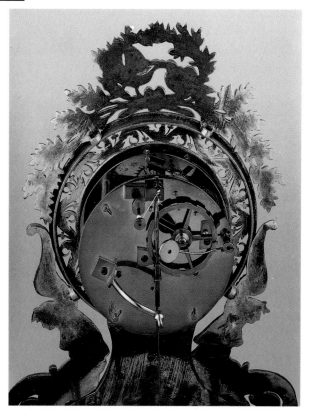

7 **View of Back plate** with silk suspension for pendulum and count wheel (bell removed). Underneath back plate part of anchor escapement is visible.

the Englishman George Graham and named after him. It was another version of a dead beat escapement, which is frequently found in French pendulum clocks. However, again many had been converted at a later date, mainly during the 19th century. Another type of dead beat escapement is that invented by Louis Amant in 1741.

Many other types of escapements do exist, however they were rarely used in figural pendulum clocks. They are mainly found in chronometers, regulator clocks, or other high precision timepieces.

Clockmakers

Many important clockmakers, with workshops primarily in Paris, made movements for pendulum clocks. Pierre Le Roy, Ferdinand Berthoud, Robin and Breguet are some of the clockmakers. They made clocks also for kings and their courts and who worked at the academy.

Yet, for this study, the clockmakers are not the primary artists of the pendulum clock, which is a complete work of art. Old invoices document that they were mere suppliers to the bronze artists or dealers, who put the pendulum clocks together. The clockmaker's share of the costs of a pendulum clock was approximately 15%. For example, the famous "Avignon Clock" (circa 1771), which now is part of the Wallace Collection in London, has the following contributors: this unique clock was made by the artist, the founder, the engraver, the gilder, the enamel artist, and the clock maker— each one of whom was a recognized artist in his field. The gilder was Pierre Gouthiere (1732 – circa 1812), the design and model were made by the famous sculptor Louis-Simon Boizot (1743 – 1809), the enamel dial was made by Joseph Coteau (1740 – 1812), and the clock movement was made by Nicolas-Pierre Guichon de Lunesy (master in 1758). The largest share of the costs, 9,200 livres, went to the gilder Gouthiere (one livre is equivalent to 5 German marks), which was six times the amount paid to the artist. What is even more surprising is that only 360 livres went to the clock maker. The gilder thus received 25 times the amount of the clockmaker (see Peter Hughes, Catalogue of the Wallace Collection).

Pendulum clocks of the 18th and 19th centuries have an amazingly long duration of life. Collectors and lovers of such pieces have to accept the fact that their possessions have been running for the last 180 to 300 years and are perfectly capable of functioning beyond their owner's life span.

Nevertheless, wear and tear is also taking their toll on clocks and alterations and repairs are common. The escapement, which frequently had been converted from a verge escapement to an anchor escapement and the silk suspension, which had been replaced by a spring suspension, are especially sensitive parts. Collectors should pay attention that the movement is not completely altered. Sometimes the movement is not original to the case and the dial, which is the part bear-

ing the important signature belongs neither to the movement nor the case. Because the number of clockmakers capable of restoring these old movements is dwindling, many movement restorations result in the destruction of the movement. The main goal of each restoration should be to replace as few parts as possible, because each new element takes away from the originality of the movement. And it is the authenticity which is the most fascinating feature of any antique object: they were part of another world – one that happened long before our time and these parts were witness to it.

9 **Drawing of a back plate,** the silk suspension and various escapements.

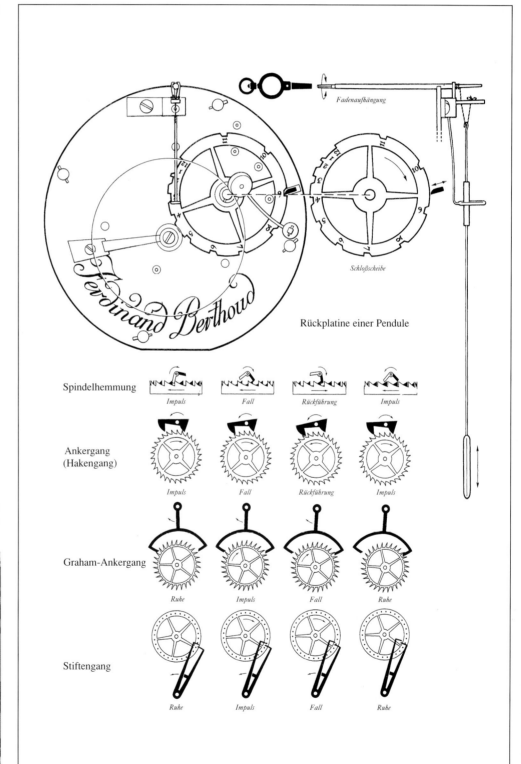

8 **Movement of a pendulum clock**
Louis XV, dial and movement signed Gilbert Paris (probably Louis-Francois-Robert Gilbert, 1734 – 1748), Galerie Caroll, Munich.

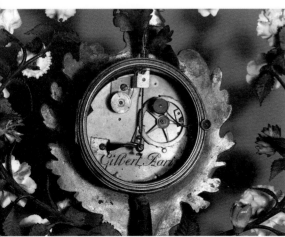

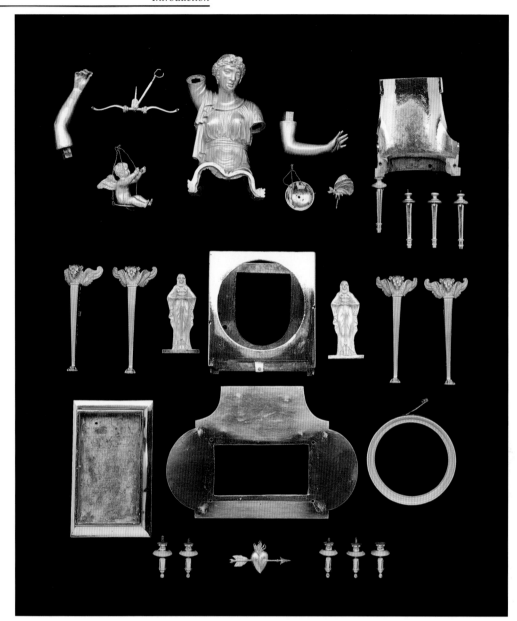

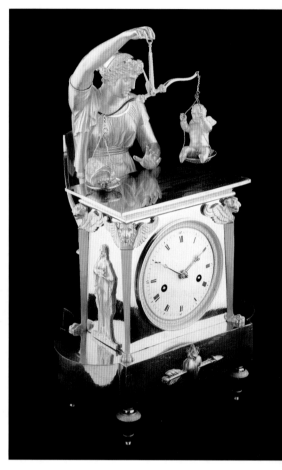

10, 11 The weighing of Amor
Though one would expect Amor to be heavier than a butterfly, the scale shows the opposite. The butterfly represents Psyche and the rational-sensual love. At the same time the scene reminds you of an antique image unearthed in Pompeii (see illustr. Page 97)

Fire gilded Bronzes – Material and Technique

A good figural bronze case appears to be made in one solid piece, yet the opposite is true. High quality bronze clocks are made of many individual parts – otherwise they are probably a cheap metal and made during the late 19th century.

The many different parts can best be seen and studied when a pendulum clock is taken apart in order to be cleaned or restored. For example, the bronze case of the pendulum clock "The Weighing of Armor" consists of 38 individual parts. What appears to be one piece is the result of a complex cooperation of highly specialized craftsmen, following the designs of artists and sculptors to the smallest detail. The complexity of a bronze cast is best illustrated by studying its construction. The most important steps are the casting, the chasing, and the gilding.

Casting

Bronze is a copper, zinc, tin and lead alloy. Each 18th century caster developed his own formula for a perfect ratio of components, which he kept top secret. In general the main component is copper, which varies between 82 and 91 %. The goal was to create a substance which is easy to cast yet results in a solid, surface without pores which is suitable for further treatment.

A high quality pendulum clock is never made in one cast. The case of "The weighing of Amor" is made of 38 individual parts, which are chased, firegilded and put together after the casting (illustr. 10)
Empire, circa 1810, fire gilded bronze.

At the beginning of the process the artist creates a graphic design or a terra-cotta model. This design is turned into a three dimensional model made of plaster, wood or wax. It is modeled by a sculptor or "modeller," and incorporates the first changes to the original design because of technical requirements.

Based on this model the "casting model" is made of plaster. This additional copy is necessary because the casting model is destroyed during the casting process.

Two different casting procedures exist. One procedure is the so-called "sand casting," which is used primarily for all flat cast parts and the bas-reliefs. The other is the "lost wax" procedure, which is used to make all sculptured and three-dimensional parts.

In sand casting, a flat wooden box, similar to a drawer, is filled with compacted casting sand. The casting model is pushed into the sand and removed. The indenture is then filled with liquid bronze, which creates a positive copy of the casting model, and can be reused for further castings.

In the lost wax procedure, which is also referred to as "lost mold" procedure, the process is much more complicated. The wax model is covered with an earthenware mixture which is hardened by firing. During this heating process the wax melts and runs off through particular channels. The resulting cavity then is filled with liquid bronze, which is poured through different channels. In order to economize on material, the wax model often had a core made of a solid, non-melting material onto which the wax was laid. After the bronzel hardened, the earthenware mold is hammered off, the channels are removed, and the surface is made smooth. This completes the founder's or caster's work.

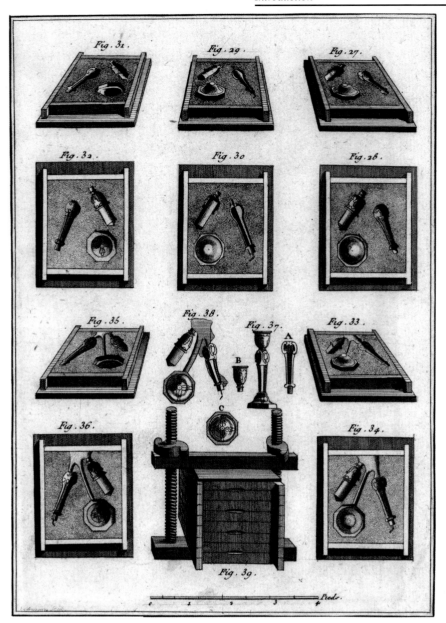

Chasing

The chaser's task is to develop the complex surface treatment of the casting. Imperfections and rough parts left from the casting have to be worked on first, followed by the fine chasing, which will determine the character of the bronze. In order to accomplish his task, the craftsman has a number of different chasing tools at his disposal. The entry in Diderot's Encyclopedia about a chaser's tool list lists a total of 28 different chisels and numerous different files.

12 **The sand cast**
The casting of a candlestick: the frame, impression of the form and case, Diderot and D'Alembert. *Encyclopedie*, 1751 – 1777, Fondeur en Sable.

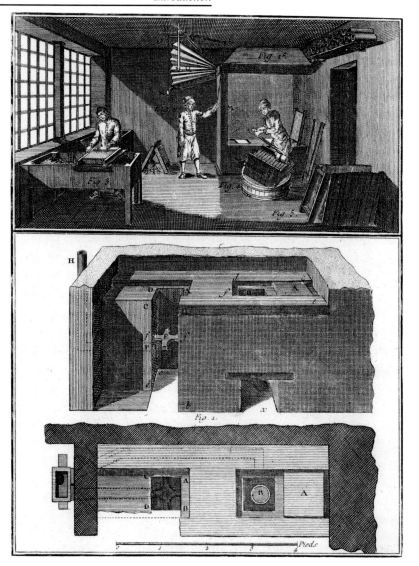

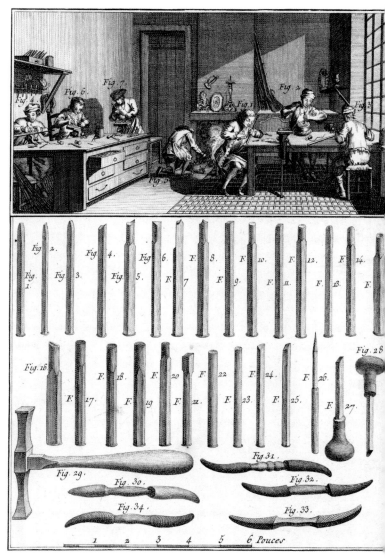

13 **Work shop of the Gilder** and its different tools and utensils. Diderot and D'Alembert: Encyclopedie, 1751 – 1777, Doreur, Sur Metaux.

14 **Work shop of the Chaser** and its different tools: Engraving chisels, chisels, files and chiseling hammers. Diderot and D'Alembert; Encyclopede, 1751 –1777, Ciseleur.

A good craftsman can use these instruments to create the appearance of a multitude of different materials. Each part has its own characteristic surface. Hair, for example, was chased in a different way from skin or fabric, and plants or rocks were chased differently from ornamental mounts.

Some parts were chased with different surfaces in order to achieve a shadow effect. The chasing is the process which translated the artistic idea best and which brings life into the casting. It was understood that the chaser had the most important role in the process and received the highest payment.

Gilding

The quality and detail of the chasing is further enhanced by the next step, the gilding. A gilded and chased surface will reflect light in many different ways. The unique color of gilding is achieved with 24 Karat gold.

French pendulum clocks are fire gilded. In this process, the bronze casting is heated and washed with nitrate and a weak sulfurous solution in order to make the surface more absorbent.

Every bronze part was covered individually with a gold and mercury amalgam. Again many different recipes exist, with the gold content ranging from 9% to 33%, and the mercury content ranging from 67% to 91%. The parts of the casting which were to remain ungilded, but were later patinated in green or black, were covered with a chalk paste. Then the object was put over fire, the mercury evaporated, and the gold was laid onto the bronze.

Today we are familiar with the toxic effects of mercury, yet many gilders at the time paid for their ignorance with their life. In 1818 a firing oven, capable of diverting the toxic fumes, was invented by D'Arcet, the director of the Parisian mint. This invention became popular quickly and took away the dark shadow of this controversial technique which was capable of producing such beautiful things.

The process of fire gilding was repeated up to four times in order to achieve the highest quality gilding. The sophistication of French craftsmanship would go even further. By various chemical treatments of the bronze surface, different shades of gold coloring could be achieved. In addition to the warm gold tone of 24 karat gold, red gold and mat-finish gold could be achieved. Some pendulum clocks have two different tones in order to distinguish between figures and background or ornamental decorations.

Finally, the flat and unchased surfaces were smoothed with an agate pen and appear highly polished. Similar to a drawing or painting with white highlights, this last step created a three-dimensional effect.

15 **Detail of the pendulum clock "The weighing of Amor"** (Female head from the back), see illustr. 11, shows the results of different engraving techniques and the polishing of the headband and the dress seam with the agate stick.

Handling Gilded Objects

Fire gilding is the most durable of all gilding procedures. Compared to gilded wood, which is wood covered with sheet gold, or oil gilding, which is gold mixed in with an enamel paint, fire gilding is very durable.

The range of condition in bronzes depends on the quality and craftsmanship of the initial gilding process. As previously discussed ,some high quality bronzes were fire gilded up to four times. The thicker the gold cover, the harder it will be to rub off. The original gold content also plays an important role, the higher the gold content, the softer and denser the gilding. Gold – and in particular 24 karat gold – does not oxidize and does not tarnish.

Nevertheless, many bronzes are found in poor condition for various reasons:

If bronzes were stored in rooms with high humidity, which causes the copper, which is the main component of the metal alloy, to oxidize, the surface will show a green tarnish and black spots similar to bubbles.

If the bronze is dull in appearance with a greasy layer of dust, smoke, and nicotine it needs to be carefully cleaned by an expert and – assuming the gilding is still intact – will again show their original luster.

Many gilded surfaces have been destroyed by inappropriate cleaning. Often the bases and exposed figural elements have been cleaned with modern metal cleaning solutions and the gilding has disappeared. Most modern cleaning solutions contain small grains, which will literally rub off the gilding. The owners of bronzes should be very careful and should remove the dust with a soft brush – preferably one made of goat hair. Every few years when dirt has built up on the surface, the object should be brought to an expert for cleaning. The best material is a mild soap solution, with which every part of the disassembled bronze is carefully washed. Sometimes ammonia and sulfurous solutions are used, which give the bronze a "like new" appearance, removing also the charm of a nice patina. The treatment with ultrasound is still controversial, because the effects of sound waves on the gilding have not yet been studied sufficiently.

When the gilding of a bronze is destroyed by unprofessional treatment, it is unfortunately impossible to renew the gilding. Mercury gilding is prohibited today and thus can not be done at all. Electrolytic gilding, a process developed in the 19th century, covers the finely chased surface with a veil of gold and thus destroys the different surface effects. With experience, one differentiate a fake by the different color of gold. Electrolytic gilding has two more characteristics: the individual gold parts appear to be applied like dots next to each other, and the surface will shimmer in the colors of the spectrum.

During the period from 1700 to 1830, various different styles and aesthetically diverse art concepts emerged in France. In general, the sequence of styles is named after the ruling French king at the time. It is a little confusing that some styles do not fully correspond with a particular reign and in some European countries these names were used in different contexts.

1643 – 1715 Louis XIV: *Baroque*

The Louis XIV period is also referred to as Louis-quatorze. The reign of the "sun king" is characterized by the desire for absolute power by the ruler, who identified himself with the sun gold Apollo. The French Academy Royal de Peinture et Sculpture was founded in 1648 in Paris by the king as an art center, fully devoted to the glorification of his divinity. Over a period of several years artists were thoroughly trained, especially in the art of the antique. Their subjects were mainly taken from Greek and Roman mythology. The artists favored the brave and good gods and heroes, such as Apollo and Hercules, who seem unapproachable and embody the principles of the world. Good examples for this principle are the dramatic pendulum clocks by Charles-Andre Boulle (1642 –1732) which show the battle between Amor and Chronos for the world rule (see illustr. 150, 183). Boulle, who owned one of the most important art collections of France, was the first artist to elevate pendulum clocks to sculptural pieces, following examples from the Renaissance – especially Michelangelo. Prior to that, clocks for indoor use where made as table clocks or as pedestal clocks in rectangular cases with sometimes allegorical ormolu applications. Boulle also made pieces of furniture with integrated clocks for the court of Louis XIV. The bronze inlay technique is named after him.

In cooperation with Nicolas Coustou (1658 – 1733), who was one of the most prominent sculptors of his time, a series of pendulum clocks with various fundamental and serious themes were created. A prominent example is a pendulum clock

Short Guide to French Art History

16 **Students drawing and modeling antique statues in the collection of the Capitol,** engraving by Giovanni Domenico Campiglia (1692 – after 1762)

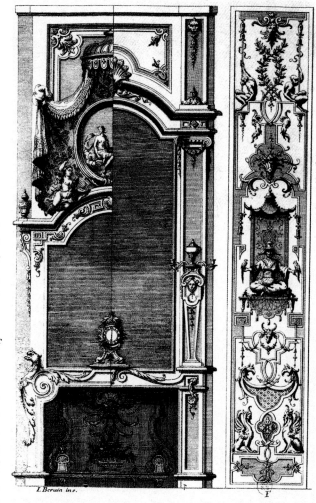

17 Drawing of a chimney mantel

At the center of the composition is the pendulum clock. At the intersection of the horizontal and the vertical axes is the large dial, which makes the clock visible from a distance. Jean Berain. Paris, circa 1690. Copper engraving.

depicting the Three Fates who, according to ancient mythology, spin the life thread for every single human being and who also have the power to cut it (see cat. Walla*ce Collection*, P. Hughes, 1994, page 22). The playful ease of the later Rococo period is not present yet.

circa 1715- circa 1725 Reign of Philippe of Orleans: Regency

Louis XIV was succeeded by Philippe II of Orleans (1715 – 1723), a period which accordingly was referred to as Regency. With respect to society, a slight revolution took place during this time which had a widespread impact on the lifestyle of the ruling class. After the death of the sun king, who had gathered the aristocracy at his court, the court literally broke apart. The consequence was a retreat into privacy. Even though as early as 1690 etchings by Jean Berain show "pendulum clocks" displayed on chimney mantels, it is only during the Regency that the pendulum clock conquered the place and changed its name to "mantel clock." The French mantel clock started a new period of interior decoration.

The Regency period is characterized by the integration of architecture and interior design where all objects in a room are perfectly coordinated. The pendulum clock as a sculpture became part of an overall scheme of art which also included paintings, reliefs, ormolu bronzes, and furniture.

At this time, the fireplace was an important element for wall and room decorations. Above the fireplace one would find a hanging mirror or a

mirror which was integrated into the wall paneling and it was flanked by a pair of sconces. The mantel clock usually rested between a pair of candelabras which were either also made of fire gilded bronze or fine porcelain mounted in ormolu. The fireplace gives a room some direction. Social or family gatherings take place in front of it, it is a place of communication. The large chair reserved for the head of the household is in front of it, surrounded by smaller fauteuils, chairs and seats, which are "filled" in a strict hierarchical order.

During the Regency period, a new set of themes were studied by artists and craftsman. Pastoral scenes and gala celebrations appear – as small scenes located in private, erotic, and sentimental places. So called cartel clocks, which are wall

clocks which optically melt into the wall paneling appear with male and female shepherds in innocent flirtations, being the first use of bronze sculptures. The most important painter of the period is Antoine Watteau (1684 – 1721). His painting " Ship leaving to Cythera" (1717) shows people longing for the blessed land Arcadia, and can be seen as the inspiration for a whole century-worth of subject matter and anticipates the Rococo style.

circa 1730 – 1745 Louis XV: **Rococo**

The Rococo period falls in the reign of Louis XV (1723 – 1774) and is therefore often referred to as Louis-quinze. The Rococo and Louis-quinz periods do not fully correspond, however, which leads to some confusion, since after the middle of the 18th century the Rococo style was gradually replaced by the Classical. Early Classical (or Neoclassical) style in France is also referred to as Transitional (transition from Louis-quinze to Louisseize).

The most prominent ornament in the Rococo period is the shell, which in many different forms decorates wall panels, furniture, mantels, and almost every element of interior decoration. Ormolu applications, wall sconces, candelabras, table decorations and pendulum clocks show shells in basic forms or in numerous variations. Typical examples are the picturesque genre designs by Justin Aurele Meissonnier (1695 – 1750) and by Francois de Cuvillies (1695 – 1768).

The typical pendulum clock of the period has fairly small figures which seem to grow out of the

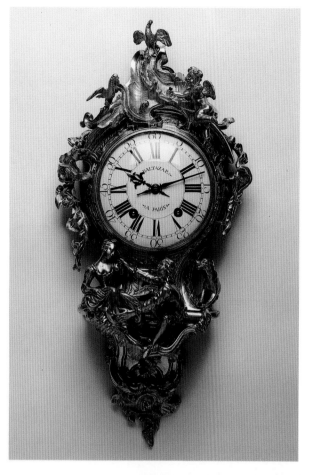

18 Amor vincit tempus – Love wins over time
The unity of figures, ornament and time measure, which was so typical for the Rococco period, is important for the composition and the underlying meaning. The loving couple, which could have stepped out of a Boucher shepards painting, is lost in time and united with nature. Cartel Clock, Louis XV, circa 1745, dial signed: Baltazar a Paris, fire gilded bronze.

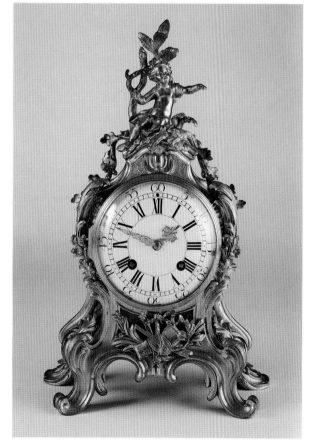

19 Pendulum Clock with Genius and Musical attributes
Typical Rococco clock with C-scrolls and Rocailles.
Louis XV, circa 1755, attributed to Robert Osmond (another signed exampl is documented, see Ottomeyer/ Proschel, I, p. 129), fire gilded bronze.

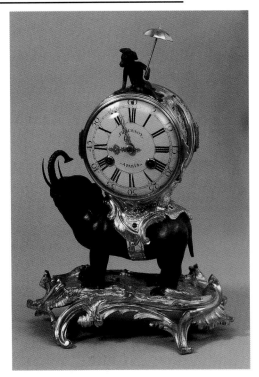
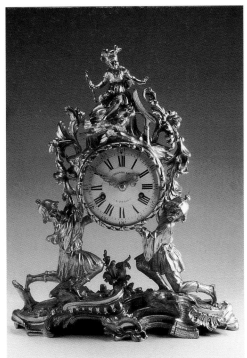

20 Elephant pendulum clock
The two animals are in a relationship around the clock. The elephant lifts his trunk and head towards the little monkey, which sits with crossed legs, very human-like, with a three pointed hat and a sun umbrella ready to go on safari. Witty themes, which make fun of humans are a favorite subject during the Roccoco period. The animals' patina is optically very contrasting to the gilding and makes them appear as independent figures. Elephant pendulum clocks were made by Jean-Joseph de Saint Germain and Jacques Caffieri.

21 Pendulum clock with chinoiserie
The two Chinese figures grow like Caryatides out of the base ornament in a very naturalistic way. They carry the pendulum clock and the boy with feather crown sitting on its top. The art of the chinoiserie which is based on the philosophy of the enlightenment, combines elements that were considered exotic or "indian". Louis XV, circa 1745, dial signed: Brindeau a Paris, bronze, probably by J.-J. de Saint-Germain (see signed example in Ottomeyer/Proschel, I, p. 119), fire gilded bronze.

ornamentation (see illustr. 19, 21). The pendulum clocks do not sit on rectangular bases or plinths as in the past, rather the objects are on c-scrolls or shell-shaped feet which are integrated into the ornamentation of the pendulum clock and which seems to melt into each other. The one exception to the size of the figures are the famous animal pendulum clocks with elephants, rhinoceros and lions, which can be interpreted as early animal sculptures. They are an expression of the playful mood of the period and its fascination with the exotic, as we see in the famous chinoiseries which are found in every castle.

The fire gilded bronze, which is the most obvious part of a pendulum clock, fits well into the period for one more reason. The Rococo period is characterized by light – everything shimmers and shines: the precious silks of the clothes, the gilded furniture and frames, the polished marble floor, the highly polished furniture, numerous mirrors, the high floor windows, the large multi-arm crystal chandeliers: yet nothing can enhance this play of light more than a fire gilded bronze, which reflects the lights on its many different surfaces in a very sophisticated way.

With respect to the choice of motifs, the Rococo period established the norm for many decades to come. As the love gods Venus and her son Amor gained popularity, the gods and heroes were replaced. Art historian Hans Sedlmayr points out that

the sculpture "Armor Cuts his Bow from the Bat of Hercules," made by Edme Bouchardon in 1739/50 perfectly symbolized this transition. Paintings by Francois Boucher show Venus and Amor in the company of nymphs, Pan (who is the god of shepherds), and playful putti, who have forgotten about hardships and live for pleasure only. An important role in this arcadian world is played by Bacchus, the god of wine, who makes you drunk. Drunkenness was a synonym for uninhibited attitudess, as opposed to disciplined and rational attitudes of the Classical style.

circa 1770 – 1830: Classical

The Classical style is divided into three periods of approximate time: 1) circa 1760 – 1790: Louis XVI style, 2) circa 1790 – 1804: Directoire and Consulat styles, and 3) circa 1804 – 1814 Napoleon I: Empire style and 1804 – 1830: Restoration style

1. circa 1760 – 1790: **Louis XVI**

By about 1745, early trends in architecture, sculpture, painting and interior design indicate a more stringent ornamentation, in contrast to the rounded, asymmetric, and unlimited ornamentation of the Rococo. By the early 1750s early Classical style can seen as a counter movement to the Rococo. The new movement shows a growing importance

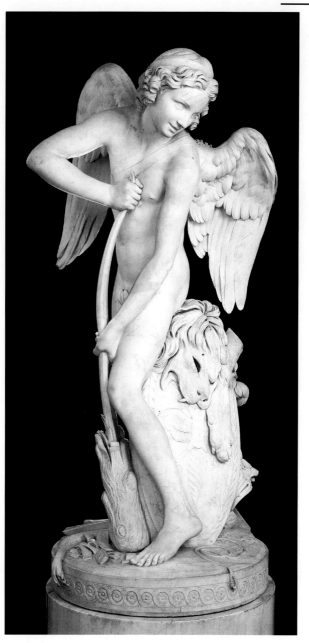

22 Edme Bouchardon (1698 – 1762): Amor cuts his bow from the bat of Hercules
1750, Marble, Musee du Louvre, Paris (Inv. Nr. MR 1761) The transition from the Louis XVI period, during which heroic myths were favored, to the galantly playful Roccoco period is obvious. The boyish Amor uses the deadly weapon of the greatest of all heroes in order to turn it into a fragile bow for his love arrows.

for individual parts of the whole, clarity, and harmony where hard edges and corners are avoided. Often bronze and white marble are used in combination. The Classical ornaments are borrowed from Greek and Roman antiquity and the style often is referred to as Greek taste. Acanthus leaves, egg and dart moldings, Greek keys, waves, and fruit garlands are decorative elements at the bases of these pendulum clocks, while ancient urns, vessels and amphoras appear at the tops. Laurel leaves and crowns appear as rewards from the gods. The figures on pendulum clocks are larger in size than in previous styles and they are not gilded, but often are bronzes with dark patinations in accordance with surface treatment and design of antique bronzes.

When Louis XVI became king in 1774, the Classical style had been fully developed. Art historians referred to the early Louis-seize period – maybe slightly exaggerated but somehow understandable – as the sweetest flower in the abundant garden of French interior decoration. (Hildebrandt, 1924, p. 9)

The interest of the art lover in antiquity was fueled by important archeological finds and art historical research. Writer Johann Joachim Winkelmann (1717 – 1768), born in Stendal, influenced the growth of Classicism. He published Thoughts About the I*mitation of Greek Pieces in Painting and Sculpture* in 1755 in Dresden. He

then moved to Rome to continue his research and in 1764 published his main work, *The Art History of Antiquity.*

In 1748 archeological excavations began in Pompeii, Italy, influencing the appearance of images from Pompeiian wall paintings and objects of everyday life such as chairs, tables, tripods and oil lamps on many pendulum clocks. The new discoveries of grotesque masks and decorations from the Etrusco-Greek culture, which had been discovered in Italy, had its impact on the Louis-seize style, which is then referred to as "Etruscan" (see illustr. 62). Very typical of this style is a delicate ornamentation with fine rolling acanthus leaves, slim griffins which seem to grow from the leaves,

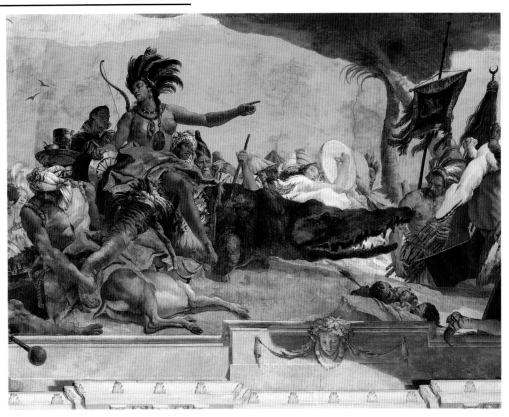

23 **America – Personification of a Continent** is part of the ceiling painting in the residence in Wurzburg (1750 – 53) by Giovanni Battista Tiepolo (1696 – 1770). The attributes, which later will be used by Deverberie for his America pendulum clocks, are all part of this lively allegorical painting by Tiepolo.

24 **Obelisk**
The obelisk, which is carried by four lions is a good example for the Egyptian trend at the end of the 18th century. The pendulum clock follows the design of the fountain at the Piazza del Popolo in Rome, which had been created by Giuseppe Valadier combining an antique Egyptian obelisk and the lions of Serapium (after 1784).
Consulate, before 1805, dial signed: Thiery a Paris, Bronzier: Antoine Andre Ravrio, fire gilded bronze, mahagony.

and slim chains with small tassels which are the connections between individual parts. Favored subject matter includes bucolic scenes incorporating Bacchus and the followers of Pan, the shepherd's god, flute playing maidens, rams and goats. Overall, the figures are smaller and not as detailed as in the early Classical stysle. The ornaments are flatter and imitate two-dimensional drawings.

2. circa 1790 – 1804, two styles: 1795-1799 **Directoire** and 1799-1804 **Consulat**

The political revolution in France in 1789 and the beheading of Louis XVI in 1793 brought the end to the "Ancient Regime." It is interesting to note that the break in the political tradition did not have as revolutionary an effect on the arts as one might expect. The period between the revolution in 1789 and the crowning of Napoleon Bonaparte in 1804 is divided in two styles (especially with respect to the applied arts): the Directoire (1795 – 1799) and the Consulat (Napoleon was first consul from 1799 to 1804).

During this period, a group of pendulum clocks showing noble savages and negroes appeared, Most of them were made by Jean-Simon Deverberie. Stylistically they fall between the

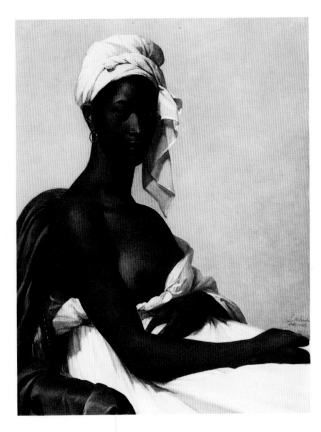

Louis-seize and Empire styles because of their oval bases, the pyramid-shaped composition, and playful putti with their long limbs and diverse figures. They clearly are the highlight of the art of the bronzes. These pendulum clocks reach a high degree of liveliness through various means, such as inlaid enamel eyes and colorful earrings. The compositions often represent the personification of countries or continents, which had been popular in antiquity and the renaissance, and were further influenceded by popular travel literature of the 18th century and its illustrations.

The Egyptian campaign of Napoleon Bonaparte (1798 –99) brought another trend with numerous Egyptian decorations such as Sphinx, Pharaohs, Obelisks, stylized lions and Scarabs, often with black marble, porphyry, and black finished bronze. The exotic and mystic symbols of this old culture were in such high demand, that an exhibition at the Louvre in 1994 referred to it as "Egyptomania."

3. circa 1804 – 1814 Napoleon I: **Empire** and 1804 – 1830: **Restoration**

The arts during the reign of Napoleon I (1804 – 1814) are characterized by a return to antique sculpture, antique architecture, and antique my-thology. The interpretations are large, tectonic and austere. The playfulness of the Rococo and the elegance of the early Classical style are gone. Bronze figures on these pendulum clocks reach frightening sizes and are on geometric shaped bases with sharp and elaborate relief on the front. The clock cases rest on this base, often in the shape of an ancient altar. In this architectural compositions, black patinated figures form a strong contrast to the case itself.

The subject matter is also serious in nature: usually taken from antique mythology, they often show a hero in a dramatic situation. The Empire style is very similar to the Louis –quatorze style in its monumentality and pathos, quite an irony, if one considers that the newcomer Napoleon was crowned emperor only, because he cleverly profited from the fall of the Bourbon dynasty.

The development of the pendulum clock case runs parallel to developments in painting styles. Jacques Louis David (1748 – 1825),one of the most prominent genre painters of his time, almost exclusively choose mythological and historical subjects, which were used to portray the current political scene. His famous painting "The Oath of the Horatio" (1784/85, Paris, Louvre, illustr. 102) shows a historical event of the Roman antiquity as told by Livius. The painting can also be seen as

25 **Portrait of a Negroe,** made in 1800, is the most famous painting by the painter Marie-Guillermine Benoist (1768 – 1826). Its subject theme and formal composition show large similarity to the figures of the "au sauvages" pendulum clocks. *Musee du Louvre, Paris (Inv. Nr. 2508)*

26 **America – Pendulum clock au Sauvage**
The dark skinned huntress triumphantly, like Diana, sits on top of the killed alligator. Her attributes – feather crown, naked upper body, feather skirt, bow, allligator, palm tree – elevate her to the personification of a continent, with traditional iconography.
Directoire, 1799 (dated drawing, en pluvoise an VII), design and bronze by Jean Simon Deverberie, fire gilded and patinated bronze, enamel eyes, Musee Francois Duesberg, Mons

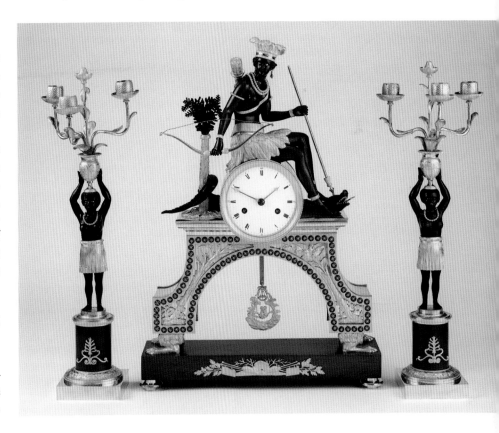

27 Alexander the Great

The god like conqueror is shown as young student. According to tradition Alexander, a pupil of Aristoteles, used to hold a ball in his hand and when it slipped into a metal basin because his hand tired, the noise would wake him again. The base relief shows him with Aristoteles in the library, his parents are seated on a bench in the back ground.

28 Allegory to study

The figures of the reader and the writer follow the models of Simon-Louis Boizot (1782), the design of the pendulum clock is attributed to Francois Remond. Applied decorations and reliefs vary with different copies. (see Ottomeyer/ Proschel, I. P. 295)

Circa 1790, dial signed: Allier a Paris, date (30 days of the month), fire gilded and patinated bronze, Griotte-marble.

a " Manifest of Classicism and the dawning political changes" (W. Hofmann The Divided Century, Munich, 1955, page 11 and 225), which portrays the political and moral demands of the middle class.

Some pendulum clocks are mere transformations of classical paintings into sculptures. This is especially true for "The Oath of the Horatio" (illustr. 101) after David, and "Phaedra and Hippolytus," which had been made after the painting by Pierre-Narcisse Guerin (1774 – 1833, Paris, Louvre).

The most important bronze sculptor of the time was Pierre-Philippe Thomire (1751 – 1843) who received many commissions from Napoleon I himself.

The emperor was an important supporter of the bronze art: never before had bronzes, on such large scale and in such numbers, been created. Napoleon employed only the most talented artists to decorate his own and the castles of his large family, who lived all over Europe. Bronze pendulum clocks had a special meaning for the emperor who liked to give them to persons as signs of special appreciation (see illustr. 28, 246). As one of the main benefactors of the art of bronzes and the large size of his orders, Napoleon also had an influence on the subject matters. Napoleon did not see himself as successor of the Bourbons but as the successor of the Roman emperors, and thus called himself Imperator – which leads to the term "Empire." The return to the Roman antique was part of his political program and was one way

for Napoleon to legalize his new powers, by putting them in an historical context.

As well as this "official" art, we find a very playful art form during the Empire period that shows many of the "small themes," which stem from everyday human life. Genre scenes were popular in paintings from the late 18th century on, especially the works by Jean Baptiste Greuze (1725 – 1805) who featured portraits of simple people whose simplicity was interpreted as purity and morality. The "good soul" in its naiveté and its belief in god is seen as the ideal member of a bourgeois society. Typical subjects of these pendulum clocks are " the huntsman resting," "the water vendor," or "the milk maid." Other historical subjects at the dawn of the Romantic period are "The good King Henry IV" or "Evening Prayer." Sometimes older, serious themes are lightened up by having children portraying the situation.

These small themes often are interpreted in smaller sizes as these clocks had been made for small, private rooms rather than large reception halls.

The preference for privacy became even greater after the emperor's abdication, which was followed by the Restoration period and the reinstatement of the Bourbon king Louis XVIII (1814 – 1824) and King Charles X (1824 – 30). Sometimes these two reigns are referred to as Louis-dixhuitieme and Charles-dix, but this distinction is rare. It is more common to refer to both periods as the Restoration.

By 1830, the period of creative bronzes is basically over. The technique of the bronze casting and the chasing and fire gilding by then had lost quality. The same can be said about the design of the figures. Instead of new ideas, we mainly find copies of older designs or regrouping of older scenes. Most of the French pendulum clocks made after 1830 are primarily artistic pieces, but not pieces of art.

29 The Painting " **Young girl mourning her dead bird**," by Jean-Baptist Greuze (1725 – 1805), which was probably inspired by a poem by Catullus, is in the tradition of sentimental genre paintings. The image of the dead bird, likely also a symbol of lost innosence, is repeated on a famous pendulum clock (illustr. 2, see also illustr. 152). National Gallery of Scotland, Edinburgh.

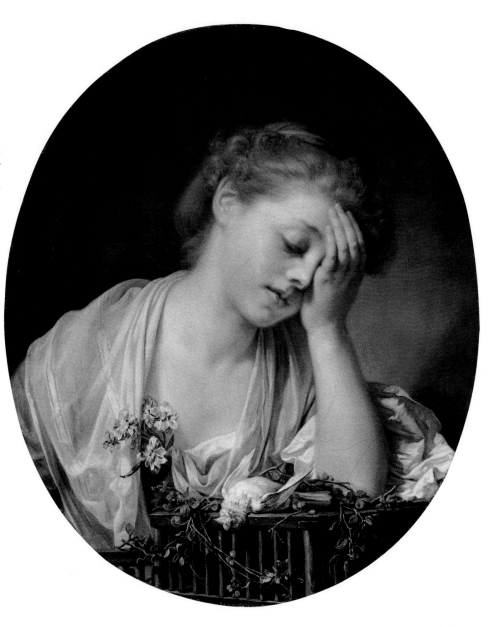

Gods, Heroes and Muses

Introduction

Gods, muses and heroes inspired the bronze artist to many different representations, which are almost exclusively based on Greek and Roman mythology. These myths were transmitted through literature and applied arts. "Mythos" is the Greek term for history and it is as old as the human language. Human beings always had the desire to name the unknown in order to make it less scary.

Frequently the name of one god is associated with numerous stories: he represents a philosophy, a life concept, a character, a certain feeling, with which the narrator or listener can identify. It was always fascinating for man, that the gods were very human-like. Which is also true vice versa: Man could become god-like without shame. The Greek and Roman gods themselves are far from perfection. They are at times revengeful, intriguing, lying, greedy, envious, and adulterers, murderers and torturers. They are known to be inventors, counsels, helpers and artists. But above all characteristics, they are very humorous. Homer writes " suddenly there was a roar of laugh from the gods' mouths." (Iliad, I 599) which shows qualities in these gods which are very different from the Christian god. One of the characteristics of a myth is, that each time it is narrated it is slightly modified in order to be adapted to the current situation. Despite these numerous variations the core meaning remains the same.

The hierarchy and relationships between the gods remains the same. At the top is Zeus (Jupiter), with his wife Hera (Juno), who rightly is always jealous. Followed by the maidenly and martial Athena (Minerva), the goddess of wisdom, and the powerful Apollo, who is also referred to as sun god Phoebus (Sol). His twin sister Artemis (Diana) is the goddess of hunting. She is always shown with her maidens, the nymphs and is the mistress of the forest. The connecting link between the gods is Hermes (Mercury), the divine messenger, whose attributes are winged helmet and shoes and who can fulfill any task. He is also the link between the gods and humans. Demeter (Ceres), the goddess of nature and corn is very powerful for mankind. In her honor the Eleusinian mystery fetes are held, which are devoted to the circle of life and death.

Heroes are the result of the union between gods and humans. Zeus again is the leader. It is interesting to see, that his half-god children such as Heracles and his lovers, such as Europa and Leda are shown more often than he is himself.

Heracles, son of Zeus and Alkmene, is allowed to enter heaven after many probes and fights. He is the big idol for warriors and rulers. The heroes of the Odyssey and the *Iliad* by Homer and other ancient myths are idolized, among them Achilles, Jason and Telemach.

Rulers always liked to identify themselves with gods or heroes from antiquity. Public acknowledgment of such an affinity shown some glory of the idol to the follower. Kings saw themselves as gods or descendants of Heracles or Ulysses and were portrait as such. Pendulum clocks with allegorical scenes for example may include an Athena (Minerva) figure, who confers with the king (Louis XVI for example) in his governing or who pays him homage and puts a laurel wreath on his head. The cornucopia is added as a sign of the prosperity which a king, who is on such good terms with the gods, can bring to his people.

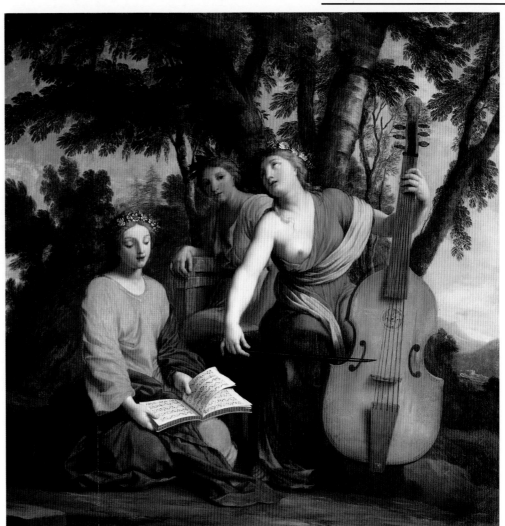

Since antiquity the cornucopia is an attribute for many goddesses and personifications, best known with Fortune.

Gods have been a favorite subject during the period from 1700 to 1830, becoming even stronger at the middle of the century and reaching a zenith during the Empire period which is known for its strong ties to historical painting – especially the works by Jacques Louis David (1748 – 1825).

During the early Classicism period, (after 1760), muses and genies, with their special attributes are favored subjects. The seven liberal arts are another popular subject matter. Unfortunately the attributes of these two groups are very similar which leads to mistakes and wrong interpretations.

The union of god and man not only results in heroes bringing battles and death, but also friendlier characters. Dionysus (Bacchus) is the son of Zeus and Semele and is the founding father of horticulture. Accordingly he is always gay and drunk and roaming the country with his companions in a panther or lion drawn carriage. His companions are minor nature gods, such as Silene, the goat legged Satyr, Fauns and his female devotees, the Bacchantes (Maenads). He is a cheerful god, who lets man forget his everyday problems. He is often depicted as a handsome young man with almost female features, with ivy and vines on his head and a drinking vessel in his hand. Part of this bacchanal scene is the pan's head and the thyrsus, a wand tipped with a pine cone and twined with ivy. These attributes can be found on many bronzes and should remind the viewer of his motto "carpe diem!" – make use of the day and remember the present time, which is an appropriate theme for a clock.

Even more suitable is the god of time himself, Chronos. He is shown either as young athletic figure with large wings, or as old man with bold head and a long, white beard, again showing the many aspects of time as past, present and future. Time is removed from the influence of man and gods alike.

30 **The Muses Melpomene, Erato and Polyhymnia** are shown in their traditional images, which are also known from pendulum clocks. This painting by Eustache Le Sueur (1616 – 1655) was made for the Muse room at the Hotel Lambert in Paris. Musee du Louvre, Paris, Collection of Louis XVI (Inv. Nr. 8058)

Apollo

...Apollo plays his lyre, high and nobly he strides, surrounded by glowing splendor, his beautiful clothes and sparkling feet shimmer.
(Homer, Hymns of the Gods, to the Pythian Apollo, verses 23-25.)

"Noble over mankind is his stature, and his stature is created by the greatness that fills him. An eternal spring, as in happy Elysium, clothes the charming manhood of complete years with pleasing youth and plays with gentle tenderness on the proud structure of his limbs."
(Winckelmann, p. 62)

Apollo, the most handsome of all Olympians, is also the most mysterious one of the gods. According to Greek mythology, he is the son of Leto and Zeus, twin brother of Artemis (the Roman Diana), born on the island of Delos. He is a very powerful god, feared by many other gods. His power is in many areas – he is the god of medicine, the god of oracle and as Apollo Musagetes the leader of the muses and as such the god of all sciences and arts. He is also the god of death, who shoots arrows with his silver bow which bring diseases and death. Despite those many different roles, he himself always gives the appearance of youth and the perfect male beauty, who over centuries has been an important inspiration to poets, philosophers and artists. See for example the Apollo bronze by Pierre-Philippe Thomire (1751 – 1843) (with stamp on back of base, illustr. 32)

The dark patinated figure is in strong contrast to the architectural gilded base and appears to be an autonomous figure. The god is naked, except for a piece of cloth, draped over the shoulders, similar to a cape. In a well-balanced step position, he faces the viewer straight. The leg taking no weigh barely touches the base and corresponds perfectly with the slight right turn of the upper body. The god rests his elbow on the altar and his hands hold a gilded lyre, which he plays with his right hand. The laurel wreathed head is turned slightly to the left and raised, the eyes looking in the distance, the singer fully captured by his inspiration.

Thomire, the artist, follows the rules of sculptures as they prevailing in Europe since Winckelmann's publications. His work is similar to the famous Apollo of Belvedere (illustr. 47) and other antique depictions of Apollo. It seems that Thomire followed the hymnal description of the Belvedere-Apollo by Winckelmann when creating his sculpture.

According to mythology, Apollo and the Muse Calliope had a son, Orpheus, whose singing was so beautiful and touching, that it was capable to move flowers, animals and rocks (see illustr. 97).

The powerful base relief (illustr. 33) shows one episode in the tragic love story of Orpheus and Eurydice. After the sudden death of this beloved spouse from a snake bite, Orpheus wanders aimlessly around. He tries to control his longing and grief for her by singing. Finally his song opens the gates to the underworld and he finds himself in front of the thrones of Hades and Persephone.

The relief shows Orpheus at the center, playing his lyre at the steps of the throne. To his left is the Charon, the boatman who ferries the souls of the dead across the river Styx, resting on his paddle. Next to him Mercury, the messenger, brings in Eurydice. Even further to the left is the three-headed guard dog of the underworld, Cerberus,

32/33 **Apollo with Lyre**
Empire pendulum clock by Pierre-Philippe Thomire with antique theme and clear outlines of the statue, which follows the rules of sculptures of the classicism period (see chapter on gods, heroes and muses).

33 The base relief shows a theme from Orpheus and Euridice. Orpheus sings to the god of the underworld trying to free his wife.

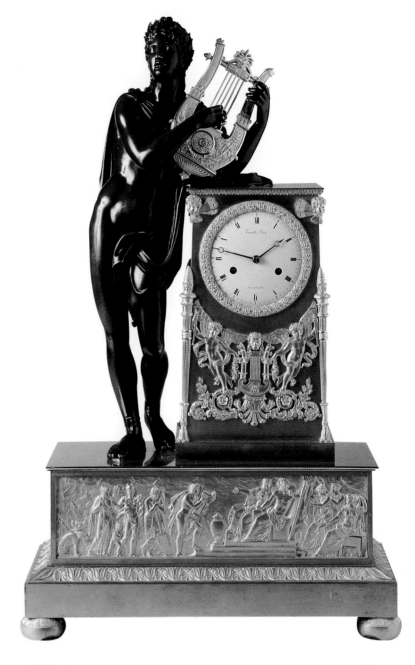

who is chained but seems peaceful. The same can be said about the three female figures sitting behind the throne. They are the Three Fates, who spin and cut every human's thread of life. One of them holds a spindle, another one some scissors, but each one of the three seems to have paused in its fateful task to listen to the music.

Orpheus gets another chance to bring Eurydice back to earth. However, on his way back from the under world to the world of the living, he is not allowed to turn his head to see his beloved. What seems an easy task proves to be a very difficult test, which neither of them passes. Orpheus looses Eurydice once again, this time for ever.

The story was very well known in France at the time, because of an Opera adaptation by Christoph Willibald Gluck (1714 – 1787), which premiered in Paris in French language in 1774 and because of Ovid's metamorphoses. Gluck was a protégé of Marie-Antoinette, who also was his student. The aria of Orpheus, lamenting over the final loss of his spouse is very famous. With the lamentation of Orpheus – son of Apollo – and the death of Eurydice – the circle closes for the most important figure on French pendulum clocks: the divine singer and god of death Apollo.

Karl Philipp Moritz found the perfect words to describe the character of Apollo in his " Study of the Gods."

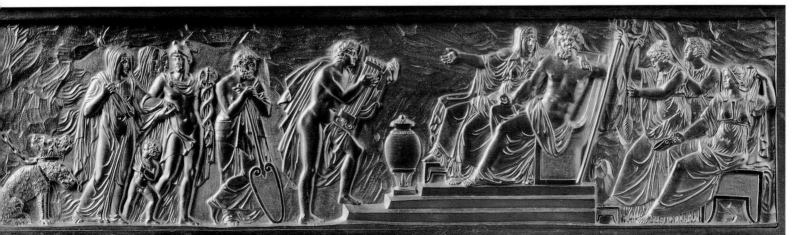

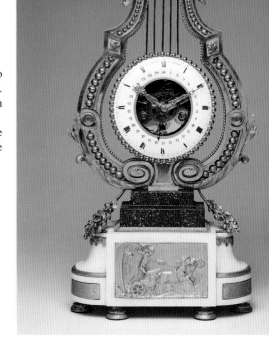

34 Apollo

This large pendulum clock by Pierre-Philippe Thomire shows Apollo and his sun charriot. According to mythology Apollo/Helios drives across the heavens with his charriot and causes sunrise and sunsets.
Empire, circa 1805, fire gilded bronze. Marble (see Ottomeyer/Proschel, I, p. 355).

35 Lyre-Form Pendulum clock

The head of Apollo, according to mythology also the inventor of the lyre, crowns this pendulum clock. The base relief shows him as driver of the sun charriot.
Louis XVI, circa 1780, dial signed: Sarton a Liege (Hubert Sarton, Paris 1748 – 1828 Liege), date, fire gilded bronze, white marble, porphyry.

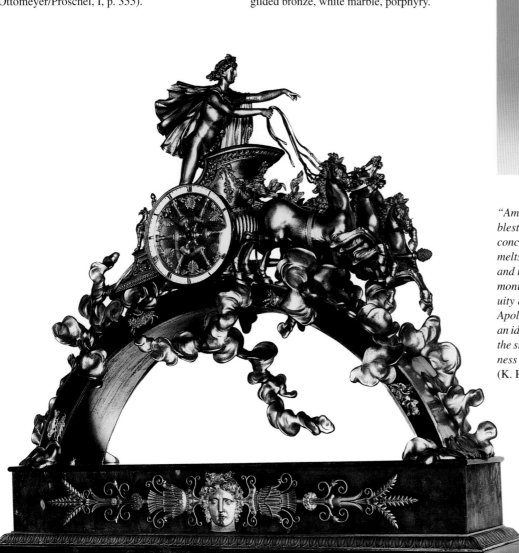

"Among the writings of old, this is one of the noblest and most admirable, because it takes even the concept of destruction, without hesitating before it, melts into the concept of youth and beauty again, and in this way gives the whole polarization a harmonious unity. Therefore the creative art of antiquity also seems, in the most beautiful portrayal of Apollo that our times still possess, to have attained an ideal of beauty that encloses everything else, and the sight of it, thanks to the unending manifold richness in it, fills the soul with astonishment."
(K. P. Moritz, Götterlehre, pp. 83ff)

36 **Europa**

"This part of the world [sic Europa] is represented by a remarkably dressed wonman: she wears a crown, which the Roman Empire had acquired for her in the universe…According to the poets, Europa received her name as daughter of Agenor, she was kidnapped by Jupiter and brought to the island of Crete."

Cochin, Iconology, Book II, Nr. 29.

Europa, who lent her name to the continent Europe is the beautiful daughter of Agenor, king of the powerful trading nation of the Phoenicians and his wife Telephassa.

The story of the rape starts quite harmless. According to mythology, Europa is at the seashore playing with some of her female attendants. Zeus watches them playing and is of course intrigued by her beauty. On the one hand he is totally smitten by the grace of the king's daughter, on the other hand is he totally aware of the his wife Hera's concern about his infidelities and her tight control over his whereabouts. Thus he sees his only chance to conquer Europa in a disguise: in another one of his tricks, where he at other occasions had been disguised as a swan or as a golden rain. Now he chooses to disguise as a bull. The beauty and the beast ? Certainly not. Of course he is the most beautiful bull ever and instantly catches the attention of the flower picking maidens. They approach the white bull and garland his horns. The fearless Europa climbs on his back.

This is the scene captured in the bronze executed by Robert Osmond around 1750. (see illustr page 34). In full Rococo style the asymmetric base is formed of C-scrolls and volutes, and fully melts into the scene. The blossoms and plants resemble a meadow, which is the scene of the story. On the right and left Europa's attendants are positioned. They focus on the bull and look up to Europa, who sits on top and looks down to them. She holds a long, full floral garland in her hand, which extends from the attendant to the left to the bull's

head. It is the connecting link between the individual figures and unites the whole composition. The three female figures form a triangle with their gestures, the garland and their eye contact at the center of which the bull and the clock, which is attached to its back, are positioned. He is seen from the side making a small step. The raised front leg can be interpreted as both, a peaceful and a moving gesture. The girl positioned to his right tries to touch his front leg and raises the right hand in order to pet the bull's head. But she is not successful. He lifts his head, thus symbolizing the connection to Europa, who is seated high above the clock and who is the only object of his interest. The majestic appearance of the bull symbolizes the powerful god Zeus.

Rape of Europa

"He, the father and leader of the gods—when he swings his right hand, / Three-forked lightning flashes, and his nodding shakes the earth—; / Now he becomes a bull… / Roars and paces, a splendid animal, on the carpet of the meadow. / Muscles tense on his shoulders, his abdomen hangs to his knee-joints; Small, to be sure, are his horns, but one might think them turned artificially… / On his forehead there is no threat; his eye / Does not frighten, but looks friendly. Agenor's daughter is astonished At how he struts so finely, without threatening to attack. / But as tame as he seems, she is at first too shy to touch him; / But soon she nears him and offers flowers to the gleaming head. / …And see, now the princess even dares / To seat herself on the bull's back—she knows him who bears her / Not—but from the land, the dry shore, there slowly walks / The god with betraying steps, first into the water, / Then goes deeper on in, and takes his prey away in the sea."

(Ovid, Metamorphoses, II, 848-870)

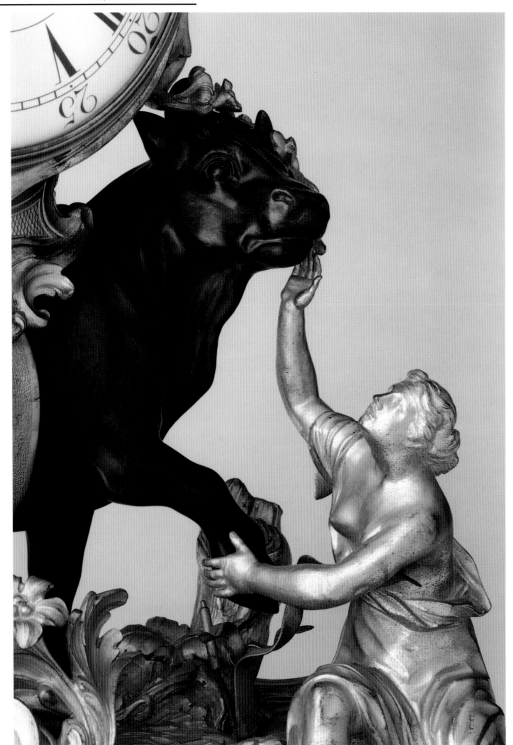

37 The bull looks up. Neither the attention nor the gentle strokes by the attendants will distract him from his goal, the rape of Europa. He is already raising his front hoof to charge ahead.

ing the Rococo also in porcelain. Osmond has taken numerous earlier examples and has created a totally new composition. It is easy to detect the connection to other pendulum clocks of the Louis-quinze and the "Gout picturesque," which show lions, elephants and rhinoceros in similar positions carrying clocks on their back. There is also a strong connection to the paintings of the Rococo, especially the famous Europa paintings by Francois Boucher (1720, 1737, 1747), Noel-Nicolas Coypel (Paris 1688 – 1737, painting from 1725, at the Pushkin Museum in Moscow), which have received even more fame as tapestries and etchings. A painting by Lemoynes, which Laurent Cars (Lyon 1699 – Patis 1771) converted into a fa-

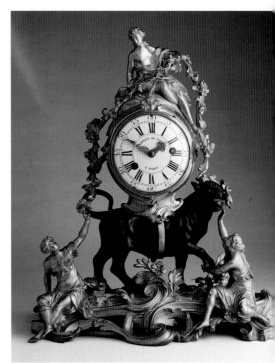

37, 38 **The Rape of Europa** is a master piece by Robert Osmond. Composition, interpretation and technical execution form a perfect harmony. Louis XV, circa 1750, stamped OSMOND at the base, dial signed Charles du Tetre a Paris, fire gilded and patinated bronze (for other examples see Ottomeyer/Proschel, I, p. 125).

This bronze composition was so well done and received, that shortly thereafter another famous bronze artist, Jean-Joseph de Saint-Germain made another bronze with only minor alterations.

In the 18th century the "Rape of Europa" was a favorite subject matter in the plastic arts. The intriguing theme of a relationship of a powerful bull with a graceful maiden was a favored theme for small sculptures, initially made in bronze dur-

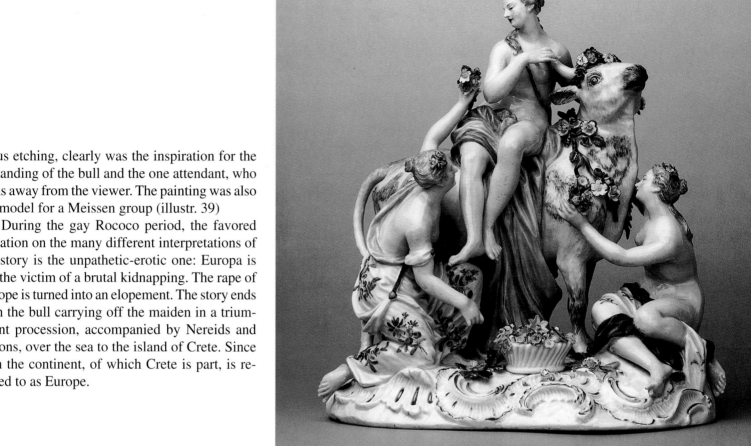

mous etching, clearly was the inspiration for the garlanding of the bull and the one attendant, who turns away from the viewer. The painting was also the model for a Meissen group (illustr. 39)

During the gay Rococo period, the favored variation on the many different interpretations of the story is the unpathetic-erotic one: Europa is not the victim of a brutal kidnapping. The rape of Europe is turned into an elopement. The story ends with the bull carrying off the maiden in a triumphant procession, accompanied by Nereids and Tritons, over the sea to the island of Crete. Since then the continent, of which Crete is part, is referred to as Europe.

39 Porcelain figure group of Europa and the Bull

The theme was a very popular one and was also interpreted as a porcelain group. The two attendants have a large similarity to the ones on the pendulum clock.
Meissen, circa 1760, modelled by Friedrick Elias Meyer, porcelain, multi-colored, Kunstgewerbemuseum, Berlin (Inv.. Nr. 18, 71).

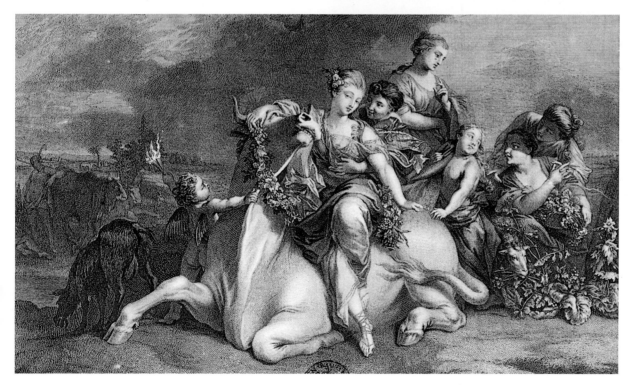

40 Europa and the Bull
Engraving after E. Jeaurat after Le Clerc ("From Gotzkowsky to KPM" Catalogue, Inv. Nr. G 1433)

Clio – the Muse of History

41 Clio, the Muse of History
"Time is shown in the back ground as God Chronos and the globe on which the prime Muse is standing convey the idea, that history encompasses all places and times. In her left hand the muse holds a book, which is inscribed Thucydide, who was one of the most prominent historians of antiquity." Another of her attributes is the trumpet. It allows the muse to proclaim the glory of big heroes, in order to teach people and kings.
Cochin, Iconology, Book I, Nr. 65.

The pendulum clock shown in illustr. 43 was made during the early Classicism period, approximately 1765. It carries the clock maker's signature, Gabriel-Pierre Peignat (died 1776) on the dial and the back plate.

It is part of a series of pendulum clocks showing the Muses and personifications of the liberal arts, which had been very popular and which were often made for libraries and studies.

The figure is Clio, the Muse of history. She can be recognized by her attribute, a book – which she is busy studying. Clio is the noblest of all the nine muses, who are the daughters of Zeus and Mnemosyne. It is Clio, who is very similar to her mother, the goddess of memory. Neither art nor science could possibly succeed without the ability to memorize. Without memory neither music, lyric or epic poetry could exist. From antiquity on, the call of the muses was the first step in every artistic-intellectual undertaking, which even the best could not ignore. Homer starts his Odyssey, which stands at the beginning of European poetry, with "tell me muses about the deeds of a far travelled man…"

Glory to the one, who has lived with distinction and whose fate endured over time. It is the task of history writing to document these fates for posterity. The complexity of this idea is transferred into the composition of bronzes, which helps the viewer to not only intellectually but also sensually understand the concept: History, personified as Clio, is leaning on time – the clock movement – and yet it is longer lasting than time itself. When Cochin wrote his iconography, he always showed Clio with Chronos, the god of time. Traditionally Chronos is an old man with a long beard, a scythe and an hour glass.

The figure of Chronos often is replaced by the clock movement and dial. The large book, which Clio holds in her hand is a book by Thucydides, the most famous history writer of antiquity. The laurel leave is another famous attribute of Clio. The laurel tree is the holy tree of Apollo, who as the master of the muses is referred to as Apollo Musagetes. Branches of the laurel tree, when woven into a wreath are a sign of glory and crown the ones, who as artists or merited people are inspired by the muses and earn distinction in history.

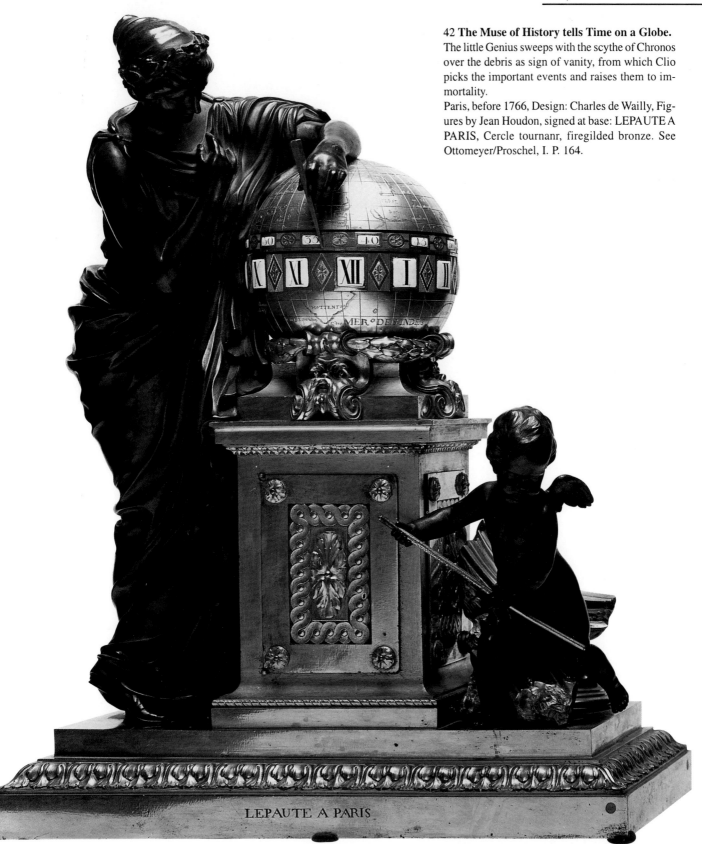

42 The Muse of History tells Time on a Globe.
The little Genius sweeps with the scythe of Chronos over the debris as sign of vanity, from which Clio picks the important events and raises them to immortality.
Paris, before 1766, Design: Charles de Wailly, Figures by Jean Houdon, signed at base: LEPAUTE A PARIS, Cercle tournanr, firegilded bronze. See Ottomeyer/Proschel, I. P. 164.

LEPAUTE A PARIS

43 Clio-Pendulum clock

The elegant figure, which appears autonomous because of its patination, is nevertheless well blended into the composition and confirms a quote by the art historian E. Hildebrandt: "The early *Louis-seize* period is the most scented flower in the large garden of French decorative arts" (*Painting and Sculpture*, 1924, p. 9).

Louis XVI, circa 1765, Movement and dial signed Peignant a Paris, pin wheel escapement, fire gilded and patinated bronze, ebonized wood.

44 Clio

A later variation of the theme adds a little Genius and globe.

It is very typical for the early Classicism, that ideas taken from antiquity are shown in a way almost identical to their antique models.

The bronze in illustration 43 shows a clear pyramidal shape: The base, which is slightly curved is decorated with a wave ornament and is the topped by another step on which the figure and the clock drum rest. The clock drum with white enamel dial and bulls eye glass is moved right off center and it forms a rest for the reading Clio, who holds the large book in her hands. The brownish bronze figure has a wonderful patina and appears in stark contrast to the fire gilded case. At the same time it perfectly harmonizes with the ebonized plane of the lower base.

The slightly turned figure forms one side of the pyramid, which corresponds to the laurel leaves to the right of the clock drum. The directions of the eye and the angle of the book direct the viewer's attention towards the dial of the clock and the inner part of the pyramid. Between the clock and the female figure a cornucopia is draped on the upper step with flowers and fruits flowing out of it. Every element of the pendulum clock has some relation to each other. The clear, pyramid shaped architectural composition does not appear stiff.

The movement in the figure, the breaking of the middle-axes principle in its composition, the rhythmic, stepped structure and the different details in every element give the bronze a very lively appearance and invite to different interpretations. The piece

perfectly translates the aesthetic premises of the Classicism, to find the harmonic equilibrium between movement and rest.

The artist of the bronze pendulum clock in illustration 44 is anonymous. It has strong resemblance to a famous pendulum clock made by Laurent Guiard (1723 – 1788) for Madame Geoffrin, who maintained an important salon for artists and politicians in Paris (illustr. 45). Because of her big influence many casts of this clock have been made, one of which she gave to Diderot as a present in 1768. One of the models is now in the Wallace Collection. The original name of the bronze "l'Emploi du Temps" refers to time without neglecting the mystery of the passing of time and the right use of the passing time.

"elle publie & consacre les faits & la memoire des grands hommes, pour l'instruction des peuples & des Rois." "She makes public and keeps in mind the deeds and the memory of great men, for the instruction of mankind, the people and the kings."
(Cochin, Clio, No. 65, author's translation)

45 "Pendulum clock a la Geoffrin"

The bronze is an allegorical portrait of Madame Geoffrin, who ran an important salon and who had been painted on the pose of a student by Nattier in 1738. Diderot called the pendulum clock "Pendulum clock a la Geoffrin". The popular mold was recast numerous times over a period of three decades, one of the earlier casts is in the Wallace collection and dates from circa 1768.

Design of the fire gilded bronze by Laurent Guirard (1723 – 1788), cast by Edme Roy (Maitre 1745), dial signed Julien le Roy a Paris, date, and day of the week.

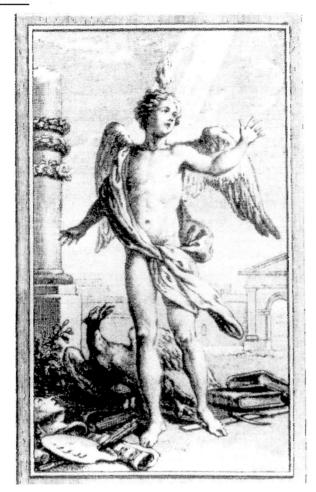

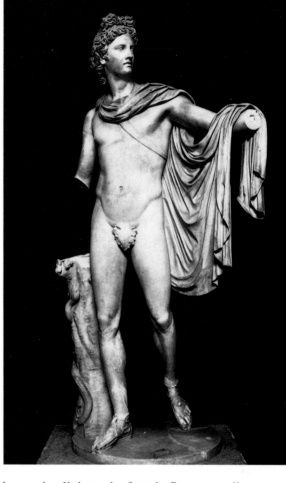

The large pendulum clock (illustr. 50) strikes the eye because of the strong contrast between the architectural, fire gilded base with the dark patinated, fluid-elegant figure. The optical clarity of the composition, which is further stressed by the classical antique appearance of the figure, is in strong contrast to the subject which is not very clear at first view.

In the center of the pendulum clock is an altar, which houses the clock movement and which is also the base for several attributes.

A naked youth with open wings approaches the altar from the right and turns to the female figure which is positioned to the left of the altar. The floating movement is enhanced by the clouds on which the youth is floating. The artist of the bronze does not want to rely exclusively on this one visible sign, the whole body language of the youth is used to further enhance the feeling of floatation: only the left leg touches the clouds with its tip, the right leg is slightly bent and is floating freely. The right arm is raised and holds a torch and the loin cloth is captured in full movement. It seems that the winged youth had just arrived in

order to give light to the female figure standing at the left.

The female figure is wearing a classical dress and – contrary to the floating youth, who is seen from the side – faces the viewer straight. Despite the peaceful figure, it does not seem to be motionless. The one step with crossed legs, the turning towards a writing table, where she is in the middle of taking some notes which is accompanied with a slight turn of the head, makes her appear very lively, despite the apparent concentration. The slight turn also creates the connection to the arriving youth and the attributes positioned between the two figures are the center of the composition. Book, scroll and spherical globe form the spiritual center of the composition.

The solution of this puzzle requires reference to contemporary iconography. The floating youth is the personification of genius, the female figure is imagination and the attributes are those for the liberal arts.

Examples can be found in the book Iconologie par Figures by Charles Nicolas Cochin (1688 – 1754), one of the most important publications of

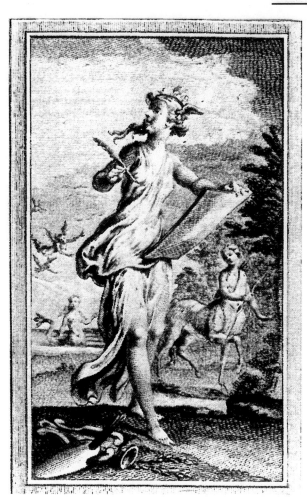

allegorical themes in the 18th century. Genius and imagination are the most important elements of any type of art, referred to by the attributes on the altar, which refer to the different types of art. Cochin gives a detailed explanation for these attributes and the different movement and defines genius. According to his explanation the nakedness is a sign of the spiritual strength of the youth who is thus similar to angels. Genius as a spiritual

48 Personification of Imagination
"The attributes which characterize the poet and the painter are very similar to imagination, in order to show how important it is for both of them
Writing table, writing feather and a classical femal figure are also found as bronzes.
Cochin, Iconology, Book III, Nr. 1.

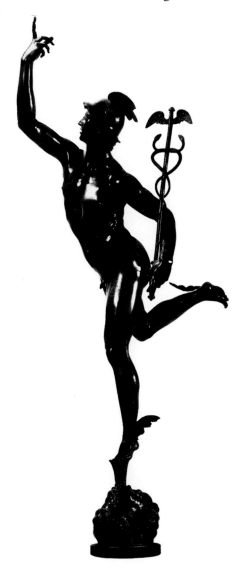

phenomenon can be understood fairly easy, while the comprehension of imagination requires some philosophical intuition. Philosophy and aesthetic of the 18th century interpret imagination not simply as fantasy, the ability to develop new thoughts, but also the ability to reach in the past. Cochin cites a text passage by Voltaire. Accordingly imagination is the ability of the soul, which also includes... to remember the ideas about objects, which have been stored in memory; therefore the Greek referred to the Muses as *"daughters of memory"*

The familiar is transferred with enthusiasm and youthful energy into something new. It therefore is personified by a young female, which gives the new creatures existence and keeps track of the new creations by writing them down on her table. In order to show how important imagination is for poetry and painting, the attributes are positioned closely to its figure.

A comparison between the figures of Cochin and the one on the pendulum clock shows how closely the artist followed the iconographic model

49 Mercury
Giovanni da Bologna's (1564 – 65) Bronze of Mercury served as a different model: the elongated figure, with raised arm, the illusion of floating, which is achieved by minimal attachement to the base, have inspired the creators of many pendulum clocks.

50 **The allegorical Figure group** translates a highly complicated philosophical and aesthetic idea: Genius and Imagination, both personified, are at the root of any art. The high quality of the bronzes and the demanding composition are probably the work of Clodion (Claude Michel, 1738 – 1814) (see his *Terre cuite* relief, *La peinture et la Sculpture,* 1779, illustr. P. 191 and 194, Catalogue Clodion, 1992),
Empire, circa 1810, fire gilded and patinated bronze.

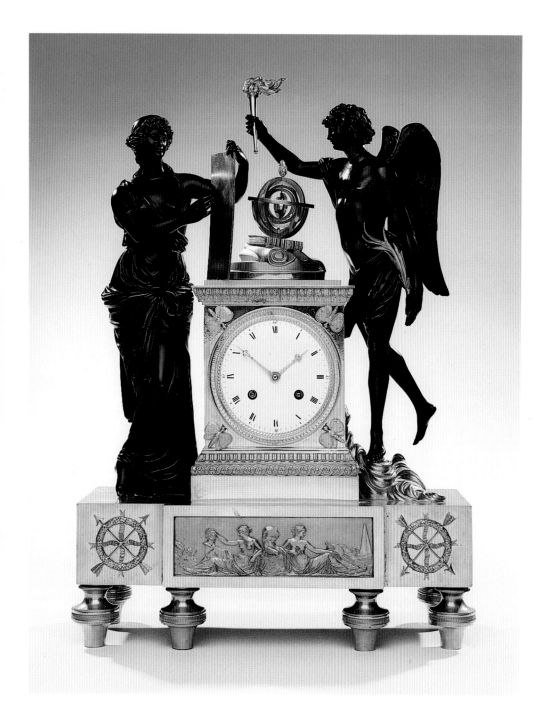

while using his artistic freedom in interpretation. The base relief, for example, does not refer to poetry and painting, but sculpture. The relief is very detailed and personifies painting and poetry, which rest on either side of a small pedestal on which one of the most famous sculptures in history rests – the torso of Belvedere, which is the model and ideal for generations of sculptors.

The composition also wants to settle the old dispute of the hierarchy of arts. For the longest time poetry and, since the renaissance paintings are considered the noble, fine arts, which were superior to the manual sculpture and looked down on it with its fine, clean hands. Maybe the artist wanted to show his own position in this eternal battle of the arts. His hidden message is that imagination and poetry form also the bases for sculpture, which is equal to the other arts.

We do not know who designed the bronze. Form, theme and composition points to an exceptional artist, trained in the classical form of sculpture. The slightly elongated figures, the deep knowledge and slight adaptation of antique models ("Apollo of Belvedere") and especially the base relief point to Clodion (Claude Michel to be specific, 1738 –1814), who was one of the most prominent sculptors of the 18th and early 19th century, who has made several significant pendulum clocks. Maybe he wanted to prove his competence as a sculptor with this piece.

51 Love and Time

Chronos is sitting in a boat, which is steered by Amor, and has his head lowered in a contemplative manner. The composition was inspired by a popular song by Joseph-Alexandre de Segur (1757 – 1805) where Amor is singing: " See young shepards and shepardesses – how love lets time fly". The song ends with the triumph of Chronos:" I sing in my own way the old refrain of wisdome: Ah! Le temps fait passer l'Amour – time lets love pass". Another copy of the group was done in biscuit pocelain by N.-J.-H. Nast, earlier bronze models are known by C. Galle and A.-A. Ravrio (1814).
Empire, circa 1815, dial signed: Le Roi Horloger de la Madame a Paris, fire gilded bronze (see Cat. Malmaison, Nr. 18).

52 Allegorical Scene: The Genius Outliving the Destruction of Time

The winged Chronos pushes the column, which contains the clock, off its base and thus shows us in a very dramatic way the destruction of everything manmade through time. Only the spiritual and intellectual can escape this destruction. This is confirmed in the works of famous Greek and French writers and philosophers, whose names are engraved in the base of the column. The verse on the base of the clock reads: "the eternal Genius outlives time. And you, time – without any amazement – think about these ravages", are a poetic commentary about the piece.

Louis XVI, circa 1780, dial signd: Boucher Horloger du Roi (Marc Boucher, Maitre 1772), date, fire gilded bronze, white marble.

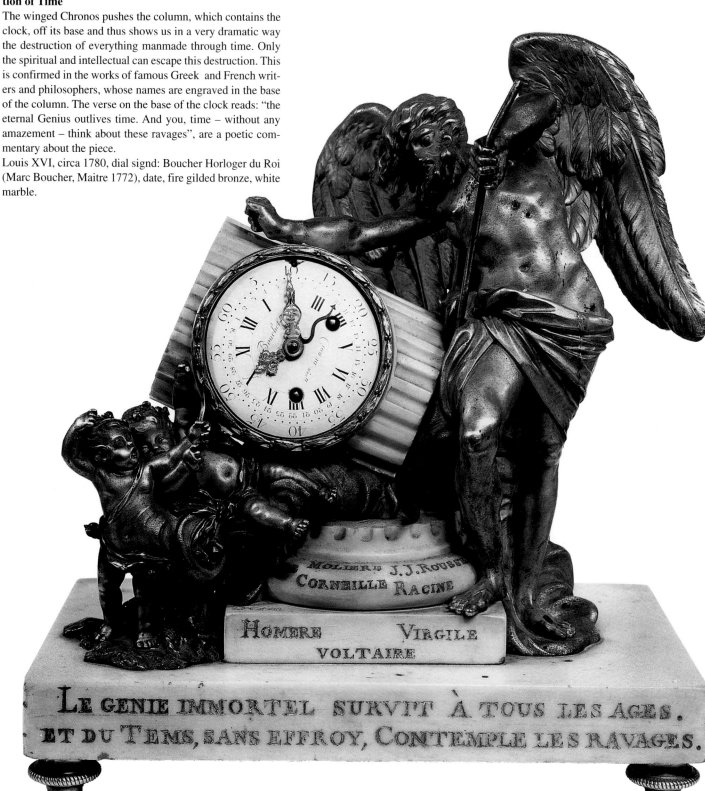

53 Zeus the Ruler over the Universe and Time

With a powerful gesture Zeus holds a bundle of lightning in his raised right arm. The eagle on his side carries the starglobe with the signs of the zodiac on his open wings. The applications on the base repeat the eagle wing and lightning motiv, and are centered by a circular medaillon of the goat Amaltheia, who had nursed the infant Zeus, after his mother Rheia had to hide him from his father Kronos and leave him with the nymphs. This trick allowed Zeus to dethrone Kronos and later forced him the devour his siblings.

Empire, circa 1815, movement signed: Hemon A Paris, fire gilded and patinated bronze, red marble.

54,55 **Leda and the Swan**

The royal daughter Leda, famous for her beauty, is surprised while taking a bath by Zeus, who desires her and has disguised as a swan. According to mythology after the union with Zeus, Leda bears two eggs, out of which the two Dioscuri Castor and Pollux are hatched. The applied decorations on the sarcophagus base follow the theme. The eagle of Zeus with the bundle of lightning in his claws is flanked by the profiles of the Dioscuri – similar to a family tree father and sons are connected by vines.

The high-quality bronze is a work by Pierre-Philippe Thomires, whose name is on the dial.

The elegant figure of the beauty, shown in divine nakedeness, reminds us in her posture, with crossed legs and the touching of the ankle of the famous , often copied antique sculptor, the "Dornenauszieher" (1st century B.C., Rome, Konservatory Palace), which during the Rococco was also shown as a female figure bathing.

Empire, circa 1810, dial signed: Thomire & C.nie, firegilded bronze.

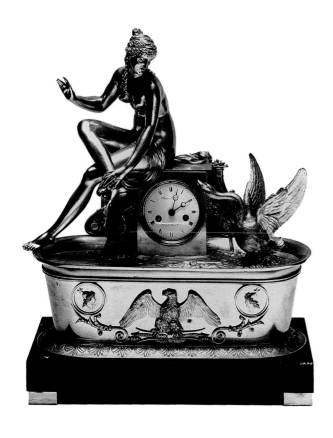

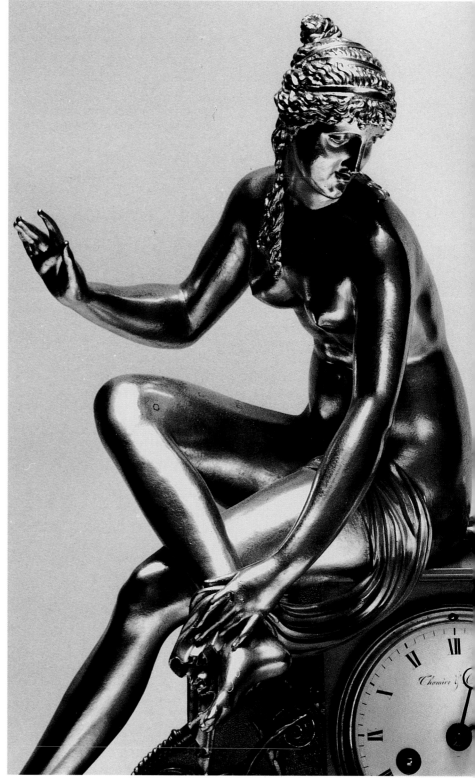

56 Victorius Athena between two Obelisks

The warrior goddess carries chest armour, helmet and the Aegis shield, which bears the head of Medusa. Like a monument, she is flanked by two obelisks decorated with trophies. She is not carrying her spear – as triumphant goddess of peace. Louis XVI, circa 1775, signed: Cronier a Paris (probably Antoine Cronier, b. 1732), fire gilded bronze, white marble.

57 Diana

The virgin goddess – with the typical moon sickel in her hair – is resting after the hunt. She holds the bow in her right hand and a dead bird in her left. A small hunting horn is at her feet, and she turns towards her hunting dog, who looks up to her dutyfully. The base relief shows hounds chasing a deer. The bronze conveyes the ambivalenz for which Diana is famous: the gracious – lovely maid turning into a cruel killer during the hunt. Empire, circa 1810, dial signed: Dubuc/ H.ger a Paris, fire gilded bronze.

58 Triumph of Diana

This large pendulum clock shows the goddess of hunt in a splendid charriot, which is pulled by two deers with large antlers. The classical figure of the goddess holds the reigns in one hand and bow and quiver in the other. A hunting dog from her pack jumps up on her. Behind the charriot one of her maiden companions is standing with another dog. The base shows a dramatic hunting scene with hounds and a wild boar. The relief is flanked by parforce horns and signaling putti.
All details are related to the main theme such as the feet of the pendulum clock which are formed as animal claws.
Empire, circa 1815, fire gilded bronze, marble.

59 History is writing on the wings of Time (*Opposite, Bottom Left*)

Clio is collecting the facts and events of history in a book. The gigantic book rests on the open wings of Chronos, who symbolizes the passing of time, as does the clock, which is at the base of the bronze group. Time destroys all man made things – symbolzed by the fallen columns, the script rolls and books – but history will elevate the past things over time and is triumphant over Chronos. The metaphysical element is symbolized by the clouds.
Louis XVI, circa 1775, Bronze: Etienne Martincourt (Maitre 1762), after a model by Augustin Pajou, clock maker: Lepaute, Horloger du Roy, fire gilded bronze, white marble. The pendulum clock is illustrated in J.D. Augarde, Les Ouvriers du Temps, 1997, p. 37.

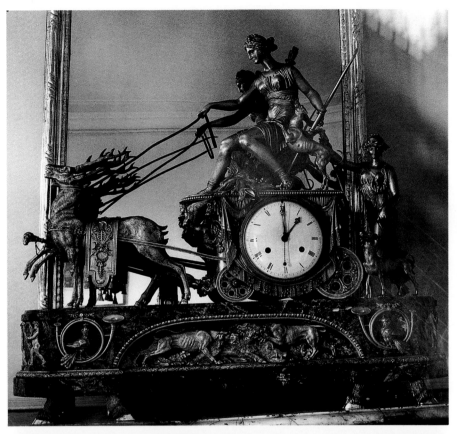

60 **Diana**

The virgin goddess of hunting is carrying her quiver with arrows and a bow. A grey hound from her pack and a tree trunk, symbolizing the forest, which comprise her world, are flanking the clock movement, on which she is sitting. In the base relief putti are playfully recreating a hunting scene.
Directoire, circa 1795, signed on the dial: Angevin a Paris, fire gilded bronze.

61 **Mercury Instructing a young Girl**

The messenger god Mercury – recognizable by his winged helmet and feet – instructs a young girl with a book of love poems. His heavenly background is symbolized by the clouds at his feet, his divine confidence is expressed in his casual-elegant posture and the caution, with which he leads the shy, inexperienced and anxious girl to the new. The figure of the girl has a large similarity with Chloe (illustr. 171)

Louis XVI, circa 1780, dial signed: Imbert L'Aine/a Paris, fire gilded bronze, white marble, Residenz, Munich (see Ottomeyer/Proschel, I. P. 248).

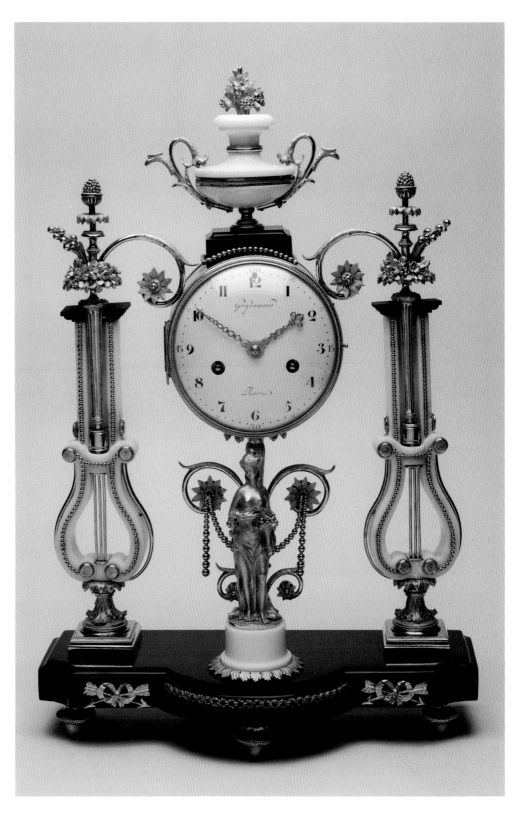

62 **Flora**

The delicate statue of Flora is fully integrated in the filigree ornamentation of the pendulum clock. The spiral shaped vines, the naturalistic flowers and leaves are typical for the grotesque style or the "gout etrusque", which, by 1770, had replaced the stricter "gout grec" of the early Classicism period.

Louis XVI, gout etrusque, circa 1780, signed on the dial: Guydamour a Paris, fire gilded bronze, white and black marble.

63 Ceres

Ceres is holding a bushel of wheat, one of her typical attributes in her hands. Masks are releasing powerful fountains of water as further symbols of fertility. Another emblem of the goddess are winged snakes which are part of the base relief. When Ceres could get her daughter Persephone back from the underworld and banish the curse of drought from the earth, she instructed the first priest of the Eleusian mysteries, Triptolemos, to teach man the art of agriculture. Directoire, circa 1795, fire gilded bronze.

64, 65 Ceres

The powerful goddess of earth is wearing a diadem of wheat and a raised sickel. She is the symbol of cyclical time, which moves in the rhythm of the seasons. All parts of the pendulum clock are subordinated to this theme: The clock is at the center of a sheaf, the gleans of which frame the dial like sunbursts. To the right of the clock movement a flail and basket are positioned. The base applications are composed of rake and spate. Empire, circa 1805, bronzier: Jean-Andre Reiche, fire gilded bronze.

65 The very detailed base relief shows a farmer plowing his field. His action again is part of the cycle of nature. Above all the sickle of the goddes – as symbol of life and death, the eternal cycle of creation and vanishing.

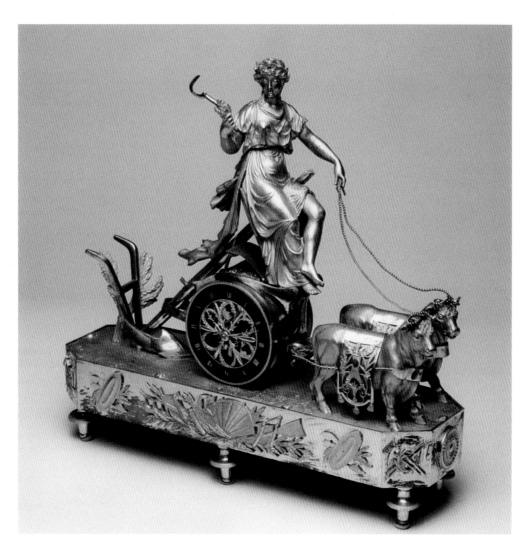

67 Triumph of Ceres

The powerful goddess drives a splendid charriot which is drawn by two decorated oxen. The drive to the field turns into a triumphant and festive parade. In her left Ceres hold the reigns, in her right the sickle, which characterizes her as the goddess of harvest and the origin of farming. The plow, which is decorated with wheat and other agricultural emblems, are part of the base decorations. The clock is perfectly integrated into the bronze, the movement is visible between the spike of the wheel. The mythos of the goddess Ceres, which mainly focuses on the seasonal changes of growing and dying, fits well to the time theme and vanity, which are symbolized by the clock. Empire, circa 1815, fire gilded bronze, blue enamel.

68, 69 **Baccantes**

The two figures are followers of Bacchus/Dionysos and enrichen the orgie-like parties of the wine god with dance (Maenad) and music from panpipes and cymbals, which a little goat legged faun holds in his hands. The excited pose of the faun and the floating appearance of the Bacchante highlight the ecstatic character of the feast, similar to the one shown in the base relief.

Louis XVI, circa 1785, dial signed: Millot a Paris, fire gilded bronze.

70 Goblet Clock

Clock in the form of an antique covered goblet with three dimensional vines and masks in a bacchantian style and base applications in the form of Janus heads.
Empire, circa 1805, signed: Pillioud, Rue de Richelieu, Nr. 55, fire gilded and patinated bronze.

71 Vase-Form Pendulum Clock with rams head handles "tete de belier", typical for the Classicism period.
Louis XVI, circa 1785, dial signed: Pierre Dupuis, fire gilded bronze.

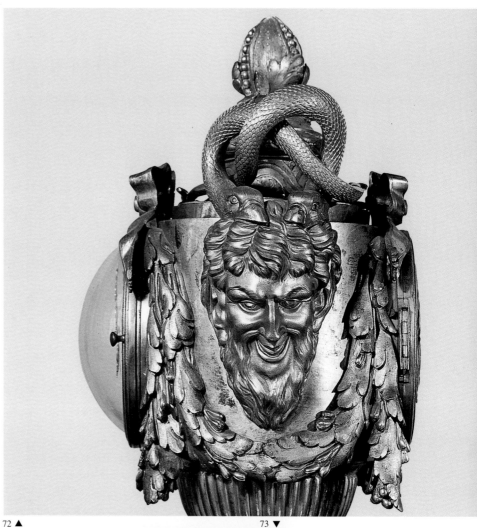

70 ▲ 71 ▼ 72 ▲ 73 ▼

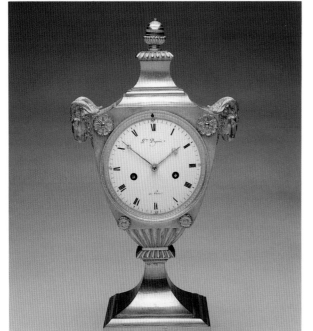

72, 73 Vase-Form pendulum Clock with Fauns heads

During the early Classicism period, starting in 1760, the form of the vase pendulum clock , which has a clock integrated into an antique style vase was developed. The big covered vase is decorated with two large, three dimensional heads of fauns. Following the "gout grec" are ornamentation with flutes and laurel wreaths.
Louis XVI, circa 1770, dial signed: Lethier Beuron a Paris, bronzier: probably Robert Osmond, fire gilded bronze, drawing in "livre de dessins", Nr. 143, anonymous.

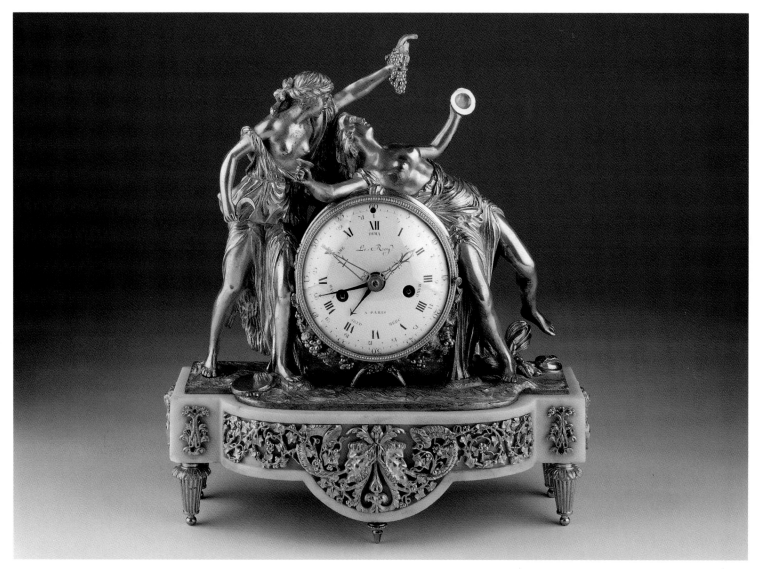

74 Bacchantes

The Bacchantes belong to the followers of Bacchus/Dionysus, the god of wine and intoxication. Their drunkenness is made clear by their unstable stance and their breasts, bared in their wild dance. The grapes held aloft, the grape sickle, drinking cup and cymbals likewise belong to the subject matter.

(Le Roy à Paris, bronze ascribed to Francois Rémond, Louis XVI, ca. 1780, fire-gilded bronze, white marle, central date, hands for names of days. *Kunsthandel Michael Nolte, Münster.*)

77 Bacchantes' sacrifice

The two Maenades are dancing entranced around a precious sacrifice vessel, which is decorated with two rams' heads. The passionate figures are bending backwards and keep their equilibrium only by holding on to wreaths made of ivy and vines, which are tied around the rams' heads. They are looking up to the flame which is burning high above the vessel. Despite this instable position and the very plastic execution of the group, the overall appearance is very harmonious and symmetric, with a strong silhouette. It is a typical example for the grotesque style, which is a combination of Roman groteques and those of the Mannierism period of the 16th century, with numerous plastic and ornametal elements. The very elaborate base application is a typical grotesque. The motiv of the raised incest vessel is found also in designs and pendulum clocks by Francois Remond (see Ottomeyer/ Proschel, I, p. 279)

Louis XVI, Gout etrusque, circa 1785, fire gilded and patinated bronze, marble, later movement.

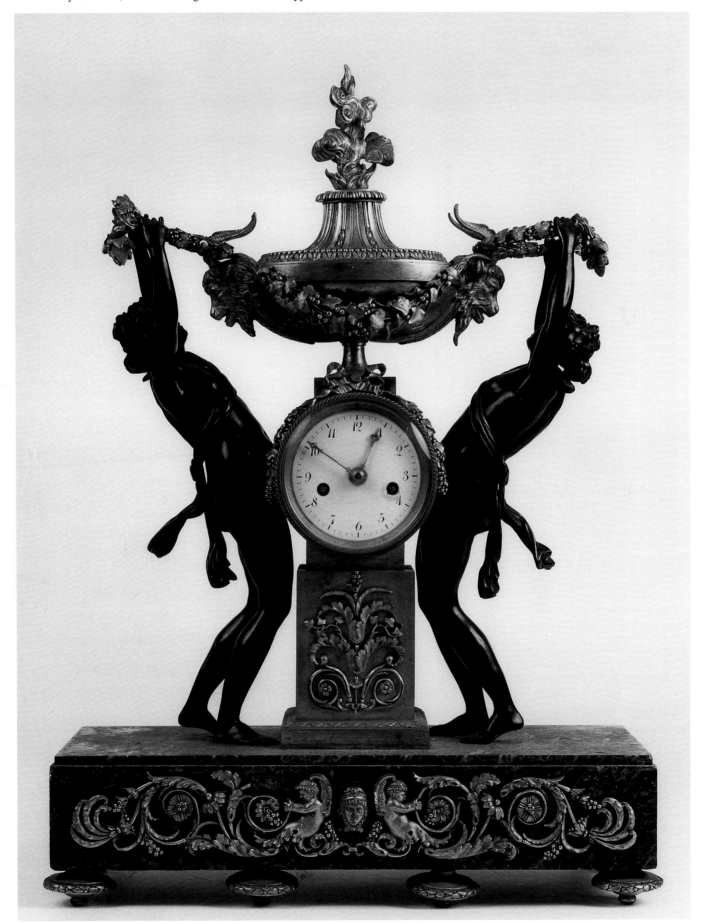

78–80 **Aurora wakes Amor**

Aurora seems to float on clouds. She holds rose stems and rosebuds graciously in her hands which she lays on the sleeping Amor, who is resting on a pillow. The Amor theme is repeated in the application underneath the dial, which shows the weapons of the love god and in the small base relief which shows playful doves. Louis XVI, circa 1780, dial signed: Imbert l'aine/A Paris (see Ottomeyer/Proschel, I. P. 248), fire gilded bronze, white marble, Residenz, Munich.

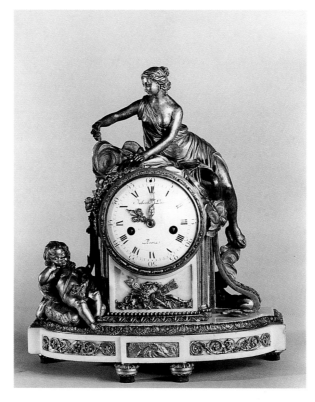

78 The figure of Aurora/Eos is a plastic translation of the famous poetic picture of the morning red, which Homer paints in his Odysse:" when the shimmering morning woke up with rose fingers" (Odysse II, 1). Posture, gesture, hand and roses form a harmonious unity.

Far left:
79 The small, sleeping amor has been portrayed by the bronze artist in a very naturalistic way. It is reminiscent of the famous children portraits by Francois Duquesnoy, which were the models for many artists of the 18th century and which were copied and executed in many different media.

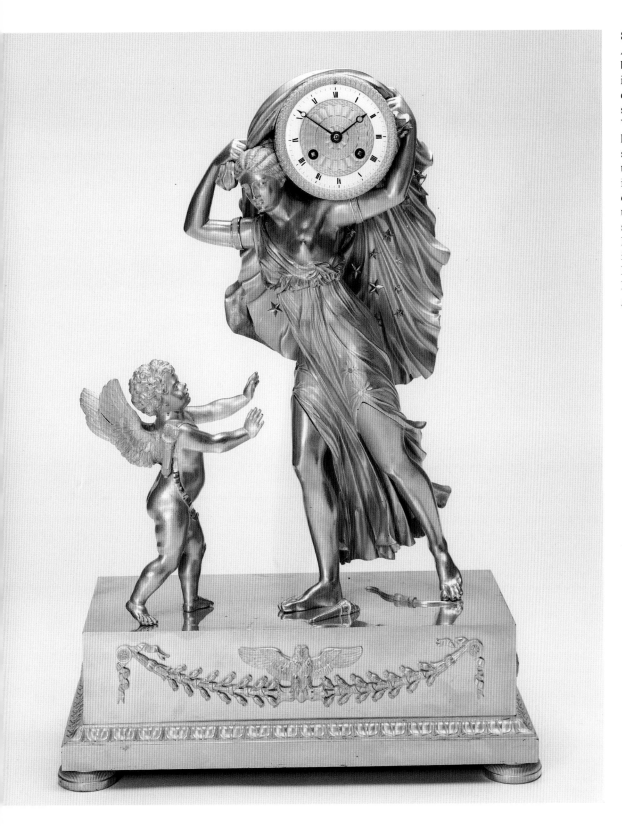

81 **Amor tries to stop Aurora**
Aurora, the morning red, is the biggest adversary of Amor, who is most active at night. She stops darkness, by pulling the star studded coat from the world. Vehemently Amor tries to stop her from going forward, which symbolizes the eternal flow of time and events, both symbolized by the clock. Amor has dropped his weapons – bow and torch. Time ignores them and steps across - Amor is powerless. The owl at the base relief is an old symbol for night. Empire, circa 1815, bronzier: Pierre-Philippe Thomire, fire gilded bronze.

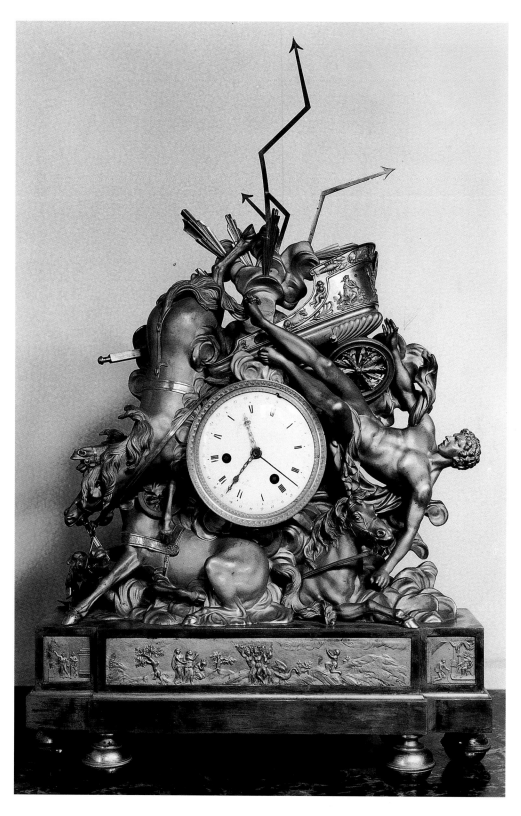

82 **Fall of Phaeton**

In order to proof his ancestry Phaeton demands from his father Helios to be allowed to drive the sun chariot for one day. The powerful horses do not follow his command and leave their path. Zeus, who is upset about Phaeton throws a thunderbolt which makes the burning chariots tumble to earth. The moment of this catastrophe and its confusion is captured by the artist. The figure of Phaeton has a strong resemblence with Falconets "Milon of Kroton" (1745/54, Louvre) and follows Baroque composition principles. The clock is at the center and turning point of the bronze. The base relief shows his sisters' fate, the Heliads, who mourn his fall and turn into poplars, their tears turning into amber. Another scene captures Phaeton in front of Helios' throne. According to mythology Helios is surrounded by his retine – Day, Month, Year and the Four Seasons. Helios is the center of time (Ovid, Metamorphoses 2, pp19.)

Paris, circa 1800, signed: a Paris, Bronzier: Romain, who in 1800 deposited a drawing of the pendulum clock at the Bibliotheque nationale, Paris (Cab. Est. Le 30, 57), fire gilded bronze.

83–86 Vase-Form Clock with Harpyien

The body of the antique amphore vessel is made of patinated bronze and is flanked by two fire gilded Harpyien. The finely worked heads and wings form the handle of the vessel, into which the clock movement is harmonously integrated. The hybrid figures with female body and bird wings are the storm goddesses in Greek mythology, daughters of the Oceanide Electra. This relationship explains the base application, which is composed of two intertwining dolphins and the trident of Poseidon, referring to his domain, the oceans.

Empire, circa 1810, bronzier: Claude Galle, fire gilded and patinated bronze.

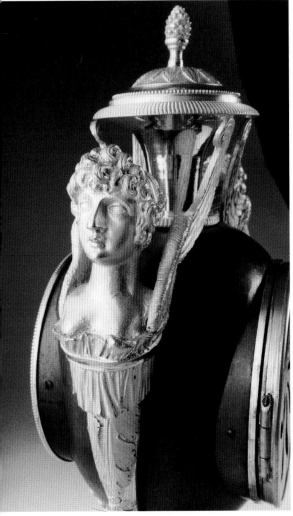

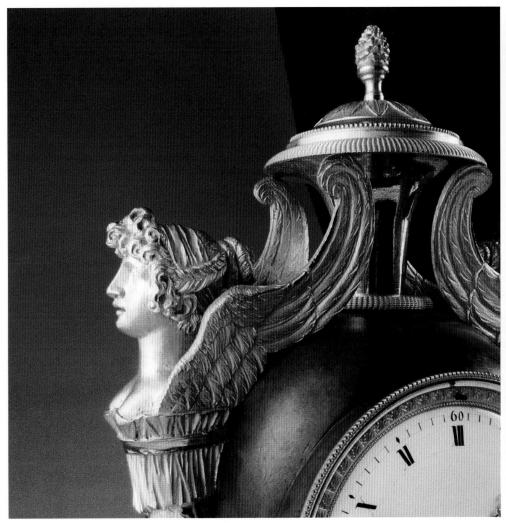

88 Vestal Virgins

The bronze composition which is one of the most significant works by Thomire has an integrated clock which is hard to detect. The movement with revolving chapterring, is hidden in the base, whose oval shape invites to view the group from any side. The temple of the goddess Vesta in Rome did not contain a picture but an altar – the holy fire, which the Vestal Virgins had to attend. Accordingly the standing figure pours oil into the flame and the kneeling figure blows into an antique double poke. Theme, execution and decorative details follow antique-pompeijan rules.

Late Louis XVI/Directoire, circa 1790, Pierre-Philippe Thomire, fire gilded and green patinated bronze. Musee Francois Duesberg, Mons. ▶

87 Vestal Virgins carrying the Altar Fire and the Sacrifice Vessel

The elaborate group shows two young priestesses of Vesta in classical cloth, who are carrying a fabric draped barrow with the altar fire and sacrifice vessel in a processional. Their utensils are very detailed – the oil can, the bowl with sacrifice gifts, the crowned holy flame, and all decorative elements such as sphinxs on which the altar is resting, the four panthers at the base, the personifications of Clio and Urania and the filigree groteques at the base front. This particular pendulum clock is attributed to Pierre-Philippe Thomire (additional references see Ottomeyer/Proschel, I. P. 297)

Late Louis XVI period, circa 1790, dial signed: Robin, fire gilded and patinated bronze, painted porcelain, marble.

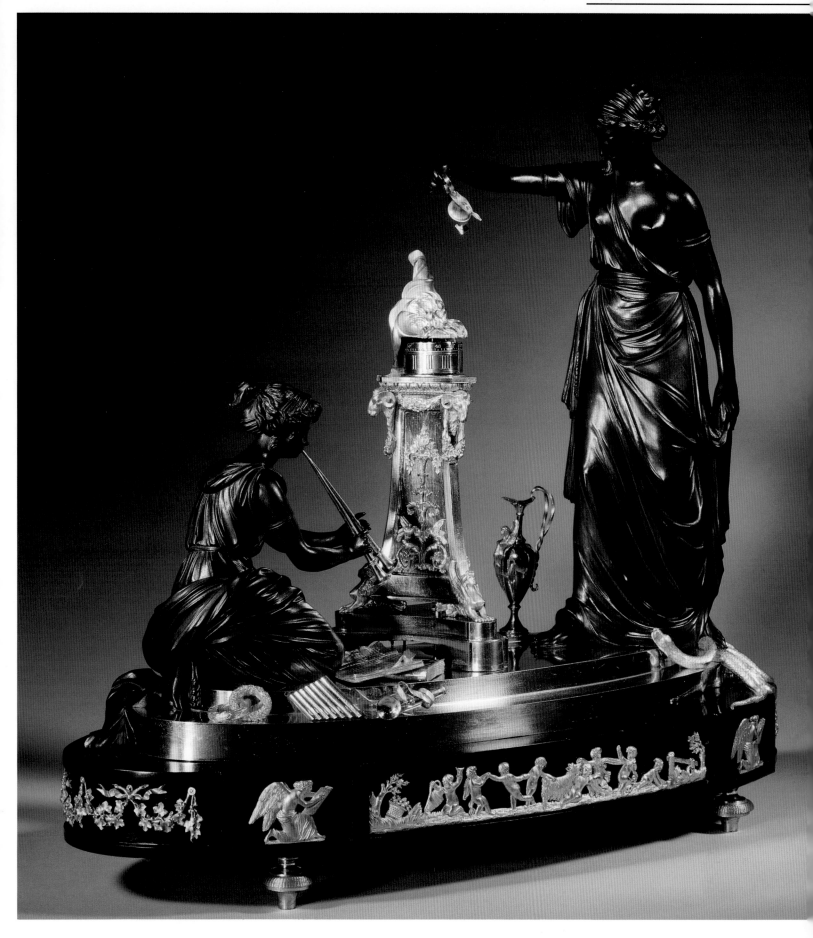

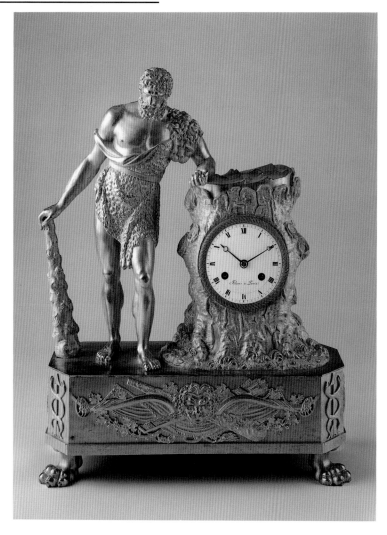

90 ▲ 91 ▼

89 Hercules (Heracles)

The most famous heroe of antiquity is depicted in a very contemplative mood. The strong, wooden club is lowered to the ground and his left arm rests on a tree trunk. All elements point towards the heroic deeds which Heracles has already performed: the lion's skin, which is draped around the muscular body, is from the Nemean lion, which he killed with bare hands. In his left hand he holds one of the golden apples of the Hesperides, which he collected with great difficulty.

With minor adaptations the sculpture is a replica of the Hercules Farnese, an antique statue (by Lysipp and Glycon), which had been rediscovered in Rome in 1556. For many centuries it had been among the most important and famous sculptures of history. Part of this tumultous history is also its in-tegration into a pendulum clock, which captures the moment of rest after difficult tasks.

Empire, circa 1815, isgned on dial: Filon a Paris, fire gilded bronze.

90 Jason steels the Golden Fleece from King Aietes

Aietes, son of the sun god, is King of Kolchis, where the golden fleece is housed. It is the skin of a golden ram, and it is the goal of the Argonauts and their leader Jason to capture the fleece. The bronze captures the moment when Jason rips the fleece from King Aietes. It is interesting to compare this early Classicistic piece with a bronze pendulum clock from the Empire period with the same theme.(see illustr. 91) Louis XVI, circa 1765. Dial and movement signed: Viger a Paris (Francois Viger, Maitre 1744), fire gilded bronze, white marble.

91 Jason captures the Golden Fleece

This rare pendulum clock seems to be a bronze sculpture rather than a timepiece. The leader of the Argonauts, with the help of Medea's magic powers, manages to advance to the Holy Grove where he captures the Golden Fleece. At his feet lays the defeated dragon " who, with comb, three tongs and sabled theet, used to guard the tree" (Ovid, Met. 7, pp. 149). Jason's shield with its figural decorations is leaning against the tree trunk and forms the dial of the clock. The dynamics of the scene and profil of the heroe stress the outstanding beauty, which seals the fate of the loving Maedea.

The artist of this exceptional piece remains anonymous: One copy in the Musee Malmaison (Cat. Nr. 17) is associated with L.-F. Fuchere, another, less dynamic version is by P.-V. Ledure (Ottomeyer/Proschel, p. 351). Empire, fire gilded bronze, marble vert-de-mer.

92 Omphale with the weapons of Hercules

After one year as slave and lover in the service of the Lydian queen Omphale, the invincible Hercules is so effeminated, that he hands her his lion skin and his weapon, the much feared club. The base relief shows the culmination of the reversed role , which was a favored subject in antique comedies: the athletic hero holds the spindle, while Omphale holds the club in her hand.

Empire, circa 1810, dial signed: Galle/Rue Vivienne a Paris/Bled H.ger, Bronze: Claude Galle, fire gilded bronze.

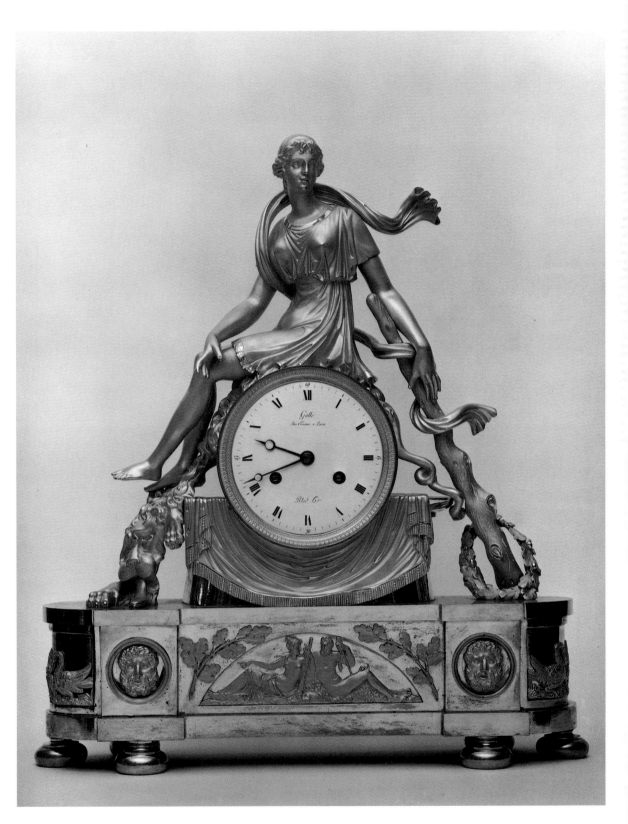

93– 95 Hector parting from Andromache

The bronze group captures the dramatic moment when the son of King Priamos of Troje, Hector, says good-bye to his wife Andromache and their infant son Astyanax and goes to war.

Empire, circa 1805, Claude Galle, dial signed: Galle, rue Vivienne a Paris, fire gilded bronze, marble

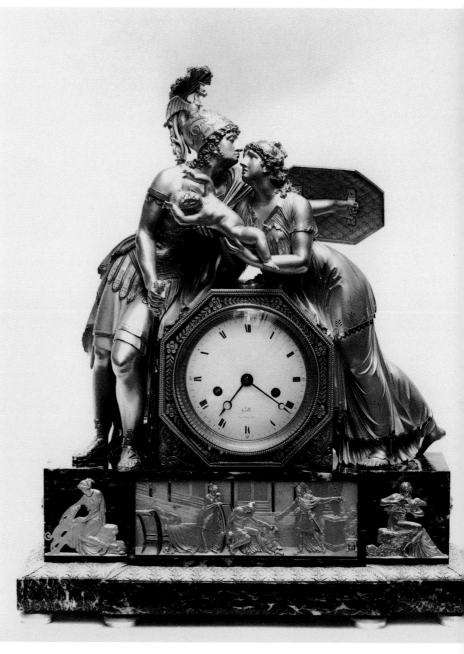

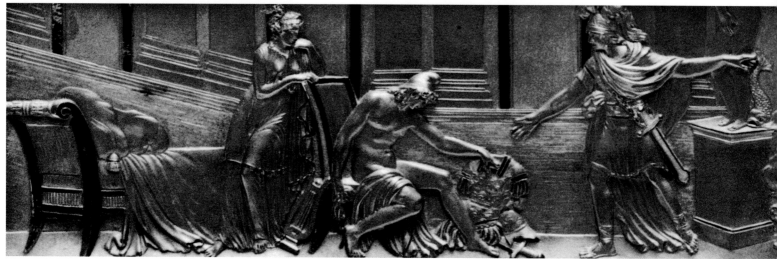

96 **Camillus**

Like a monument, the name of the figure is engraved in the base, adorned by weapons, laurel and Roman field insignia. Marcus Furius Camillus saves Rome from the invading Celts and was the victor over the Etruscans in Veji in 396 B.C.. The Roman historian Livius therefor refers to him as the second founder of Rome (ab urbe condita, 5, 49, 7; 7, 1, 10). The bronze clock shows him in his Roman warrior uniform, his hand raised above his laurel wreathed sword, which is resting on an altar, which integrates the clock movement. The clock is part of a series of art works, which glorified Roman history and heroes in monument-style compositions and integrated them into the actual political scene.

Empire, circa 1810, signed: Gigault a Nantes (1809 – 1838 as watch maker and gold smith, see K. Maurice, 1990, p. 94), fire gilded bronze.

Left:

94 In the manner of historical paintings the conflict between Hector and his brother Paris is shown in a very narrative way. Hector, the warrior, fully armored heroe, storms towards the hesitant Paris and challenges him to participate in the war. Yet Paris, whose armour lays untouched on the floor, remains hesitant and can not leave Helena and her splendid palace. The composition focuses on the difference between Hector and Paris, who is described by Homer as very handsome but weak and the heroe Hector, who sacrifices for his town without taking his personal- emotional demands into consideraton. The same theme is the center of "The oath of the Horatier" (see illustr. 101, 102).

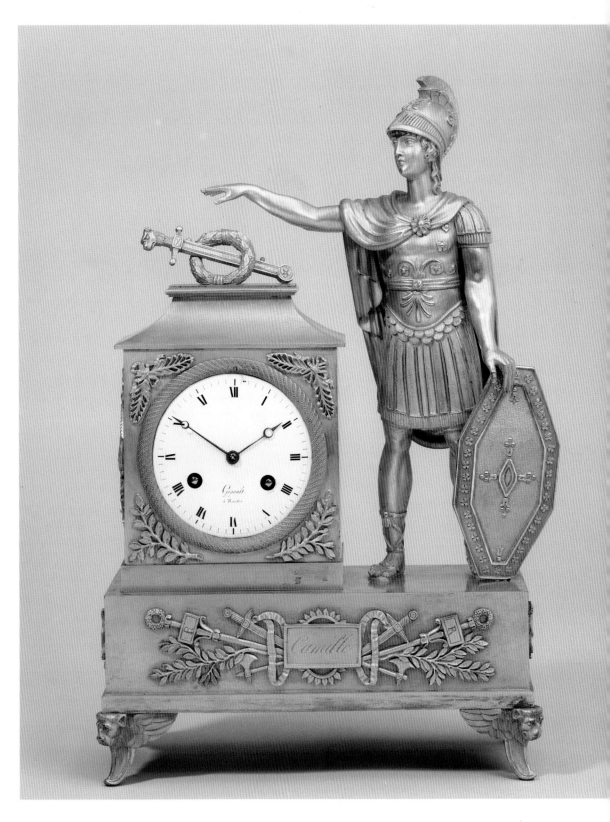

97 Orpheus plays to the Animals

Orpheus, the son of a river god and a Muse is predestined to be close to nature and the arts. The bronze group shows him as the divine inspired musician, whose play moves animals, plants, even rocks and creates an athmosphere of harmony and peace around him. He still carries quiver and arrows on his back – maybe as sign of his participation in the crusade of the argonauts – but the bow is put aside. The paradise-like scene is further emphasized by the peacefully gathered animals, the sprouting water and the attentively listening dog. In addition to the wild animals, time – symbolized by the clock and the signs of the zodiac in the base – also looses its horror in this harmonious world of Orpheus.

Empire, circa 1805, dial signed: Tarault a Paris/Faub. St. Honore, fire gilded and patinated bronze.

98– 100 Chariot of Telem-achus

This pendulum clock is often referred to as "Charriot of Diomedes". An early scetch by the bronzier Jean-Andre Reiche (1752 – 1817), which initially at the Bibliotheque imperiale (circa 1807 is now part of the Bibliotheque nationale, Cabinet des Estampes, Le 30, fol. 43) referrs to it as "char de Telemaque". The clock is perfectly integrated in the bronze : the enamel chapter ring of the dial forms the wheel, the skeletonized movement is visible behind the spikes of the wheel.

Empire, circa 1810, signed on the dial: Chopin a Paris, bronzier: Jean-Andre Reiche, sculpteur: probably Jean Baptiste Boyer (b. 1783),(see Cat. Malmaison, 1991, pp. 21 and 22), fire gilded bronze.

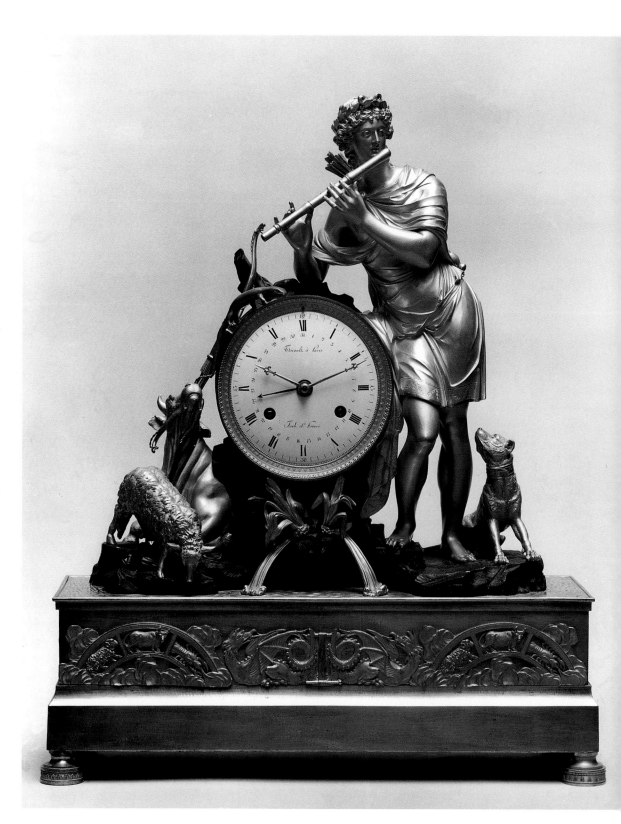

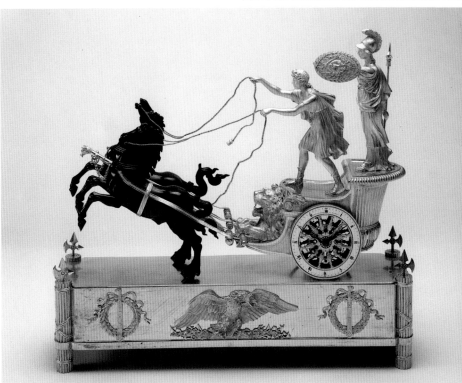

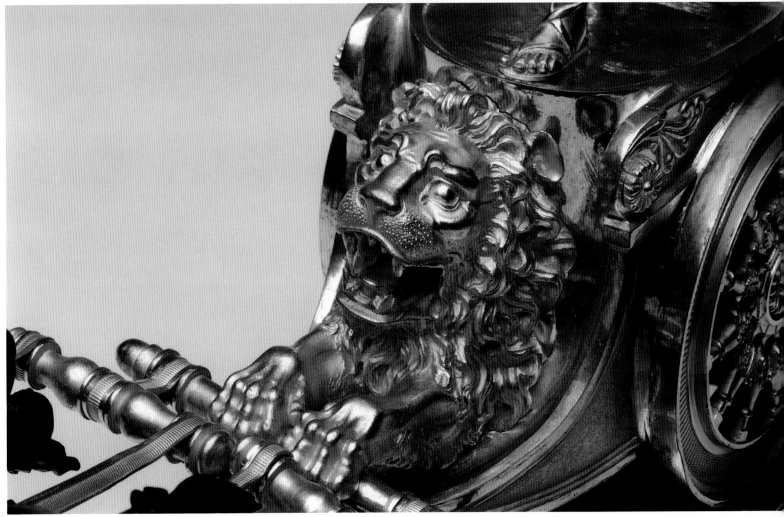

101 **Oath of the Horatii**

The Empire pendulum clock is the translation of the famous painting by David into a bronze. On the left, the three sons, with arms raised, are taking the oath, on the right, their father, Horatius, accepting their oath and symbolically holding three swords in his hands. On the base of the clock laurel wreaths are resting in anticipation of a victory. The base relief shows a battle scene. The tale ideolizes the personal sacrifice for the good of the country, leaving personal and sentimental interests and feelings behind. Several variations of this famous clock do exist, one of which is by Claude Galle (see Zick, I and Ottomeyer/Proschel, p. 367).

Empire, circa 1815, fire gilded bronze, marble.

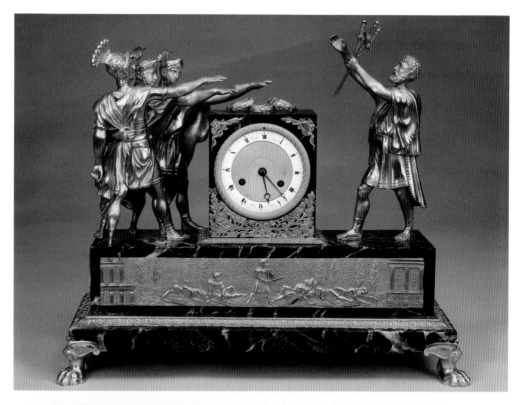

102 **Jacques Louis David: Oath of the Horatii**

Oil on canvas, 330 x 425 cm), Musee du Louvre, Paris.

The mourning woman in the background of the painting by David give away the tragic ending to the story. The monumental painting marks the beginning of a new era in French historical painting, which glorifies the republican trends of the prerevolutionary period. The return by David to heroes of the Roman republic era has political meaning and shows them as virtuous and selfless models for contemporaries.

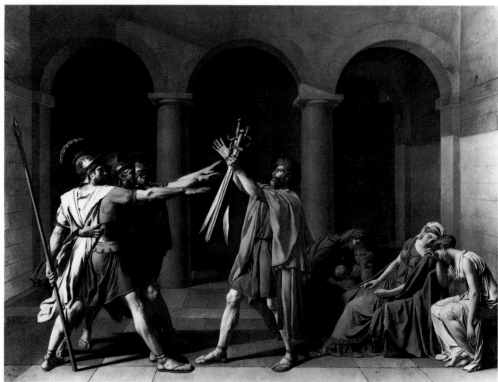

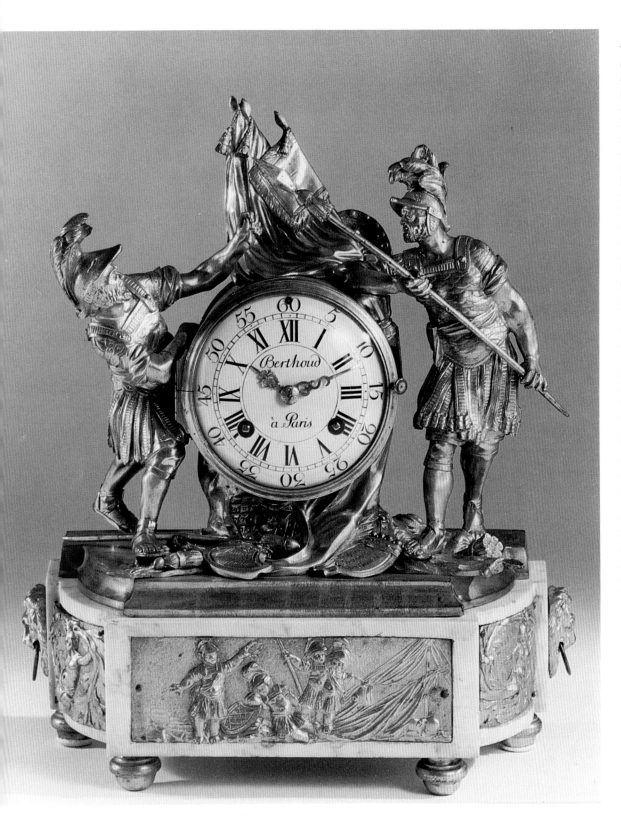

103 Hannibal and Scipio
The two famous military leaders of the antique, whose deeds decided the second Punic war (218–201 B.C.) are facing each other. Hannibal, siding with Karthago, is a charismatic and genial military leader. His crossing of the Alps (218 B.C.) and the victory at Cannae (216 B.C) over the much larger Roman army are legendary. For the longest time Rome could not stop him. Finally the young Scipio was the first to be considered his equal and defeated him at the outscirts of Karthago (Zama, 202 B.C.) and is therefore referred to as "Africanus". The second Punic war is considered a highlight and a difficult test in Roman history, which layed the foundation for its later world dominance. The hostile relationship of the two warriors is shown in the bronze as is their similarity. The upright posture of one figure with raised lance pointing towards the other and the strangely devout posture of the figure to the left, clearly shows winner and looser. The names are engraved: "Anibal, General des Cartaginois – Scipio, General des Romains".
Louis XVI, circa 1770/80, dial signed: Berthoud a Paris, dial with quarter hour strike on two bells, hour strike on one bell, fire gilded bronze, white marble.

104 Minerva teaching Louis XVI

The goddess of wisdome arrives on clouds, grabs the arm of the King of France and with a dynamic gesture seems to lead him to the future glory of his reign. The idealized personification of the king shows him as Roman warrior with a youthful head. With their arms touching and their eyes crossing, the goddess and the king start a dialog. Next to the king a little column is decorated with the bourbon lily and the insignia of his rule, crown, scepter and court hand, he leans against a globe, which as a sphere is an emblem of world rule since antiquity and which is also decorated with fleurs-de-lis. It contains the clock movement in the form of a *cercle tournant*. Louis XVI rests his right arm on a rudder, which points him out as the navigator of his country. The relief at the front shows him as the law maker, who with the help of Justitia, who is holding an open book, dictating the laws to a personification of France. The relief on the left shows him at a banquet with Marie-Antoinette and his brothers, the one on the right in a dialog with allegorical figures and virtues, while Amor writes the names of five children in a book which is held up by Chronos. The complex iconography of the pendulum clock is a layout for the status, the future plans of the monarch with respect to his government and his personal and family goals.

The design is attributed to Louis-Simon Boizot (1743 – 1809) (see P. Hughes, Cat. The Wallace Collection, p. 70. Inv. Nr. F 259).
Louis XVI, circa 1774, fire gilded and enamelled bronze, white marble, The Wallace Collection, London.

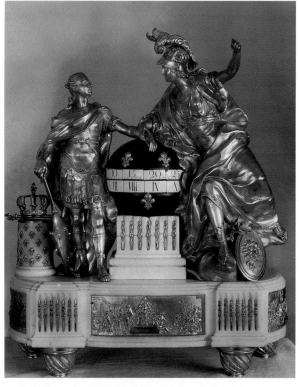

Bottom left:
105 Ship with Navigator

The ship which is overloaded with cargo and lays low on the waves, carries a clock which is crowned by a medallion carrying a portrait of Louis XVI, a female allegorical figure carrying a scroll and a navigator, who points towards the king with his right hand. The little putto who is almost going over board tries to gage the depth of the water.

The metaphor of a ship as state and the ruler as the navigator has a very old tradition. In illustr. 104 the king is also holding a rudder. The gesture of the navigator confirms the king as the one and best.
Louis XVI, circa 1775, dial signed: Berthoud a Paris, fire gilded bronze, marble.

106 Pendulum Clock with Fama

The female figure crowning the clock forcefully points towards a sun medaillon, which she holds up. After his death, the sun remained the iconographic symbol for Louis XVI.
Louis XV, circa 1750, dial signed: Ripert a Paris, fire gilded bronze.

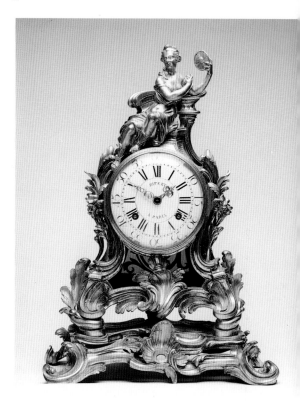

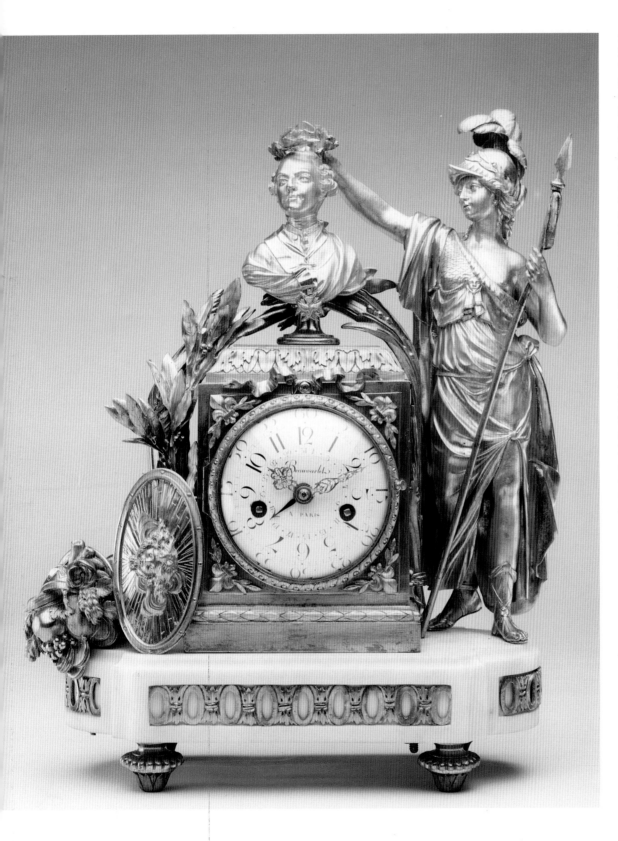

107 Athena crowning Louis XVI

The goddess of wisdom honors the bust of Louis XVI, who is wearing the order of the Golden Fleece and the order of the Holy Spirit, with a laurel wreath. The warrior like goddess wears helmet, lance and Aegis armour. The shield with the head of the Medusa is leaning against an altar which contains the clock movement. A cornucopia with blossoms, fruits and gold coins rests next to it as does a book decorated with fleurs-de-lis. The allegorical group is a glorification of a ruler, who as the king gets the assistance of Athena/Minerva, and brings prosperity and wise government to his country. Similar monumental clocks are part of important collections, see the pendulum clock "Mi-nerva instructs Louis XVI" which is attributed to Louis-Simon Boizot, 1774, and is part of the Wallace Collection. (illustr. 104).
Louis XVI, circa 1775, dial signed: Beauvarlet a Paris (maitre 1756), date, fire gilded bronze, white marble.

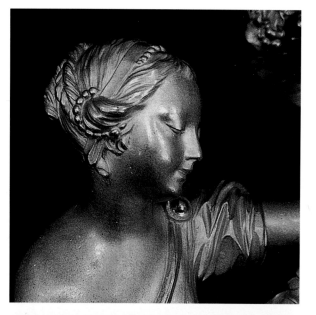

108 The figure of Francia, the personification of France appears graciously like a female figure in a Boucher painting or a sculpture by Flaconet. She glorifies the king and looks benevolent at Mars the god of war.

108–110 Allegorical Scene with Francia and peaceful Mars

The female figure to the left is the personification of France, identified by the fleur-de-lis covered dress and the similarly decorated ball – the traditional emblem of the house of Bourbon – at her left. In the raised hand she probably used to hold a medallion with the profil of the king, whom she wants to decorate with the laurel wreath in her left. She turns towards to other side where Mars is peacefully resting on his waepons – canon and quiver. The god is as always in full armour. He surprises with his casual gesture and his peaceful look towards Francia. In connection with an allegorical scene including the ruler this scene can be interpreted, that the reign of the king allows Mars to rest, it brings peace to the country. It is interesting to see, that the same bronze with different attributes was used to glorify different European nations: Augard (*Les Ouvriers du Temps*, 1997, p. 236)

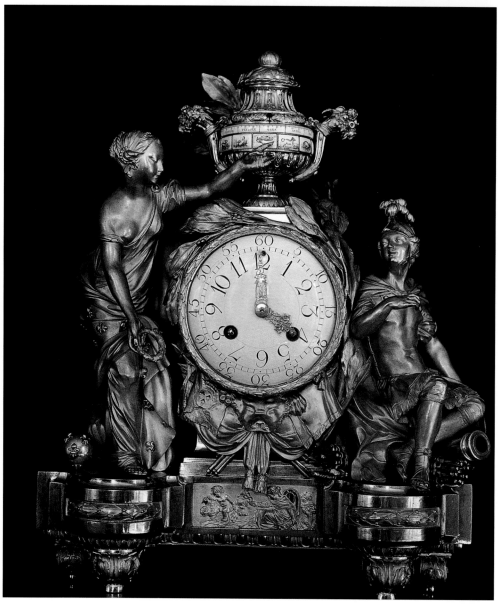

shows a pendulum clock with Brittania and the fitting national symbols and refers to yet another version with the personification of Russia and the initial model which had been in the possession of Louis XV.(today at the Musee National du Chateau de Versaillles).

Louis XVI, circa 1770, fire gilded bronze.

110 Mars gazes peacefully at Francia. His composure and gesture are lacking the agressiveness, which he usually displays, despite his full armour.

111 Allegory of the Wasa Dynasty

The pendulum clock which is housed in the castle in Stockholm is a miniature memorial. The central axes is formed by the cube containing the clock which is surmounted by an obelisk applied with three medaillons with portraits of Wasa kings: Gustav I., Gustav II Adolf and Gustav III. The female figure on the left who holds the hand of a young boy and who points at the rulers is a personification of Sweden, the Sveva. The boy is probably a reference to the crown prince, who had been born in 1778. The standards on the right refer to glorious battles, the powerful lion who rests his paw on a ball applied with Wasa crowns is the traditional sign for reign and the power of the rulers. The bow of a ship which is visible underneath the clock and its gallions figure refers to sea battles and trade, themes which are repeated in the base relief of the composition.

The monumental composition is in the tradition of the baroque allegories to glorify the ruler, as had been pointed out by Ottomeyer/Proschel (I, p. 233). France, Louis XVI, circa 1780, dial signed: Hessen, Hr. de Monsieur, fire gilded and patinated bronze, white marble.

112 **Pegasus**

The winged horse Pegasus is the son of Medusa. He sprang out of her body, when Perseus cut off her snake draped head. Despite this gruesome birth Pegasus is the horse of the Muses and the emblem for spiritual achievements and eternal glory. In this context he is also referred to as the poet's horse, which carries the poet to mount Parnassus, where Apollo thrones amongst the Muses. Empire, circa 1815, dial signed: a Paris, fire gilded and patinated bronze.

Right page:

114, 115 **Allegory to Study**

The personification of study is in the antique tradition and leans against a pile of books holding a scroll in its hand. Rooster and torch are symbols of the intellectual and physical allertness which are important prerequisities of studying and science (see Cochin, Etude, No. 27).

The base shows a large winged Genius holding a scroll inscribed " traite de la sphere" in its hand, referring to astronomical studies. He is surrounded by various attributes of the seven liberal arts (painting, architecture, sculpture and poetry). A bust of the goddess of wisdome Athena and her attribute, the owl are further reference to the main motive of the bronze clock, the study.

Empire, circa 1815, dial signed: H. Motel a Paris (Jean-Francois Henri Motel, 1786 – 1859, "Horloger de la Marine"), Bronze probably by Pierre-Victor Ledue (see Ottomeyer/Proschel, I, p. 349), fire gilded bronze.

113 **Urania and Clio**

The two Muses engage in an academic dispute, which is well expressed in their gestures and mannerisms. Because of a known design sheet, the sculpture, which is of superior quality is attributed to Etienne Martincourt, the dial which had been made by the enamel crafts man Merlet is signed by the famous clock maker Lepaute (Jean-Andre Lepaute, 1720 – 1788). An identical pendulum clock is in the collection of the J.Paul Getty Museum , Malibu (see Cat. Partidge, 1995 p. 104, which also contains an illustration of the drawing from the Collection Jacques Doucel).
Paris, circa 1765, fire gilded bronze.

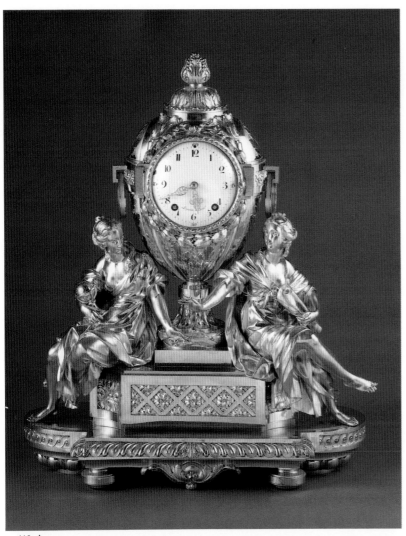

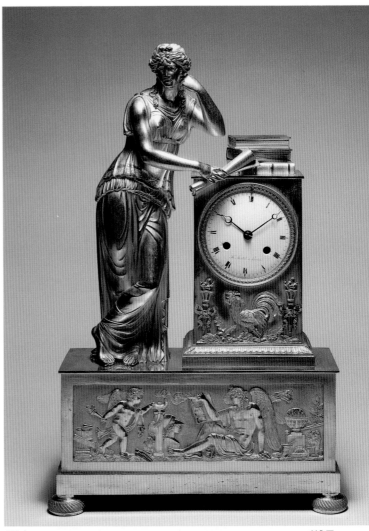

113 ▲

114 ▲

115 ▼

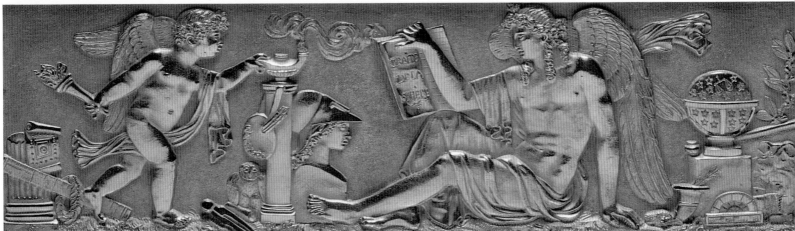

116 **Peace/Bellona**

Bellona, the sister of Mars, sits on a cannon, its barrel lowered as a sign of peace. In the elaborate base relief, amorettes use their torches to light the heroic war trophies, which are made up, in antique style, of breastplate, helmet, shields and standards. The age of love replaces that of war.

Directory, end of 18th century, bronze ascribed to Pierre-Philipp Thomire, fire-gilded bronze with patina. *Kunsthandel Michael Nolte, Münster.*

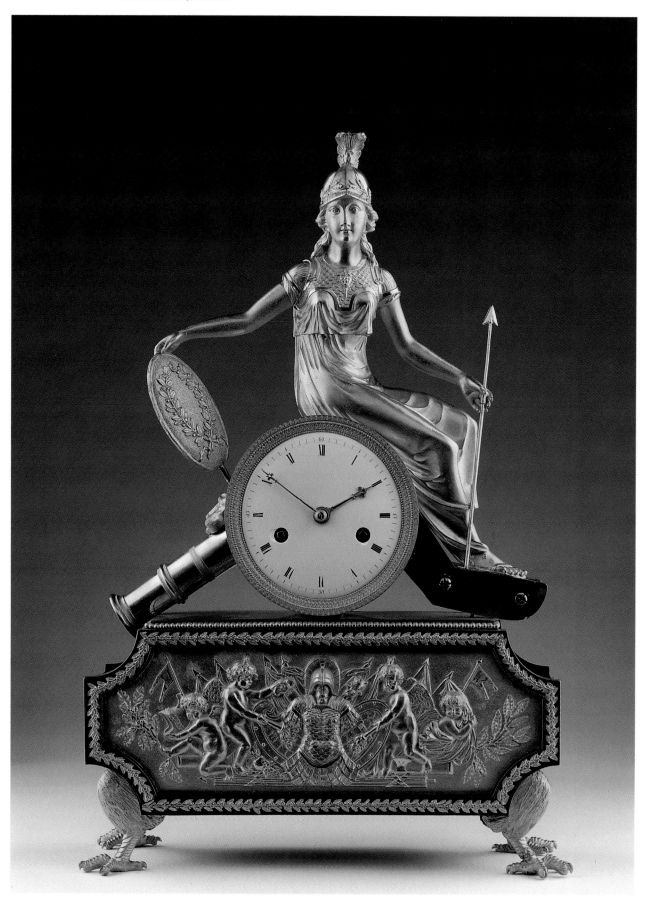

118 Genii with Attributes of the Seven Liberal Arts
The two putti are playing with various attributes of the seven liberal arts, which may vary with other models of this clock. The ones shown on this clock are Music (trumpet), painting (palette), sculpture (an antique bust with tools), architecture/geometry (drawing-compass and drawing), book (Rhetoric and literature) and a globe (Astronomy). Architecture is also symbolized by the portico structure with doric columns and marble base of the clock case.
Louis XVI, circa 1775, dial signed: Millot a Paris (Pierre Millot, horloger du Roi, made high precision clocks), unusual clock movement with cenral seconds and date, bronze: attributed to Robert Osmond, fire gilded bronze, Griotte marble.

119 Genius of Rhetoric
The little genius is leaning elegantly against the drum of the clock movement and is focusing on a sheet of paper which he is reading. The open mouth and the gesture of his hand indicate that he is reciting. Rhetoric has a mediating and regulating function among the seven liberal arts. Different models of this pendulum clock vary with respect to the different attributes of sciences shown.
Louis XVI, circa 1770, dial signed: Cronier a Paris, fire gilded bronze.

120, 121 Erato

Erato is the muse of lyric and love poetry. The classical – antique pose, the drapesry and the overall composition of the clock refer to Pierre-Philippe Thomire, to whom it is attributed by Ottomeyer. (see Ottomeyer/Poschel, I, p. 343). A copy of the clock was delivered to Emperor Napoleon in 1807 and referred to as "Sappho". The famous Greek poet is closely associated with the muse and is often seen as her personification.

Empire, circa 1805, Pierre-Philippe Thomire, fire gilded and patinated bronze, marble.

121 Erato is looking up with her eyes wide open and plays the strings of her instrument. She is inspired by the gods and sings, removed from reality. The inner movement is expressed in the flowing of the shawl. The laurel crowned head of Apollo Musagetes is on the base. The clock is integrated in the slightly tilted kithara in such a perfect way, that one almost overlooks it and, like the singer looses track of time.

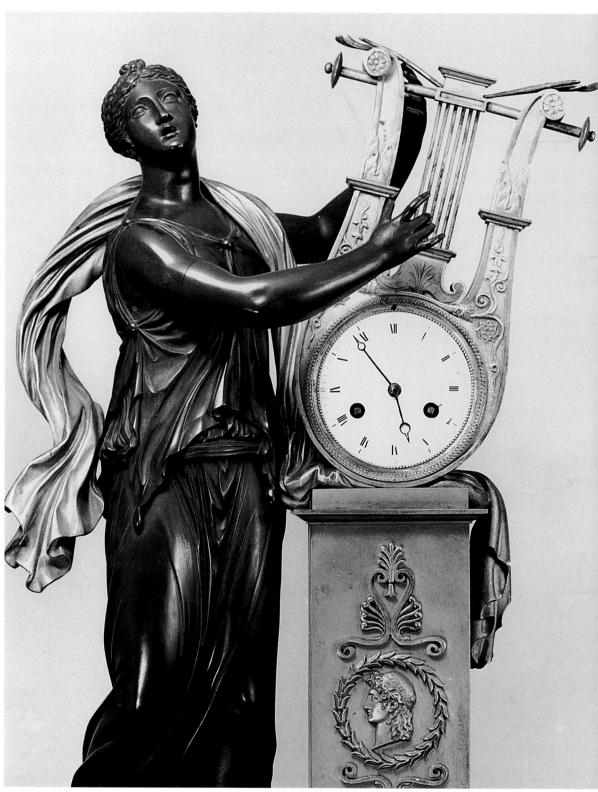

122-123 **"L'Emploi du temps"—The Use of Time, so-called "Pendule à la Geoffrin"**

The variation of the famous pendulum (see p. 39) emphasizes, with the dark-patinaed figure of the reader, the portrait nature of the three-dimensional bronze, as well as, with the added rooster, the aspect of studying and the purposeful use of constantly feeding time. According to Cochin (II, no. 27), this has the following significance: *"La lampe & le coq sont des emblémes des veilles & de la vigilance, qualités qu'exigent toujours le desir d'apprendre."* The lamp and the rooster are emblems of the sleepless nights (on account of studying) and wakefulness, qualities that studying requires (author's translation).

The design of the bronze is by Laurent Guiard (1732-1788), the casting by Edme Roy (master 1745). Dial marked Paris, with date, fire-gilded and patinaed bronze, white marble. *Kunsthandel Michael Nolte, Münster.*

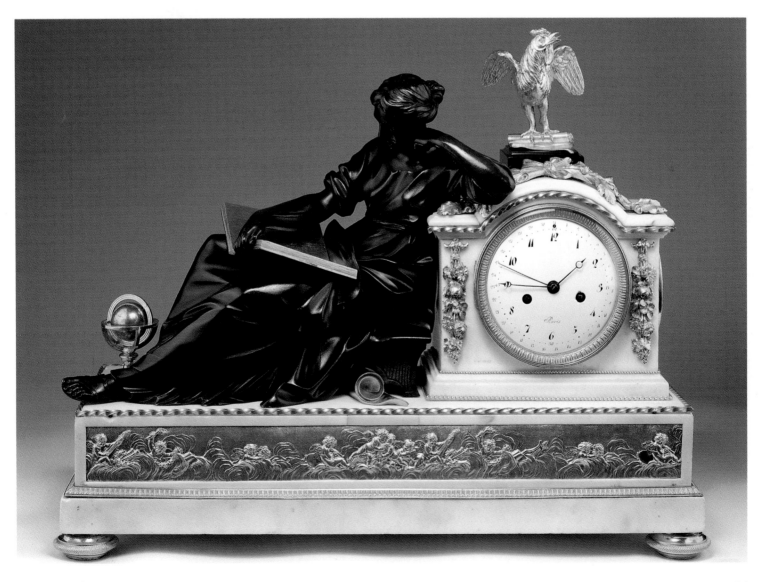

124 –126 **Urania**

The Muse of astronomy reaches with a wide gesture around the clock movement. Since antiquity the celestial globe and the scientific instruments are her attributes which are resting at her feet. The high quality of the bronze must have been made by a known sculpture, as Ottomeyer/ Proschel point out, probably Augustin Pajou (1730 – 1809). He dark patination of the figure further underlines her autonomy as a sculpture. Based on a scetch, the bronze is attributed to Pierre-Antoine Foullet (see Ottomeyer/ Proschel, I, p. 162).

Louis XVI, circa 1765, dial signed: Julien Le Roy, fire gilded and patinated bronze.

125 Large books and maps – such as the one with the sign of the zodiac – are the base on which the clock movement is resting. The detail reveals the high quality of the bronze and the elegance of the draped dress very well.

126 The muse reaches for the clock movement with a very pensative gaze . The short life span of man kind is further stressed by the astronomical eternity. Contrary to later depictions of astronomy the genre-playfulness is lacking. The muse is still part of a baroque tradition.

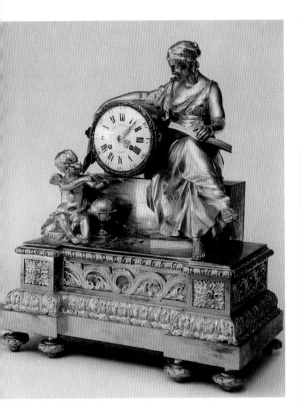

127 Urania
The muse is sitting next to the clock with crossed legs and looks at a small putto, who is playing at her feet with celestial globe and drawing compass. She seems to introduce him the art of astronomy. In her left she is holding a large book, her right is resting in an elegant yet confident manner on the clock.
The bronze composition is a good example for the early classicism period, during which artists were outstanding in showing serious and complex subjects in an easy and understandable manner.
Louis XVI, circa 1765, fire gilded bronze.

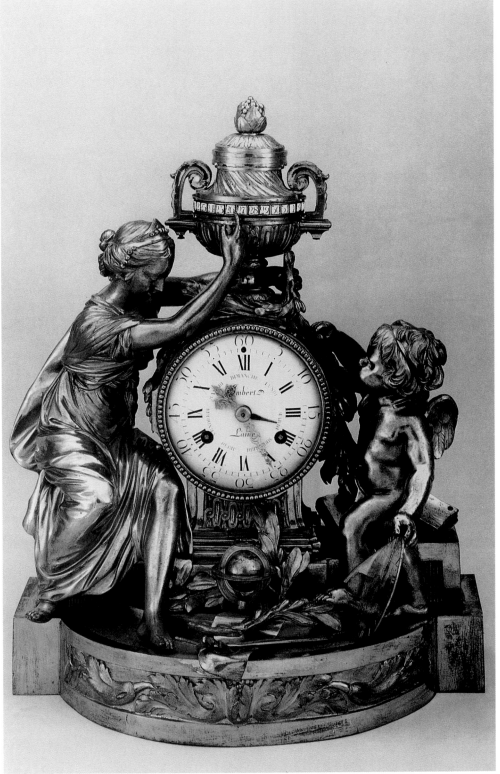

128 Urania again is instructing an inquisitive putto. The attributes of astronomy are after intense studies spread all over the base of the clock. With paedagogic strictness and a teaching gesture the putto is asked to follow the passing of the days, which can be seen on display at a revolving ring on an antique vessel. The clock itself is harmoniously integrated in the action – the studies and the dialog between the two figures .
Louis XVI, circa 1770, dial signed: Imbert L'aine, dire gilded bronze.

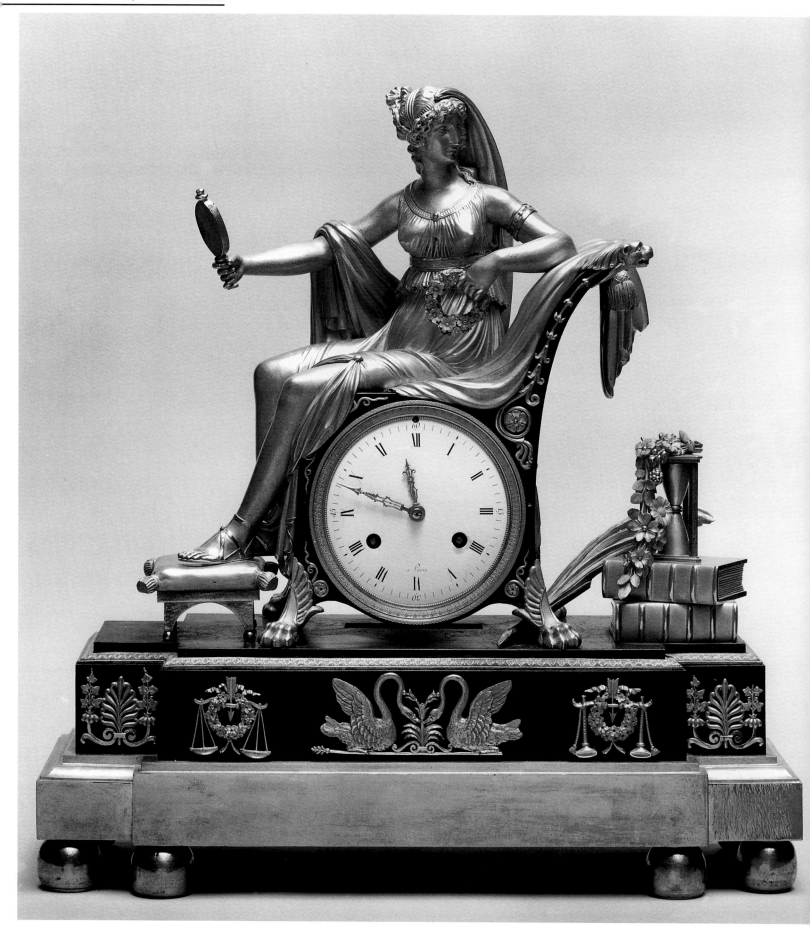

◀ ◀ 129 **Prudentia**

Wisdome is always personified as a young woman, Here she is dressed in an antique style, sitting in a period chair, in her right she holds a mirror in the left a flower wreath. To the right of the chair some books are stacked, topped by a large hour glass. The mirror is a typical attribute of wisdome (see illustr. 130/131). The books represent encyclopedial knowledge, which also includes the acceptance of the passing of time, symbolzed by the hour glass. Scales as part of the base applications are another attribute of Prudentia: it symbolizes the measuring and judging intellect. The motto of Prudentia is: Cognosce, elige, matura" –Examine, choose and act fast (See Emblemata, Cit. 1554). This attitude is also translated into her pose, which conveys spontaneity and fast observation.

Empire, circa 1810, dial signed: a Paris, fire gilded bronze.

130, 131 **Allegory of Wisdome**

Because of its graceful pose and the snake, which curls around its arm, the present figure has been interpreted as Cleopatra (Tardy). However, the snake is also one of the early symbols for wisdome and the mirror does not stand for vanity, but for self reflection, which is necessary in order to reach wisdome. The knowledge of fleeting time is part of wisdome and represented by the integrated clock. Because of a surviving early drawing (Livre de dessins, No. 34) the artist of the bronze is known to be Pierre-Antoine Foullet (see Ottomeyer/ Proschel, I. P. 162; one copy is at the Louvre, Inv. No. 0A6625). Other copies of the clock have different bases, with ebonized wood or stiff ornamentation, which points to an earlier design.

Louis XVI, circa 1765, dial signed: Le Nepveu a Paris (Nicolas-Antoine Lenepveu), Pierre-Antoine Foullet, fire gilded bronzes, white marble.

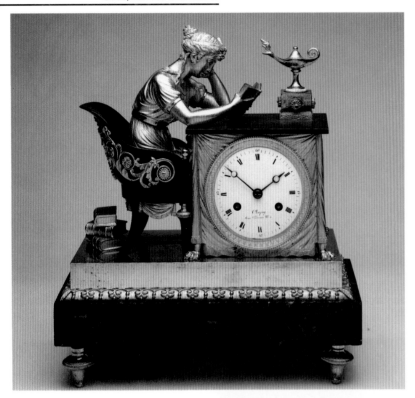

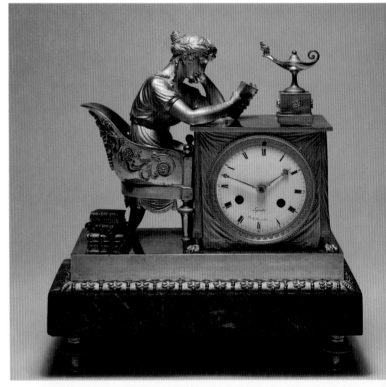

132 The reader
The original model by Jean-Andre Reiche is one of the most liked and often copied pendulum clocks. This version has a patinated antique chair, creating a good contrast to the gilded acanthus scrolls.
Empire, circa 1810, dial signed: Chapy Rue Vivienne, No. 4, fire gilded bronze, vert-de-mer marble.

133 The reader
Cochin gives a very good account of the iconography (Book I, No. 27): the figure is that of a young woman" because that is the best age for the acquisition of knowledge", the oil lamp is an emblem for alertness and prudence, two important qualities for studying"and the books which are " the source, from which the sciences take". He design is by Jean-Andre Reiche, who had a colored drawing registered in the bibliotheque imperiale on February 19, 1805 as "la liseuse". (see Cat. Musee Fontainbleu, 1989, No. 15; Ottomeyer/Proschel, I, p. 374-75).
Empire, circa 1810, dial signed: Lepaute Horloger du Roi a Paris, Bronze: Jean-Andre Reiche, fire gilded and patinated bronze, vert-de-mer marble.

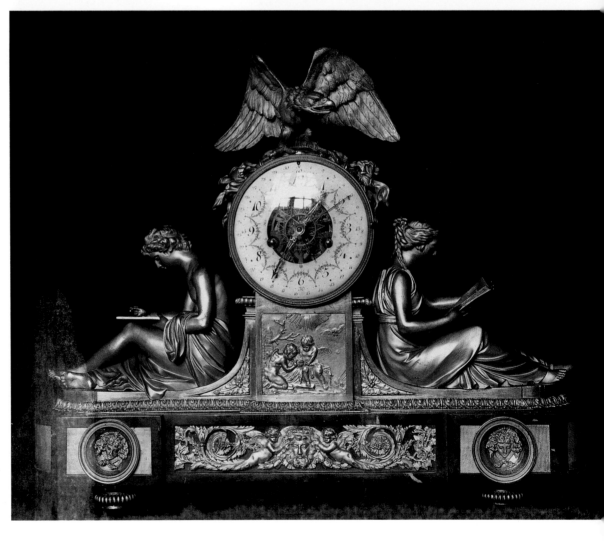

135 – 137 **Allegory of Astronomy**
The present clock is a variation of the portico clock in the "gout etrusque". The columns are replaced by three legs which are surmounted by a celestial globe and a sphere. Head and feet of the bronze figures are executed as birds heads and feet. The clock seems to be floating in the air between the columns held by some filigree garlands from which a second dial indicating the day and day planets. The clock is topped by the figure of an eagle with opened wings, who holds a bundle of lightning in his claws, as a symbol for Zeus.
Louis XVI, circa 1780, dial signed: Thiery a Paris (Jean-Baptiste Thiery), fire gilded and patinated bronze.

135, 137 The impressive figure of the eagle demonstrates the power of Zeus, the supreme ruler of the gods, the universe and the human beings to the viewer. His physical features are shown thanks to the talent of the bronzier and the high quality of the work of the chaser.

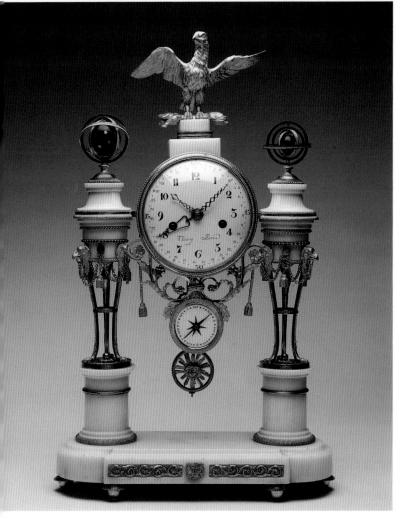

◀ ◀ 134 **Allegory of Study**
The figures are based on a model by Simon-Louis Boizot (1782), after a documented drawing of the clock case by Fancois Remond (see Ottomeyer/Proschel, I, p. 295). Numerous copies exist of this pendulum clock (see illustr. 28). The relief under the dial shows two putti, handing a letter to a pigeon, a subject matter which does not seem to fit the theme of the composition, but which is repeated on other similar clocks.
Louis XVI, circa 1785, semi sceletonized dial, date, fire gilded bronze, marble.

138 Genius with Rooster and the Attributes of Mars

This early classicism period pendulum clock is in the Greek style with its clear composition. The stepped base is surmounted by a fluted pillar which contains the clock movement, is topped by a rooster with open wings. The winged putto wears an antique presentation helmet and originally probably held a medallion with the portrait or the emblem of a king. Any symbols or monarchy were frequently removed after the revolution.

The rooster, a sign of alertness is also found on a signed pendulum clock from 1775 by Lean-Louis Prieur. Design 1766 (see Cat. Musee du Louvre, Acquisitions 1980 – 84, No. 32)

Louis XVI, circa 1770, dial signed: Gille L'aine a Paris, fire gilded bronze, ebonized wood.

139 Putto

The composition with a putto standing on a stack of books and who playfully grabs a rooster, refers to the act of studying and the necessity of an alert and sharp mind.

Louis XVI, circa 1770, dial signed: Leppens Cie/Bruxelles, fire gilded and patinated bronze.

Right:

140 Allegory of Astronomy

The two putti fullfil their astronomical calculations diligently. The one on the left is leaning against the centrally located clock- accurate measuring of time is the start and goal of their studies and completes some measures with the drawing compass. The one on the right is standing up and looking through a telescope against the night sky. Books and angle are spread over the floor. The composition seems humorous and shows the light heartetness of the period, because of the translation of serious studies of science and philosophe into a childish-seroius play.

Louis XVI, circa 1770, gout grec, dial signed: Blondel a Paris, fire gilded bronze.

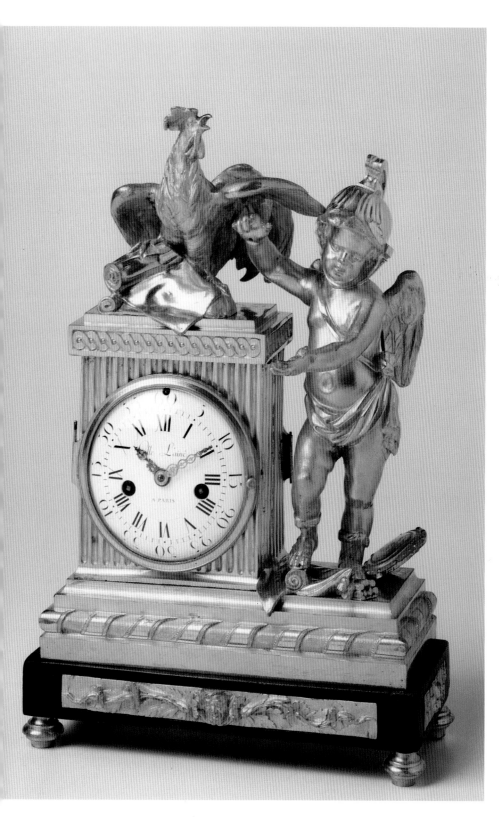

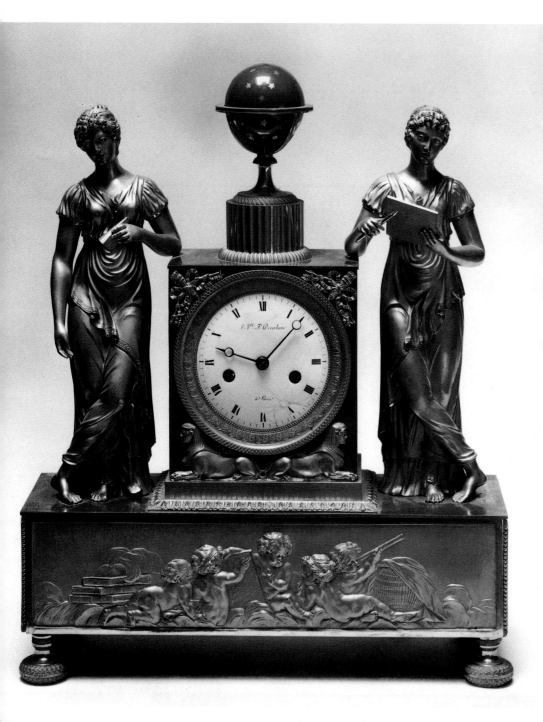

141, 142 Allegory of Astronomy

The central axes of this symmetrically composed pendulum clock is formed by the cube containing the clock which is surmounted by the celestial globe sitting on a doric fluted column. The flanking female figures are employed to keep symmetry. The crossed legs – which is a common pose in antiquity (as example see: Thusnelda, now at the Loggia dei Lanzi, Florence) – is in a mirror image. Both figure are focused on studies. Two sphinxes seem to carry the dial on their backs.

Early Empire, circa 1805, dial signed: I.F.V. Deverberie a Paris, fire gilded bronze.

142 Five putti are busy in the clouds with their astronomical instruments. Their childish clumsiness and carelessness in the use of scientific instruments is in harsh contrast to the strict order and concentration conveyed by the main figures.

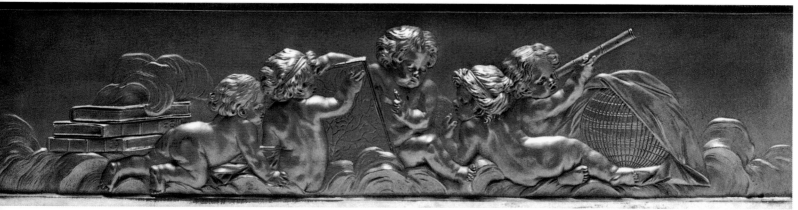

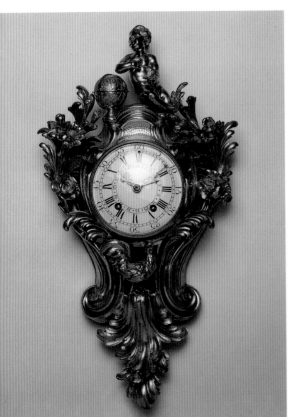

143, 144 **Allegory of Astronomy**

The female figure in antique dress is a personification of astronomy. She is working with the typical instruments, the drawing compass, the celestial globe and the books which are stacked on the floor as sign of study. The connection between astronomy and time measure is shown through the overall composition of the pendulum clock. Stars are applied around the dial.

An early design by Jean-Andre Reiche is known (Bibliotheque national, Cabinet des Estampes Le 30, see Ottomeyer/Proschel, I, p. 375).

Empire, circa 1810, fire gilded bronze.

145 **Genius of Astronomy**

The cartel clock is surmounted by a genius with celestial globe and drawing compass. Underneath the dial is a rooster as symbol of alertness – especially important for nocturnal studies such as astronomy. The overall composition shows the relationship of time measure and astronomy.

Louis XV, circa 1755, dial and movement signed: Baillon a Paris (Jean-Baptiste Baillon, maitre 1727), dumerical date, fire gilded bronze.

144 A putto is playfully studying the stars. He is very concentrated while looking through the telescope, a scroll in hand and seems to fly up to the stars.

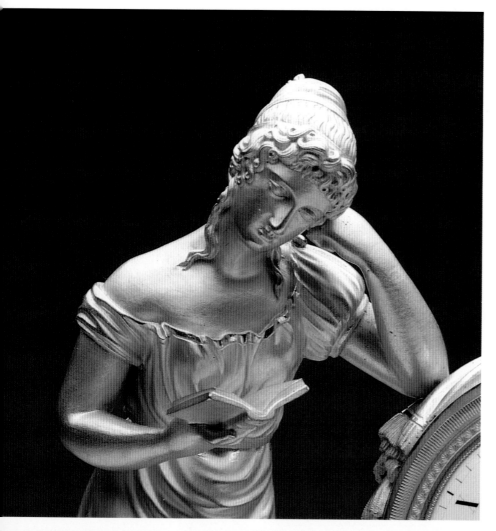

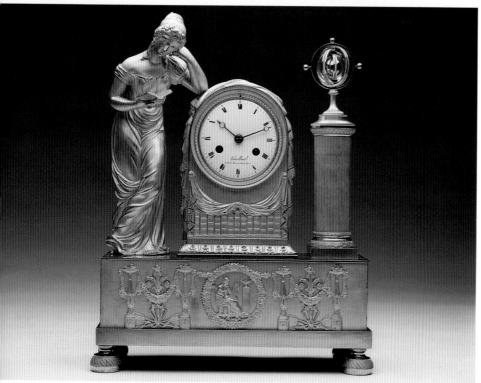

146 – 148 Allegory of Astronomy
The pendulum bronze has a strict symmetric composition after a design by Jean-Andre Reiche, whose original design, dated 1809 has survived (Bibliotheqye Nationale, Cabinet d'Estampes Le 30, 18). The base relief again refers to the subject of studying: a genius and an oil lamp are shown within a laurel wreath.
Empire, circa 1810, dial signed: Leurilliard Faubg., St. Honore No. 46 a Paris, fire gilded bronze.

148 The astrolab is the universal scientific instrument for astronomical and nautical measures and supposedly had been invented by Hippard (circa 150 B.C.). Through Arab scientists it found its way to western Europe. During the 16th century when its making and utility were carefully studied it became a symbol for astronomy and scientific speculation in the applied arts.

147 The personification of astronomy is an antique figure with crossed legs and lowered head.

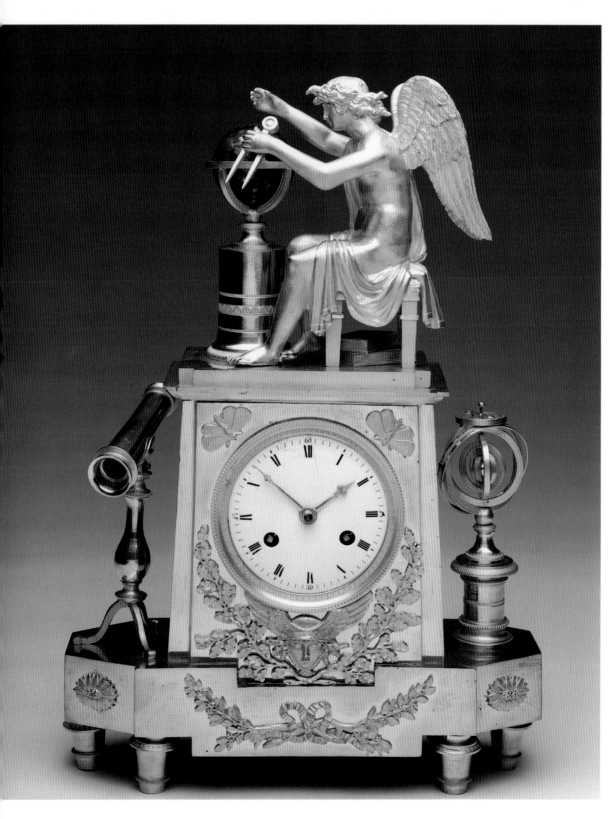

149 Allegory of Astronomy
The relationship between astronomy and time measure is the main theme of the pendulum clock. The dial and clock movement are flanked by an astrolab and a telescope and form the base for astronomy which is personified by a winged genius, which is seated with a drawing compass in hand in front of a celestial globe. The mercurial mask with its winged helmet seems to carry the dial, is the god of astronomy as well as trade and merchants. Without astronomy and navigation see travel and trade would be impossible.
Empire, circa 1810, fire gilded bronze.

Amor and Venus

Introduction

"Amor vincit omnia et nos cedamus Amori"
(Amor defeats everything, we also yield to Amor)
(Vergil, Bucolia, 10.Ekloge)

The Armor figure in 18th century art has as many variations as there are feelings which it represents. The gallant period was obsessed with love and was imaginative enough to give it many different forms. It is not by coincidence that the group of pendulum clocks, which show the god of love is by far the vastest. Amor seems more popular than his own mother, Venus, who in painting and large sculptures one of the favored subjects.

They are both important elements of the shepherd and pastoral scenes, which brought the excessive court society "back to nature and privacy." It was also a refuge from the strict etiquette and imperial pomp which prevailed at the court of Louis XIV. It is the theme with which 18th century society can identify best: the stories and anecdotes about the playful, mischievous, shameless, dangerous yet so charming god Armor. Needless to say that society only refers to aristocracy, which had the education, leisure time and wealth to understand these pieces of art and actually buy them.

The numerous myths and stories about Amor and Venus, who were represented in these pieces, were well known. They are a central theme in the plastic art, in plays, poems, operas and pastoral scenes, which were the daily past times of the upper class. Today many of these stories are not as easily understood. Many of the little motifs remain undetected and many variations and attributes are seen as mere decorations.

Development of the Amor figure in the 18th century

The Amor figure underwent a fundamental change in interpretation over the course of the 18th century, which was primarily caused by the shift in power in France.

From the original idea to the rascal

As many earlier periods, the 18th century derives its main ideas from the large repertoire of antique literature and art. The selection from this repertoire gives us a first insight into the mood of the times. During the reign of Louis XIV all arts were abused to glorify the power and majesty of the sun king. The chosen gods were: Apollo, the sun god, with whom the king identified himself and has himself personified as; Jupiter – the heavenly pendant to the ruler on earth; Athena – the strict and virtuous goddess of heroes. There is little interest at the court of the sun king, where the god-like majesty is worshipped, in the playful Amor, who does not appear very representative. Therefore the few Amor studies which were done in the Louis XIV period show Amor as the powerful god of love, who represents one of the fundamental principles of the world and who is powerful enough to battle the other powerful forces at the beginning of the world: Chronos, the vanishing time. "Amor vincit omnia" is inscribed in the pendulum clock by Andre-Charles Boulle (circa 1720), which is full of drama and the importance of the battle between these two original principals. (illustr. 150). There is no room for decorative elements. The composition makes use of the significance of up and down. Chronos, a strong, muscular man with large wings, as the looser is positioned at the base of the pendulum clock, underneath the dial, which shows the time passed. Chronos raises his hand, which holds some type

of scale, which has a different meaning from the original justice and Justitia connection. Chronos is primarily law and never considered fair. The attribute has to be seen in connection with the clock movement. Technically it is the part of an early clock movement which regulates the division of power into smaller segments and thus is the basis for the measurement of time. High above both, time as an original principle and the measured time – Amor sits triumphantly. Subject matter and form create a remarkable unity, which fits well into the dramatic forms of the Baroque period.

Antique mythology is diverse enough to allow for both Amor interpretations: the powerful principle of Eros and the frivolous, charming dangerous love god. This evolution from the original idea to the rascal is possible because of the diversity of the original god, which had been set more than 2500 years ago.

At the beginning was love

The early myths of the Greek, which describe the beginning of the cosmos and the gods, have various explanations for the creation. But they all are based on Eros, a subject without beginning or parents, with an incredible power at the beginning together with "Chaos" and "Gaia." Hesiod sees him as creative power, which forms and enlivens nature, who can also be dangerous. Love is capable of moving not only the cosmos, it conquers humans and gods. Amor/ Eros have a two-folded, overpowering nature from the beginning.

The School of Orphicus (a religious-philosophical secret philosophy in ancient Greek) is the first one to point out the relation between Eros and Chronos – which will later turn into a

conflict. For them Chronos is the earliest principal, which again is without beginning and end and which is described as "never aging time." From this three-some of "Aither" (aether), "Chaos," and "Worldegg" the powerful Eros is formed. He then creates and enlivens the world. (Pauly's Real-Encyclopedia of *classical antiquities*, Sp. 486).

150 Love triumphant over Time

The God of Time, Chronos, is lying on the floor holding the heart of the clock movement, the foliot. Amor, the winner of the duel, is flying off with the scythe (missing). Another symbol, that he takes time its power away.

The case of this important pendulum clock is by Andre-Charles Boulle (1642 – 1732), the figure of Chronos by Francois Girardon (1628 – 1715), and the clock movement by Claude Martinot (signed and dated 1726). The elaborate case is ebony veneered oak with Boulle inlay of brass and tortoise (premiere-partie and contre-partie).

Circa 1726, The Wallace Collection, London (F 41, see also page 116)

"Who buys gods of love? O see the little dove, the dear turtle-dove! The maidens are so lovely, understanding and gracious, they like to adorn themselves and utilize your love. The tender little bird, it is for sale here.

We do not want to praise him, they stand through every test, they love that which is new, but over their loyalty documents and seals do not reign, they all have wings. How clever are the birds, how charming is their sale!"

(Goethe, Poems, 4th/5th verses)

151 Amor as Singer
The God of Love is in a triumphant selfconfident pose.
Empire, circa 1810, dial signed: Michelez a Paris, fire gilded bronze

In early mythology the idea was formed, that Eros is of youthful stature, which is in stark contrast to his invincible power as a principal power. In antique sculpture he is always shown as a young boy, a tradition which was continued for many centuries.

The battle between Chronos and Eros/Amor is rooted in many stories. A study of the Boulle clock shows that their battle for dominance has been interpreted by many artists in many different ways.

The most famous attribute of Chronos, his wings, date back to the pre-Socrates Cosmogo-

nies. In the comedy The Birds by Aristophanes (premiered 414 BC), which is a parody on early myths, Chronos, hatching from an egg, receives his characteristic golden wings.

Another story brings the connection between Eros and Chaos, who is also thought to be winged. Both together create the birds, which therefore are closely associated with Eros. The old tradition, that lovers give each other birds as presents, which again confirms the relationship between the winged ones, dates back to antiquity. The bird motif is a very popular one on pendulum clocks and can be traced back to these sources (see illustr.

153 **Mural "The Sale of Eros"**
The vendor lifts a little Amor on his wings from a small cage and offers him to the ladies on the left. Figure and arm movement of the vendor, in particular, are very similar to the figure of the pendulum clock. The antique wall painting was discovered in 1759 and shortly thereafter became well known through prints and paintings all over Europe. Museo Nazionale, Neapel (inv. Nr. 9180).

Below:
154 **The Weighing of Amor**
The pendulum clock is another variation on the theme of the sale of love gods after antique models (see p. 14).

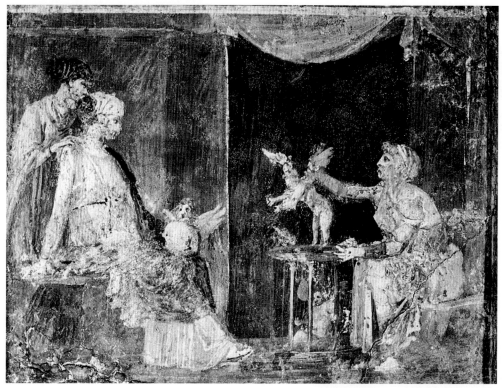

2, 152, 221). A poem by Goethe, written in 1795, shows how much these myths were still alive in the 18th century. It is a song in which bird sellers offer their ware at market and which has the title "Who wants to buy a love god."

The idea for this poem most likely stems from the discovery in 1759 of a particular painting in Herculaneum. The spectacular find became famous all over Europe through numerous prints and was the idea for a pendulum clock (see illustr. 153)

The synonymy of love gods (plural), pretty birds, and attractive girls shows the ease with which antique myths and human

152 **Amor comforts with a Bird**
This pendulum clock deals with a popular sensual theme (see also pages 6 and 27)
Louis XVI, circa 1775, Francois Vion, fire gilded bronze; a preliminary scetch from his workshop is documented (see Ottomeyer/Proschel, I, p. 247).

love affairs are brought together in the 18th century. It is not anymore the same Eros, about whom Goethe wrote, it is Eros the fickle love god.

The oldest aspect of the multifaceted Amor shows him as creative and powerful principle, which marks the beginning of the world and the cosmos. He says of himself in a proud and self-confident way: I am certainly not a child, I might look like a young boy, but I am older than Chronos and all times." (Longos, 2nd book, 5,2).

The cosmic side of his character is rarely shown, yet it is in the mind of the viewers and the afflicted. Much greater is the desire for the myth of individual love.

Finally: Amor as God of Love

The mythological background behind the humanly-everyday experiences with love was very different in the antique. Eros/Amor is the child of Aphrodite/Venus and is the god of love, who rules

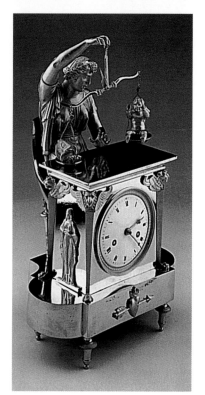

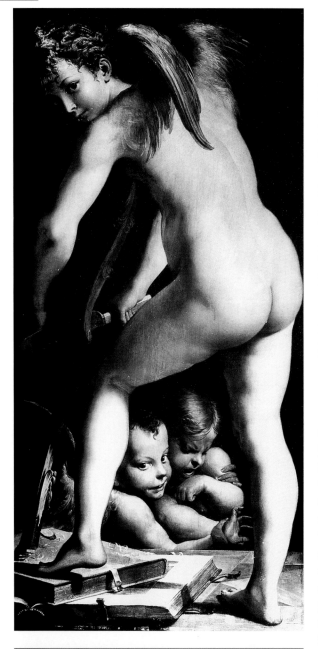

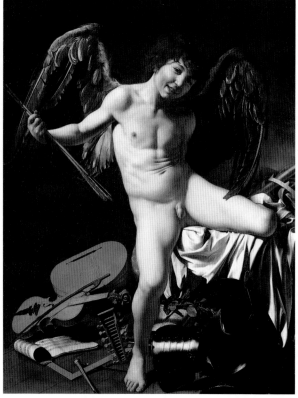

155 Amor carving his bow
by Francesco Mazzola, called Parmigiano (1503 – 1540).
Museum of Art History, Vienna.

over all lovers. This helps explain his enormous power, which he has also over the gods. However there is a difference between the worldly Amor – who promotes the bodily and spiritual pleasures – and the heavenly Amor, who has higher metaphysical goals. Originally Eros had Anteros, who had very similar features, on his side: one ignites love, the other wakes the responding love. With the increasing moralization Anteros became more of a counterpart of Eros, leaving Amor/Cupid the proponents of the fleshly-physical love and Anteros the proponent of the pure, heavenly love, who has to fend off the attacks of the first. There are several representations, which show Amor triumphant, as for example Caravaggio's Amor, who boldly rises above the symbols of science and arts. The pendulum clock "Amor as singer" deals with a related matter. It reminds us of the painting "Amor carving his bow" from 1541/43, which also shows Amor triumphant above the spiritual feelings and desires of man (illustr. 155).

Representations of " the punishments of Amor" theme are also part of this theme. In the 18th century, punishment is handled by his mother, Venus, who resorts to various means. She disarms him. By taking away the bow and the arrows she takes away his power over his victims. (illustr. 157, 213 and 215)

157 Venus and Amor
In a playful way Venus takes the weapon from her son Amor.
Empire, circa 1810, dial signed: a Paris, fire gilded bronze.

156 **The terrestrial Amor as winner (1601/1602)**
by Caravaggio (1571 – 1610), oil on canvas, 156 x 113 cm.
Staatliche Museen in Berlin – Prussian Art treasure, Fine Arts
Galerie

The attributes, which are part of the equipment of the love god of the 18th century, date back to the poetry of the classical antique: arrows, quiver, bow and torch. Another sign are doves, which actually are the attributes of his mother Venus, who is also involved in love related matters. Additional attributes are the lyre, floral and rose garlands, which are favored presents for lovers (illustr. 158, 169, Amor and Psyche).

The positive side of him is shown as a power of nature, like a god of spring: surrounded by flowers with a pomegranate in his hand, which with its many seeds symbolizes endless fertility. In earlier representations Amor would step out of a pomegranate, whereas in the 18th century he merely holds the fruit as an attribute (illustr. 159, Love nurtures life).

In literature and art the bow and arrows are the more often used attributes, which can cause wounds and pain for lovers. The Roman poet Ovid refers to Amor as " this winged rascal, whose bad behavior ignores public moral, who throws flames and arrows into strangers houses, who destroys marriages, who does incredible mischief without punishment and rarely does anything decent. (metamorphoses, IV, 30, 4-5)

The Honey Thief

The story about Amor the honey thief shows us a darker side of the god. He has – among many other things – a sweet tooth, he is addicted to sweets, licks and steals honey. At one of his stealing excursions he is stung by a bee and runs crying to

The Weapons of the God of Love – Heroic and Naughty Deeds

158 **Psyche crowning Amor**
The supreme god has the last word:"The issue should have an end one and for all, it is about time that his youthful elation be tamed by marriage.. he should have and keep her and should be happy for ever in Psyche's arms." (Apuleios, 6th book). Overall view on page 105.

159 L'amour alimentant la vie – Love nourishes Life

This allegorical scene shows Amor refilling a lamp with oil, which is the symbol of life. The pomegranat with its many seeds is anothr sign of fertility and life.

Paris, circa 1825, dial signed: Berthet a Paris (see Ottomeyer/ Preeoschel, I, p. 399), fire gilded bronze.

160 Bronze Groupe

The very vivid and expressive bronze group by Claude Galle is based on a painting by Antoine Coypel (1661 – 1722) and a print by Calude Duflos (see Garnier, A. Coypel, No. 287).

Empire, circa 1810, dial signed: Hartmann a Paris, fire gilded bronze.

his mother Venus. However Venus shrugs his complaints off by pointing out, that he can feel now on his own body, how painful the wounds which he afflicts with his live arrows to human beings are; and how large the impact of the smallest wound can be (illustr. 160)

The Greek poet Theokrit was the first one to tell this story and over the centuries the motif has been taken up again and again. The pendulum clock " Amor as honey thief" is the sculptural representation of the subject in a pyramid-shaped composition. Venus and Amor are the main characters and therefore are crowning the form, to the right and left of the dial the holy animals of Venus, the doves are positioned as well as a bee-hive, which refers to the underlying tale.

The very detailed base relief, which is inscribed with verses shows the little greenhorn, saucy and immature, doing more misdeeds. He tries to break a rose. There is a clear connection to a picture in Amorum Emblemata by Otho Vaenius (1556 –1629). (illustr. 161) The relief is flanked on either side by an applied ormolu rose bush, which again are attributes of Venus, once again referring to the love theme.

The overall composition guides the viewer to aim his eyes at the top of the pyramid. The pointed gesture of the little god is at the center of the mother son group. Who would not feel some satisfaction when observing the educational replies given by the experienced and wise goddess of love.

The Archer

In some illustrations Armor is holding two different types of bows in his quiver: golden and lead ones. The first ones cause love, the other hinders and kills it. Amor thus has double the power, which he will also use in battle. One of these battles between Amor and the sun-like Apollo is discussed in Ovid's "Metamorphoses." Phoebus/Apollo, also bearing bow and arrow, has just won against the dragon monster Python which makes him very proud and he makes fun of Amor, who himself tries to use the bow. Amor is not intimidated by Apollo and starts a counter attack: " the son of Venus replied: Your bow might injure everything, Phoebus, mine will hit you and as sure as a god is above any other subject, your glory will weaken before mine" (I, 464 – 466).

Amor uses his weapons passionately and without mercy "and took two arrows from his quiver; they had two different tasks: the one shies away, the other lightens love. The latter is golden with a sharp tip; the first is blunt; the shaft is weighted with lead." (I, 519 –520).

Apollo can not ward off Amor. Not even by making use of one of his other abilities, the art of medicine, he remains a helpless helper. "Medicins are also my discovery: the helper, as I am called on earth; I know the effect of all herbs; too bad that no herb will cure from love!" (I, 521-523)

161 There is no rose without thorns
The image from "Amorum emblemata" by Otho Vaenius (1556 – 1629) was the model for the base relief in illustration 160. "The thorn is the roses weapon, honey is guarded by the bees, while Amor (look at him) picks a sweet rose from the rose garden, is hurt by its stiff thorns. The joys are very small; the lovers are indeed very much in pain." (translated from latin)

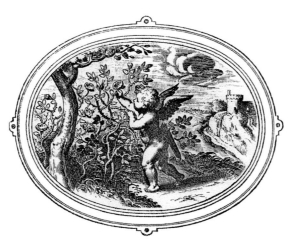

Apollo follows the nymph Daphne in a wild chase, but looses her when she transforms into a laurel tree.

From then on it is the holy tree of Apollo, its branches are used to decorate the winners in sports and artistic competitions.

This ongoing battle is a good example for the power, the mischief, and the revenge of Amor, who is invincible, resourceful, and dangerous in his field.

The care of his weapons is very important to him. Many pendulum clocks show him as blacksmith or in the process of sharpening his bloody instruments (Horaz, c. II 8, pp. 14) (illustr. 162, 163, Amor sharpening his love arrows). The diligence with which he completes his task, gives the viewer the feeling, that nothing can be done against love and that there is nothing good in his own future.

"The thorn arms the roses, the bees protect the honey while Cupid (just look) chooses the sweet rose from the rose garden with his hand, his wounded limbs smart from the stiff thorns. What makes pleasure is only very little; what pains the loving is more: whatever they may bear, all the more do the thorns drip of bitterness."
(O. Vaenius, Amorum emblemata, author's translation)

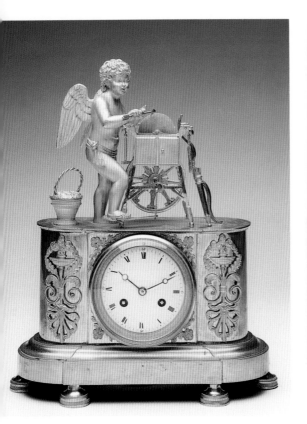

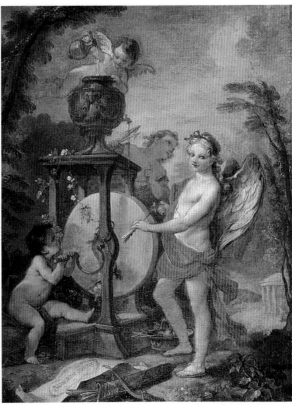

162 A smiling Amor sharpens the love arrows, these bloody weapons (Horaz), the bow is leaning next to the whetstone. Empire, circa 1815, fire gilded bronze.

163 The image of the arrow-sharpening Amor is a very well liked theme in the arts. The painting by Charles Joseph Natoire (Nimes 1700 –1777 Castel) seems to translate directly into the pendulum clock of the arrow sharpening Amor, which is a mirror image, reduced to the most important attributes. The scroll on the ground shows the phrase "NONDUM PUNGIT" – he does not hurt yet. The phrase captures the ambivalence between the dangerouse weapons and the seemingly harmless smile on the god's face.

Love makes wings – Amor and the philosophers

Besides the mythological figure of Eros, the philosophical Eros is also known during the classical antique, especially in Plato's dialogs.

Everyone is certain to know the meaning of the term platonic love. However, Plato originally did not mean an a-sexual and purely intellectual relationship between two superior spirits. In his "Symposion" and "Phaidros" – Eros is the intermediary between the material, actual world and the spiritual world of ideas, between human beings and the gods. The love for the beautiful leads the soul from worldly beauty – which the Greek always saw in the form of a handsome young boy – to the spiritual and finally to the understanding of the general and eternal, the world of ideas. In "Symposion" Plato challenges the participants of a dinner party to discuss the meaning of Eros.

One participant after the other discusses his theory, which were primarily based on the pre-Socrates myths, until at last Plato gives us his own, differing opinion, which is delivered by Socrates himself. Socrates claims, that his knowledge comes from a wise woman, Diotima. Accordingly Eros is not the handsome, brave and wise god who should be honored and praised – at the contrary.

He is an important instrument for the soul to master the steps from the love of a beautiful human body, to the pure soul and the pure sciences, finally to the understanding of the idea of the beautiful and thus the eternal idea itself.

In Phaidros Eros is seen as Psychagoge – the guide of souls and the power of love is a central theme. It is interesting to see how Plato translates the idea of the immortal soul: it is feathered. Be-

164 **Amor floats** in a butterfly-pulled chariot above the clouds. The motive is often repeated on antique cameos.
Empire, circa 1815, semi-sceletonized, fire gilded bronze.

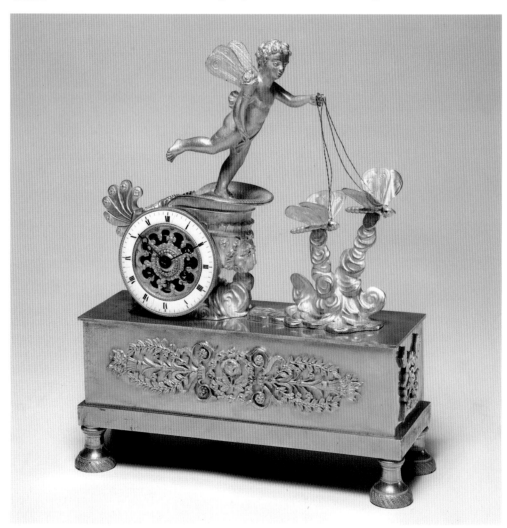

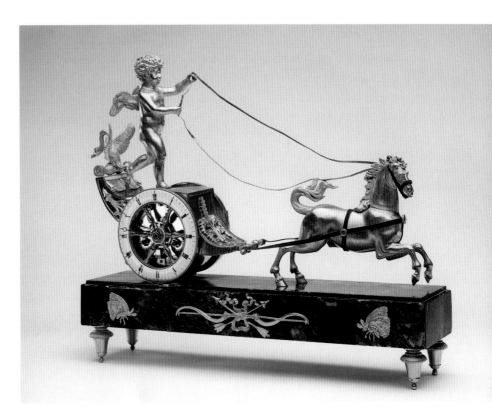

fore the soul enters a human being, it can see the ideas, upon its connection with the human body it looses this ability and its wings. Only when the beauty of the desired love is light and Eros is present, does the soul regain this ability and the wings are growing again. Love gives wings. Despite of all the problems – sometimes even insanity-which love can cause, the philosopher insists that it be held in highest esteems. " If it were true that insanity is only evil, it would be easy: however, sometimes the greatest treasures spring from a god given insanity. (244 a)"

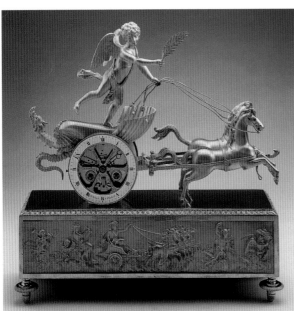

166, 167 A triumphant Amor steering the two horse charriot
The very lively horses with flying tails and wide open eyes and the dragon add drama to his success.
Empire, circa 1810, dial signed: Lebrun a Charleville, semi-skeletonized, fire gilded bronze, enamel eyes.

167 The base relief shows Apollo/Helios crossing the heavens with cloud-whirling speed. Similar to a triumphant parade a winged Genius holding an overflowing basket and Mercury are at the head. Amongst his companions are the writing Muse, who is surrounded by her sisters' attributes and a putto holding a laurel wreath. Apollo is shown as "Apollo Musagetes" – the leader of the Muses. The doubling of the triumph motif is an optical interpretation of the competition between the two gods, with the fragile Amor winning over the powerful god.

165 The charging horse and the steering Amor convey the dynamic of the love god very well. His weapons and two butterflies, symbols for Psyche/the soul, are applied to the base.
Empire, circa 1810, semi-skeletonized, fire gilded bronze, vert-de-mer marble.

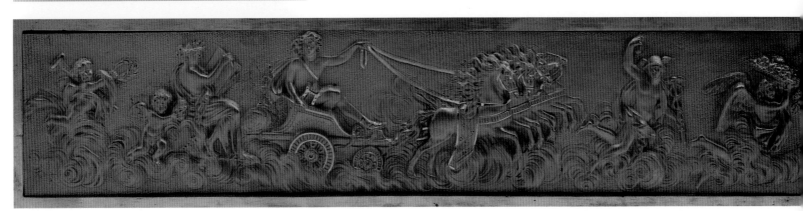

168 Amor is in melancholic pose, contemplating vanity. Empire, circa 1810, dial signed: Bodot a Dijon, fire gilded bronze.

Amor on a serious mission – guide for the soul and carrier of death

The combination between the platonic interpretation of Eros as a soul moving power and the symbolic vision of the soul as a butterfly leads to the pictorial interpretation, which shows Amor on a butterfly -drawn chariot. It is a popular theme for pendulum clocks (Illustr. 164). Amor guides the soul.

The composition of Amor in a horse drawn chariot can be interpreted similarly, with the addition of the triumphant chariot (illustr. 165, 166). Other – more serious interpretations of his character show Amor with his torch pointing down (symbolizing death) or with his head lowered in a melancholic gesture, which shows a pensive and self-conscious emotional stage (illustr. 168). It shows Amor as Eros-Thanatos and as carrier of death. The figure is similar to Christian angels and on 18th century pendulum clocks he is often shown as tall, winged Genius, holding a medallion or shield.

The sleeping Armor, laying on vines and vine leaves, his head resting on his arm and his weapons in his lap (illustr. 172) is also part of this group. The vines symbolize a bacchanalian feast and in a figurative sense the drunkenness of lovers, from which Amor is recovering by sleeping – the "sleep is the little brother of death."

Two important literary pieces of the antique "Amor and Psyche" and "Daphnis and Chloe" have had a large influence on the Amor interpretations of the 18th century. They are a model for numerous pendulum clocks.

Amor in Love—the Tale of Amor and Psyche

The tale of Amor and Psyche shows the god of love very private, he himself being tangled in the net of love. The tale was written by Apuleios (born, circa 125 AD) and had reached fame in antiquity. During the classicism period of the late 18th and early 19th century the tale was again very popular and was shown in many different ways. It was a perfect mirror and ideal of the emotional and romantic-enthusiastic society of this period.

The main figure of the tale, Psyche, is the personification of the human soul, which after many missteps and a painful search at the end is united with the heavenly love – Amor. The Greek word for "Soul" is "Psyche," but it also means "Butterfly." Therefore the butterfly became one of the attributes and symbols of the Psyche figure in the arts. Frequently Psyche herself is shown with small wings (illustr. 191, 193).

The relief on the front of the base shows an exciting scene from the tale – it is after the famous painting by Francois Edouard Picot (1786 – 1868), which now is part of the Louvre collection (illustr. 170). The relief shows the winged Amor, leaving the nuptial bed and leaving the sleeping Psyche behind. The importance of the scene can be found in the literary text: Psyche is engaged to Amor, who has brought her to his magnificent castle, without her ever laying eye on him. She has to promise, that she will never look at him. Therefore Amor leaves

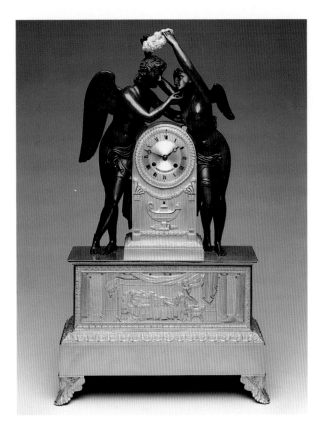

Literary Influences

169 **Amor and Psyche**
Amor and Psyche are leaning against each other, in the manner of a famous antique marble sculpture, the "Capitolinic Kiss" (Roman copy of a Greek sculpture, circa 200–150 B.C.). This pendulum clock is based on a design by Calude Michallon (see Ottomeyer/Proschel, p. 350).

170 **Amor leaves Psyche at dawn**
painting by Francois Edouard Picot (Paris 1786 – 1868) is the model for the base relief of the pendulum clock in illustr. 169. Musee de Courage (oil on canvas, 43 x 52 cm, Inv. Nr. CH 153).

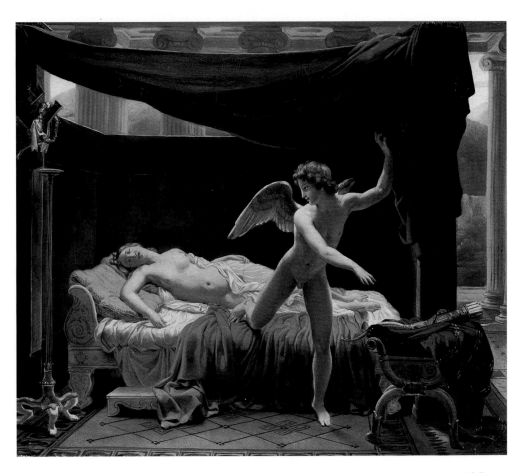

171 **The shepard – Chloe**
The graceful figure is attributed to Etienne Maurice Falconet (1716 – 1791). It helps us fully understand the quote by Longos, that Chloe is "…. the maiden, whose fate is used by Amor to weave the myth of love" (Longos, II, 27, 2)
Louis XVI, circa 1775, dial signed: Carcel Jne. A Paris, fire gilded bronze.

sees that Psyche has not held her promise he fulfills his warning. He leaves her and she stays behind unconscious. After several adventures the two lovers are united again. Venus, the jealous mother is calmed and Psyche as Amor's wife enters heaven.

The pendulum clock (illustr. 169) is executed very detailed and full of fantasy, the artists gets some inspiration from old models, which he recomposes. The gesture of Amor gently touching the chin of Psyche can be seen already on antique sculptures (Amor and Psyche group on the Capitol). Similar details, as the oil lamp and the knife underneath the dial are also taken directly from the original text.

The scene is thematically and formally the bases for the reunion of the lovers, which the bronze shows symbolically and actually. Different from the rest of the case, the two figures are not gilded, they are made of patinated bronze, and are therefore optically in a strong contrast and appear like independent plastics. Nevertheless they harmonize very well with the clock case. The two figures standing next to each other follows antique representation, which is artistically further developed when the two figures turn towards each other. The gesture of the embrace and the crowning is the culmination of the story as well as the formal end to the composition. Subject matter and outer form are identical and form a harmonious and lively unit.

For Apuleios – as an antique thinker – the happy ending was the reunion of the two lovers. For the frivolous sensibility of the 18th century and the following romantic period this event is a symbol for the fate of the soul, who gives itself up for love, deals with its fright and finally looses the burden of its body.

No other myths had more influence during this period. Therefore a large number of works exists, which show the many different events of the story in many different variations.

"But their games were those of herders and children. She obtained reeds somewhere outside and wove a cricket-cage; but he cut the thin tubes...and practiced playing the flute until late at night." (Longos, Daphnis and Chloe, I, 10, 1 and 2)

her every morning before dawn. The happy relationship is disturbed by the jealous sisters of Psyche. They tell her that her spouse does not want to be seen by her because he is a monster. Psyche, therefore decides to look at her husband despite the prohibition, in order to have peace of mind. During the night, while Amor is sleeping, she lights an oil lamp and approaches Amor with a knife in hand, in order to be prepared against the monster if necessary. While looking at him, some oil drips on Amor's shoulder and he wakes up. When he

The birth of the lover's hour –
The myth of love in nature

The Duke Philippe II of Orleans had the book "Daphnis and Chloe" by the antique writer Longos translated into French and published it with his own illustrations in 1718. It became the most read and favorite book of the period. The story is the source for idealized vision of a perfect landscape with happy human beings, who live in harmony with nature and the gods. The text combines numerous attributes, which find their way to many pieces of art and also to pendulum clocks.

Shepherds poetry and pastoral scenes are an important part of the plastic arts and literature of the 18th century. Various motifs were turned into plays and acted out in aristocratic circles. Palace gardens were transformed into arcadian landscapes, in which king and queen as shepherd and shepherdess play out the dramatic and idyllic love stories as for example the one of Daphnis and Chloe. In a cultural historical context this transformation into the playful, which started during the Regency period, is in contrast to the strict and stiff etiquette at the court of Louis XIV. From this point on ease, gentleness, sentiment and grace were the measure of any action and of all the arts.

Longo's story shows the large influence Amor has over the fate of the individual and despite the age and cultural context of his story, it offers numerous ways for identification. Daphnis and Chloe are abandoned as children and are saved from starvation by animals. A goat takes care of the boy Daphne and a sheep nurses Chloe. Finally both are found by shepherds and spend a wonderful time – he guards the goats, she takes care of the sheep – in an idyllic and paradise-like land.

It is the world of Pan, who is the inventor of a flute, the syrinx – which is named after one of the nymphs – which is the most important musical instrument for shepherds. Pan is the god of nature, who has goat legs and horns on his head, who together with the Nymphs rules over the forests and meadows. In his honor Daphnis and Chloe sacrifice ivy wreaths, vines and pomegranates and perform dances and songs for the shepherds. The nymphs play an important role in the story: In the grotto of a nymph which also contains a spring, the shepherds find Chloe when they follow a sheep which always disappears in the grotto to nurse the infant. In the same grotto Chloe notices Daphnis' beauty, while he is taking a bath. The time of innocence and naiveté is now over for both of them. Amor has his own plans: Chloe is the girls, whose fate Amor wants to make into one of the myths about love (Longos, Daphnis and Chloe, II, 27,2).

Amor is described as being bird like. He hides between very symbolic bushes, the myth and the pomegranate: his wings, which are fast and light, make him a very agile being, which can not be caught, his laugh is as bright as the tone of silver, nothing like it had been heard before, neither from swallows nor nightingales (II, 4 and 5). This passage started the custom that lovers give each other birds as a symbol of their love.

The bronze (illustr. 171) shows Chloe in a very suggestive pose and the sheep which looks up to her full of confidence. The figure is very graceful and of such high quality, that it is customarily attributed to the most famous sculptor of the 18th century, Maurice Etienne Falconet (1716 – 1791). Chloe is barefoot, her hair and cloth are in the antique style, and she has a rose in her hair as sign of love. The little sheep is resting on a pile of rocks, which remind the viewer of pristine nature or maybe even the grotto in which Chloe had been found. The proximity to the sacred place of the nymphs and the holy spring is symbolized by the bowl, over which Chloe holds her hand in a very gracious manner. This gesture is one of innocence and purity (see Cochin, Iconography, L'Innocence, Book III, 13, same gesture and lamb).

The decorations on the pendulum clock are carefully chosen and refer to the antique text. The

"But as the reflected light reveals the secrets of the camp, she notices the gentlest and dearest monster...himself, Cupid, the splendid god, lying there gloriously, in whose sight even the lamplight began to glow more brightly for joy, and the knife regretted its shameful sharpness....She sees the golden head's charming hair, fragrant with ambrosia, sees the profusion of locks flowing over the white shoulders and the purple cheeks, tastefully tangled, some falling on the shoulders, the others on the back; their powerful gleam now even making the light of the lamp flicker. On the shoulders of the winged god, the feathers shimmer like flowers shining with dew, and although the feathers are at rest, yet the outermost delicate and fine featherlets hop lightly, trembling for restless joy. The rest of the body was smooth and shining, and thus that Venus need not be ashamed of having birthed him. At the foot of the bed lay the bow, the quiver and the arrows, the joyful weapons of the great god" (Apuleius, 5th Book)

bezel is decorated with a floral band of pomegranates, grapes and rose blossoms. The base relief shows exuberant, winged figures of Eros with wind instruments, dancing around a vessel with rose buds, celebrating a shepherd's feast, where music plays an important part.

The artistic –technical execution of the bronze clock equals the quality of the design. Even the smallest surface has its own treatment: the coat of the sheep, the rocks, Chloe's skin, her clothing and hair, the festoons and the relief – every little detail is chiseled with different tools and smoothed with the agate pen. All these different effect breath life into the figures. In addition different gold tones are used, which helps distinguish between individual elements and which increases the plastic effect.

The pendulum clock is a good example for the art of early Classicism, which one art historian referred to. as "rational paired with grace" (Hildebrandt, 1924, S. 9 and 10). If this is a true also for the Chloe clock – and every observation points in this direction – then the high demands on the pendulum case become clear, which are certainly much higher than the mere decoration of the clock movement.

Conclusion

The many different meanings of the Amor figure can be shown on numerous pendulum clocks. The composition and attributes frequently come from antique motifs which are further developed or returned to. The viewer, who carefully studies the literary and artistic sources, will quickly understand, that nothing, not even the smallest attribute and composition is coincidental or has only a decorative purpose.

At the contrary, it is often the smaller details, which are very important for the meaning of the group as a whole, deepen the theme or open new aspects.

No other period was as obsessed with the Amor and Venus theme as the 18th century. The antique mythology has a very wide spectrum of different Amor figures, corresponding with the many variations of the phenomenon "love." One of the primary purposes of myths is to explain the important and unexplainable aspects of life. It is not surprising that the plastic arts and the pendulum clocks of the "gallant" period often focused on the Amor/Venus myths. Love was the theme of the century.

The different interpretations of the Amor figure show the different intellectual movements over the century. While Amor as an original principle and power was the prevailing interpretation during the reign of the sun king, he turns into a mischievous, frivolous, always dangerous boy over the course of the century. The joy in the playful culminates in the genre scenes of the late Empire, when Amor is shown as a cute and playful little boy with wings. In these genre scenes he is as far removed from the original idea as from the reality of the human feeling which he represents.

left:
172 Sleeping Amor
The god of love is exhausted after work and resting in a basket, which is filled with grapes and vines. Since antiquity this theme is known (See for example the sleeping Eros, 200 B.C., Metropolitan Museum, New York). The initial drawing is by Jean Andre Reiche and was registered on June 1, 1807 at the bibliotheque Imperiale ("l'amour endormi sur la corbeille", see Cat. Musee Fontainbleau, No. 19). The pendulum clock used to be housed at the Chateau Fontainebleau in the bed chamber of the Prince of Neuchatel.
Empire, circa 1807, Jean-Andre Reiche, fire gilded and patinated bronze.

173, 174 Amor in a nest
The case is composed of C-scrolls and leafage and flower ornamenation and houses the clock in an organic way. It is crowned by a small bronze group, in which Amor is triumphant over time.
Louis XV, circa 1755, dial signed: Filon a Paris (Maitre 1751), style of Robert Osmond, fire gilded bronze.

173 Amor is sitting in a little nest and has just released some birds from their cage. According to mythology he himself hatched from an egg and therefore is also the creator of birds... and out of it crawled the desire evocing Eros, with golden wings on his shoulders.. it is certain that we are fathered by Eros: just like himself we like to fly and seek the company of lovers." (Aristophanes, The birds, V. 697-705.) Birds in cages were a common present among lovers.
The figure is very similar to a marble sculpture by Jean-Baptiste Pigalle (1714 – 1785), "Child with bird cage," 1749, which later was copied in bisque porcelain.

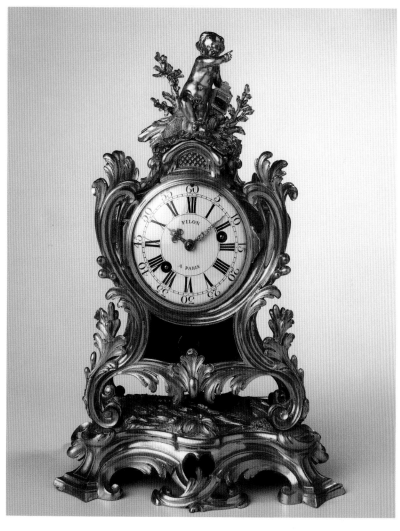

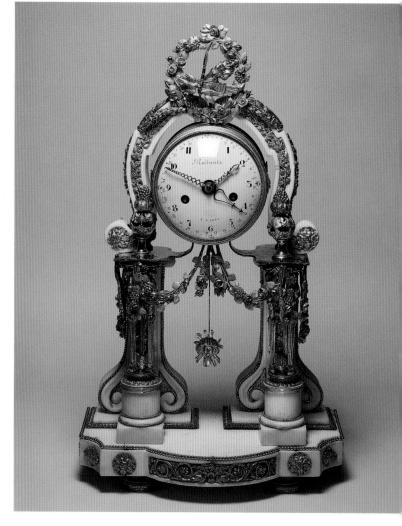

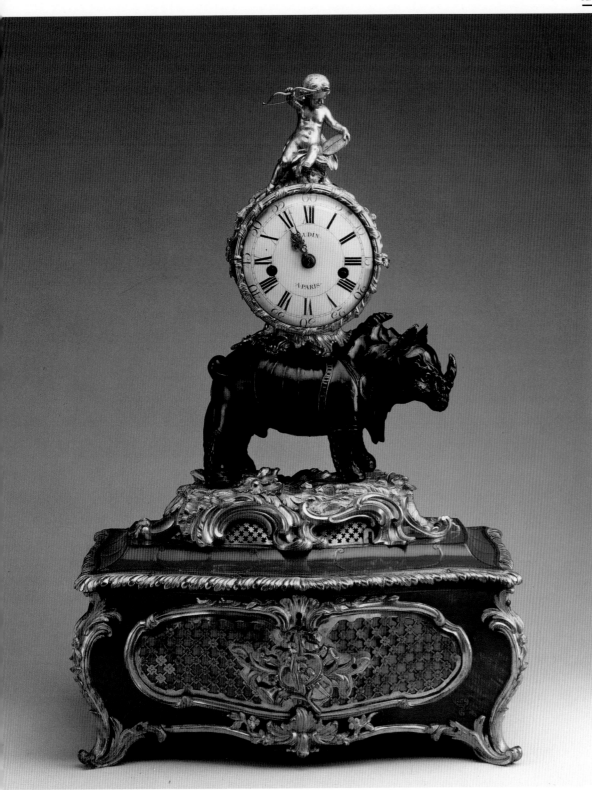

176 Amor on top of a Rhinoceros

Amor is at the top of the composition showing his status within the world order – Amor vincit omnia –. Neverthelss the rhinoceros is the more interesting feature. It stands on a typical Roccoco base which is raised on a box covered with green horn veneer and which contains a musical movement. In the 18th century the rhinoceros was a novelty. In 1749, the first rhinoceros was exhibited in Paris and Versailles, at which time it stood model for a sculpture by St. Germain (a stamped copy is listed in Cat. Partridge, 1997, p. 88). The creator of the present rhinoceros never saw a living example. It has scales on its legs, which look almost like shingles, the remainder of the skin is very smooth, it also has two horns, one of which is growing out of its neck pointing forward. The artist is following closely the wood cut by Albrecht Duerer from 1515! (see Anzelewsky, 1988, p. 189). This makes clear how rare these animals were and which large historical significance they had.

Louis XV, circa 1745, dial signed: Gudin a Paris (Jacques Gerome Gudin, Maitre 1750), fire gilded and patinated bronze, green horn on oack.

p. 110, lower right

175 The triumph of love

Two turtle doves, surrounded by a wreath of rose buds crown this pendulum clock, which form-wise is classified as a portico clock. The very detailed leave and flower garlands, which are interwoven with the architectural form are very typical for the "*gout etrusque.*"

Louis XVI, circa 1780, dial signed: Radant a Paris (Pierre-Georges Louis Radant, Maitre 1783), date, fire gilded bronze, white marble.

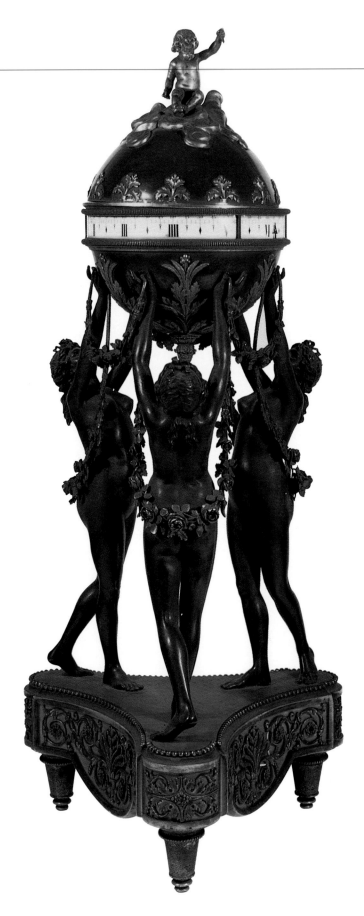

177 The three Graces and Amor
The three gracious daughters of Zeus are connected by a garland of rose buds and are holding a spherical globe in their hand, on top of which Amor triumphantly raises a torch. In 18th century art the three graces were personifications of friendship and were adversaries of Amor, who symbolized the longing love, who often brought disaster. The three became his teachers, who, when he behaved well, carried him triumphantly. This subject theme is taken from F. Boucher's famous painting "The Graces and Amor" (1768/69, Louvre, Paris). The Three Graces are holding Amor on their shoulders, who is spending light to the world with his torch of love. The same subject has been made into a pendulum clock with marble figures by E.M. Falconet (circa 1770, Paris, Louvre) and became one of the favorite subjects during the Classicism period, (see Cat. Schwabischer Klassizismus, p. 289 –303). Similar clocks are documented and signed Le Paute.
Louis XVI, circa 1780, fire gilded and patinated bronze, white marble.

179 Amor fleeing with Time

Amor, equipped with a bow, is carrying time – symbolized by the clock - on his wings. The speed with which he seems to get way is emphasized by the waving cloth and seems frightful despite the smile on the love god's face. The free standing figure follows the same compositional rules as the "Portefaix" and the pendulum clock "Amor with laterna magica".
Late Empire, circa 1820, fire gilded bronze.

181, 182 **"L'Amour fait triompher la Beaute"**
In a triumphant parade Venus presents the golden apple with the inscription "For the most beautiful", a distinction which she had received in her competition with Hera and Athena from Paris.
Late Louis XVI, circa 1790, bronze, white marble.

180 **War and Love (Triumph of Love)**

The clock is highly decorated with rhinestones and flanked by two genii. It has the form of a love altar, as was common in the 18th century. It is surmounted by two doves, which are floating on clouds – signs of the Venus. The genius to the left of the clock is dressed like the warrior god Mars with spear, shield and helmet and symbolizes war. The little Amor to the right is representing love- eventhough he is also carrying arms. The old conflict between Mars and Venus, between war and love/peace is adressed. The altar of love which is elevated over everything is indicating that ultimately love is victorious. The original red chalk design of a "piece de bureau " in the "livre de dessins" is from the atelier of Francois Vion (Maitre 1764) (see Ottomeyer/Proschel, I, p. 180). The execution of the smallclock is jewel like.

Louis XVI, gout grec, circq 1770, dial signed: Gilles L'aine a Paris (Pierre Gilles, Maitre 1746), fire gilded bronze, grey marble, rhine stones set in silver.

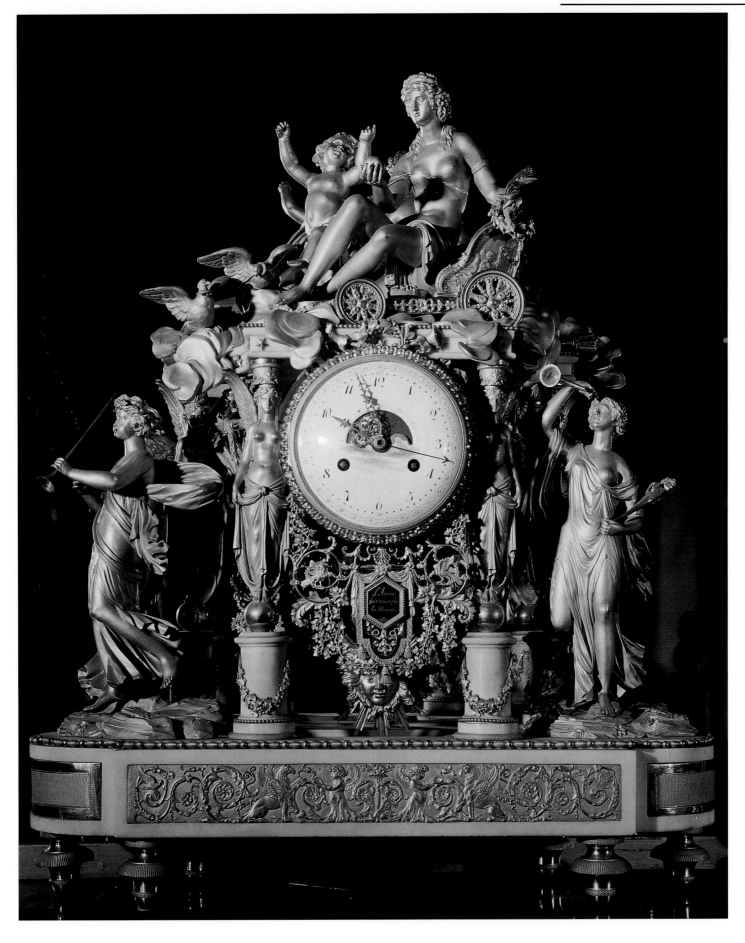

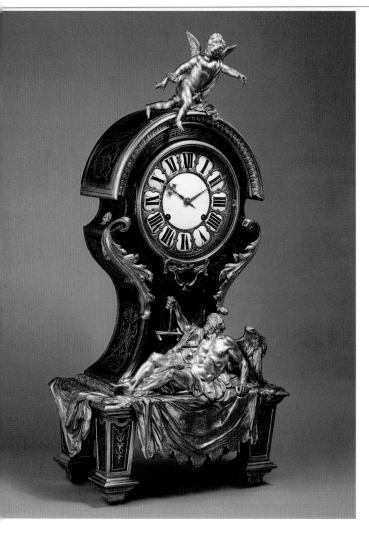

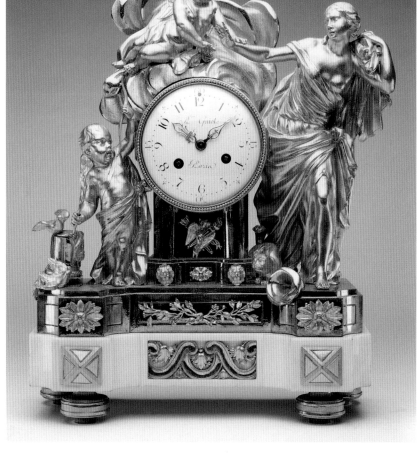

183 Love triumphant over Time

Several variations are known to exist of this famous clock (see page 95). The pendulum clock is a good example for the cooperation of several artists. The case can be attributed to Andre-Charles Boulle, based on a design at the Musee des Arts decoratifs, Paris, 732 D, the figure of Chronos was designed by Francois Girardon (1628 – 1715), the clock movement is signed THURET (probably Jacques-Augustin Thuret, horloger du roi 1694).

The elaborate case with pedestal, circa 1712 – 1720, has an oak case veneered with ebony with Boulle inlay (premiere-partie and contre-partie) in brass and tortoise and fire gilded bronze applications. The Wallace Collection, London (F 43, F 55).

184 The rebuff of Amor

This unusual bronze group shows an unsuccesful Amor. A young woman wearing a volu- minously draped dress, retreates in shock from Amor, who approaches her riding on a cloud. Amor hold her arm tenderly, but her facial expression and gesture make it clear, that she does not want to have anything to do with Amor. The kitten at her feet also reflects her hostile mood. Amor's little helper hands bow and arrow. Two doves, em- blems of the goddess of love Venus, are sitting on a column. The rebuff of Amor, who besides joy can also bring sorrow, has an iconographic tradition. (see illustr. 155). Inter- estingly this scene also has a parallel in the biblical scene of Mary, who wants to ward off the Archangel Gabriel.

Louis XVI, circa 1775, fire gilded bronze, white marble.

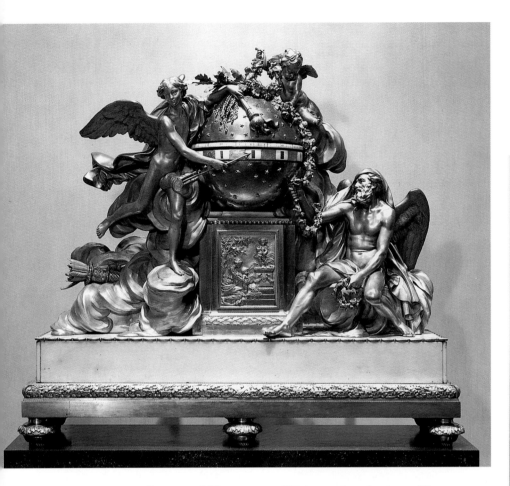

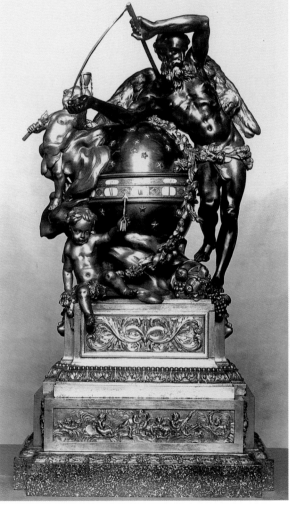

186 **Amor - Ruler over Cosmos and Time**

This monumental bronze group is modelled after a design by Augustin Pajou (1730 – 1809) and was executed by Lepaute. The triumph over Chronos is modified and symbolized as Four Seasons. At the center is an altar with a celestrial globe with applied stars. The *Cercles Tournantes* are formed as signs of the zodiac, which show the passing year. The young Amor, who, with large wings, storms down from the clouds, points at it with his love arrow. He holds the globe and rests his flaming torch on it – a sign of Amor ruling over the Cosmos. The contrasting figure is the defeated Chronos – despite being strong and muscular he seems weak and bent over like an old man. As a sign of his defeat he holds a wreath and a garland of rose blossoms, which are draped around the globe. He has his head covered with a piece of fabric, which gives the appearance of a winter personification. The other seasons are symbolized by vines – for autumn and wheat – for summer, which a fleeting putto is holding. God Amor is also shown on the altar relief "L'Adoration d'Amour," a sacrifice and prayer at the altar of Amor.

Louis XVI, circa 1780, fire gilded bronze.

187 **Amor triumphant over Time**

The well composed group and the high quality of the figures are after a design by the sculptor Augustin Pajou (1730 – 1809), the casting is attributed to Etienne Martincourt.

It shows the battle between Time and Love. The powerful Chronos and the clock represent time, three winged little Amors are its adversaries. The difference between the two is further enhanced by the patination and firegilding of the figures. The mighty God of time is attacked from three sides: first he is held by a rope of rose buds, second, one of the winged putti has stolen the hour glass – symbol of fleeting time – from his hand, the arm is still resting on the celestial globe and the empty hand confirms the deed. Another one holds the scythe from behind, which Chronos is desperately trying to retrieve. His ability to end lives is taken from him. The third putto holds the rose bud cuffs and points a love arrow towards the celestial globe, which symbolizes the universe. The *Cercles Tournantes* form its equator.

The battle between the two powers and the triumph of the small love god over the muscular and powerful Chronos is shown as an allegory and through the movement and the action of the figures, the clock movement is perfectly integrated into subject and formal composition of the bronze.

A larger model had been made for the Duchesse of Mazarin, which in 1824 had been part of the collection of the bronzier Pierre-Francois Feuchere.

Louis XVI, circa 1780, fire gilded, patinated and enamelled bronze, The Wallace Collection, London (see Hughes, Wallace Collection, p. 82, Inv. F 264)

188 Psyche in front of a Mirror

Psyche looks at her image in a mirror while holding a little vase in her hand. It is a variation of the jar with beauty lotion, which Psyche at the request of Venus gets from the goddess of the underworld, Persephone. The scene had been made famous by a short story by Jean de La Fontaine (1669) and has been the subject of numerouse paintings. The most famous one is by

Angelika Kaufmann (1741 – 1807) " Amor wiping off the tears of Psyche", 1772, Kunsthaus Zurich, see Cat. Amor and Psyche, 1994, pp. 68), which shows Psyche holding a similar vase. Despite strict orders to the contrary, Psyche opens the vessel and the fumes make her ugly. (This scene has never been shown in the arts). Yet Amor can save her and comforts the confused. See also illustr. 229.

Empire, circa 1805, fire gilded and patinated bronze.

189 Amor unveils Psyche

Claude Galle (1759 – 1815) shows the happy ending to the love story. This bronze is a smaller and slightly modified version of a large pendulum clock by Pierre-Philippe Thomire (Madrid, Patrimonio Nacional) after Francois-Nicolas Delaistre, which shows Amor and Psyche sitting on the matrimonial bed after their reconciliation.

Empire, circa 1810, dial signed: Galle/rue Vivienne, fire gilded and patinated bronze.

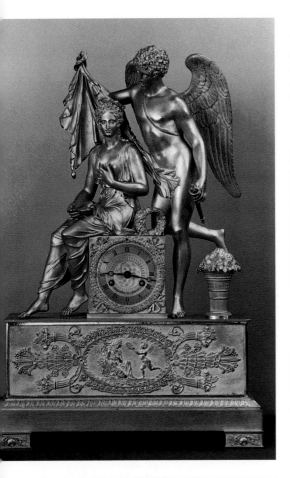

190 **Amor takes the veil off Psyche**
The unveiling of Psyche is a familiar subject ever since the pendulum clocks by Claude Galle (illustr. 189). Now it is turned into an independent scene. Psyche has a dove sitting in her lap and one hand resting on her bossom. The figure of Amor has very large wings and lifts the veil while approaching from the back is very similar to images of Chronos unveiling the truth.
Paris, circa 1820, dial signed: Canaillon a Paris, fire gilded bronze.

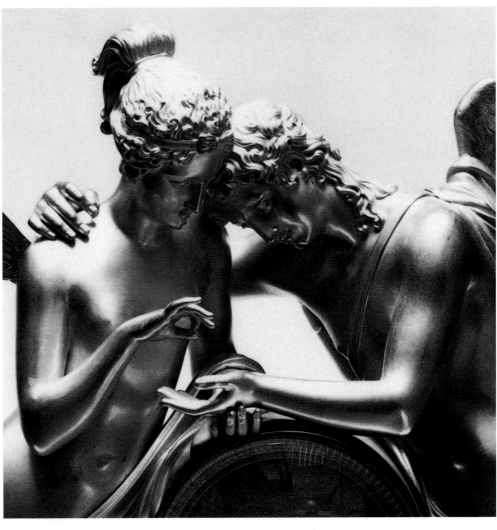

191, 192 **Amor and Psyche**
The group is based on a marble sculptur by Antonio Canova. The amorous relationship between the two figures is reflected in their closeness over the column holding the clock. The oil lamp and dagger underneath the dial symbolize the mistrust and passed trials of their love.
Empire, circa 1815, fire gilded bronze, marble.

192 Psyche – shown with butterfly wings – gently puts a buttlerfly (missing) in Amor's palm. The term "Psyche" means butterfly and soul in ancient Greek.The two lovers convey total harmony and peace. Their love is triumphant over time, as Mercury had predicted when Psyche joined the gods and married Amor:" (Apuleius VI, 23).

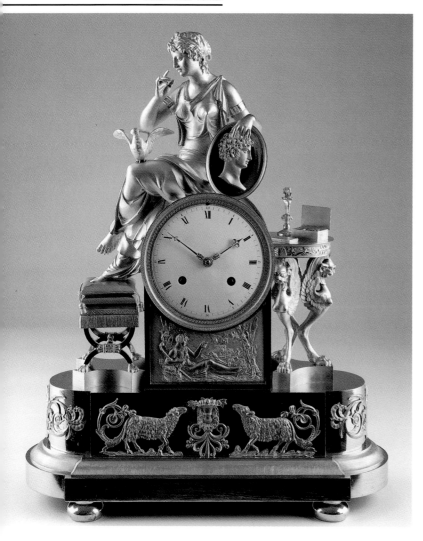

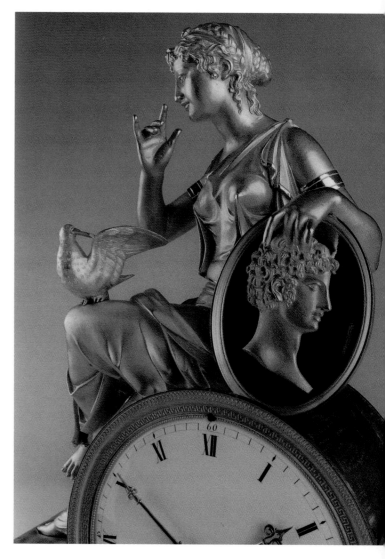

193, 194 The Love Letter

The young woman who holds the medallion portrait of her lover has given her message of love to a carrier pigeon. The narrative portrayal is centered around a pastoral setting. The relief shows the receiver to be a young shepherd, who receives the letter while lying in an idyllic landscape, with the lambs on the base repeating the theme. The narrative portrayal is supported by the especially finely worked details. Bronze by François-Louis Savart (design at the Bibliothèque nationale, Cabinet d'Estampes 30, 37, compare Ottomeyer/Proschel, I, p. 376), Empire, ca. 1810, fire-gilded bronze. *Kunsthandel Michael Nolte, Münster)*

195 Allegory to Fidelity

Two putti, one male and the other – which is very rare – female are on top of the composition, which is unfolding around the dial. The clock seems to float in clouds and is held up by the third putto. The mountains of clouds are decorated with roses, doves and quivers with love arrows. A little dog, the symbol of fidelity, is positioned between the pair of putti. The raised wreath symbolizes the triumph of love and fidelity.

A drawing of the pendulum clock on a piece of furniture , which is attributed to La Rue is known (circa 1780). The two crowning figures can be found on several pieces of furniture, such as the Bureau du Roi by Riesener and Oeben in Versailles (1760 – 1769, see Ottomeyer/Proschel, I, p. 251).

Louis XVI, circa 1780, fire gilded bronze, white marble.

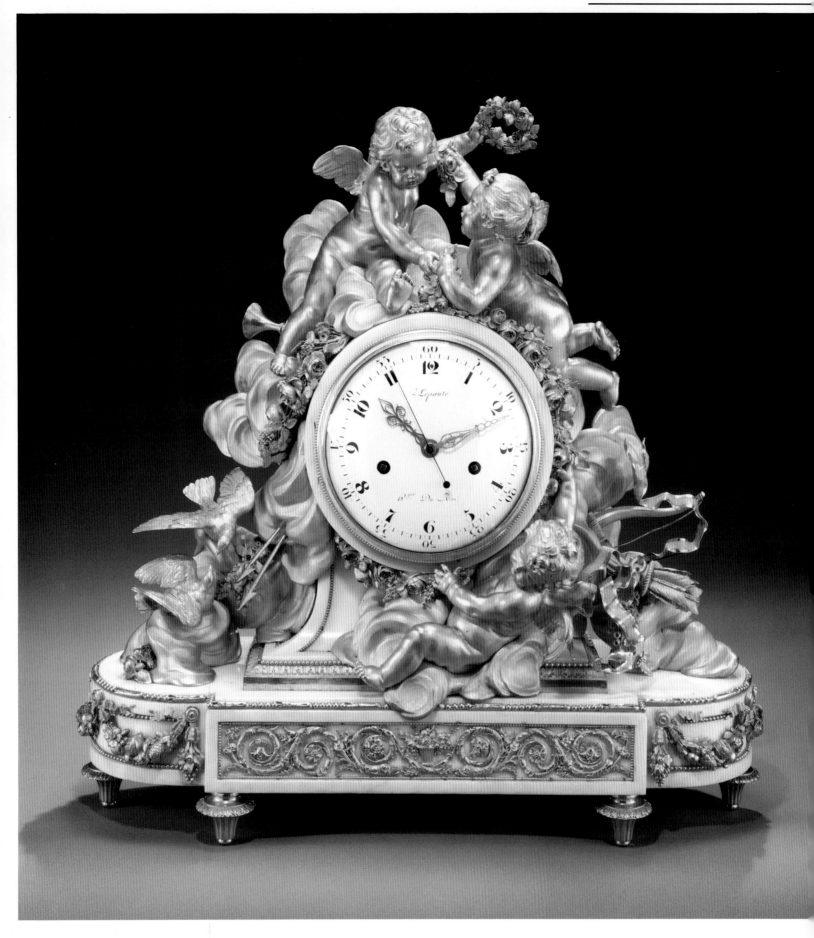

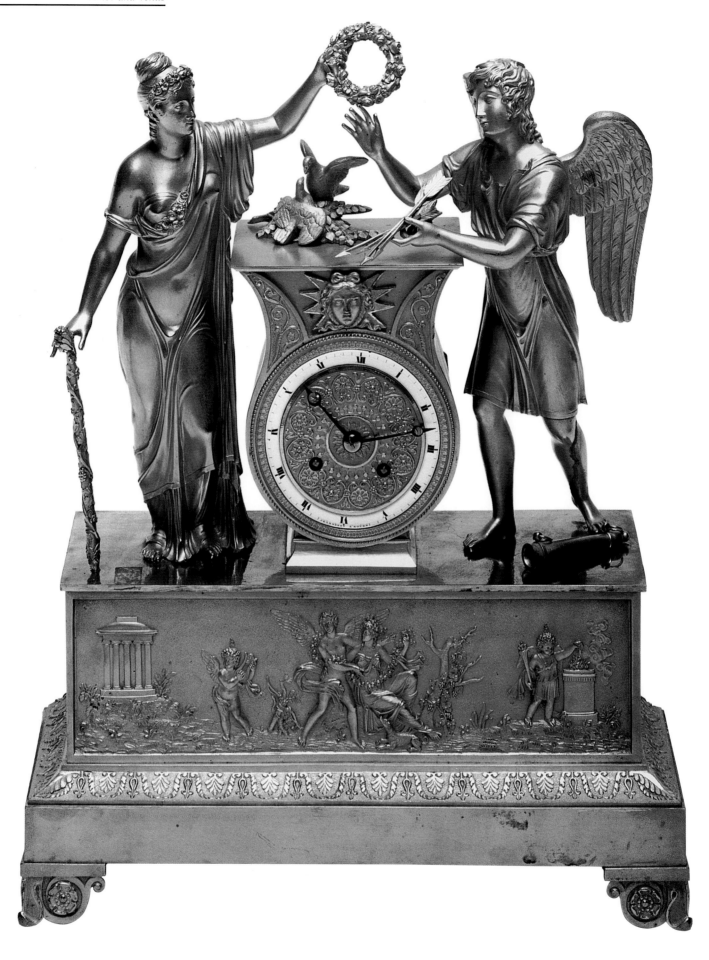

198 Amor at the bossom of hope. Love needs nurishement, which is well known since antiquity, when Terenz wrote: "Sine Cerere et Baccho friget Venus" (in: Eunuchus IV, 732) – Without bread (ceres) and Wine (Bacchus), love will freeze (Venus).

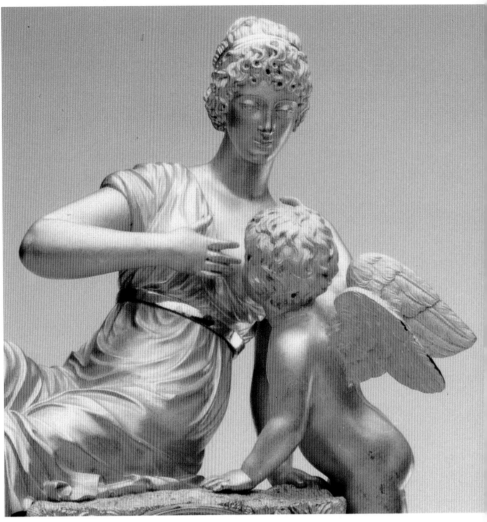

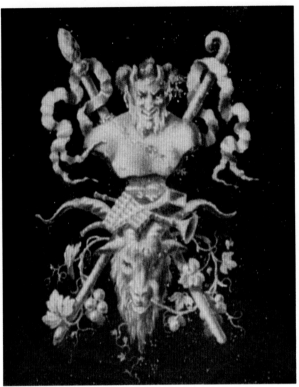

197 –199 **Hope nurses Love**

This very rare pendulum clock shows the allegorical representation of the motto. The female figure of hope nurses the little amor. The stepped base, which is decorated with grasses and laurels leaves, also holds an anchor, the traditional symbol for hope. The unusually high plinth repeats the traditional symbols. The enamel plaque with grisaillle painting, shows Venus shells and Bacchus and is executed very delicately. Empire, circa 1810, dial signed: Chopin a Paris, fire gilded bronze, enamel.

Left:
196 **Amor handing over his Love Arrows**

Contrary to images, where Amor looses his weapons because of his misdeeds (illustr. 214), in the present scene, he voluntary hands over his love arrows to the female figure on the left and in return receives a flower wreath. The young woman leans against an ivory covered cane and can be identified as the personification of fidelity and friendship. She, at the same time is a representation of Psyche, whom Amor weds after many adventures and who promises marital fidelity. The scene deals with a subject which was of particular interest during the 18th century: the polarity between friendship and fidelity on the one and the longing, superficial love – represented by Amor – on the other side (see. Pp. 99 and illustr. 177). The two opposites are at peace, Amor has changed. Under the raised arms two doves are playing, which are referring to the same love theme as is raised on the base relief. It shows the famous pair Amor and Psyche in a landscape. Again the attributes of friendship and fidelity are present: Psyche is sitting next to an ivory covered tree trunk, at her feet a dog , another symbol of fidelity.
Charles X, circa 1820/30, dial signed: Jeanneret a Rouen, fire gilded bronze.

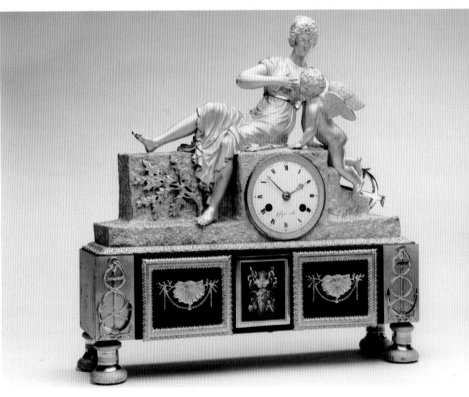

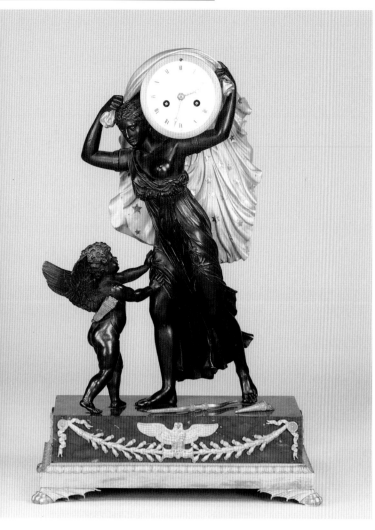

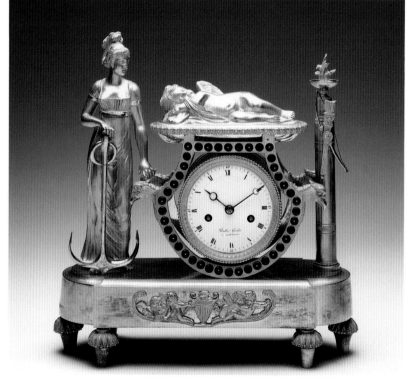

200 Amor trying to stop Aurora – the morning red, from lifting the star coat from the earth. This pendulum clock by Pierre-Philippe Thomire, is a variation of the illustration on page 59 with patinated figures and marble base.

201 Amor triumphant over time
Triumphantly Amor sets his foot on the bald head of the ancient Chronos. The power of the love god becomes obvious by this submissive gesture. The physical features of Chronos who is looking straight at the viewer, summarize the experience and wisdome of Chronos. His long and waverly beard grows around the dial. The integration of all important elements such as dial, Chronos and Amor further stressses the connection. The contrast between the childish, yet powerful Amor and the old, defeated Chronos is at its ultimate.

Louis XVI, gout grec, circa 1770, date, dial signed: Musson a Paris (Louis Musson, Maitre 1770), fire gilded bronze, white marble.

202 Love and Hope
Amor is sleeping. He has put down his weapons – bow and quiver with arrows and torch – and is resting in a type of crib which is decorated with griffin heads and blue enamel buttons. At his left a woman in the greek style is standing guard, her right hand resting on an anchor, which helps us to identify her as a personification of hope.

Directoire, circa 1795, dial signed: Pradier Guidee a Compiegne, fire gilded bronze, blue enamel.

203 A Sacrifice at the Altar of Love

The *Adoration of Love* is a very famous theme during the 18th century and subject of many small bronzes and paintings. The composition always is comprised of an altar with the figure of Amor who receives an offering from a young woman. In the present image she hands him a dove. At her feet are several other offerings.

Louis XVI, circa 1780, dial signed: J.H. Gay, Horloger du Roy. Fire gilded bronze, white marble.

204 Meeting of Amor and Innocence

A Young girl – the personification of innocence – hands a dove to the god of love as an offering. The iconography of the composition has also strongs ties to the Annunciation (see also Ottomeyer/Proschel, I. P. 249). The unusually tall Amor floats on clouds and is very similar to the Archangel Gabriel. He has a message for the virgin Mary, who joyfully receives it. The script banner is another typical sign of the sacred image in paintings. It this case, however, it contains a warning with respect to amourous experiences" Le danger vole autour de la simple colombe" The case relief shows putti while catching birds and at play.

Louis XVI, circa 1785, dial signed: Ragot a Paris, fire gilded bronze, white marble, Residenz, Munich.

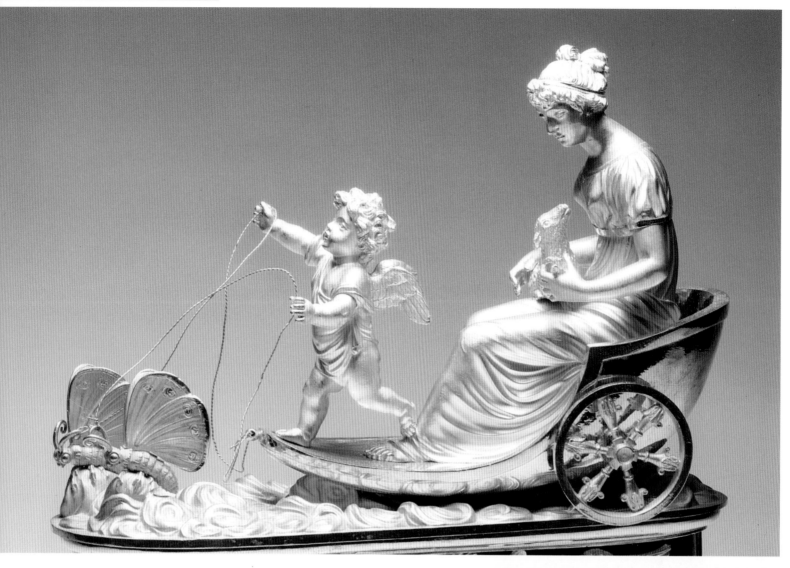

205, 206 Amor and Psyche
The group, sitting on very plastic sphings, is in its ornamentation and subject in the antique style.

205 Amor is steering the buttlerfly drawn carriage on the clouds and a young woman, holding a sheep in its lap, is sitting in it. It is Psyche, whom he has just kidnapped and who later becomes his rightful wife and who finally is accepted into the divine heavens. The lamb is not part of the mythology, traditionally is a sign of innocence.

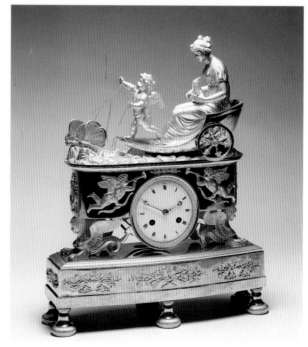

207 The Toilet of Venus – Vanitas

This bronze group seems to be an independent plastic, which can be viewed from any side and angle, the clock is set as a Cercles Tournants in the table. The high quality of the figures allows for an attribution to the oevre of Etienne-Maurice Falconet (1716 – 1791),as does the similarity of the standing figure with his *Baigneuse* (1757) and the pendulum clock *Chloe* (see illustr. 171) (see Hughes, p. 74).

The goddess of love and beauty is sitting at her vanity table in divine nakedness, holding a mirror. She is approached by a woman, who hands her a rose as jewelry – which in allegorical representations is always an attribute of Venus. A small box is standing on the floor, which contains other accessories: precious silk bands, which were important adorations for cloth and hair during the 18th century. Like in a genre scene, a very intimate and care free moment is captured. The group has an even deeper allegorical context.

At his mothers feet the little Amor is playing with his love arrows, the torch is lying next to him. His finger points at the fleeting time. The context of vanity (mirror), beauty (Venus) and luxury (precious furniture and accessories) and time forms a vanity group aimed at the passing and emptiness of all earthly affairs.

Louis XVI, circa 1775, fire gilded bronze, The Wallace Collection, London (F 260).

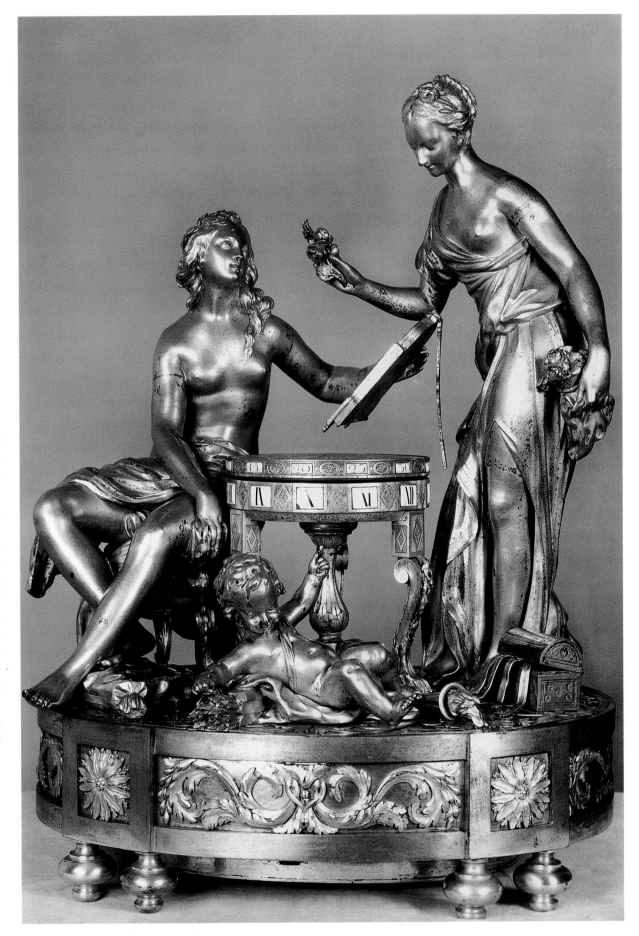

208 Hunting Amor

Amor is guiding a carriage which is drawn by doves, the birds of his mother Venus over the clouds. He is going on a hunt, symbolized by the falcon which he is holding in his right hand. The danger in his dynamic attack can be felt despite his youthful figure. Swans necks form the handles of the vase case, which has thee clock movement integrated and is crowned by the bronze group. Empire, circa 1815, dial signed: Lecointe a Caen, fire gilded bronze.

210 **Amor carrying a laterna magica**

Amor is forecefully hiking along. On his wings he is carrying a laterna magica. This is an optical instrument developed at the end of the 17th century, which can create picture illusions. The projection window is replaced by the clock's dial, which shows us the fleeting time. Amor challenges the viewer with his provocatice looks and points at the clock, implying that time is an illusion – just like the illusions created by the laterna magica. The bronze perfectly integrates the clock with the bronze figure thus enhancing the plastical appearance.

Paris, circa 1800, dial signed: Pinart a L'orient, fire gilded bronze, enamel.

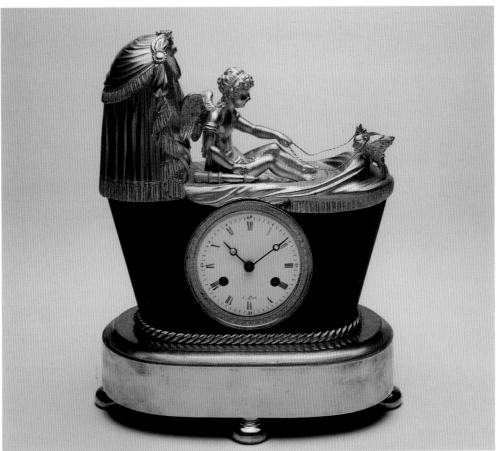

211 **Amor in the Infant's crib**

Amor is playing with his mother's doves. He has them harnissed and thus converts a crib into a triumphant wagon. The bed is in the antique style typical for the Empire and reminds us of the famous crib, which had been made by Thomire and the goldsmith Odiot after a design by Prud'hon for the king of Rome (son of Napoleon and Marie-Louise) (At the Louvre). However instead of the doves an eagle is sitting at the end. The playful execution and humorous conversion of known subjects are typical for genre scenes.

Empire, circa 1810, probably by Jean-Francois Reiche (see Cat. Fontainebleau, p. 60, pendulum clock with sleeping Amor), fire gilded and patinated bronze.

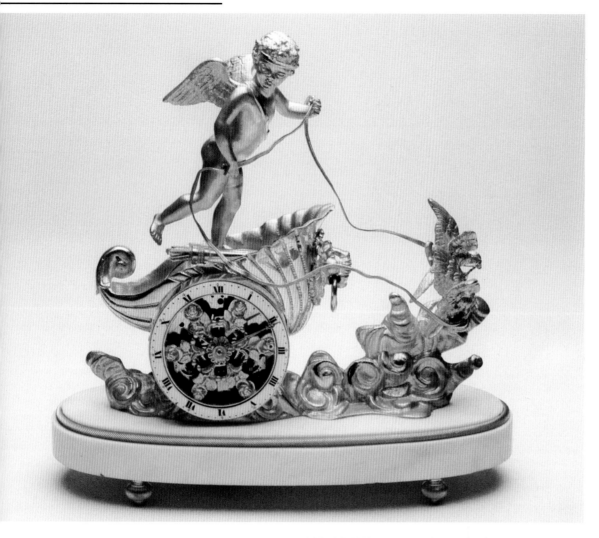

212 Amor drives a dove drawn carriage over the clouds
The details of this pendulum clock are taken from the symbolic of the Amor and Venus mythology: the carriage is in the form of a shell, one of the attributes of Venus, the spokes, behind which the clock movement is visible are made from rose twigs and blossoms. Amor has pushed the blindfold up and is on the look out for new victims. The image of Amor in a charriot is quite common. (see illustr. 165, 166).
Paris, circa 1800, fire gilded bronze, white marble.

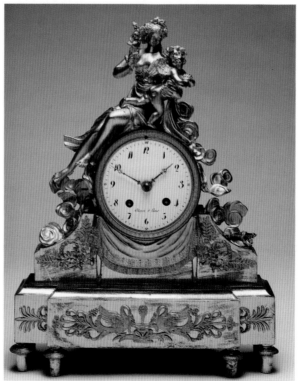

213 The punishment of Amor
The love goddess Venus is scolding her son Amor with a rose twig. He looks at her wresting his hands and pleading and trying to flee.
He has already lost his weapons. The clouds lift the scene from a genre scene to an idealized-ethical level.
The punishment of Amor is an often repeated theme in painting and sculpture. Similar: bronze group by Giovanni Francesco Susini, 1639; marble group after Falconet, 1770 – 80, in the Wallace Collection, London; painting by Nicolas Vleugels, circa 1720, Ermitage, St. Petersburg, Inv. No. 220.
Directoire, circa 1795, dial signed: Clerget a Paris, fire gilded bronze.

214, 215 Amor looses his Weapons

The mischievous deeds of Amour have led his victims to resort to strong countermeasures. Here, a young woman, who is standing to the right of the clock is stealing his weapons. Like a trophy she arranges them on top of the clock: the torch is at the center, behind it the arrows, with rose garlands. The small Amor, floating on clouds cries bitterly and wipes tears from his eyes.

The figures are of very high artistic quality, in accordance with the high quality clock movement. At the base a monogrammed cartouche is applied, which has not yet been attributed.

Louis XVI, circa 1780, date, day of the week and astronomical hand, dial signed: Lechopie a Paris (Adam L'echopie, Maitre 1758), fire gilded bronze, white marble.

215 The graceful young woman is not impressed by Amor's tears. She arranges the trophy composed of Amor's weapons gentle, yet determined. The surface of the artistically superior bronze shows very differentiated and fine chasing, which gives life to the figure.

216 **Amorettos in a Nest**

A young woman with dress and hair "*a la grecque*" holds a wreath of roses over a nest-form basket with three Amorettos. It is sitting on the clock movement which is integrated into a tree trunk referring to the surrounding nature. The little Amoretti show an agitation and wittiness, which makes the viewer fear the worst.

Empire, circa 1805, dial signed: Galle/ Rue Vivienne a Paris, fire gilded bronze.

Right:
217 **Love temple**

A "*Temple de L'Amour*" was part of any 18th century garden architecture. Usually these love temples were built in an antique manner as small round temples surrounded by columns. This basic layout was used during the Louis XVI period for pendulum clocks. The unusual feature of this pendulum clock is its oval base. Between two columns a little Amor statue made of white porcelain is postiioned (maker unknown). The columns are made of elegant grey marble with bronze-filled flutes and gilded korinthian captels, which carry the upper structure. The horizontally positioned and uncased clock movement is composed of *Cercles Tournantes* and integrated in the architecture. The hours are given by a centrally positioned star. This pendulum clock is a well balanced combination of esthetical and technical achievements.

Louis XVI, circa 1780, movement signed: Le Roy a Paris, fire gilded bronze, grey and white marble.

218 The nest of the love gods

A young woman in antique cloth discovers during a walk with her little dog in the underbrush under an old oak tree a nest with three little love gods, who are frightened at her sight (more on the bird-like character of Amor see page 96 and illustr. 152). The image of the discovery in the midth of abundant nature creates a scene similar to the one in the antique story *Daphnis and Chloe* by Longos. In order to introduce the love theme to the two, the old Philetas tells about his ancient paradise garden:…it is under a sky of trees which spend shadow , watered by three springs…when I entered today around noon, I noticed a child under the pomegranat and myrth bushes…white as milk..shining, like fresh from a bath" He tried to captue it but" he lifted off like the child of a nightingale ..from branch to branch he disappeared between the leaves. Then I saw wings between his shoulders…"

The naturalism of the bronze statue finds its climax in the three springs, which are composed of turned crystal rods. They are moved by a complicated automaton movement and create the illusion of running water. A similar pendulum clock is at the Chateau de Fontainbleu (see Cat. Fontainbleau, 1989, p. 51)

Directoire, circa 1795, fire gilded bronze, crystal.

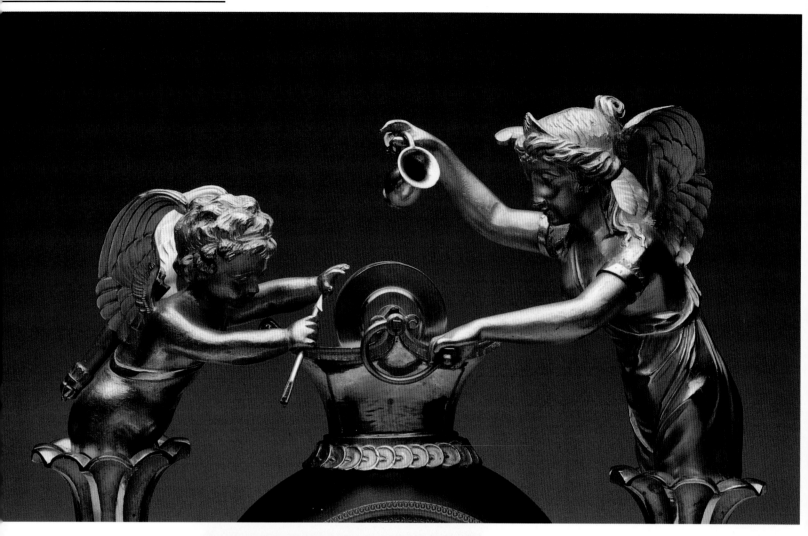

219, 220 Amor sharpens the love arrows

The pendulum clock is in the form of an antique vase and exemplifies the total merger of ornamentation and figural image, which has its roots in the antique grotesques of the 18th century.

Empire, circa 1810, dial signed: Foucet Noel a Tours, Bronze probably Claude Galle (see Ottomeyer/Proschel, I, p. 364 – 365), fire gilded and patinated bronze.

221 Amor comforts a Woman with a little bird

This pendulum clock deals with a favorite sentimental theme (see page 6 and 27).

Louis XVI, circa 1775, Francois Vion, fire gilded bronze; drawing exists from his studio (see Ottomeyer/ Proschel, I, p. 247)

224 Amor sawing up Time

Amor is in the role of a stone sculptor. With a large saw, which has his love arrows as handles, is sawing up a massive boulder, which forms the case of the clock. Next to him are his quiver and a long handled hammer. The base mounts show the weapons of Armor – arrows and quiver – and tools of the stone sculptor trade. The application in the center is also composed of stone cutter's tools: an angle, a perpendicular and drawing-compass, intertwined with laurel.

This bronze group shows the power of Amor over time being similar to the stone cutter, who can conquer the hardest of all materials.

Empire, circa 1810, fire gilded and patinated bronze.

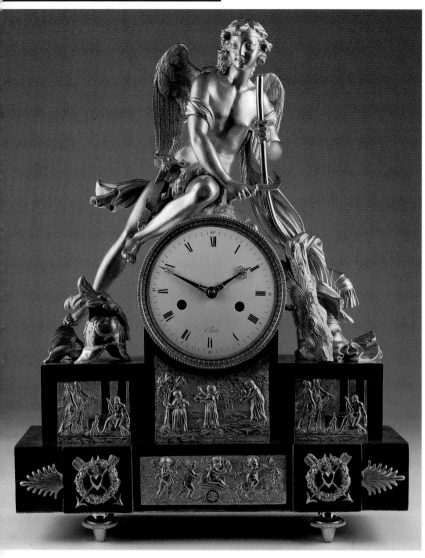

225 Cupid Carves his bow out of Hercules' club

Cupid is shown here not as a cute little cherub, but as he was imagined in antique times: as a handsome, boyish young man, whose power defeats the entire worlds of men and gods: *Amor vincit omnia*. This power is demonstrated here by an example that could not be clearer: Hercules was the greatest and bravest of all heroes. Yet Cupid has disarmed him of his fearsome wooden club and is making a bow of it, with which he will shoot his arrows and thus awaken love. What power love can have over even the greatest hero is shown in the base relief: fully "disarmed" by love, there sits muscular, athletic Hercules in front of his wife Omphale, holding a distaff in his hand. The theme of love is also taken up in additional appliques, such as the burning of hearts, pierced by arrows, surrounded by a wreath of roses.

The motif of the main figure was already utilized in the history of art by the famous marble sculpture of Edme Bouchardon (1698-1762), made in 1750 (see #22, p. 23).

Bronze ascribed to Francois-Louis Savart, Empire, ca. 1810, fire-gilded bronze, from Paris, compare #193-194, p. 120. *Kunsthandel Michael Nolte, Münster.*

226 The Sermon of Amor

The love god is dressed in the robe of a capuchin monk and holds his "capuchin sermon" (lecture) to a woman kneeling in front of him. He holds a flaming heart in a pathetic gesture. The young woman kneels in front of a book, which is opened like a prayer book. It is however "L'Art d'aimer" by Ovid (Art amatoria – the art of love). The book which had been written approximately 1 B.C. contains poems about love and is the young woman's bible. The burning oil lamp shows, that the scene takes place at night and the oddly dressed Amor preaching from an Empire´chair seems to indicate that he is a mere illusion. The scene at the base of a flying Amor is just as unusual: Amor carries a rose with butterfly in his right, and a set of chains in his left. The pendulum clock is under a glass dome, as was customary in the 19th century.

Directoire/Empire, circa 1800. Dial signed: Joseph Guillet a Grenoble, fire gilded bronze.

227 Two Amoretti carrying a Vase

The high quality bronze shows the effort with which the two putti are carrying the antique vase with integrated clock.

Empire, circa 1810, without striking mechanism, fire gilded bronze.

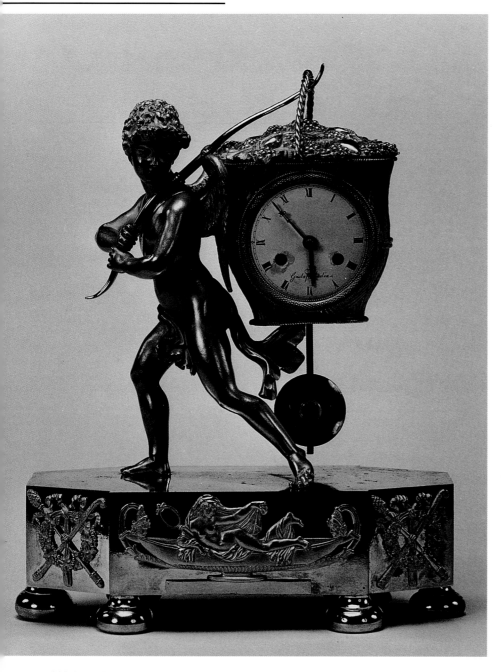

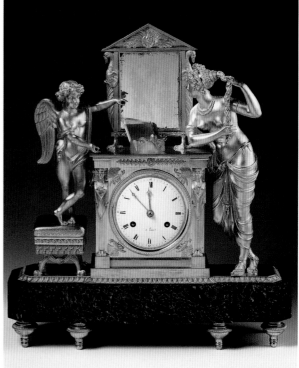

229, 230 Amor and Psyche

Until recently this particular pendulum clock had been referred to as "Toilet of Venus", however it is – in close association to a familiar scene in art history (see illustr. 207) – a scene from Amor and Psyche. The change in iconography is based on the enthusiasm for the tale by Apuleios.

The most important reference for this new interpretation is a piece of furniture which is at the center of the composition. It is in the style of the *Retour d'Egypte:* a console with egyptian style figures which form the base for a large mirror with triangular pediment. The dominating location for such a piece of furniture is very unusual and must therefor have another meaning. This type of mirror is referred to as Psyche and was a favorite object to portrait the soul. This is also evidenced by the four butterflies which are applied around the dial and which are symbols for Psyche and the soul. (See page 105). The beauty at the right, who takes from an over-

228 Amor harvesting Grapes

The love god is stepping ahead busily. He carries his bow over his shoulder on which a large basket is hanging filled with grapes. The image of a walking, free standing figure is common since the Directoire. Here Amor is integrated in a Bacchanalian theme, as the grapes and the applications at the base, which refer to the attributes of Bacchus, a wreath of vines and ivory and the thyrus, which is a straight cane with vines and a pine cone at the end. The female nude at the centre (either Venus or one on the Bacchantins) is resting in an oversized antique wine bowl.

Empire, circa 1815, fire gilded bronze.

flowing jewelry case and brushes her beautiful hair, is not Venus, but Psyche, whose beauty arouses jealousy in the goddess of love. During the conception of this pendulum clock, Psyche's faith is interpreted as a parallel to the human soul, which frees itself from vanity and the burden of earthly things - like a mirror image. This also helps explain the gesture of Amor, who points at the earthly treasures and the mirror glass.

Empire, circa 1810, dial signed: a Paris, fire gilded bronze, marble, see Cat. Partridge, 1997.

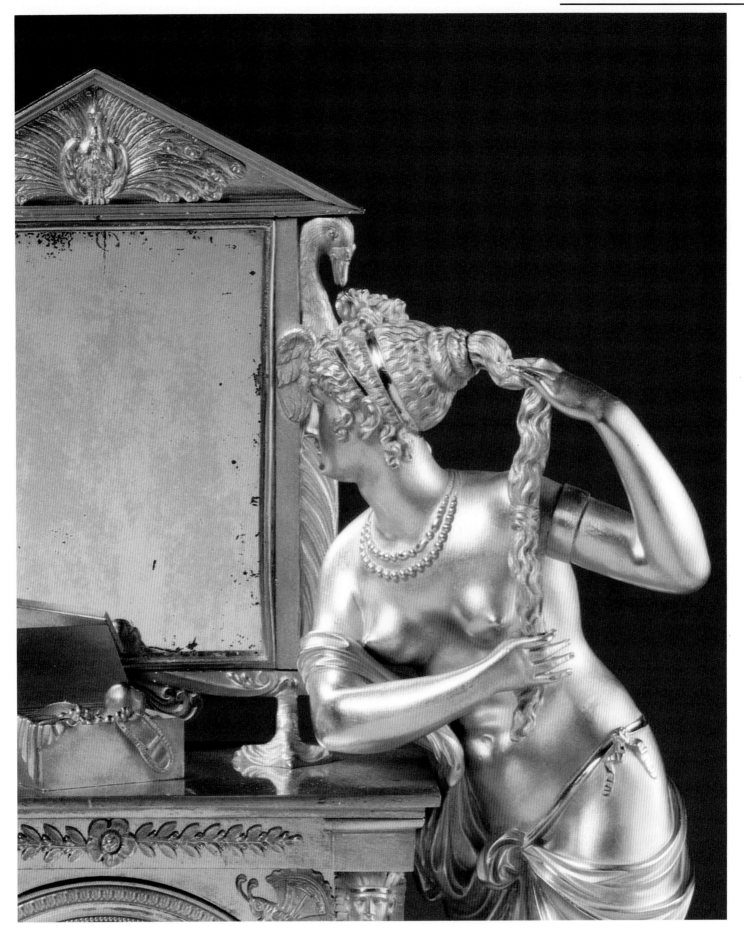

Noble Savages

Introduction

When the witty Voltaire sent his critique of the "Tractat about the origins and the differences of human races" to its enthusiastic author Rousseau, who had been anxiously waiting for it, Rousseau must have been hard hit. Voltaire joked: "Never has anybody spent more thought about the fact that human beings are animals and after reading this piece one has the desire to walk on all four."

Despite the criticism from this enlightened spirit, Rousseau's ideal of a "homme naturel," the unspoiled natural-being became popular and inspired the thoughts of philosophers, researchers, artists, world travelers and home-bound people alike. The contrast between nature and civilized life had never been formulated prior to Rousseau. It culminated in the admiration at anything exotic, which was considered the original and thus morally superior.

As with any other new idea, it was also interpreted in a figurative way. During the time period from 1795 to 1815 the most spectacular group of bronzes was made: the pendulum clocks "au bon sauvage" – various interpretations of the "wild savages."

The contemporary viewer usually reacts to these objects with fascination and irritation. Impressed by the undoubtedly superior quality of the detailed bronzes and the attraction of the exotic, one is also carefully distanced because of the potential underlying discriminatory aspect. This duality invites us to look more careful at the background and the provenance of these pendulum clocks.

The sources for these idealized human beings can be found in the fictitious and realistic travel reports about the North American Indians, the blacks of Africa and the islanders in the South Sea: some of these reports are still part of what is called world literature, such as Jonathan Swift's "Gulliver's Travels" (1726), and Daniel Defoe's "Robinson Crusoe" (1719). The novel "Paul and Viginie" by Bernardin de Saint-Pierre (1787) and "Atala" by Francois Rene Vicomte de Chateaubriand(1801) were best sellers at their time and well known. In addition to these utopian-fictitious and sentimental pieces, writings by the important discoverers such as James Cook and Louis Antoine Bougainville inspired the fantasy. In 1769 and 1775 two natives from the South Sea, Omai and Aotourous, were brought to Europe and created big excitement in London and Paris. They were presented to the aristocratic society, shown to the general public and examined by scientists. Omai had an audience with King George III and was portrait by the most famous portrait painter of the time, Sir Joshua Reynolds (1723 – 1792).

Not even more realistic reports and stories about personal experiences could stop the Europeans from idealizing the inhabitants of these exotic plates. This is also reflected in various artistic interpretations. Savages were good at heart, lived in paradise-like settings and thanks to their closeness to natures and their natural freedom, they were also closer to their creator. In the European tradition such a creature had to be also of superior beauty. Curly hair, fuller lips and stark white eyes were the only features referring to a different race. Otherwise the figures looked like beautiful Europeans, strictly following the ideas set forth by Winkelmann in his "Thoughts about the copy of Greek works in paintings and plastic arts" (1755) which was the source for European plastics from then on. Some added attributes, such as feather

crown, pearls, bangles and sandals were enough to create an exotic appearance and show the image of a savage. The same classical rules about antique sculpture – contraposition, slight step position, harmonious proportions – are followed and emphases the beauty of the muscular body and its elegant posture.

Without doubt the master of this type of pendulum clock is Jean-Simon Deverberie (1764 – 1824). He was the creator of the most famous examples: The American and African huntress (illustr. 236, 237), the kissing aristocratic couple, which is shown with feather crown and precious jewelry in idyllic landscape (illustr. 252) and the Huntress with bow and arrow, who, like a queen, is carried on a sedan-chair by four little black boys (illustr. 248)

In addition to the European body features, the composition of the bronze group follows traditional iconographic patterns of European Art. The American huntress is a personification of the continent, her attribute, the alligator, refers to the Rio de la Plata in South America. The African Huntress is shown with turtle and panther, which had always been symbols of the African continent. Both figures are thus personifications of the two continents Africa and America.

The wild huntress, who is carried around in a sedan-chair reminds us of Diana, which has been shown in similar ways – except for the color of the skin-in contemporary paintings and sculptures (the figure is very similar to Venus of the pendulum clock "Amor the Honey thief," see illustr. 160)

The kissing couple mirrors one of the favorite ideals of the gallant period, which is also integral to the shepherds scene and well known from the paintings of Boucher and Watteau. The longing for the mystic island of "Cythera," where the Goddess of love Venus rules, is transformed to the actual but distant islands of the South Sea, where the Europeans have discovered natural love among the savages.

Another trend seen in this group of "au bon sauvage" pendulum clocks, points towards the Empire and Restoration periods. The "Portefaix" bronze by Jean Francois Reiche (1810) (illustr.) is a good example. The figures appear more independent, they are removed from the base and not as much integrated into the overall composition, as had been typical during the Rococo and early Classicism period. They become subject matters without a direct connection to literature, myths or time. In the "Portefaix" bronze the artist used the dynamics of the statue. The capture of the movement was a way to show the strength and natural way of these noble savages as independent sculptures and not as allegorical interpretations.

The pendulum clocks "au bon sauvage" want to translate the admiration for the exotic, which was an important feature during the period of enlightenment at the end of the 18th century. They show the longing of a society which so far had only focused on Europe, but which had just conquered the seas and which had gone through the revolution of 1789, to broaden its horizon.

The seaman – allegory to trade

The pyramid shaped composition of the pendulum clock shown in illustration 231 is dominated by the figure of a young black seaman, who in a very casual pose has his elbow resting on a bale of tobacco leaves and is smoking a pipe.

Overall, the composition stylistically is a Directoire piece (circa 1795), the subject matter encompasses the spiritual tradition of the 18th century. The pendulum clock has carefully chosen elements, which are all related to each other. It is an allegory to trade. However, the artist does not go back to the personification of Greek gods, which the aristocracy of the 18th century liked to be identified with. After the revolution the middle class was strengthened sufficiently that the new reality of trade created its own myths.

The pendulum clock was created after a very detailed initial design, which has survived as "Michel, no. 120, aoust 1808 du depot legal" (Paris, Bibliothek national, Cabinet d'Estampes, Album le 30). It refers to the bronze artist Michel, who according to Tardy was active in Paris. His atelier was located at rue Pastourelle in 1812 and at rue du Parc in 1820.

The bronze figure is of highest quality in its craftsmanship as well as its artistic design. The standing figure is very complex and clearly shows reference to antique forms. The crossed legs, the tilting of the upper body and the turn of the head to the right gives the figure some movement despite its calm position. The muscle tone is very plastic and anatomically correct and the dark patination of the surface adds to the liveliness. The contrast between the dark skin and the gilded upper arm bangles, the pipe and the rope form a charming contrast. The white eyes are in strong contrast to the dark and add even more life to the

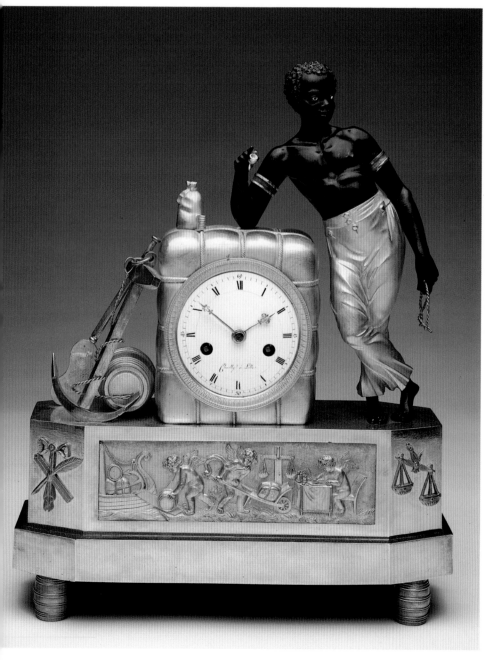

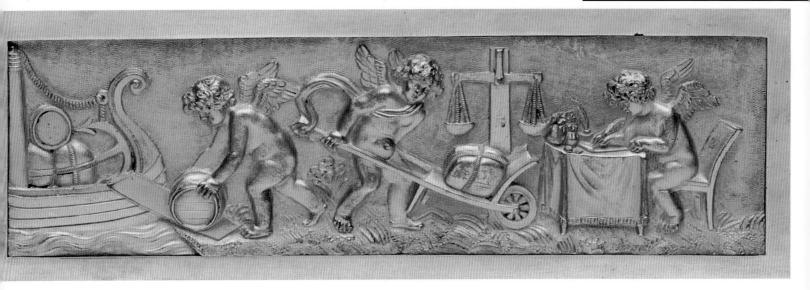

figure. The sea man shows all his beauty without falling into a stiff pose. He perfectly embodies the "noble savage."

The quality of the pendulum clock is also underlined by the harmony between the figure of the seaman and the composition overall. While leaning against the tobacco leave bales to his right, anchor, a steering paddle and a barrel of rum, symbols of trade, lean at the left. Both flank the central bale, which houses the clock movement and its bright white enamel dial.

The large bag with money, which sits on top of the bale refers to the profitability of the trade with colonial products. The shaped rectangular base is also bearing various references to the trade theme: the four feet are rum barrels and the front relief shows small winged putti, who are playing out the different jobs associated with the trade from colonial countries. One of the putti is rolling a barrel of rum, another one is busy carting a bale of tobacco, and another one is busy counting money and doing administrative work at a desk.

The applied decorations in the edged corners are writing pen, measure and scale refer to the same theme.

The influence of the antique Eros relief is prominent. The antique tradition of little, winged love gods imitating serious businesses in a playful way, is revived on base reliefs of pendulum clocks during the Classicism. More commonly the putti will play with the classical attributes, such as musical instruments, birds, arrows or the attributes of the seven free arts. They also enjoy joining the companions of Bacchus.

It is new and remarkable, that the putti are busy in a new sphere, the materialistic world of trade, which is the opposite of their usual playground. The artist closes the gap between the classical antique and the contemporary, modern world, which is guided by colonialism and the desire to make money. Formally it combines classical figures with the contemporary genre scene and is a forerunner for the popular genre and subject-scenes, which will dominate during the Empire period.

231, 232 The Seaman

The pendulum clock with a pipe smoking sea man is an allegory to trade with the colonies. The tightly roped tabacco bundle and the rum barrel next to it are symbols for goods imported from overseas, the anchor and steering rudder are symbols for seafaring, which is the base for trade.

Empire, circa 1808, design by Michel, dial signed: Chailly a Lille, fire gilded and patinated bronze, enamel eyes.

232 Putti are busily loading colonial goods for shipment. The putto on the right is keeping accounts, based on a picture from Otho Vaenius " Horatii emblemata" (1612), which had been used as source book by many artists and which apparently had also been used by the designer of this pendulum clock, Michel.

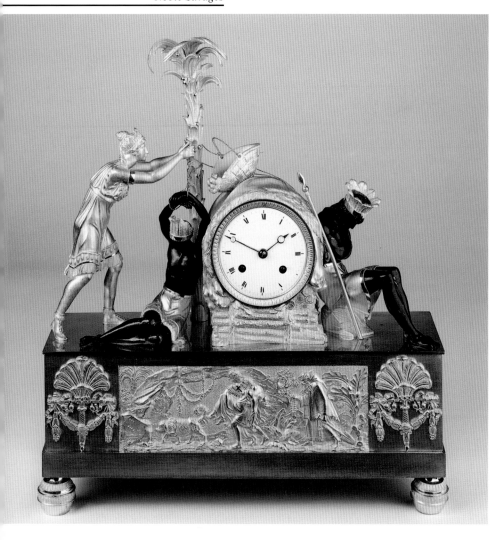

Atala and Chactas

There is only one error in the translation, which is hard to ignore for the careful reader: The Indian Chactas did not have dark skin...

The tale was extremely popular at its time. It was known not only to the literate society – which was fairly small in number, but also to the large audience, which went to boulevard theaters, to musical plays, to wax figure cabinets and pantomime theaters and through pictures and medallions. The bronze composition of the pendulum clock refers to two famous paintings, "The funeral of Atala" by Anne-Louis Girodet de Roussy-Trioson (1767-1824) from 1808 and "The liberation of Chactas" by Pierre Jerome Lordon (1780 – 1838), which was made famous by a print by Jean Pierre Simon (circa 1750 – 1810).

Chateaubriand tells the very dramatic love story of Chactas, a young Natchez Indian and Atala, the beautiful daughter of a Spaniard and an Christian Indian woman. The story takes place in Louisiana, which is referred to as "New Eden."

Chactas is taken prisoner during a tribal dispute and is chosen to be sacrificed. Atala, who is the adoptive daughter of the tribal chief, has secretly met him and fallen in love with him. She wants to save him from the barbaric ritual and convert to Christianity at the same time. In order to protect his life, she sets him free. During their flight though the wild and beautiful North American landscape, they discover their love for each other. They are threatened by a dangerous storm and miraculously saved by an old missionary and hermit.

After the rescue and the overcoming of all dangers a happy end seems in sight. The young Indian seriously considers converting to Christianity – which calms Atala. The small village, for which the hermit is the priest, seems to be the ideal spot for a happy life together: in the middle of the familiar, untouched nature a small civilized society, regulated by Christianity.

The tale of Atala and Chactas, which had been published in 1801 as "Atala or the love of two savages in the dessert," made its author, Francois Rene Vicomte de Chateaubriand (1768 – 1848) famous and became the best known love story of its time. Today it is of interest only to scholars in literature as an important piece of romantic literature.

It is very rare in art history, that a bronze would follow its literary model in such a literal way-one might even call it a sculptural quote (illustr. 233).

144

233. 234 **Atala frees Chactas**
Another variation of this subject is known, which is lacking the guard at the right of the clock.
Empire, circa 1810, fire gilded and patinated bronze, Musee Francois Dueberg, Mons.

Now the story takes a tragic turn: Atala, who had given her mother the promise to remain a virgin, is torn by her new feelings and commits suicide. Chactas and the hermit do not understand her intentions in time. The priest's offer to release her from the egoistic and unchristian oath, which her mother forced on her, did not reach her in time. It is too late. The counter poison, which the medically trained hermit mixes for her does not word and she dies.

The inconsolable Chactas and the hermit, who accepts the god given fate start a heart breaking death song and bury the beautiful virgin at sun set under an arched rock, which is described as the ultimate exotic landscape.

The two highlights of the story are integrated into the composition of the pendulum clock: The main group shows the rescue of Chactas by Atala, which marks the beginning of their relationship. Atalas is portrait in classical outfit and hair, in order to appear more exotic: The flowing dress is short and she wears ankle high shoes. The hair is worn high with a feather crown symbolizing her status as "daughter" of the chief. Chacta's dark skin is his exotic trademark, as is the palm tree, which is not the same type usually found in Ameri-

can forests. The piled wood with animal skins thrown over it and the weapons and spears leaning against the wood are associated with of a night camp in the forest. The clock movement is well integrated into the overall composition. The detailed base relief tells the end of the love story, the burial. The captivating, but tragic love story refers to the main theme of the story: the grief over the vanity of everything human. The saddest stories and views can be dealt with either by immersion or by distance and can lead to some enjoyment. This might explain the popularity of the story of Altala and Chactas. Chateaubriand was lovingly referred to as "magician" by his contemporaries.

234 The narrative sets the literary origin in a plastic portrayal: "I invited her onto my shoulders, the hermit stepped, a spade in his hand, ahead of me....At the sight of the dog, who had discovered us in the woods,...I burst into tears. Sometimes the morning breeze played in Atala's long hair....Finally we came to the place....We climbed down under the arch of the bridge." (page 71)

235 **The funeral of Atala**
Painting by Anne-Louis Girodet de Roussy-Troison (1767 – 1824). The wall of the grotto is inscribed:"J'ai passe comme la fleur/J'ai seche comme l'herbe des champs – I died like a flower/ I vanished like the herbs on the field" The painting had been presented at the Salon in 1808.
Musee du Louvre, Paris (oil on canvas, 207 x 267 cm, Inv. Nr. 4958).

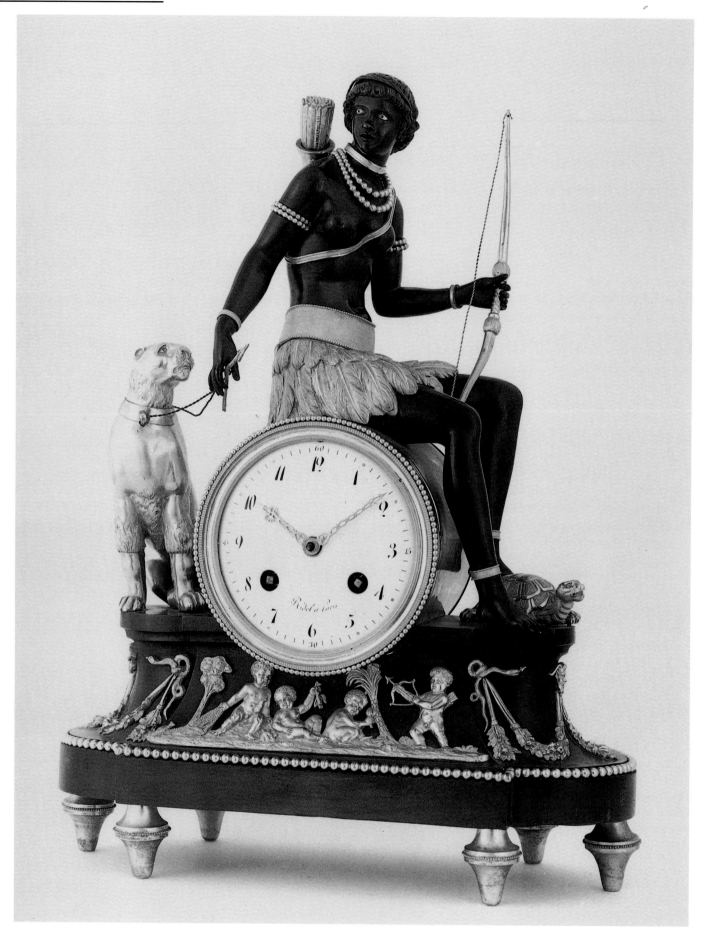

236 Africa

The bronze is the pendant to the personification of America (see page 147). Deverberie created it also in 1799 (design signed "DEVERBERIE horloger"). The choice of attributes follows a familiar iconography. Cochrin writes:" Africa…one paints her al-

most naked, in order to show her living in a hot climate. The pearl necklace is a common piece of jewelry for woman in hot zones…the lion (and other animals) shows that Africa is the cradle of many dangerous animals" (Book I, No. 11)

This pendulum clock typically had an oval base, the fluting is applied with playing and hunting children between exotic trees.
Directoire, dial signed: Ridel a Paris, fire gilded bronze.

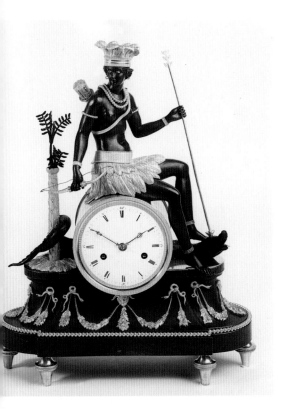

237, 238 **America**

The figure designed by Jean Simon Deverberie (1784 – 1824) was created during the Directoire period and is part of an early group of "pendules au sauvages". A colored pendrawing , dated January 22, 1799 (3 pluvoise an VII, no. 12 du depot legaldoes exist. The style, later known as "Style Deverberie" is characterized by its motives, and the perfect technical execution and the finely details in choice of material and was copied many times.

238 The figure of America is very lifely. Deverberie managed to achieve this effect by adding movement and very naturalistic details, such as the enamel eyes, the patinated skin and the finely formed beads and the pearl earrings. Despite all this spontaneity the composition follows the traditional iconography (see America by Tiepolo, page 24 and the portrait of a negroe by Benoist, page 25).

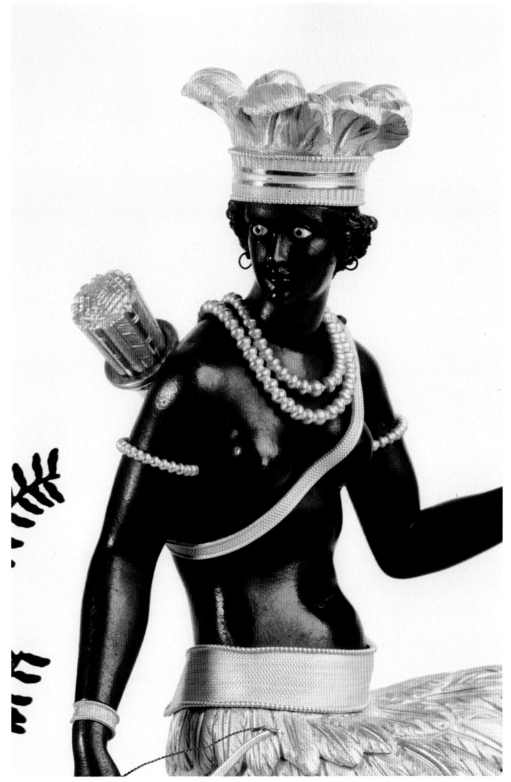

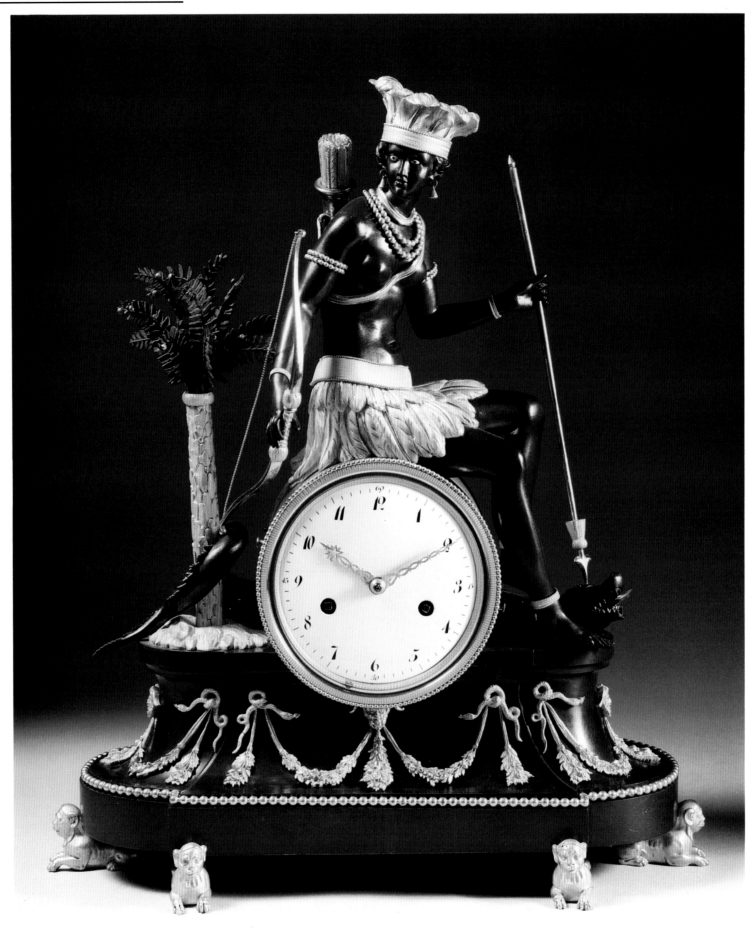

239 **America**

This model is especially well executed, which can also been seen on the feet, which are modelled after egyptian lions and which are based on a design by Deverberies of January 22, 1799 (for more details see caption for illustr. 237). Cochin writes in his iconography: "America is represented by a woman with olive/coffe colored skin, partially covered with a feather dress, in her hands she holds bow and arrow, which she, as a woman, uses like a man to defeat her enemies…The kaiman, which is a type of crocodile is one of the characteristics of the New World" (Book I, No. 22)
Musee Francois Duesberg, Mons.

240 "**Portefaix**"

is a work by the bronzier Jean-Andre Reiche, who registered the design in January 1808. The novelty of the composition is the free standing figure, like an independent plastic, and the clock is integrated into this figure. The piece can be viewed from every side, which is further stressed by the oval base, which is decorated with an applied monkey, swinging between two palm leaves. The figure is in a very dynamically forward stepping position and carries a large bundle of cotton on its back-basket. In his right he holds a letter, in his left he leans against a cane. A broad rimmed hat gives shadow to his friendly face with its shining white eyes. The "noble savage" is presented as a " gentle savage", combining helpfullness and trustworthyness.
Empire, circa 1810, fire gilded and patinated bronze.

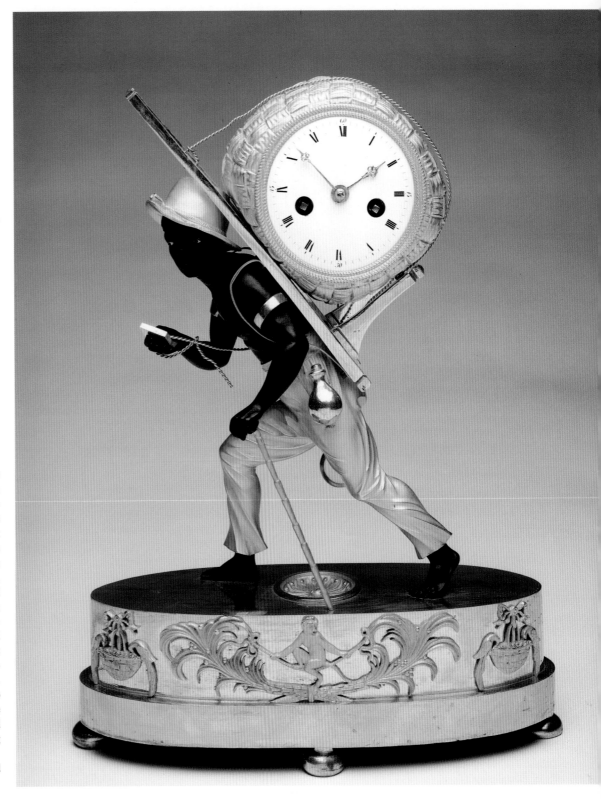

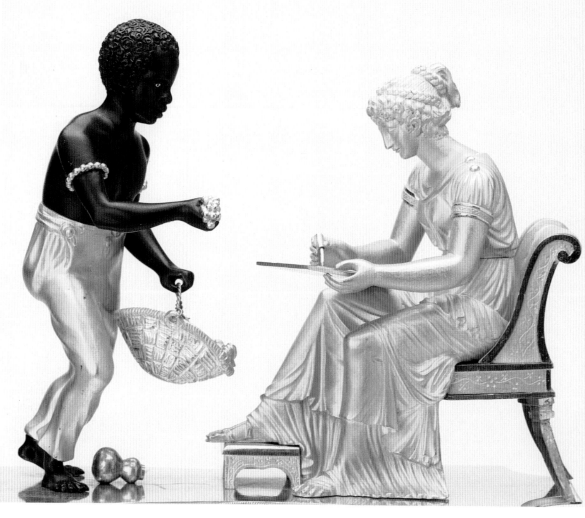

241, 242 Dominigue and Virginie

A scene from "Paul and Virginie". Following Deverberies, many artists and bronziers focused on exotic themes. There is a whole group of pendulum clocks based on the book by Bernardin de Saint-Pierre from 1788. The tragically ending love story takes place between 1735 – 1762 at the Ile de France (today Mauritius) and combines descriptions of an exotic- paradise like landscape, religious observations and the concept of "Sensibilite", as personified by the heroine, Virginie.

Direction/Consulat, circa 1800, fire gilded and patinated bronze.

242 A black boy approaches a seated young woman and offers her fruits from a basket. She is leaning over a table and writing: "One fears the unknown". The boy is Domingue, the loyal slave of Virginie and her mother, who - unhappy about the affairs in France – had moved to the Ile de France. Virginie falls in love with Paul, the son of another immigrant, but has to leave the island. The slave Domingue is the perfect personification of the " noble savage". The group skillfully plays with the charming contrast between the strong nature boy, who offers fruits and the fragile elegantly dressed "civilized"woman, who knows how to write.

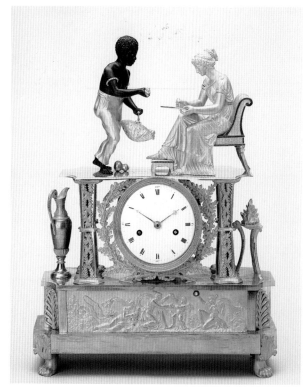

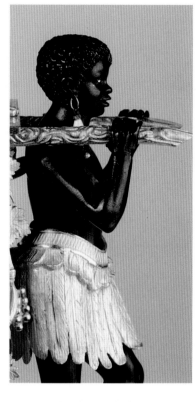

To page 152:
246, 247 **Paul and Virginie**
This is one of the few pendulum clocks, where commission, artist, date and provenance are known. In 1802 Napoleon Bonaparte commissioned Pierre-Philippe Thomire to make the bronze, which he intended to give to the author of "Paul and Virginie", Bernardin de Saint-Pierre, because of his deep admiration for the book. No other copy is known. The bronze is similar to a smaller version (page 151), its monumental size and quality are exceptional (height 70 cm).

The athletic carriers have the appearance of black patinated antique sculptures. All negroid features have been eliminated. The determined look with concentrated eyebrows, the forceful stepping forward and their demeanour are not anymore the good and devoted savages, who serve the white man. The muscular bodies is a version of the classical antique tradition (step, expression and the hair locks resemble the famous antique group " The murderes of the tyrannt", 475 B.C., Naples, Museo Archeologico Nazionale). In accordance with classical esthetics, the figures do not have applied eye balls, which is one of the characteristics of high quality pendulum clocks au sauvage.

Consulat, 1802, Pierre-Philippe Thomire, fire gilded and patinated bronze, Musee Francois Duesberg, Mons.

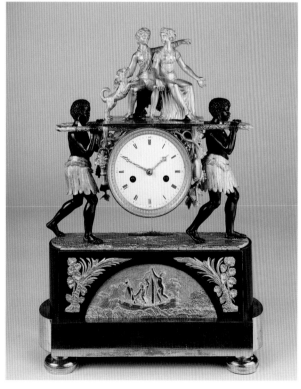

243 – 245 **Paul and Virginia**
Consulat, 1802, Pierre-Philippe Thomire, fire gilded and patinated bronze, Musee Francois Duesberg, Mons.

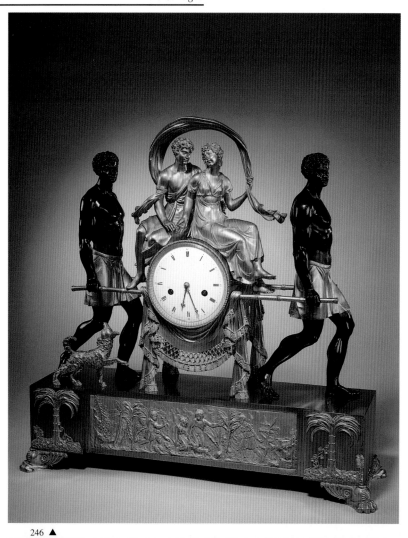

246 ▲

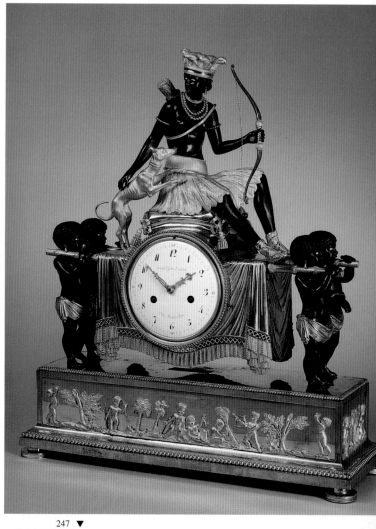

247 ▼

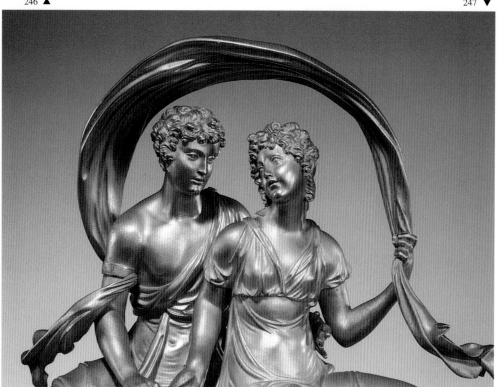

243 – 245 **Paul and Virginia**
See description of this clock on page 151.

Page 152, Right:

248, 249 **American Indian Huntress**

This rare pendulum clock by Jean Simon Deverberie shows a black huntress, which is carried on a sedan-chair. The figure, which is another personification of America, has a grey hound on her side, who jumps up. She is similar to the goddess of hunting, Diana (see Diana, illustr. 58). The elegant drapery and the pillow with precious decorations elevate her to a godlike ruler. The little blackamoors are very vivid and are a good example for the diversified artistry of Deverberie who signed the dial with : "Invenit et fecit DEVERBERIE rue Barbet a Paris"
Consulat, 1799, fire gilded and ptinated bronze, enamel eyes, pearl, Musee Fancois Duesberg, Mons.

250 **Virginie and Domingue**

The loyal servant Domingue – the personification of the noble savage - kneels in front of the swiftly approaching Virginie. The scene takes place under a tree, whose large leaves hold the clock movement. The phantastic abundance of the vegetation, which is very skillfully described by Bernardin de Saint-Pierre, is translated into this pendulum clock. Again the contrast between the man of nature and the civilized one is stressed, but they form a friendly relationship.(see page 150). The figure of Domingue is also part of the Robinson pendulum clock (page 160).
Directoire/Consulat, bronze attributed to Claude Galle, circa 1800, dial signed: a Paris, fire gilded and patinated bronze, Musee Francois Duesberg, Mons.

251 Man from the Orient on a Mule

The dark skinned rider is wearing oriental attire: baggy trousers, pointed shoes and a short embroidered veste and a turban. He is riding on a mule with very ornate briddle. The base relief with two doves and putti refers to a love theme. It might be a literary figure, which has not been identified yet.

Empire, circa 1810, fire gilded and patinated bronze, enamel eyes.

252 Kissing American Indian Couple

Rightly this famous piece by Jean Simon Deverberie is considered his master piece and the most spectular "Pendule au Sauvage" known. The beauty of the bending bodies, the casulaty of the embrace and the harmonious union with the paradise-like nature with water fall and vegetation, make this group the best representation of the idealized noble savage of the 18th century " Born under the most beautiful sky, nourished by the fruits of earth without having to cultivate it, the only god known to them is the one of love" Ph. De Commerson referrs to their land as "Nouvelle Cythere" and merges the exotic with the idyllic Rococco (cited after Bitterli, p. 389)

Directoire, 1799, design drawing dates, dial signed: Lepine, fire gilded and patinated bronze, enamel, pearls.

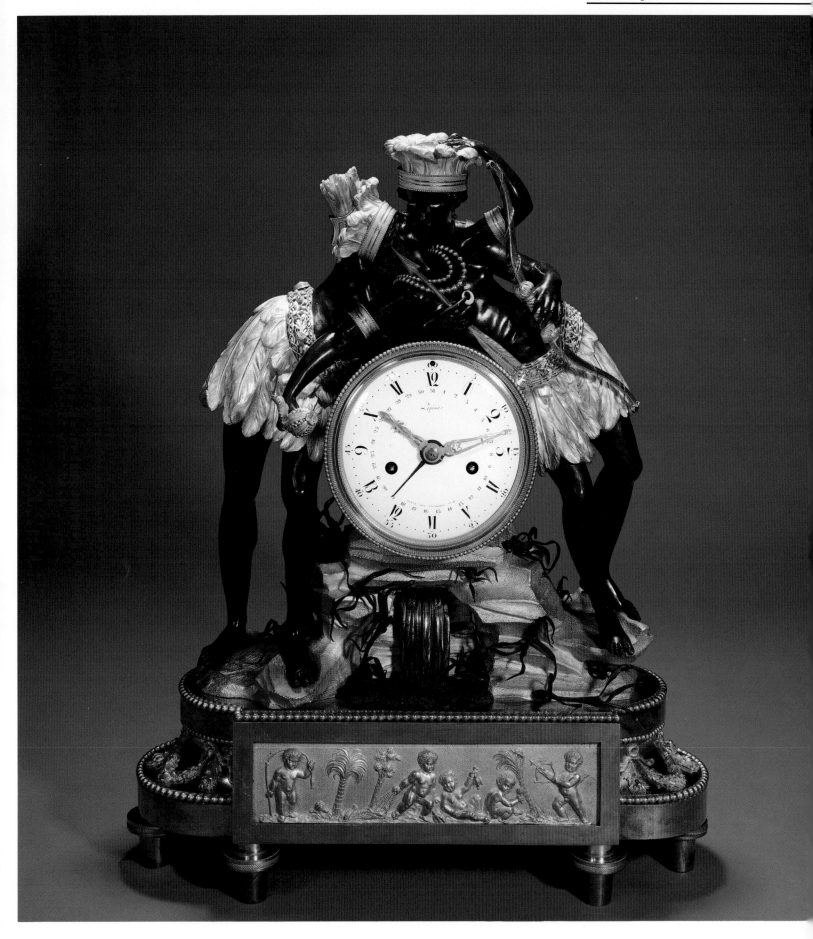

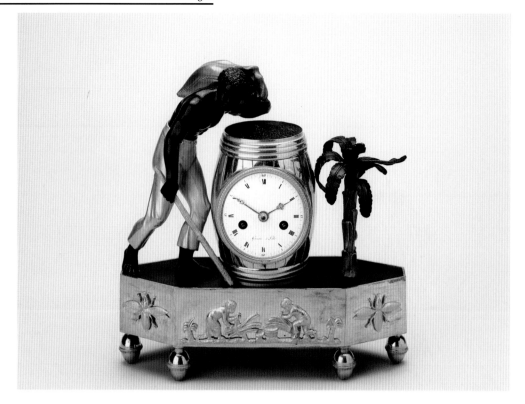

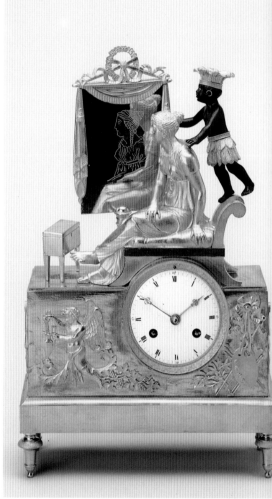

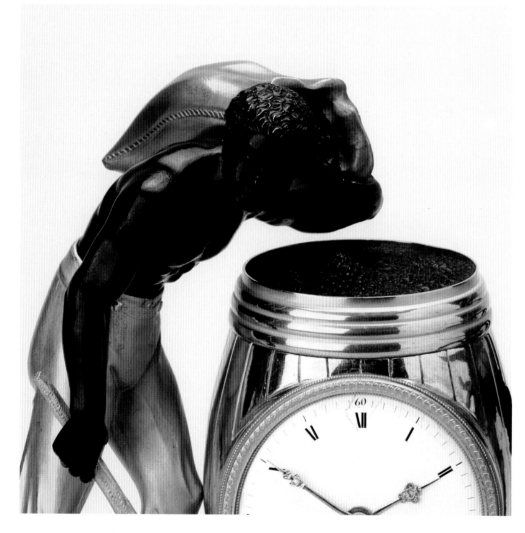

253, 254 **A Blackamoor** empties a bag of coffee beans, which he had been carrying on his back into a large barrel. At the right is a small palm tree with green patinated leaves. The base shows several tasks and two beas- symbols of diligence of the Bon sauvage, the good wild one.
Empire, circa 1810, fire gilded and patinated bronze.

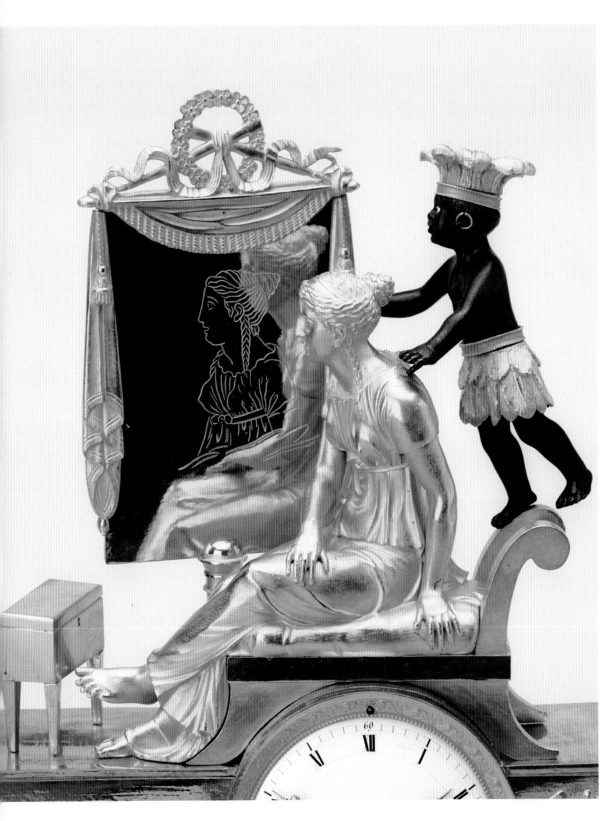

Page 156 top right:
255, 256 **Woman seated in front of a Mirror with Black-amoor**
This group is probably a variation of the Paul and Virginie story. A definite interpretation is not known.
Empire, circa 1810, fire gilded and patinated bronze.

256 The little blackamoor playfully assists the young woman, whose profile is reflected in the mirror, while she does her toilet.

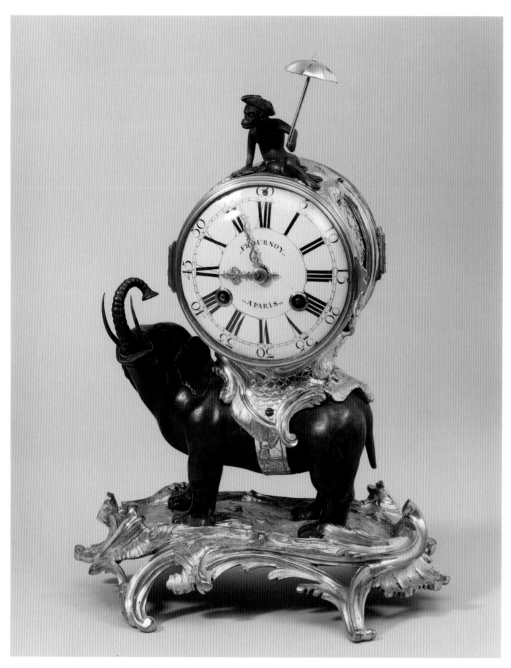

257 Elephant Clock with Monkey
The "style pittoresque" combines Rocaille with the exotic. In 1686 the King of Siam gave an elephant to Louis XVI as a present, which later was shown at the famous menagerie at Versilles. Jacques Caffier made the first example, who, dif-

ferently from Bernini's elephant (1667, Rome) does not carry an obelisk, but a pendulum clock with varying exotic figures on its broad back.
Louis XV, circa 1745, dial and movement signed: Flournoy a Paris, fire gilded and patinated bronze.

258 The Parrot Vendor
This particular pendulum clock is part of a group of "negre au travail" and shows a black vendor with feather hat, who offers a parrot for sale which is sitting on his raised right hand. Other goods are inside a bundle, with integrated clock movement or are leaning against it. The exotic goods are symbolic for the trade with foreign countries. The base relief shows a European and a native, who midst a palm forest offers parrots and other objects for sale.
Empire, circa 1805, dial signed: Barbier, rue Greneta no. 51 a Paris, fire gilded and patinated bronze, Glass eyes, Musee Francois Duesberg, Mons.

259 Allegory of the Discovery of the New World
This very rare and unusual pendulum clock shows a native American wearing feather crown and feather skirt, sitting in a phantastic- historical barche. His dynamic pose shows him ready for combat with drawn arrow and raised bow. The clock refers to the conquer of the New World more than to its discovery. The base applications show the peaceful-idyllic world with young savages, who in an exotic vegetation prepare the goods of their country for export to Europe. The trade theme is found on many pendulum clocks.
Directoire, circa 1795, the exceptional dial with blue enamel star chapter ring by the Parisian enamel artist Dubuisson, fire gilded and patinated bronze, glass eyes, Musee Francois Duesberg, Mons.

260 The little Fowler

The little "Noble savage" tries to catch one of two birds, which are sitting on branches of an exotic tree. Another reference to nature is the tree trunk on which he climbs. The base relief shows the purpose of this hunt: the sale of the birds to Euopean dealers (a similar motiv is the parrot vendor).

Empire, circa 1805, dial signed: Thiery a Paris, fire gilded and patinated bronze, Musee Francois Duesberg, Mons.

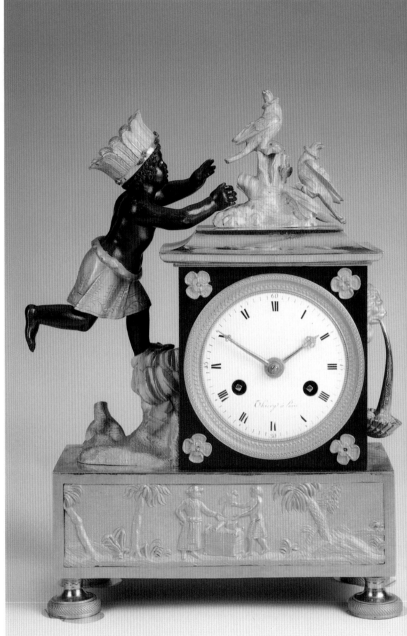

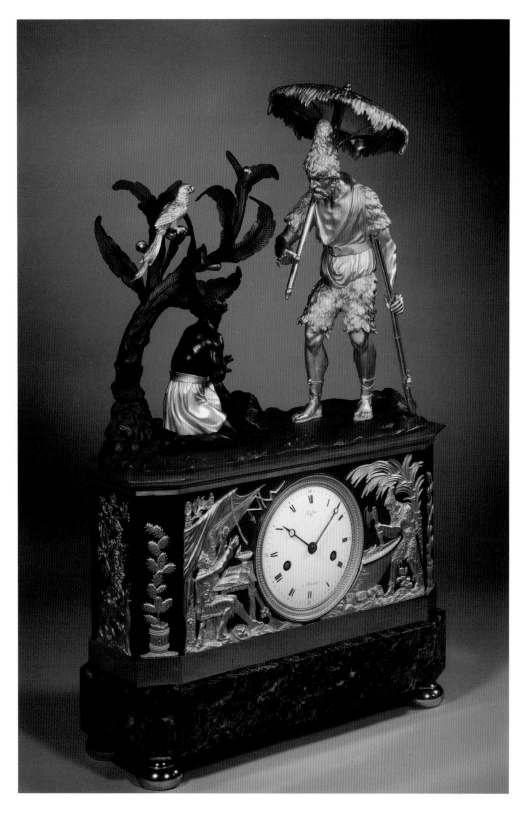

261 Robinson and Friday

The scene from Daniel Defoe's famous 1719 book *Robinson Crusoe* shows the moment, when Robinson meets another human being on his island the first time. He saves him from being killed by cannibals and gives him the name Friday. Robinson almost looses his umbrella in astonishment, Friday is begging on his knees (see Virginie and Domingue, page 153). The bronze by Claude Galle, is very detail oriented and the quality of the chasing unmatched.

Consulat, circa 1800, bronze Claude Galle, dial signed: Le Clerc a Bruxelles (Philippe Celestin Le Clerc, Mons 1762 –1846 Brussels), fire gilded and patinated bronze, vert-de-mer marble, Muse Francois Duesberg, Mons.

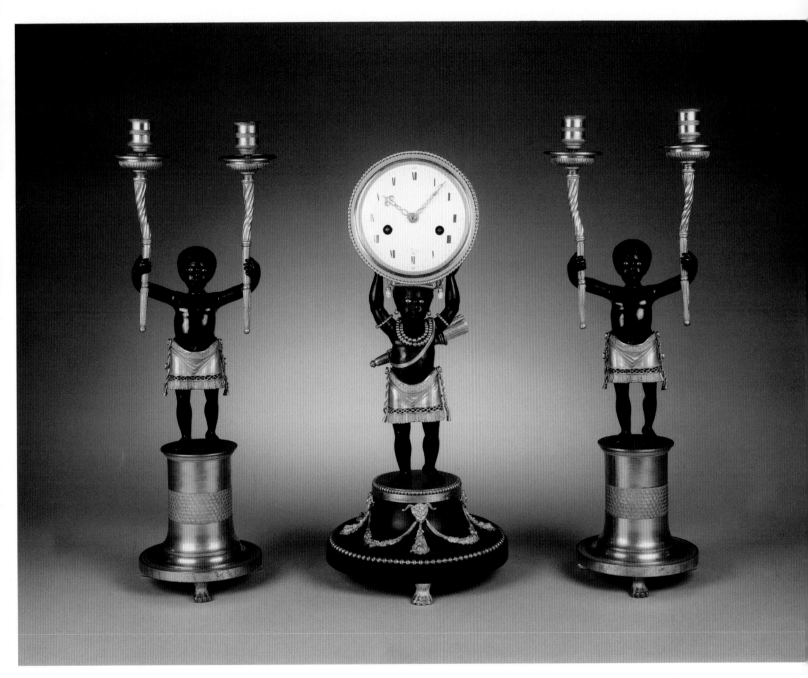

262 **The little balckamoors** with raised candleholders are grouped with small pendulum clocks in two or four somes to form garniture sets. They are also designed by Deverberie and with their shining eyes and finely worked waist cloths are very typical of his style. (see illustr. P. 152)

Consulat, 1799, Jean-Simon Deverberie, fire gilded and patinated bronze, enamel eyes, Musee Francois Duesberg, Mons.

Genre Scenes

Introduction

In the hierarchy of arts, genre scenes were always at the bottom. The depiction of everyday life, folk scenes and amusing scenes was clearly below the historical, religious and mystical themes of historical paintings. Despite or maybe because of that it was always the most popular and widespread style, because it aims at the soul and not the intellect.

The golden age of pendulum clocks with genre scenes was during the Empire period and the reign of Louis XVIII (Louis-dixhuitieme, 1814 – 1824) and Charles X (Charles-dix, 1824 – 1830). Its predecessor were courtly genre scenes with pastoral, arcadian and gallant scenes. Many porcelain figures showed pastoral and folk scenes with farmers, shepherds and folk artists. During the second half of the 18th century the painter Jean-Baptiste Greuze (1725 – 1805), who joins the academy in 1769 as "Peintre du genre," shows life and morals of simple people with his moralizing genre paintings ("peinture morale"). In the literary sector the book "Tableau de Paris" by Louis-Sebastian Mercier (1740-1814), which had been a big success and found over 100,000 readers all over Europe was important. Similar to Diderot's encyclopedia, Mercier gives an account of the everyday life and documents the streets and people of Paris in a new way. Not the gods, aristocrats and kings, but the water porters, merchants, thieves and numerous poor on the street are at the center of his interest. The high period of the genre art is parallel to the social chances following the French revolution and the industrialization at the beginning of the 19th century. The wealthy bourgeoisie took over the social position of the aristocracy without sharing its taste. Bronze pendulum clocks continue to decorate mantels and chests, but with the clients the themes also changed.

The bourgeoisie did not identify with antique gods and heroes as the aristocracy had done. They were not interested in divine ideals presented in a Greek manner. They wanted to be entertained by everyday scenes, which touch the spirit and emotions and distract from everyday life.

During the early Romantic period historical events and persons such as "the good King Henry IV," who is especially famous in France as a wise and just king and who is at the center of many stories (illustr. 273, 274) were popular. Surpassed in popularity by musicians, who play their instruments in mediaeval costume and who idealize the past in a fairy tale manner. The figures are representing different types and loose their individual character. Important events at the time, such as the birth of the Duke of Bordeaux following the attack on his father was called "L'enfant du miracle," were cast in bronze and translated into a family setting

Genre scenes mark the end of the images of the Classicism, which were idealized copies of the antique and its heroes and thus presented the old regime. They are part of the bourgeoisie world, which proofed with the abdication of Charles X (Who wanted to reinstate the old royal power) in 1830 and the reign of Louis Philippe of Orleans, "The Bourgeois King," that it had established its position, also politically.

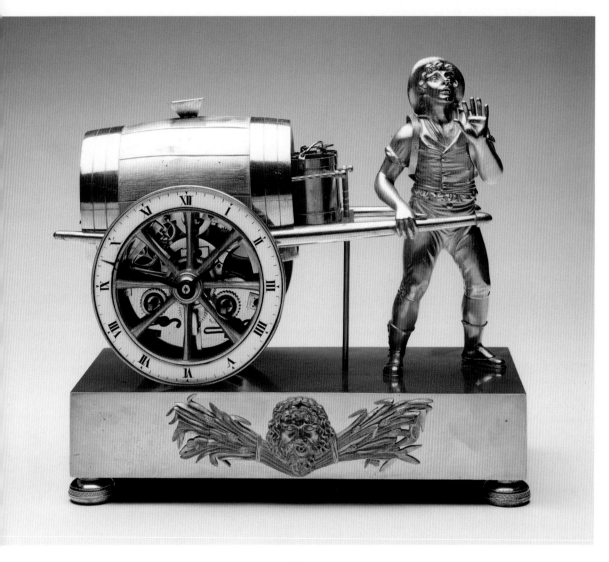

The Water Vendor — Allegory to Trade

263, 264 **Genre scene of a water seller** with perfectly integrated clock movement. Empire, circa 1810, fire gilded bronze.

The figure of a young man, who is pulling a two-wheeled wooden cart with a water barrel and two buckets, appears frozen in its movement. (illustr. 263)

He has halted the cart, secured it and is now turning to the side facing the viewer almost direct. One hand is raised as if talking or greeting. The man looks up, the mouth open at the moment before starting to shout. It is a water vendor, who is about to call out the familiar words "a l'eau!" and turning towards the houses. His clients will respond by calling out their orders from their win-

"In Paris one buys water. The public wells are so rare and so badly kept up that one turns to river water. No citizen's house is supplied with enough water." (Louis-Sébastien Mercier, Tableau de Paris, pp. 172-173)

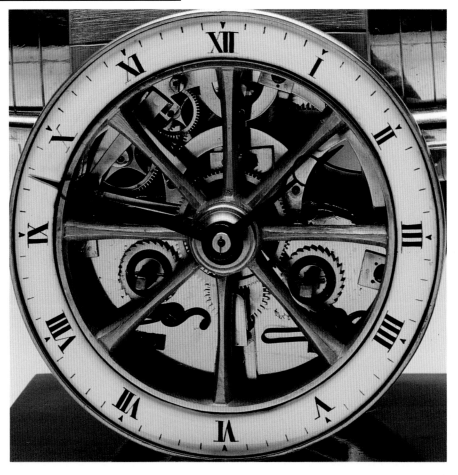

264 The wheel of time, detail of illustration on page 163

The base of the clock is very simple and reflects the ordinary of the image, avoiding to overemphasize the scene, and focusing in the moment. The applied decoration is the only mythological connection: it shows, surrounded by water grass, the head of a man with waving hair and a curly beard, which clearly is the representation of a river god. Mythology has not disappeared totally, despite the prosaic theme…River gods always have been male in antiquity, and because the water vendor is a Parisian character, it is easy to identify the mythological figure is a personification of the river Seine.

However, this aspect is only of secondary importance. It is the representation of the daily scene – which upon closer look – has both, a very heroic and a tragic side. Mercier shows us, that the profession of a water vendor in Paris during the 18th century was a very dangerous one. Not the mythological river god, but social injustices posed the danger. Similar to Mercier and his documents– which were read all over Europe with large interest – the bronze case of the pendulum clock shows the life of one individual man in a big city and the viewer can participate for a moment in his particular life.

"Twenty thousand water carriers climb from the first to the seventh floor, and sometimes even higher, from morning to evening with two buckets; the amount of water costs six liards or two sols. If the water carrier is strong, he makes the climb thirty times a day."
(Louis-Sébastien Mercier, Tableau de Paris, pp. 172-173)

dows. The viewer of the pendulum clock is taking the position of the client and feels instantly integrated into the scene. The raised head and the open look make the figure appear very lively, an effect which is further enhanced by the very realistic clothing. The water vendor wears boots, britches, vest and shirt with rolled up sleeves, which is visible between vest and pants. The strong neck and muscular arms are signs of his heavy work as water vendor and water porter. The belts around his shoulders are the carriers for the two buckets, which at the moment are standing on the cart in front of the barrel.

Louis-Sebastian Mercier gives us in his "Tableau de Paris" a realistic description of the work of a water carrier and a good explanation for their strong physics. (see text to the right).

The wooden barrel with the funnel is executed in a very detailed and naturalistic manner by the bronze sculptor. The alternating matte and polished surface shows the wood planks and the metal rings in a very realistic way. The clock movement is perfectly integrated. The wooden wheel houses the enamel chapter ring with Roman hour numerals. The clock movement is visible behind the strong spikes of the wheel.

"The same could be said of the unlucky board by the river, where the water carriers fill their buckets when the wells are frozen. Several lose their lives there every year. One lets them pay with their lives and possesses the gruesomeness of not laying down a couple of boards with safety railings to protect these unfortunate men from life-threatening danger."
(Louis-Sébastien Mercier, Tableau de Paris, pp. 104-105)

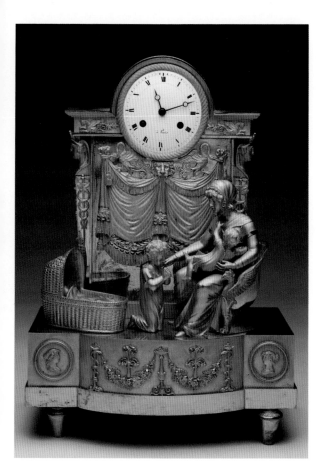

265, 266 "**Evening prayer**". The young Louise, daughter of the Duchesse of Berry, kneels in front of her mother saying her evening prayer.
Paris, circa 1820, fire gilded bronze.

was the political and social theme number one at time. The son, referred to as "l'enfant du miracle" and his destiny were the talk of the nation.

The scene not only combines the idyllic family scene with its political undertone, it also allows the viewer to see everyday life of the privileged class. The Duchess is sitting on a chair with lion paws and arm rests in the form of winged grif-

"The Evening Prayer" Pendulum clock commemorating the birth of the Duke of Bordeaux

The pendulum clock in illustration 265, 266 shows us a rather idyllic scene: A young mother nurses her son, who playfully grasps her, and at the same time she attends to her kneeling daughter, who is doing her evening prayer. To her left is a baby basket with carefully arranged pillow and blanket.

The high back wall gives the appearance of a stage setting, but at the same time the scene is very private and removed from the outside world. The elaborate setting of the back wall, which in the antique style is draped with fabric and flanked by two He-men which had sphinx heads, is an indication, that the illustrated figures are special. And indeed: the group shown in front of the richly decorated wall can be identified as members of the high aristocracy.

The infant boy, who is nursed by his mother, the Duchess de Berry, is the later Duke of Bordeaux. Kneeling in front is the older daughter Louise. The birth of the boy in 1820 was the reason for the creation of this pendulum clock by the most important bronze sculptor at the time, Jean Andre Reiche. The birth became even more significant, because of the sudden death of the father, who was murdered during an attack, which

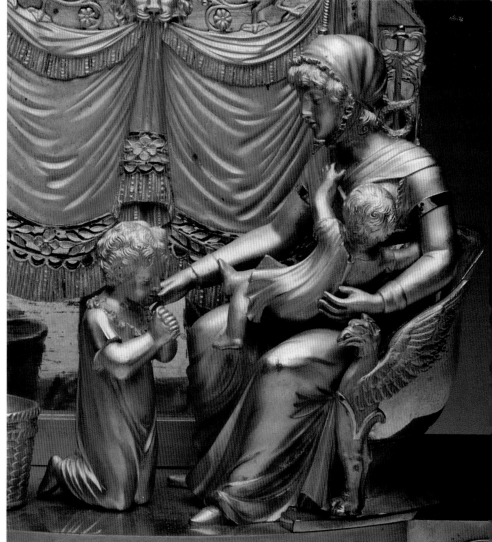

fins, which was a typical piece of furniture during the late Empire. It might have come form the work shop of the Jacob family. The baby basket is executed in a very realistic manner. The movements of mother and children are frozen in action. The viewer looks at a family, which feels unnoticed and thus acts very natural.

The representation of an aristocratic family is such an intimate setting would have been impossible during the 18th century. Only after the revolution and its resulting changes in society, is it possible to show such a family and biedermeier-style scene.

Noteworthy is the perfect execution of gilding, chasing and surface treatment. Matte and polished parts change in a manner that the bronze appears very lively. Because of its outstanding quality, pendulum clocks by Jean-Andre Reiche often ended up in the inventory of imperial families.

The clock, which is integrated in the wall, is only of secondary importance. It is part of the stage-like setting and is elegantly merged with the splendid wall decoration. The bronze case itself is more important.

267 Evening prayer (detail from illustration 265)
The almost naturalistic worked basket shows the desire to integrate everyday objects referring to time in an authentic way.

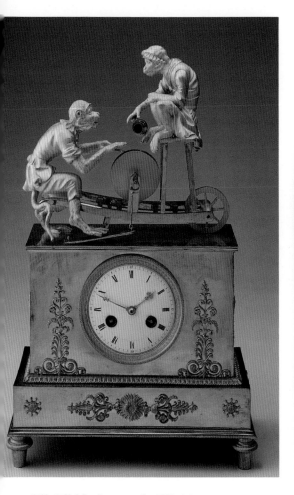

268, 269 Monkeys on the Whetstone

This is a very rare scene of a "singerie" (le singe is French for monkey) where monkeys imitate various human activities. One monkey is sharpening his knife, the other one sits above the stone and pours water on it to cool it. The oeuvre of Jean Baptiste Simeon Chardin (1699 – 1779) contains a series of paintings ("The monkey as painter, "The monkey as antiques dealer", 1726, see Rosenberg, 1983, 93-94, 23 –28), Christophe Huet painted a whole "Salon des Singes" in 1735 (Chantilly, Musee Conde).
Empire, circa 1810, dial signed: Lepine a Paris, fire gilded bronze, steel (Knife).

269 The typical feature for a singerie in fine arts is the extrem naturalism and the perfect imitation of human activities. The bronze shows every detail of the whetstone, the tools, the clothing and especially the fur of the monkeys which is achieved by a very fine chasing to achieve a fabric like character.

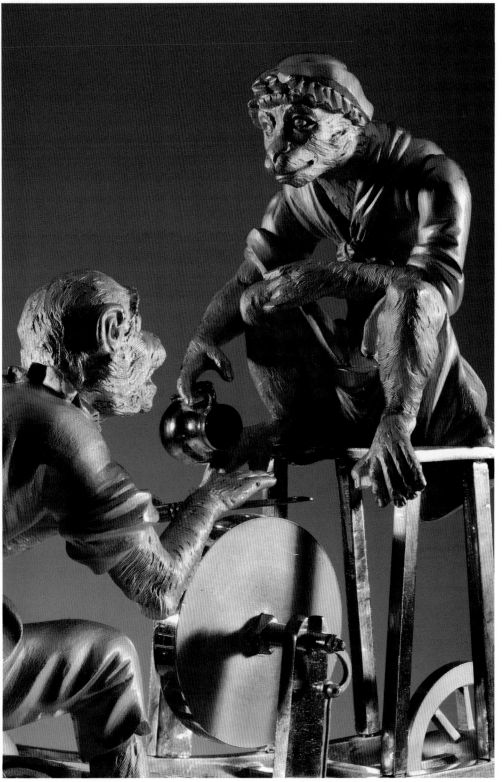

270 **Harlequin**

The figure of Harlequin is an important role in the Italian *Commedia dell'arte,* which became one of the most liked and known forms of theater in France during the 18th century. Its typical features are improvised scenes, which surprise the viewer and its crude jokes. The free standing figure of harlequin is caught in the middle of a prank. He is wearing the typical tight fitting costume with lozenge-shaped pattern, which underlines his smooth movements. His face is hidden behind a mask, behind which the wide-open, shining and threatening eyes are sparkling. He is balancing a Comptoise clock on his hip, which has a bird peeking from an opening in its gable. The little door is inscribed "L'artiste du Jour" (Artist of the day). The harlequin is pointing at the bird . In his role as fool he shows us both, the vanity and the dependence of man on time and makes fun of it.

Empire, circa 1815, fire gilded and patinated bronze, enamel eyes.

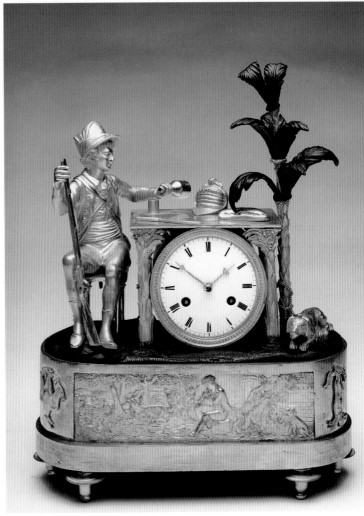

271 Hunter at a Spring

The pendulum clock catches the moment where a hunter, gun in hand, approaches a spring to get some refreshment after the exhaustion of the hunt. The base relief shows hunter and dog in a forest following a rabbit who is getting away. The clock is integrated into a rock, water bursts out of the spring, the tree on the right symbolizes the landscape. In a typical genre scene a particular moment is captured and the spontaneity of an everyday scene is reproduced in a realistic way. Empire, circa 1815, fire gilded and patinated bronze.

272 Resting Hunter

The hunter is peacefully resting after a successful hunt, which is documented by the killed hare and duck. He uses the case of the clock as table top, on which bread, knife and a cake wrapped in a napkin, are spread out. He is in the process of pouring wine from a bottle. His exhausted dog is resting in the shadow of a tree. All details are carefully arranged and reflect the importance of the moment in the genre scene. The large base relief shows a flute playing sheperd in an arcadian landscape. This idyllic pastoral scene is the opposite to the use of nature by the hunter, similar to the transition from the courtly *ancien regime* to the bourgoise life of the 19th century.
Empire/Charles X, circa 1820, fire gilded and patinated bronze.

169

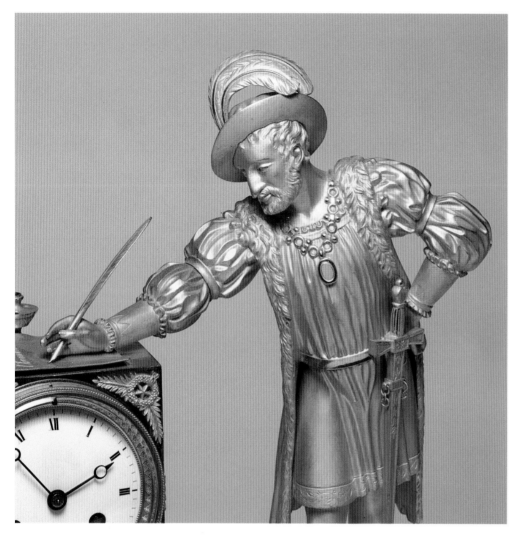

275 **George Washington (1732 – 1799)** is standing in full uniform – he was commander in the war of independence against England (1775 – 1783) – next to the case containing the clock, using it as a rostrum and having his elbow leaning against it. He is about to start a speech and holds a document in his hand, which refers to his participation in the drafting of the constitution, which was done during a convention which he headed in 1787.

The banner underneath the dial reads WASHINGTON, First in WAR, First in PEACE, First in the HEARTS of his COUNTRYMEN. The base relief shows him as judge, mediating between two fighting parties. *Empire/Charles X, circa 1820, dial signed: Dubuc/ Rue Michel-le-Comte No. 33 a Paris, fire gilded bronze.*

273, 274 **Henry IV**

Henri Quatre (1553 – 1610) is adored by the French as a tolerant and beneficent people's king. This romantic-historical representation shows him standing at the writing desk, into which the clock is integrated. He holds a writing feather and writes the following about vanity on a scroll:" Tout est perdu fors (?) l'honneur" (probably: all is vanished, except for honor). His heroism is further enhanced by the trophies underneath the dial and the three honorable tables at the base. They are applied between midieval swords and helmets with visors. The two outer ones refer to victorious battles, the one in the center calls the king "restaurateur des lettres".
Empire, circa 1815/1820, dial signed: Lopin/Palais Royal No. 143, fire gilded bronze.

273 Henri Quatre has the typical beard and Renaissance clothing, which is reproduced by the bronzier in every detail. The king's hat, decorated with a feather is also typical. He is quoted as having said before a battle"Suivez mon beau panache blac" (Just follow my white feather bush).

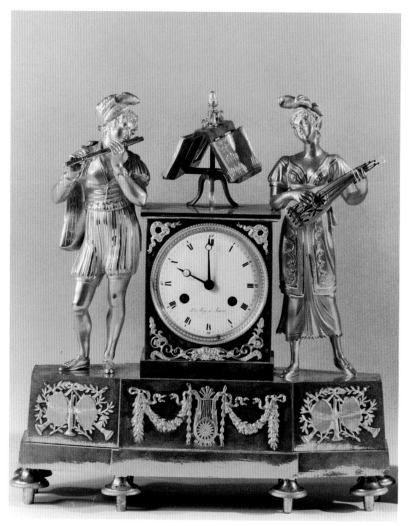

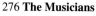

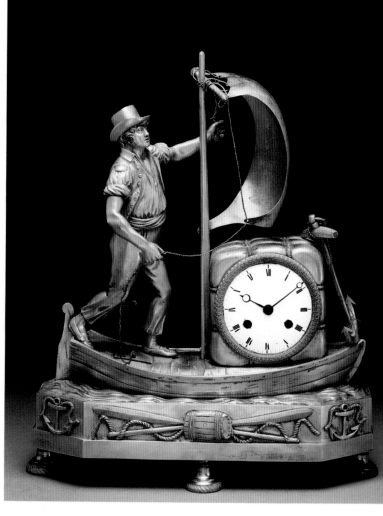

276 The Musicians

This scene shows the importance of historical costumes and situations during the Romantic period. The pair of musicians transposes us into the middle ages. The two figures are standing right and left of the clock case , on which two note stands are positioned. The male figure is playing the German flute, the female figure is playing the lute.

The note sheets are inscribed *"Aria de Troubadour"*. The French troubadour Trouvere was a poet/musician during the middle ages, who performed his songs at the courts of Europe. A lyra and other ancient instruments such as shawms and tambourins are applied to the base.

Empire, circa 1815, dial signed: Le Roy a Paris, fire gilded bronze.

277 The Seafarer

The strong seaman holds the inflated sail of his boat. Its cargo is a roped bundle of cotton with integrated clock movement. The bronze is in accordance with the realism – especially in the clothing and the waves – typical for the period. The figure has a strong stylistic resemblance with the water vendor (illustr. 263), cotton bundle and anquor are similar to the ones in the pendulum clock "Allegory to trade" (illustr. 231, 232).

Empire, circa 1810, fire gilded bronze.

278 "The Deserter"

This unusual pendulum clock shows a scene from the opera "Le Deserteur" by Michel-Jean Sedaine (1719 – 1797), which premiered in 1769 and was very popular at the time. The represeantation which consists of many little details captures the moment when the deserter, whose head is visible behind the lattice window – is about to be captured by the soldiers. Based on a drawing this bronze can be attributed to Jean Goyer (see Tardy, II, p. 297; Ottomeyer/Proschel, I, p. 197).

Louis XVI, circa 1775, dial signed: Trouvez a Paris (Maitre 1777), fire gilded bronze, white marble.

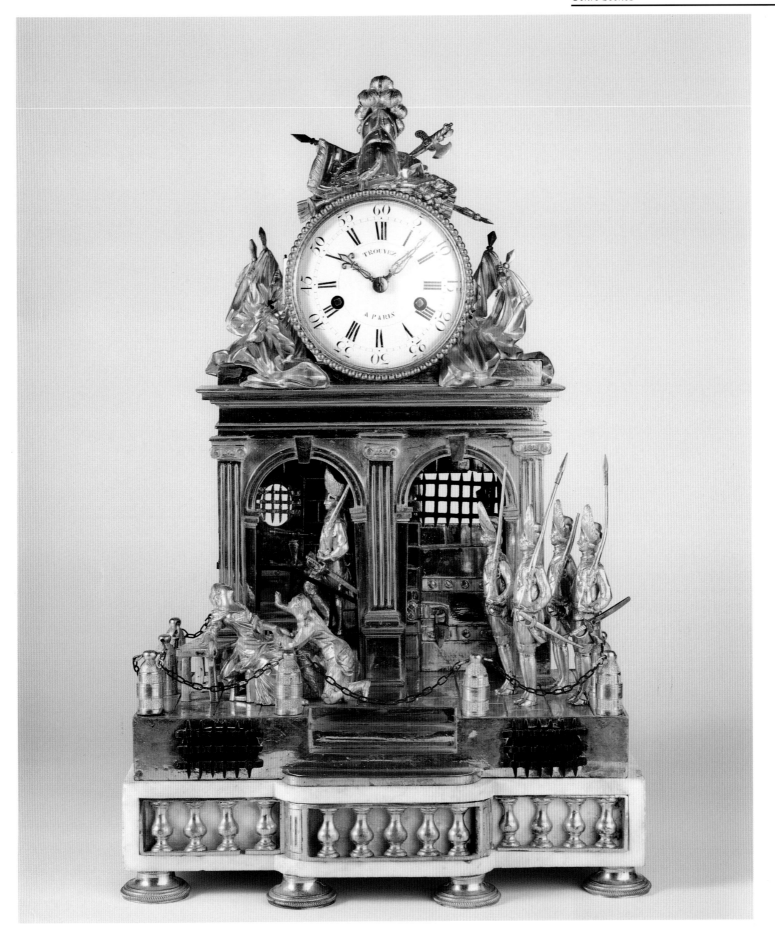

279 Insomnia

The very complex composition is by P.P.Thomire after a model by L.S. Boizot. It shows a splendid bed, in which a young woman is disturbed in her sleep by a young boy. Except for a nightcap she is naked and is only sparsely covered by the very finely layered sheet, which she is trying to rearrange. The little boy is peeking from underneath the sheet which shows the outline of his body. The scene reminds us of Amor in a playful battle with his mother Venus or Psyche (illustr. 157, 213). It is an entertaining genre scene, which had been executed with high technical and artistic abilities and which pays great attention to details and their textures. Paris, circa 1805, fire gilded bronze, Griotte marble (see G. Zick, publication for M. Prutscher, 1984).

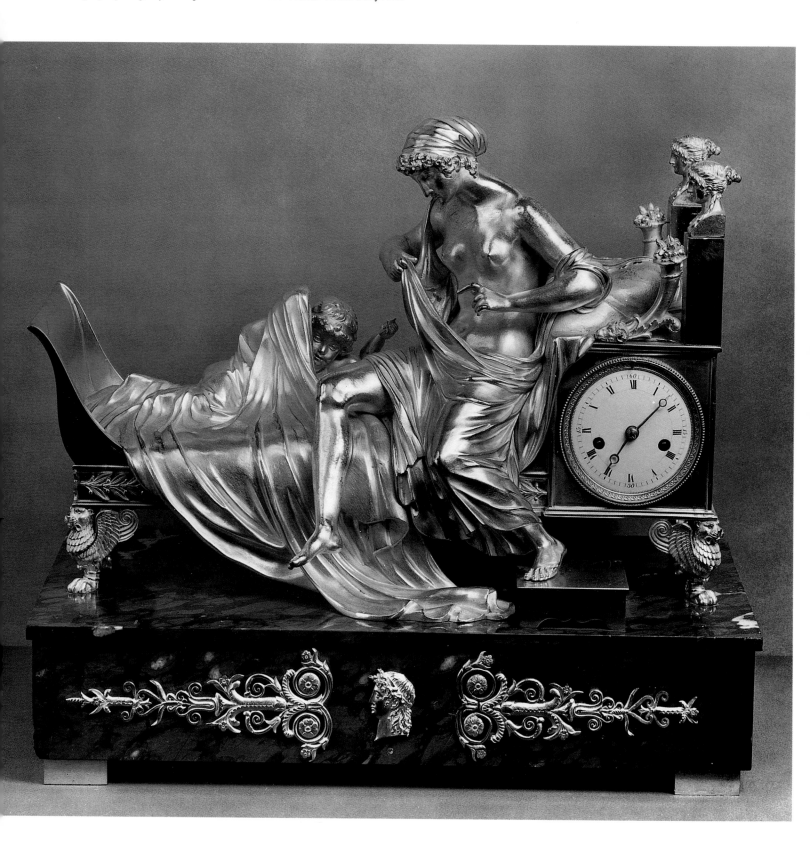

280 The Reconciliation

This elegant pendulum clock is in the form of an antique column ("forme borne") which underneath the dial has a finely chiseled relief showing an embracing and kissing couple. The love theme is enhanced by the bezel of roses surrounding the dial. The corners have applied burning torches and point to Amor. The reconciliation theme only becomes clear when one knows the pendant pendulum clock, which shows the quarrel and the splitting of the couple. One copy by Claude Galle exists, which has three dimensional figures: he has also made several pendulum clocks of the "Forme borne" type. (see Ottomeyer/Proschel, page 369 and 372).

Empire, circa 1810, Claude Galle attributed, dial signed: Bled a Paris, fire gilded bronzes, vert-de-mer marble.

281 Reading Woman on a Reclining Sofa

The bronze artist has captured the casual-elegant and focused reading position of the woman in a very realistic way. The way the large pillow is dented by the ellbow and the draping of the thin clothing, which lets us see the body contours are signs of high artistic mastery. Dial, book and the bent head of the reader are on one axes and thus form a unity. The reading process lets her forget all about time. The motiv of a young woman, dressed *a la grecque*, elegantly reclining on an antique chaise, had been made famous through a painting by Jacques Louis David (1748 – 1825), which shows Madame Recamier on the meuble which later had been named after her. The equally famous Paolina Borghese, a sister of Napoleon, had been painted by Antonio Canova (1757 – 1822) in a similar pose – except that she was almost naked.

Empire, circa 1805, dial signed: Jn. Fcois Barthet a Marseilles (Jean Francoise Barthet, Maitre 1790), fire gilded bornze.

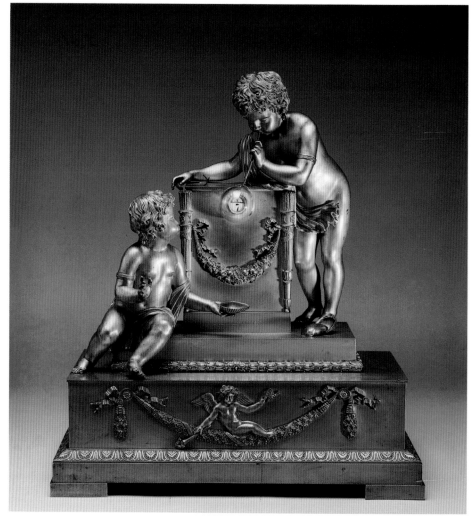

283 **Flute playing Shepperd**

The young sheperd is sitting down and is focused on playing his flute. He wears antique cloth and sandals. At his feet lays a pan flute. His devoted dog looks at him attentively and seems to listen to the music. The attributes are from Daphne. The crossed torches and quiver with love arrows of Amor point at the famous love story of antiquity, Daphnis and Chloe by Longos. Nevertheless this pendulum clock is considered a genre scene because it captures a particular moment.

Empire, Charles X, circa 1820, fire gilded bronze.

284 **Love can burst like a soap bubble**

The two boys are completely caught up in their game. The deeper meaning of the genre scene in conveyed only by the verses added to the original design (design see Ottomeyer/Proschel, I, p. 400). "*Un souffle la fait naitre, un souffle la detruit?Ainsi dans nos plaisirs l'heure apparait et fuit*". The scene can be traced to an emblem by Daniel Heinsius (see Emblemata, Sp. 1316). The text says: "*Affection is like a soap bubble. Like a soap bubble, which is easy to make but* just as fast in bursting, affection of those, who chose us as their object of affection. It goes as it comes, and comes, as it goes…"

Instability is symbolized by the soap bubble, behind which the hour numeral is seen. *Cercles Tournantes* are used to technically solve the time giving, the winding holes are hidden by flower garlands.

Paris, circa 1830, design by Louis-Stanislaus Lenoir-Ravrio, bronze signed: L.J.Lepaute, fire gilded bronze.

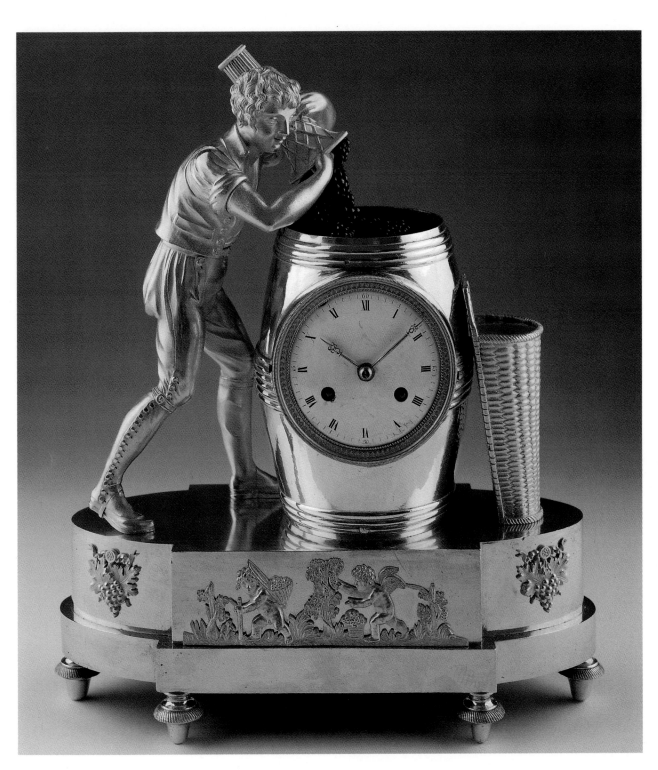

285 **The Grape Harvest**

The center of the bronze group is a big barrel, into which an arriving grape-grower is dumping picked grapes from a basket. At right is a wicker basket, likewise a symbol of grape-picking. The base decoration also refers to the theme of the grape harvest; here we see winged cherubs who playfully imitate the work in the vineyard: one of them cuts the grapes from the vine, another carries them to the big barrel in a basket.

In a manner typical of it genre, a moment of daily life is portrayed in great detail.

Empire, ca. 1810, fire-gilded and patinaed bronze. *Kunsthandel Michael Nolte, Münster.*

286, 287 Couple playing Checkers

The two figures are facing each other on a game table, covered by a table cloth, which drapes around the clock. The siderial view allows the viewer to observe the game, which is characterized by active gestures and the body language. The players, dressed in antique clothing are seated on antique style bow-legged chairs, which were popular during the Empire period. All details are finely executed. Empire, circa 1815, fire gilded bronze.

287 The bronze captures the moment, when one of the players grabs a stone in order to make an important move. His eyes are wide open and his gesture is tense. The defensive gesture of his partner confirms that she is aware of the danger of the situation.

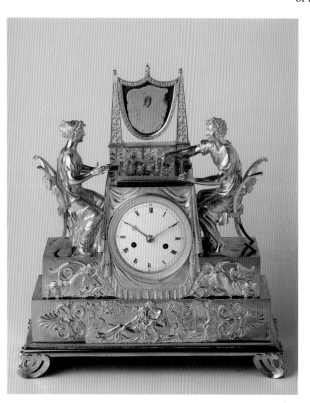

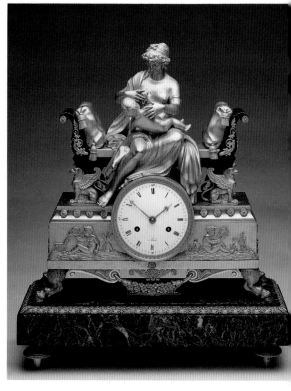

288 Mother nursing Child

The pendulum clocks shows the intimate relationship between a mother and her baby, whom she is nursing in a very elegant setting. The two are sitting on a precious day bed, similar to the ones made by an important furniture maker, such as Jacob or Molitor, for the Emperor of his family. Golden shinxes are carrying the antique style bed , two pillows add comfort. The artist skillfully conveys material and softness of the pillows. The base relief is very detailed and shows childrens' toys. The exceptional quality of the bronze and the choice of furniture point at a genre scene with an important person at its center.

Empire, circa 1810, fire gilde dand patinated bronze, vert-de-mer marble.

289, 290 Amor as painter. This bronze shows an amusing and for genre scenes typical travesty of the representation of "painter and model", which has a long and serious tradition in art history.
Empire, circa 1810, dial signed: Thonisen a Paris, fire gilded and patinated bronze.

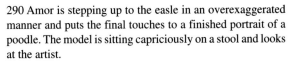

290 Amor is stepping up to the easle in an overexaggerated manner and puts the final touches to a finished portrait of a poodle. The model is sitting capriciously on a stool and looks at the artist.

291 Little Red Ridinghood and the Wolf
The use of fairy tale themes on pendulum clocks is very rare. Interest in folk tales and myths in general only started during the Romantic period which was chronologically after the high time for pendulum clocks. Little red riding hood – in French referred to as "Petit Chaperon rouge" carries presents for her grandmother, who lives in the midst of the forest – which is indicated by the wooden hut with integrated clock. The girl looks frightened and curious at the submissively approaching wolf, who almost appears to be talking to her and tries to convince her of his harmlessness.
Empire, circa 1815, fire gilded and patinated bronze.

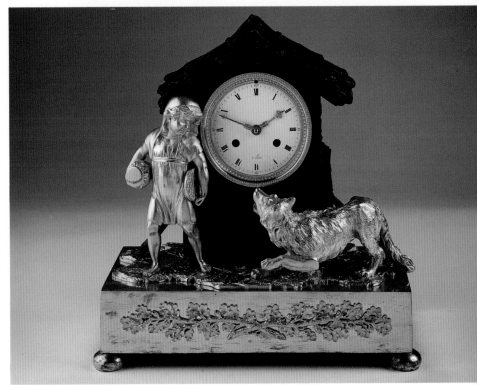

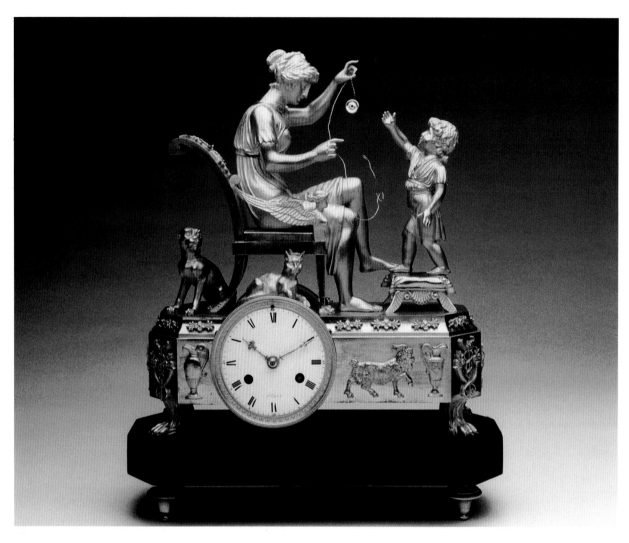

293 Domestic Scene

A young woman plays with a boy. In order to reach the toy, which the she is holding up high, he has stepped on a footstool. A dog and a cat are lying underneath the chair, which is done very elaborately with sphinx bodies and bow legs and could have been done in the workshop of George Jacob, who has become famous for this type of furniture. The clock is integrated into the high base which is sitting on paw feet, which again are resting on a marble plinth.

Empire, circa 1815, dial signed: a Paris, fire gilded bronze, marble.

294 –297 **The Sculptor**

The clock is integrated into an architectural case. It is in the antique doric order and is the base for a figural interpretation of the art of the sculptor.
Empire, circa 1815, fire gilded bronze.

294 ▲ 296 ▼ 295 ▲ 297 ▼

294 A putto is kneeling on the floor and is working on a bust of a bearded man which is not yet finished. A large wooden hammer for the embossing chissel , which is used to give the rough form to the stone scuplture is laying next to him.

296 His opposite shows a putto performing some finer tasks. He is sitting on a stone boulder and drawing scetches on a wax table. A circle, which is used to confirm proportions and convey them on the stone block, an integral part of the sculptor's work, is at his feet.

297 This scene shows the vision the 19ᵗʰ century had of a sculptor's work shop. The athletic young man is wearing a short chiton and sandals and sits on a low doric column. With a chisel in his raised hand, he is looking at an almost finished bust, which is sitting on a three-legged table. The work shop athmosphere is further enhanced by the antique vessel and a finished piece leaning against it. The artist's beard is very typical for the fashion of the 19ᵗʰ century.

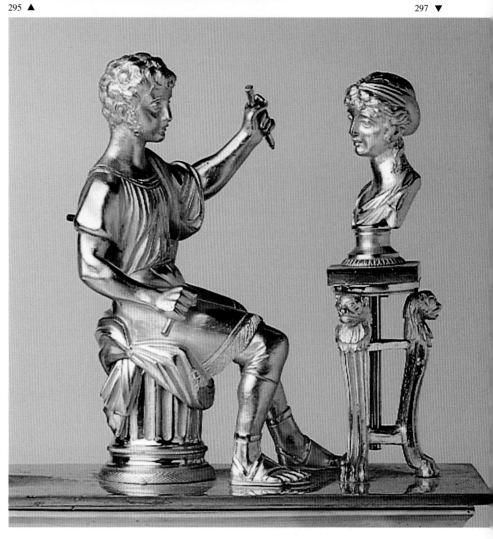

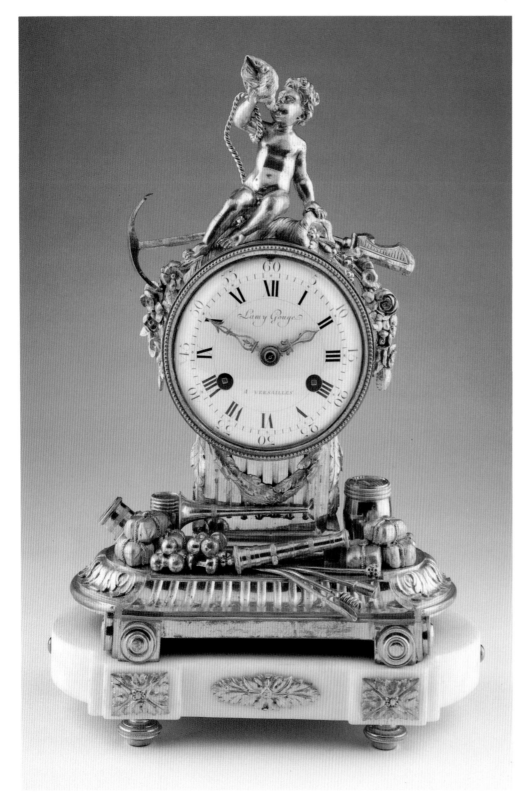

298 Small Triton – Allegory to Sea Faring

A putto, blowing a large shell like a Triton, crowns the pendulum clock. Anchor and rudder refer to sea faring, as do several tools and utensiles which are located on the base. They include a rum barrel, tobacco bundles (over-seas trade) and canons with shells. A whispering cane, which is a tool for communication on ships, gives us an idea about the rough everyday life on a boat and its dangers.

This rare pendulum clock from the early Classicism period unites in a very playful way the ancien regime with playful-mythical and everyday elements.

Louis XVI, circa 1765, dial signed: Lamy Gouge a Versilles, fire gilded bronze, white marble.

299 **Dog saves Child**

A baby , sleeping in an antique child bed, tries to fend off a snake with loud cries and raised arms. The snake is ultimately defeated by a dog who jumps up the bed and kills it. The very naturalistic scene captures every detail and seems frozen in this dramatic moment. The open mouth of the child, the rummaged pillows and sheets, the waving ears and large eyes of the dog and its dynamic stepping convey the danger of the situation.

Empire, circa 1810, dial signed: Lefevre duc de De Belle a Paris, fire gilded bronze.

300 **Reading Plutto**

The heavy portico seems with its squareside pillows like a triumphant arch. The two water spitting lions applied at the base refer to Rome. The two ancient egyptian lions are two famous fountain figures in Rome, with water pouring from their mouth (Piazza del Popolo, Fontana dei Quattro Leoni). The fountain is by Giuseppe Valadier and had been built during the Napoleonic regime.

The naked boy is sitting on a thick book and is all focused on the book, which he is holding on his knees. The siderial view clearly shows the bent back and the bent head; it shows highest concentration and focus of the young scientist.

Empire, circa 1815, dial signed: a Paris, fire gilded bronze.

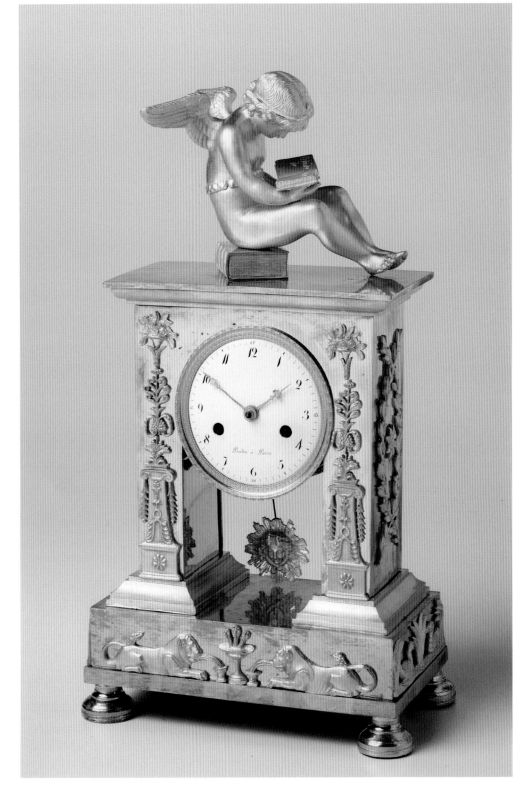

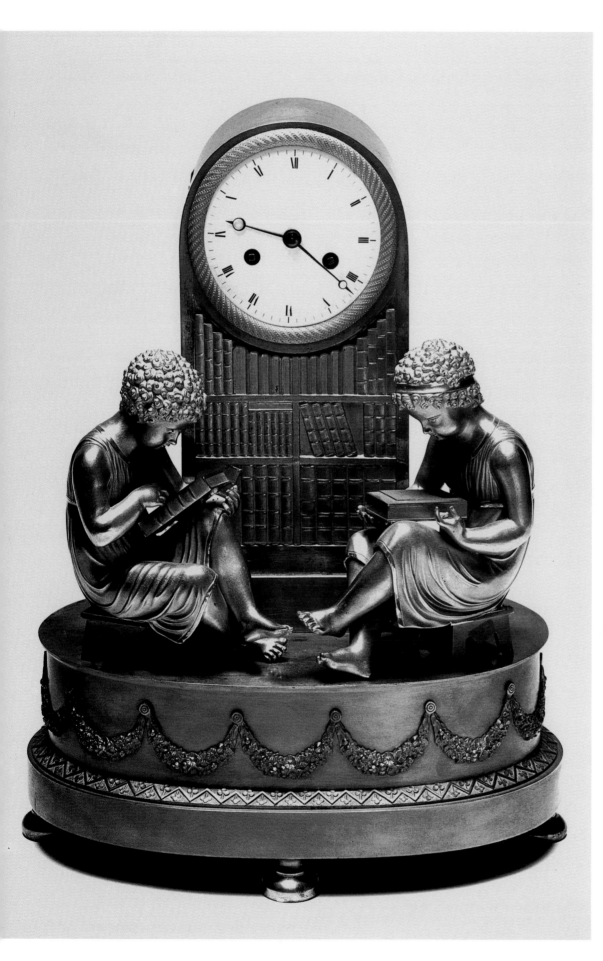

301 **Studying children**

Two boys are diligently studying in a library. Without any regard to time, both are sitting in front of a clock, which is integrated into a column, which also serves as a bookshelve. Both are wearing short chitons and are barefoot. Their curly hair is their only ornamentation.

The refinement of the composition is achieved by variations of a uniform theme: The rounded oval base is repeated in the arched top of the column following the circle of the dial, the curved backs of the boys and the rounded heads and limbs. The boy at the left holds the book and follows the text with his finger at an especially interesting point . The boy on the right seems to read loud, which is stressed by the gestures of his left hand. This gives liveto the scene despite its order and symmetry and the academic athmosphere.

The children are dressed in classical cloth, any kind of complicated symbolism and allegorical figures, as was popular with earlier personifications of study are missing. The genre scene uses simple figures to bring the theme to the viewer.

Empire, circa 1810, fire gilded bronze.

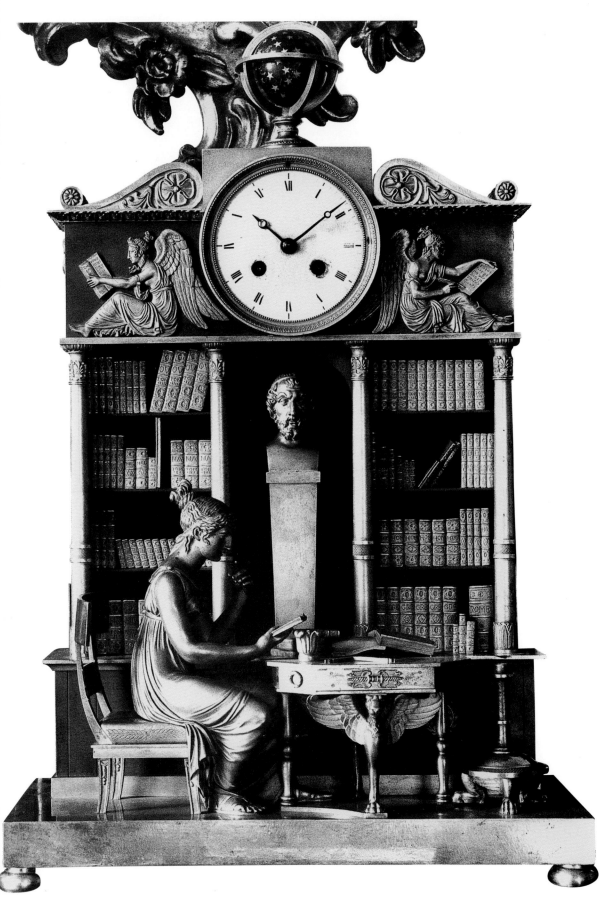

302 **Antique Library**

A library is created in front of the viewer like the back drop of a stage, the wall filled with book shelves and columns. The freeze has an integrated clock, which is flanked by Genii/ Muses. Both have books in front of them with Greek text. All elements are taken from Roman and Greek antiquity. At the center – of the composition and meaning – is a portrait bust of Aristoteles. He is often shown in the circle of the seven free arts, with Aristoteles representing dialectics. The pendulum clock is crowned by a celestial globe, which represents astronomy. The *"philosophorum princeps"* is surrounded by other important writers and philosophers. They are represented by books on the shelves. Some of the titles on the books are readable such as Ov(id), Hom(er), Em(pedokles?), Rome. The young woman – in a period cloth is engaged in the lecture of "The Old". Typically for genre scenes is the capture of a particular everyday moment. The viewer feels like looking into an ancient library . Empire, circa 1810, fire gilded and patinated bronze.

Addendum

References

APULEIOS: The tale of Amor and Psyche, published and translated into german by K. Steinmann, Stuttgart, 1978
ARISTOPHANES: The Comedies. Edit. By Hans Joachim Newiger, New edition and translation by Ludwig Seeger, Munich, 1976.
BEAGLEHOLE J.C.: The Journals of Captain Cook on His Voyages of Discovery, Cambridge, pp. 1961.
BERNARDIN DE SAINT-PIERRE, JACQUES-HENRI: Paul and Virginie, german by Ch. Schuler, Darmstadt/Weimar 11912.
CATULL: Poems, german by Rudolf Helm, Stuttgart, 1992.
COCHIN, CHARLES-NICOLAS a. H.-F. GRAVELOT: Iconologie par Figures ou Traite complet des Allegories, Emblems etc. A l'Usage des Artistes, en 350 Figures, Paris, n.d. (1757), Minkoff Reprint, Geneve 1972.
CHATEAUBRIAND, FRANCOIS RENE DE: Atala, Die Liebe zweier Indianerkinder, german by Trude Geissler, Stuttgart 1962.
DEFOE, DANIEL: Robinson Crusoe, german by F. Riederer, Munich 1966.
EMBLEMATA: Handbuch zur Sinnbildkunst des XVI. und XVII. Jahrhunderts, publ. by Arthur Henkel and Albrecht Schoene, Stuttgart 1967.
Gessner, salomon: Idyllen, publ. By E. Theodor Voss, Stuttgart 1988.
GLUCK, CHRISTOPH WILLIBALD: Orpheus and Euridike, publ. by Wilhelm Zentner, Stuttgart 1949.
HOMER: Ilias and Odyssee. German by Johann Heinrich Voss, Munich 1971.
HOMER: Die Homerischen Gotterhymnen, german by Thassilo von Scheffer, Leipzig 1974.
LONGOS: Daphnis and Chloe. German by Otto Schoenberger, Stuttgart, 1988
MORITZ, KARL PHILIPPE: Goetterlehre oder Mythologische Dichtungen der Alten, Frankfurt am Main, 1979.
OVID: Methamorphosen, publ. And german by Hermann Breitenbach, Stuttgart 1980.
PLATON: Politeia, Symposion: The complete works: German by Friedrich Schleiermacher, publ. Bei Ernesto Frassi, Bk. II and III, Hamburg 1958.
ROUSSEAU, JEAN-JACQUES: Sozialphilosophische und politische Schriften, in first translation by Eckhart Koch and later edited translations and editions from the 18th and 19th century, Munich, 1981.
THEOKRIT: Die echten Gedichte, German by Emil Staiger, Zurich and Stuttgart, 1970.
WINKELMANN, JOHANN JOACHIM: Thoughts about the imitation of Greek works in Painting and Sculptor: Desctiption of the Torso of Belvedere in Rome, in: Winkelmanns Work, Bibliothek Deutscher Klassiker, Berlin and Wimar, 1976.
VERGIL: Bucolica, Hirtengedichte, transl. by Rudolf Alexander Schroeder, Frankfurt am Main, 1990.
VERGIL: Georgica, Agriculture, transl. by Otto Schoenberger, Stuttgart 1994.

Bibliography

Abeler , Juergen : Meister der Uhrmacherkunst , Wuppertal 1977;
Abeler.: 5000 Jahre Zeitmessung , Wuppertal 1978
The Age of Neo – Classicism , The Fourteenth Exhibition of the Council of Europe , The Royal Academy and the Victoria and Albert Museum , London 9. September – 19. November 1972 , London and Harlow 1972.
Kat. Amor und Psyche , Ein Blick auf Amor und Psyche um 1800 , Exhibition, Kunsthaus Zuerich , 20. Mai – 17. Juli 1994 , Zuerich 1994.
Antal , Frederic : Classicism and Romanticism , London 1966.
Anzelewsky , Fedja : Duerer , Werk und Wirkung , Erlangen 1988.
Apuleios : Das Maerchen von Amor und Psyche , publ. and edit. by . K. Steinmann , Stuttgart 1978.
Argan , Giulio Carlo : II Neoclassicismo , Rom 1968.
Aristophanes : Saemtliche Komoedien , publ. by Hans – Joachim Newiger , newly editited translation by Ludwig Seeger , Muenchen 1976.
Arnason , H. H.: The Sculptures of Houden , London 1975;
Arnason.: Jean – Antoine Houden , Le plus grand Sculpteur francais du XVIIIe Siecle , Lausanne 1976.
Augarde , Jean – Dominique: Les Ouvriers du Temps , La Pendule a Paris de Louis XIV a Napoleon Ier , Genf 1996.

Baillie , Grandville Hugh: Watchmakers and Clockmakers of the World , London 1947.
Ballot , M. J.: Charles Cressent , Sculpteur , Eveniste et Collectionneur , Paris 1969.
Brandmann , Guenter : Melancholie und Musik , Ikonographische Studien (= Wissenschaftliche Abhandlungen der Arbeitsgemeinschaft fuer Forschung des Landes Nordrhein – Westfalen , Bk. 1 2) , Koeln , Opladen 1960.
Bauer , Hermann : Rocaille , Zur Herkunft und zum Wesen eines Ornament – Motivs , Berlin 1962.
Bauer , Hermann u. Sedlmayr , Hans : Rokoko , Struktur und Wesen einer Epoche , Koeln 1992.

Baulez , Christian : " La Pendule a la Geoffrin " , in : L`Estampille/L`Objet d`Art , 224 , April 1989 , pp. 34 – 41.
Baumstark , Reinhold : Ikonographische Studien zu Rubens' Kriegs – und Friedensallegorien , Sonderdruck aus Bd. 45 der Aachener Kunstblaetter , Aachen 1974.
Beaglehole , J. C.: The Journals of Captain Cook on his Voyages of Discovery , Cambridge 1961 ff.
Becker, Karl – Ernst und Kueffner, Hatto : Uhren (Battenberg Antiquitaeten – Katalog), Augsburg 1984.
Bellaigue, Geoffrey de : The James A. de Rothschild Collection at Waddesdon Manor , Furniture , Clocks and gilt Bronzes , 2 Bks. , London 1974.
Belting, Hans : Bild und Kult , Eine Geschichte des Bildes vor dem Zeitalter der Kunst.
Bengtson, Hermann : Roemische Geschichte, Muenchen 1973.
Benzaken , Jean Charles : Hercule dans la Revolution francais ou les " nouveaux traveaux d` Hercule", in : L' image de la Revolution Francaise, edit. by Michel Vovelle , Paris 1990, pp. 203 – 214.
Berckenhagen, Ekhart : Zeichnungen franzoesischer Bildhauer , in : Sitzungsberichte der Kunstgeschichtlichen Gesellschaft zu Berlin, 18, 1969 – 70;
Berckenhagen, Ekhart: Die franzoesischen Zeichnungen in der Kunstbibliothek Berlin, Berlin 1970.
Berliner, Rudolf und Egger, Gerhart: Ornamentale Vorlageblaetter des 15. – 19. Jahrhunderts, 3 Bde., new edition, Muenchen 1981.
Bernardin de Saint-Pierre, Jacques-Henri; Paul und Virginie, german by Ch. Schueler, Darmstadt/ Weimar 1912.
Beutler, Christian : Marmorbilder, in : Kunst um 1800, Werner Hofmann zu Ehren, edit. by Christian Beutler u. a., Muenchen 1988, pp. 98 – 107.
Beyer, Andreas (Hrsg.) : Die Lesbarkeit der Kunst, Zur Geistes-Gegenwart der Ikonologie, Berlin 1992.
Kat. Bilderwelten, Franzoesische Illustrationen des 18. und 19. Jahrhunderts, Aus der Sammlung von Kritter, Museum fuer Kunst und Kulturgeschichte Dortmund 1985.
Die Bildwerke des 18. Jahrhunderts, Museum fuer Kunst und Gewerbe, Kataloge des Museums fuer Kunst und Gewerbe, Hamburg, IV, Braunschweig 1977.
Bitterli, Urs: Die "Wilden" und die "Zivilisierten", Grundzuege einer Geistes- und Kulturgeschichte der europaeisch – ueberseeischen Begegnung, enlarged edit.. Muenchen 1991.
Blondel, Jacques-Francais : De la distribution des maison de plaisance et de la decoration des edifices en general, 2 Bks., Paris 1737 – 1738.

Blumenberg, Hans: Arbeit am Mythos, Frankfurt am Main 1979.

Boffrand, Germain: Description de ce qui a ete pratique pour fondre en Bronze, d' un seul jet, la figure equestre de Louis XIV, Paris 1743.

Boschloo, Anton W. A. u. a. (Hrsg.): Academies of Art between Renaissance and Romanticism, 's – Gravenhage 1989 (Leids Kunsthistorisch Jaarboek V – VI, 1986/87).

Bosseur, Jean-Yves: Music, Passion for an Art, New York 1991.

Bresc-Bautier, Genevieve: La sculpture francaise du XVIIIe siecle, Paris 1980.

Brink, Claudia u. Hornbostel, Wilhelm (Hrsg.): Pegasus and the Arts, Hamburg 1993.

Britten's Clocks and Watches and their Makers, edit. by Cecil Clutton and others, Norwich 1973.

Brookner, Anita: Jacques-Louis David, London 1980.

Bryson, Norman: Word and Image, French Painting of the Ancien Regime, Cambridge, London, New York 1981.

Kat. Das Buch als Kunstwerk, Franzoesische illustrierte Buecher des 18. Jahrhunderts aus der Bibliothek Hans Fuerstenberg, Schloss Ludwigsburg, Ludwigsburg 1965.

Budde, Ludwig : Ara Pacis Augusta, Der Friedensaltar des Augustus, Hannover 1957.

Burchard, Ludwig u. d' Hulst, R. – A.: Rubens Drawings, 2 Bde. Bruessel 1963 (= Monographs of the "National Centrum voor de Plastische Kunsten van de XVIde en XVIIe Eeuw", Bd. II).

Burckhard, Jacob : Die Kultur der Renaissance in Italien, Leipzig 1926.

Busch, Werner: Das sentimentalische Bild, Die Krise in der Kunst des 18. Jahrhunderts und die Geburt der Moderne, Muenchen 1993.

Caldwell, Marilyn : Amor vincit tempus, in : North Carolina Museum of Art Bulletin, Bd. VIII, Nr. 1, 9; 1968.

Cardinal, Catherine : Catalogue des Montres du Musee du Louvre, Bk. I, La Collection Oliver, Paris 1984;

dies.: La Dynastie des Le Roy, Horlogers du Roy, Tours 1987;

dies.: La Revolution dans la Mesure du Temps, Calendrier Republicain, Heure Decimale, 1793 – 1805, La Chaux-de-Fonds 1989.

Cartari, Vincenzo; Vere e nove imagini (First edition 1556), Reprint of the edition of 1615, New York und London o. J. (Philosophy of images, Bk. 1 2).

Caso, Jacques de : Sculpture et monument dans l'art francais a l' epoque neo-classique, in Stil und Ueberlieferung, Akten des 21. Internationalen Kongresses fuer Kunstgeschichte, Bonn 1964, Bk. 1, pp. 190 – 198, Berlin 1967.

Cassirer, Ernst: Wesen und Wirkung des Symbolbegriffs, Darmstadt 1976.

Kat. Catalogo de Relojos del Patrimonio National, hrsg. v. J. Ramon Colon de Carvajal, Madrid 1987.

Catull: Gedichte, german by Rudolf Helm, Stuttgart 1992.

Caylus, Anne-Claude-Philippe Comte de : Recueil d' Antiquites Egyptiennes, Etrusques, Grecques et Romaines, Paris 1752-67.

Cellini, Benvenuto: Leben des Benvenuto Cellini, autobiography, translated by Johann Wolfgang Goethe, Berlin 1924.

Chabert, Philippe-Gerard : La Pendule au Negre, Exhibition Catalogue, Orleans 1978.

Champeaux, Alfred de : Dictionnaire de Fondeurs, Ciseleurs, Modeleurs en Bronze et Doreurs, Depuis le moyen-age jusqu' a l' epoque actuelle, A-C, Paris 1886 (D-Z als Manuskript in der Bibliotheque Musee des Arts decoratifs, Paris).

Chapeaurouge, Donat de : Theomorphe Portraits der Neuzeit, in : Deutsche Vierteljahresschrift fuer Literaturwissenschaft und Geistesgeschichte 42, 1968.

Chapiro, Adolphe : Jean-Antoine Lepine, horlogerie en France, de 1760 a l' Empire, Paris 1988;

Chapiro, Adolphe: Jean-Antoine Lepine, Paris 1988;

Chapiro, Adolphe: La montre francaise , Paris 1991.

Chateaubriand, Francois Rene de : Atala, Von der Liebe zweier Indianerkinder, german by Trude Geissler, Stuttgart 1962.

Clarke, T. H.: The Iconography of the Rhinoceros from Duerer to Stubbs, l.a. 1986.

Clifton-Mogg, Caroline : The neoclassical Source Book, London 1991.

Kat. Clodion, 1738 – 1814, Poulet, Anne L. und Scherf, Guilhelm, Musee du Louvre (cat. 1 1), Paris 1992.

Cochin, Charles-Nicolas : Voyage d' Italie, 3 Bde. Paris 1758, newly published, Geneva 1972.

Cochin, Charles-Nicolas u. H. – F. Gravelot : Iconologie par Figures ou Traite complet des Allegories, Emblemes, etc., A l' Usage des Artistes, en 350 Figures, Paris o. J. (1757), newly published Geneva 1972.

Consibe, Philip : Chardin, Oxford 1985.

Conti, Natale: Mythologiae (first edition 1551), reprint of the edition of 1616, New York and London , n.d. (The Philosophy of images, Bd. 1 3).

Cramer, Friedrich : Der Zeitbaum, Grundlegung einer allgemeinen Zeittheorie, Frankfurt am Main 1993.

Cuzin, Jean-Pierre : Fragonard, Leben und Werk, (Euvre-Katalog der Gemaelde), Muenchen 1988.

Defoe, Daniel: Robinson Crusoe, german by F. Riederer, Muenchen 1966.

Delafosse, Jean-Charles : Nouvelle Iconologie historique de J.-Ch. Delafosse, Paris o. J.

Dell, Theodore: The Gilt-bronze Cartel Clocks of Charles Cressent, in: The Burlington Magazine, April 1967.

Diderot, Denis : Salons 1759 – 1781, edit. by Jean Seznec and. Jean Adhemar, 4 Bks., Oxford 1957 – 67.

Diderot, Denis und D' Alembert, Jacques : Encyclopedie, ou Dictionnaire raisonne des Sciences, des Arts et des Metiers, par une Societe de gens de lettres, 35 Bde., Paris, Genf, Amsterdam 1751 – 1780.

Dixon, Pierson French Empire Clocks in the British Embassy at Paris, in : The Connoisseur, 159, 1965.

Duerr, Hans Pete: Der erotische Leib, Mythos vom Zivilisationsprozess Bk. 4, Frankfurt am Main 1997.

Dumonthier, Ernest : Les Bronzes du Mobilier National, Pendules et Cartels, Bronzes d' eclairage et de chauffage, Paris 1911.

Edey, Winthorp : French Clocks, New York 1967;

Edey, Winthorp.: The Frick Collection, French Clocks in North American Collections, New York 1982.

Kat. Egyptomania, L' Egypte dans l' art occidental, Exhibition Catalogue, Paris, Musee du Louvre January 20 – April 11, 1994, Paris 1994.

Eliade, Mircea : Schamanen, Goetter und Mysterien, Die Welt der alten Griechen, Freiburg im Breisgau 1992.

Emblemata, Handbuch zur Sinnbildkunst des XVI. und XVII. Jahrhunderts, edit. by Arthur Henkel und Albrecht Schoene , Stuttgart 1967.

Erichsen, Johannes: " antique" und "grec", Studien zur Funktion der Antike in Architektur und Kunst theorie des Fruehklassizismus, Dissertation. Koeln 1975.

Ericsen, Svend: Early Neo – Classicism in France, London 1974.

Kat. Europa und die Kaiser von China 1240 – 1816, Berliner Festspiele, Exhibition Martin-Gropius-Ban, Berlin 1985.

Kat. Europaeisches Rokoko, Kunst und Kultur des 18. Jahrhunderts, Muenchen 1958.

Falconet, Etienne : Reflexions sur la sculpture, in : (Euvres completes, Bd. III, S. 1 – 46), Paris 1808, reprint Geneva 1970.

Feulner, Adolf : Kunstgeschichte des Moebels (Propylaeen Kunstgeschichte, Sonderband II), Frankfurt am Main, Berlin, Wien 1980.

Filseck, K. Moser von: Kairos und Eros, Bonn 1990.

Flechon, Chantal und Dominique : La Pendule an Negre, in : Bulletin de l' Association Nationale des Collectionneurs et Amateurs d' Horlogerie Ancienne 63, Spring 1992, pp. 27 – 49.

Fleckner, Uwe : Napoleon I. als thronender Jupiter, in : Idea, Jahrbuch der Hamburger Kunsthalle VIII, 1989, pp. 121 – 134.

Kat. Fontainebleau: Pendules et bronzes d' ameublement entres sous le Premier Empire, von Jean-Pierre Samoyault, Musee national du Chateau de Fontainebleau, Catalogue des collections de mobilier, Paris 1989.

Forty, Jean-Francois: (Euvres de sculptures en bronze – Contenant Girandoles, Flambeaux, Feux, Pendules, Bras, Cartel, Barometres et Lustres, Inventees et dessinees par J. F. F., Gravees par Colinet et Foin a Paris chez Chereau…, Paris n.d.

Fransolet, Mariette: Francois du Quesnoy, Sculpteur d' Urbain VIII, 1597 –1643, Bruessel 1942 (= Memoires, Academie Royale de Belgique, Classe des Beaux –Arts, Collection IN-4, Deuxieme Serie, Tome IX).

Kat. Franzoesische Pendeluhren des 18. Jahrhunderts, Eine Stiftung fuer das Deutsche Uhrenmuseum Furtwangen, edited by Jacob Messerli, 16. Mai 1997 –17. Aug. 1997, Furtwangen 1997.

Fuchs, Eduard: Illustrierte Sittengeschichte vom Mittelalter bis zur Gegenwart, Die galante Zeit, Muenchen n.d. (1910).

Fuerstenberg, Hans: Das franzoesische Buch im 18. Jahrhundert und in der Empire – Zeit, Weimar 1929.

Gaborit, Jean-Andre : Jean-Baptiste Pigalle, 1714 – 1785, Sculptures du Musee du Louvre, Paris 1985.

Garnier, Nicole: Antoine Coypel (1661 – 1722), Paris 1989.

Gay, Marcel und Yves: Collections d' Horlogerie en Belgique, Mons et le Musee F. Duesberg, in : Bulletin de l' Association Nationale des Collectionneurs et Amateurs d' Horlogerie Ancienne 73, Summer 1995,
pp. 5 – 20.

Gendolla, Peter: Zeit, Zur Geschichte der Zeiterfahrung, Vom Mythos zur " Prunkzeit", Koeln 1992.

Gessner, Salomon : Idyllen, edited by E. Theodor Voss, Stuttgart 1988.

Kat. Salomon Gessner 1720 – 1788, Maler und Dichter der Idylle, Exhibition catalogue Herzog August Bibliothek Wolfenbuettel, Wolfenbuettel 1980.

Gluck, Christoph Willibald : Orpheus und Eurydike, edited by Wilhelm Zentner, Stuttgart 1949.

Gombrich, Ernst H.: The Dream of Reason, Symbolism of the French Revolution, in : The British Journal of 18th Century Studies, II, 1979.

Goncourt, Edmund u. Jules : L' Art du dix – huitieme siecle, German: Die Kunst des 18. Jahrhunderts, Muenchen 1921.

Gordon, S. K..: Madame de Pompadour, Pigalle and the Iconography of Friendship, in : Art Bulletin, L, 1968, 249ff.

Gowing, Lawrence : Die Gemaeldesammlung des Louvre, Koeln 1994.

Guerin, Jacques : La chinoiserie en Europe au XVIIIe siecle, Paris 1911.

Guiffrey, Jean : L' (Euvre de Pierre Paul Prud' hon) , Paris 1924.

Guiffrey, Jules : Les Caffieri, Paris 1877.

Gurlitt, Christian : Das Ornament des Rokoko, Esslingen 1894.

Haskell, Francis u. Penny, Nicolas : Taste and the Antique, The Lure of Classical Sculpture 1500 – 1900, New Haven und London 1981.

Hautecoeur, Louis : Rome et la Renaissance de l' Antiquite a la fin du XVIIIe siecle, Paris 1912.

Held, Jutta : Antoine Watteau, Einschiffung nach Kythera, Versoehnung von Leidenschaft und Vernunft, Frankfurt am Main 1985.

Hernmarck, Carl : Die Kunst der europaeischen Gold – und Silberschmiede, von 1450 bis 1830, Muenchen 1978.

Hess, Guenther : Allegorie und Historismus, Zum " Bildgedaechtnis " des spaeteren 19. Jahrhunderts, in : Festschr. F. Ohly, Verbum et Signum, hrsg. v. H. Fromm u. a., Muenchen 1975, S. 555 – 591.

Heuer, Peter u. Maurice, Klaus : Europaeische Pendeluhren, Dekorative Instrumente der Zeitmessung, Muenchen 1988.

Hildebrandt, Edmund : Leben, Werke und Schriften des Bildhauers E. – M. Falconet, 1716 – 1791, in : Zur Kunstgeschichte des Auslandes, Heft 63, Strassburg 1908;

Hildebrandt, Edmund.: Malerei und Plastik des achtzehnten Jahrhunderts in Frankreich, Wildpark – Potsdam 1924, (= Handbuch der Kunstwissenschaft, edited by A. E. Brinckmann, Bd. 17)

Hinz, Siegrid: Innenraum und Moebel, Von der Antike bis zur Gegenwart, Berlin 1989.

Hodgkinson, Terence: The James A. de Rothschild Collection at Waddesdon Manor: Sculpture, London, 1970.

Hoelscher, Tonio: Victoria Romana, Archaeologische Untersuchungen zur Geschichte and Wesensart der roemischen Siegesgoettin von den Anfaengen bis zum Ende des 3. Jahrhunderts n. Chr., Main 1967.

Hofmann, Werner: Das Entzweite Jahrhundert, Kunst zwischen 1750 und 1830, Munich 1995.

Hofstaetter, Hans H.: Geschichte der Kunst und der kuenstlerischen Techniken, Bk. 5, Metallplastik, Tonplastik, Wachsbildnis, Munich 1967.

Von Holst, Christian: Johann Heinrich Dannecker, Der Bildhauer, Bk. 2, Stuttgart-Bad Cannnstatt 1987.

Homer: Ilias und Odysee, German by Johann Heinrich Voss, Munich 1971.

Honour Hugh: Chinoiserie – The Vision of Cathay, London, 1961.

Honour Hugh: Neo-Classicism, London 1968.

Hubert, Gerard: Sculptures and Bronzes of the first Empire, in Apollo 5, 1976, pp. 464 –71.

Hughes, Peter: Clocks and Barometers in the Wallace Collection, French Eighteenth – Century, London 1994.

Hunger, Herbert: Lexikon der griechischen and roemischen Mythologie, 8th edition, Vienna 1988.

Hunter-Stiebel, Penelope: Elements of Style, The Art of Bronze Mount in 18th and 19th Century France, New York 1984.

Hussey, Christopher: The Pitturesques, sudies in a Point of View, 2nd. Edition, London 1967.

Jagger, Cedric: Wunderwerk Uhr, german edition Zollikon/Schweiz 1977.

Jagger, Cedric: Royal Clocks – The British Monarchy and its Timekeepers 1300 – 1900, London 1983.

Jenzen, Igor: Uhrzeiten, Die Geschichte der Uhr und ihres Gebrauches, Marburg 1989.

Jessen, Peter: Der Ornamentstich, Geschichte der Vorlagen des Kunsthandwerks seit dem Mittelalter, Berlin 1920.

Kaemmerling, Ekkehard (published by) : Bildende Kunst als Zeichensystem, Bk. 1, Ikonographie und Ikonologie, Koeln 1979.

Kjellberg, Pierre: Le Mobilier Francais du XVIIIe Siecle, Paris 1989.

Klibansky, Raymond, Panofsky, Erwin und Saxl, Fritz: Saturn und Melancholie, Studien zur Geschichte der Naturphilosophie und Medizin, der Religion und der Kunst, Frankfurt am Main 1992.

Kluge, Kurt u. Lehmann-Hartleben, Karl : Die antiken Grossbronzen, 2 Bk., Berlin/Leipzig 1927.

Knabe, Peter-Eckard : Schluesselbegriffe des kunsthistorischen Denkens in Frankreich von der Spaetantike bis zum Ende der Aufklaerung, Duesseldorf 1972.

Koch, Georg Friedrich: Die Kunstausstellung, Ihre Geschichte von den Anfaengen bis zum Ausgang des 18. Jahrhunderts, Berlin 1967.

Krauss, Heinrich u. Uthemann, Eva: Was Bilder empfehlen, Die klassischen Geschichten aus Antike und Christentum in der abendlaendischen Malerei, Muenchen 1987.

Kuendzl, Ernst: Der roemische Triumph, Siegesfeier, im antiken Rom, Muenchen 1988.

Kurz, Otto: European Clocks and Watches in the Near East, Studies of the Warburg Institute, vol 34, London, Leiden 1975.

Lami, Stanislas: Dictionnaire des sculptures de l' Ecole francaise au XVIIIe siecle, 2 Bk, Paris 1910.

Lampe, Peter: Pocahontas, Die Indianer – Prinzessin am Englischen Hof, Muenchen 1995.

Langdon, Helen: Claude Lorrain, Oxford 1989.

Lasseur, Denyse le: Les deesses armees dans l' art classique grecque et leurs origines orientales, Paris 1919.

Ledoux – Lebard, Denis: Les Ebenistes du XIXe siecle, 1795 – 1889, leurs oeuvres et leurs marques, Paris 1984;

Ledoux – Lebard, Denis: " Rabiat, Fournisseur des grands bronziers et marchands de l' epoque imperiale"
in : L' Estampille – L' Objet d' Art 246, 1991.

Levey, Michael : Painting and Sculpture in France, 1700 – 1789, New Haven und London 1992.

Levitine, Georges : The Sculpture of Falconet, New York 1972.

Licht, Fred : Antonia Canova, Beginn der modernen Skulptur, 1983.

List, Claudia: Kleinbronzen Europas : vom Mittelalter bis zur Gegenwart, Muenchen 1983 (= Keysers Handbuecher fuer Kunst – und Antiquitaetensammler).

Locquin: La Peinture D' Histoire en France de 1747 a 1785, n. d. 1978, KG Inst. F 1720. 1.

Longos: Daphnis und Chloe, german from Otto Schoenberger , Stuttgart 1988.

n. p. Der Louvre, Die europaeische Plastik, von Jean-Rene Gaborit, Muenchen 1995.

n. p. Malmaison : La Mesure du Temps, dans la collections du musee de Malmaison, von Bernard Chevallier, 29. Mai 1991 – 15. Sept. 1991, Paris 1991.

Mann, James: Wallace Collection Catalogues : Sculpture, London 1931.

Maurice, Klaus: Die franzoesische Pendule des 18. Jahrhunderts, Ein Beitrag zu ihrer Ikonographie, Berlin 1967;

Maurice, Klaus : Schoene Uhren des 17. – 19. Jahrhunderts, Die Pendulen der Sammlung S.; nebst einem Essay ueber die Frage , warum man Uhren sammelt, wenn man damit weder mehr noch bessere Zeit gewinnt, Muenchen 1990.

Menestrier, Claude-Francois : Traite des tournois (Ersterscheinung 1669), New York und London n.d. (The Philosophy of images, Bk. 16.).

Mercier, Sebastian: Tableau de Paris, 12 Bk., Amsterdam 1783/1788.

Merot, Alain; Nicolas Poussin, New York 1990.

n. p. Die Moebel der Residenz Muenchen, attided Brigitte Langer, published by Gerhard Hojer und Hans Ottomeyer (Kataloge der Kunstsammlungen/ Bayerische Verwaltung der staatlichen Schloesser, Gaerten und Seen, Bk. 1), Muenchen, New York 1995.

Moeseneder, Karl: Zeremoniell und monumentale Poesie, Die " Entrée solenelle " Ludwigs XIV. 1660 in Paris, Berlin 1983.

188

Montague, Jennifer : Bronzen, Frankfurt am Main 1963.

Moritz, Karl Philipp: Goetterlehre oder Mythologische Dichtungen der Alten, Frankfurt am Main 1979.

Muehe, Richard: Uhren und Zeitmessung , published by the Historischen Uhrensammlung Furtwangen, Furtwangen 1974.

Muehe, Richard und Vogel Horand M.: Alte Uhren, Ein Handbuch europaeischer Tischuhren, Wanduhren und Bodenstanduhren, Muenchen, 5. Addition, 1991.

n. p. Le Musee Nissim de Camondo, Nadine Gasc und Gerard Mabille, l. a. 1991 (Musees et Monuments de France).

Niclausse, Juliette : Thomire, Fondeur – Ciseleur (1751 – 1843), Sa Vie – Son (Envre), Paris 1947.

n. p. " De Noir et d` Or", Pendules " au bon sauvage ", Collection M. et Mme. Francois Duesberg, Musee Royaux d` Art et d` Histoire, Musee Bellevue, Bruessel, Bruessel 1993.

Nowotny, Helga : Eigenzeit, Entstehung und Strukturierung eines Zeitgefuehls, Frankfurt am Main 1989.

Oechslin, Werner : Pyramide et sphere, Notes sur l' architecture revolutionnaire du XVIIIe siecle et ses sources italiennes, in : Gazette des Beaux-Arts LXXVII, 1971, S. 201 – 238.

n. p. Orologi negli arredi del Palazzo Reale di Torino et delle residence sabaude, Ausstellungskatalog , Turin 1988.

Ottomeyer, Hans : Bronzekunst 1720 – 1880, Eine Ausstellung feuervergoldeter Bronzearbeiten in der Alten Schatzkammer der Residenz Muenchen, 5. Nov. 1977 – 8. Jan. 1978, in : Weltkunst 1977, p. 2 155 – 9;

Ottomeyer, Hans: Die klassizistischen Uhren der Muenchner Residenz und Schloss Nymphenburg, in : Alte Uhren 4, 1978, p. 161 – 180.

Ottomeyer, Hans und Proeschel, Peter: Vergoldete Bronzen, Die Bronzearbeiten des Spaetbarock und Klassizismus, 2 Bk., Muenchen 1986.

Ovid (p. Ovidius Naso) : Ars amatoria, Liebeskunst, trans. und published by Michael von Albrecht , Stuttgart 1992; Metamorphosen, published by and germain from Hermann Breitenbach, Stuttgart 1980.

Pallot, Bill G. B.: L' Art du Siege au XVIIIe Siecle en France, Paris 1987.

Panofsky, Erwin: Sinn und Deutung in der bildenden Kunst, Koel 1978 (Erstveroeffentlichung 1957);

Panofsky, Erwin: Studien zur Ikonologie, Humanistische Themen in der Kunst der Renaissance, Koeln 1980 (Erstveroeffentlichung 1939).

Passe, Crispijn van de : Metamorphoseon Ovidianarum (Ersterscheinumg 1602), New York und London n. d. (The Philosophy of images, Bk. 8).

Pauly's Encyklopaedie der classischen Altertumswissenschaft, published by G. Wissowa, Stuttgart 1894pp.

n.p. La Pendule a Sujet, du Directoire a Louis Philippe, Ausst. Musee Sandelin, Saint-Omer 26. Juni – 12. September 1993.

n. p. St. Petersburg um 1800, Ein goldenes Zeitalter des russischen Zarenreiches, Meisterwerk und authentische Zeugnisse der Zeit aus der Staatlichen Ermitage, Leningrad, Ausstellung Kulturstiftung Ruhr, Villa Huegel, Essen 1990, Recklinghausen 1990.

Picard, Gilbert Charles: Les Trophees romains, Contibution a l' histoire de la religion et de l' art triomphe de Rome, Paris 1957.

Platon: Politeia, Symposion, in : Saemtliche Werke, germain from Friedrich Schleiermacher , published by Ernesto Grassi, Bk. II u. III, Hamburg 1958.

Poeschel, Sabine: Studien zur Ikonographie der Erdteile in der Kunst des 16. – 18. Jahrhunderts, Muenchen 1985, Diss. Muenchen 1984 (= Beitraege zur Kunstwissenschaft, 3).

n. p. Portraet 1, Der Herrscher, Graphische Bildnisse des 16. – 19. Jahrhunderts aus dem Portraetarchiv Diepenbroick, Muenster 1977.

Pradere, Alexandre : Die Kunst des franzoesischen Moebels, Ebenisten von Ludwig XIV. bis zur Revolution , Muenchen 1990.

n. p. Prag um 1600, Kunst und Kultur am Hofe Rudolfs II., 2 Bk., Freren 1988.

Proszynska : Zegary Stanislawa Augusta, Warschau 1994.

Raetsch, Silvia H.: Der Augenblick als Kategorie (Literaturhistorische Studien, published by D.-R. Moser u. H. Zeman, Bk. VIII), Wien 1994.

Reallexikon zur Deutschen Kunstgeschichte, Hrsg. v. Otto Schmitt, Stuttgart 1937.

n. p. Das Reich der Jahreszeiten, Eine Ausstellung der Praesidialabteilung der Stadt Zuerich, Strauhof Zuerich 21. Maerz bis 15. Mai 1989, Zuerich 1989.

n. p. Guido Reni und Europa , Ruhm und Nachruhm , Katalog hrsg. v. Sybille Ebert – Schifferer u. a., Schirn Kunsthalle Frankfurt, Frankfurt 1988.

Ripa, Cesare : Iconologia (Ersterscheinung 1593), in der Fassung von George Richardson (Ersterscheinung 1779), New York und London 1979 (The Philosophy of images, Bk. 20).

Ripa, Cesare : Des beruehmten italienischen Ritters Caesaris Ripae allerly Kuensten und Wissenschaften dienliche Sinnbilder und Gedanken, verlegt bei Johann Georg Hertel in Augsburg, Nachdruck published by Ilse Wirth, Muenchen 1970.

Roettgen, Herwarth: Caravaggio – Der irdische Amor oder der Sieg der fleischlichen Liebe, Frankfurt am Main 1992.

Rosenblum, Robert: The International Style of 1800, A Study in Linear Abstraction, Diss. New York 1956, New York 1976.

Rosenberg, Pierre: L' opera complets di Chardin, Mailand 1983.

Rousseau, Jean-Jacques: Abhandlung ueber den Ursprung und die Grundlagen der Ungleichheit unter den Menschen; Abhandlung ueber die von der Akademie zu Dijon gestellte Frage, ob die Wiederherstellung der Wissenschaften und Kuenste zur Laeuterung der Sitten beigetragen habe, in : Sozialphilosophische und politische Schriften , in Erstuebertragung von Eckhart Koch u.a. sowie attided u. erg. Uebers. aus dem 18. u. 19. Jahrhundert, Muenchen 1981.

Roworth, Windy Wassyng (published by): Angelica Kauffmann, A. Continental Artist in Georgian England, Brighton 1992.

Saint Girons, Baldine: Estetiques du XVIIIe siecle, Le Modele Francais, Paris 1990.

Sanfilippo, Mario: Die Brunnen von Rom, Muenchen 1996.

Schneider, Norbert: Stilleben, Realitaet und Symbolik der Dinge, Koeln 1989.

Schramm, Percy Ernst: Sphaira, Globus, Reichsapfel, Wanderung und Wandlung eines Herrschaftszeichens von Caesar bis zu Elisabeth II., Ein Beitrag zum " Nachleben" der Antike, Stuttgart 1958.

n. p. Schwaebischer Klassizismus zwischen Idealund Wirklichkeit, 1770 – 1830, published by Christian von Holst, Staatsgalerie Stuttgart 1993, Stuttgart 1993.

Seelig, Lorenz: Eine Pendule Charles Cressents, in: Kunst und Antiquitaeten, V, 1985.

Seznec, Jean : The Survival of the Pagan Gods, New York 1961.

Shearman, John: Manierismus, Das Kuenstliche in der Kunst, Frankfurt am Main 1988.

Siefert, Helge: Themes aus Homers Ilias in der franzoesischen Kunst, (1750 – 1831), Munich 1988 (Beitraege der Kunstwissenschaft., Bk 24)

Cat. Skulptur aus dem Louvre, 89 Werke des franzoesischen Klassizismus 1770 – 1830, Wilhelm Lembruck Museum Duisburg, Duisburg 1989.

Souchal, Francois: French Sulptors of the 17th and 18th century, The reign of Louis XVI, 3 Books, Oxford 1977.

Souchal, Francois: Les Freres Coustou, Paris 1980.

Souchal, Francois: Les Slodtz, sulpteurs et decorateurs du Roi (1685 – 1764), Paris 1967.

Starobinski, Jean: 1789, Les Emblemes de la Raison, Paris 1979.

Stein, Henri: Augustin Pajou, Paris 1920.

Stendhal (Henri Beyle): Wanderungen in Rom, edit. by Bernhard Frank, Berlin n.d.

Stuermer, Michael: Hoefische Kultur und fruehmoderne Unternehmner, zur Oekonomie des Luxus im 18. Jahrhundert, in: Hisstorische Zeitschrift 2 2 9 , 1979, pp. 799 – 805.

Stuermer, Michael: Herbst des alten Handwerks, Zur Sozialgeschichte des 18. Jahrhunderts, Muenchen 1979.

Stuermer, Michael: Handwerk und hoefische Kultur, Europaeische Moebelkunst im 18. Jahrhundert, Munich 1982.

Tardy (Pseudonym for H. Lengelle): Bibliographie general de la mesure du temps, Paris 1980.

Tardy: Dictionnaire des Horlogers Francais, Paris 1971 – 1972.

Tardy: La Pendule Francaise des Origines a nos Jours, 3 Bks., Paris, n.d. (1974)

Theokrit: Die echten Gedichte, german by Emil Staiger, Zurich and Stuttgart 1970.

Thornton, Peter: Authentic Décor, The Domestic Interior 1620 – 1920, Avenel, New Jersey 1985.

Uresova, Libuse: Alte Uhren, Prag, 1986.

Cat. Luigi Valadier au Louvre, ou l' Antiquite exaltee, Les dossiers du musee du Louvre, 46. Exposition-dossier du departement des Objets d'arts, Paris 1994.

Veen, Otto van: Amorum Emblemate, edt. By Tschizewskij, Dmitrij and Benz, Ernst (+ Emblematisches Cabiner, Bk. II) Hildesheim, New York, 1970.

Verdier, Pierre: Eightennth-Century French Clocks of Love and Friendship, in: The Connoisseur 5, 1960.

Cat. Die Verfuehrung der Europa, Ausstellung im Kunstgewerbemuseum Berlin. Staatliche Museen Preussischer Kulturbesitz, August 2 to October 30, 1988, Frankfurt am Main 1988.

Vergil: Bucolica, Hirtengedichte, transl. by Rudolf Alexander Schroeder, Frankfurt am Main, 1990.

Vergil: Georgica, Vom Landbau, Translated by Otto Schoenberger, Stuttgart 1994.

Verlet, Pierre: Les Bronzes Dores Francais du XVIIIe siecle, Paris 1987.

Verlet Pierre: La Maison du XVIIIe Siecel en France, Freiburg 1966.

Vollmer, Wilhelm: Woerterbuch der Mythologie aller Voelker, Leipzig n.d. (reprint of Original edition of 1974).

Voltaire, Francois Marie Arouet de: Le Temple du Gout, 1733, reprint edited by E. Carcasonne, Paris 1938.

Walraven, Hartmut: China illustrata. Das europaeische Chinaverstaendnis im Spiegel des 16. Bis 18. Jahrhunderts (Ausstellungskatalog der Herzog August Bibliothek, No. 55), Weinheim 1987.

Wannenes, Giacomo: Le piu belle pendole francesi, Mailand 1991.

Watson, Sir Francis J.B.: Wallace Collection Catalogues: Furniture, London 1956..

Watson: The Wrightman Collection, Furniture, Gilt Bronzes, Carpets, 2 Bks., New York 1966.

Weihrauh, Hans R.: europaeische Bronzestatuetten, 15. – 18. Jahrhundert, Braunschweig 1967.

Weinreich, Renate: Leselust und Augenweide: Illustrierte Buecher des 18. Jahrhunderts in Frankreich und Deutschland, Berlin 1978.

Weisbach, Werner: Trionfi, Berlin 1919.

Wendorff, Rudolf: Tag und Woche, Monat und Jahr, Eine Kulturgeschichte des Kalenders, Opladen 1993.

Wilson, Gillian: French Eighteennth-Century Clocks in the J.Paul Getty Museum, Malibu 1996.

Winckelmann, Johann Joachim: Gedanken ueber die Nahahmung der griechischne Werke in der Malerei und Bildhauerkunst; Beschreibung der Torso im Belvedere in Rom, in: Winkelmanns Werke, Bibliothek Deutscher Klassiker, Berlin und Weimar 1976.

Wind Edgar: Heidnische Mysterien in der Renaissance, 1st. edition 1958, Frankkfurt am Main 1987.

Whitehead, John: The French Interior in the eighteenth century, l.a. 1992.

Whitrow, Gerald J.: Die Erfindung der Zeit, Hamburg 1991.

Wildenstein, Georges: Chardin, Zurich 1963,

Woelke, Karl: Beitraege zur Geschichte des Tropaions, in: Bonner Jahrbuecher 120, 1911, pp. 126 – 235.

Zick, Gisela: "Wie schwer verfolgt die Liebe dieses Haus". Eine Kaminuhr als Beispiel fuer die Verflechtung von Malerei, Literatur und Zeitgeschichte, in: Kunst & Antiquitaeten, 3, 1982. Pp. 48 – 61 and 4, 1982, pp. 48 – 53.

Zimmermann, Reinhard: Kuenstliche Ruinen, Studien zu ihrer Bedeuting und Form, Dissertation Marburg 1984.

Index of Names

Picture Credits

Clemens von Halem

Directory of Documented Bronze Pendulum Clocks from the Louis XV to the Empire Period

Contents

Introduction

This catalogue of illustrations contains 1365 illustrations of French bronze table clocks from the Louis XV to the Empire period, which are documented in literature. The caption to every illustration lists one or several references to literature (#1 to 72, found on pages 266 and 267). The purpose of this catalogue is to assist the collector, dealer or auctioneer in researching a particular pendulum clock. The author does not consider the catalogue as being complete, - it is ment to be a listing, which can be used similar to the address search in a telephone book, which leads to a particular illustration in literature. Details of the research, such as age, artist or bronze sculptor, are not answered here but can be found in the reference book, where the pendulum clock is discussed and where answers to these questions can be found.

In order to facilitate the use of this list, complicated orders are avoided, because too many clocks would be found in numerous categories. In the current order the viewer should not be discouraged if a pendulum clock is not found in a particular chapter. For example a pendulum clock with a porcelain elephant figure could be found either in Chapter II.C.A*nimals* or in Chapter I.B. *Porcelain Clocks* depending on the overall appearance of the clock (See example above right) of the most cherished characteristics of French pendulum clocks is the endless variation of decorations, relieves and bases, which accompany the core image. In order to limit this catalogue to a manageable size, clocks which only vary in decorations and bases, but which represented the same image, where listed under one representative illustration.

Example:

Chapter II. C. *Animals* Chapter I.B. *Porcelain Clocks*

 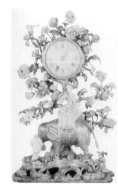

867 Reference 4, 383; 120 Reference 3, 119
Reference 24, 29
Reference 61, 292

Every entry in the catalogue is composed of an illustration and one or several references in the following manner:

The first number is the numerical order of the illustrations, then Reference number which corresponds with the numbering in the literature index,

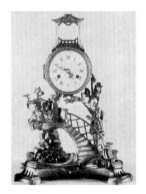

1 Reference 61, I, 282

if appropriated with Book and page number. If the number refers to a catalogue number or a plate this is noted separately.

Abbreviations

Bk.	– Book
f., ff.	– following pages
publ.	– published by
Cat. No.	– Catalogue number
n.d.	– no date
l.a.	– location anonymous
o. S.	- no page
anonym.	– anonymous
Pl	- Plate

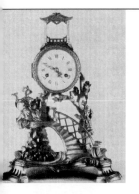

1 Ref. 61, I, 282

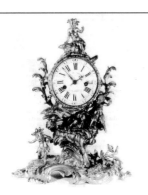

2 Ref. 65, 108

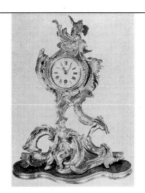

3 Ref. 61, I, 282

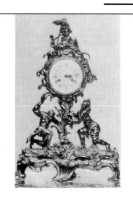

4 Ref. 61, I, 282

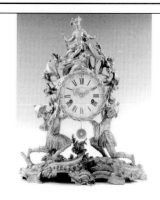

5 Ref. 3, 111; Ref. 38, 106; Ref. 40, 22; Ref. 58, I, 119; Ref. 61, I, 191; Ref. 65, 192

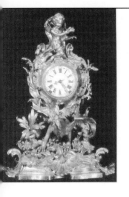

6 Ref. 58, I, 108

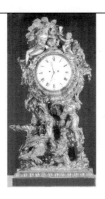

7 Ref. 27, 161

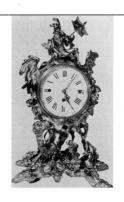

8 Ref. 3, 110; Ref. 4, 56; Ref. 17, Pl. 11; Ref. 58, I, 119; Ref. 61, I, 290; Ref. 66, 69

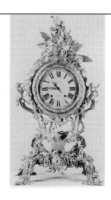

9 Ref. 58, I, 108

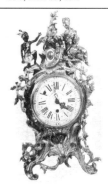

10 Ref. 61, I, 277

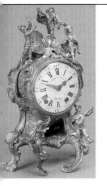

11 Ref. 25, 41; Ref. 38, 101; Ref. 66, 72

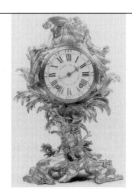

12 Ref. 48, 87

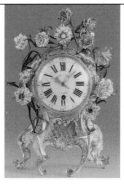

13 Ref. 4, 180

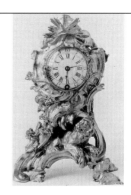

14 Ref. 58, I, 108

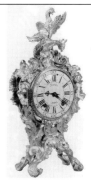

15 Ref. 66, 63 + 64 + 72; Ref. 71, 79

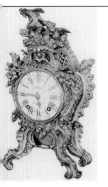

16 Ref. 17, Pl. 9

17 Ref. 61, I, 280

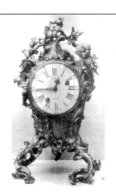

18 Ref. 61, I, 281

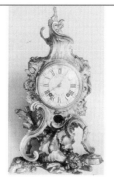

19 Ref. 58, I, 108

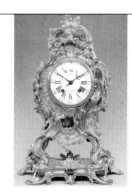

20 Ref. 3, 110

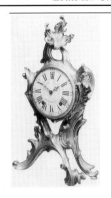
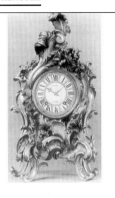
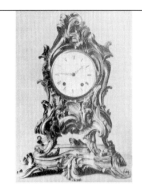
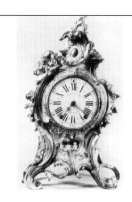
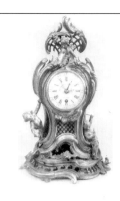

21 Ref. 66, 73

22 Ref. 58, II, 528

23 Ref. 61, I, 188+278

24 Ref. 61, I, 188 + 278

25 Ref. 24, 27

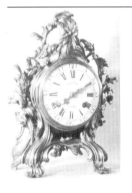
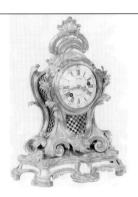
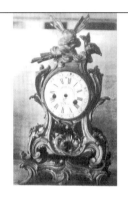
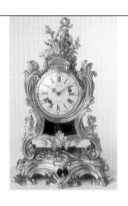
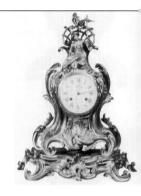

26 Ref. 61, I, 281

27 Ref. 58, I, 131; Ref. 66, 74

28 Ref. 61, I, 281

29 Ref. 40, 110

30 Ref. 3, 8, 104;
Ref. 66, 71

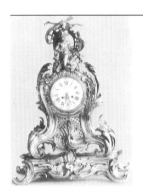
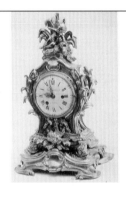
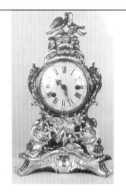
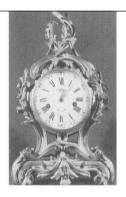
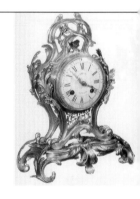

31 Ref. 58, I, 130

32 Ref. 58, I, 128;

33 Ref. 58, I, 127

34 Ref. 65, 255

35 Ref. 66, 72

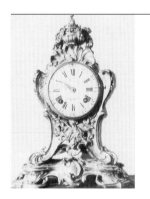
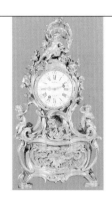
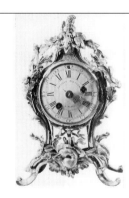
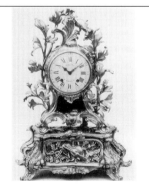

36 Ref. 24, 27; Ref. 58,
I, 128: Ref. 65, 112

37 Ref. 58, I, 126;
Ref. 61, I, 189 + 276

38 Ref. 38, 100

39 Ref. 58, I, 126;
Ref. 65, 112

40 Ref. 23, Pl. 2

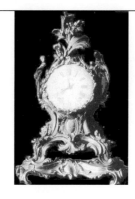
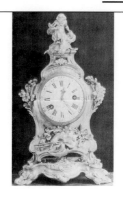
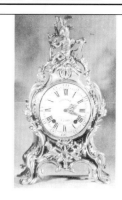

41 Ref. 3, 109

42 Ref. 24, 25

43 Ref. 58, I, 127

44 Ref. 44, 110

45 Ref. 40, 21; Ref. 61, I, 280; Ref. 58, I, 129

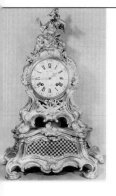
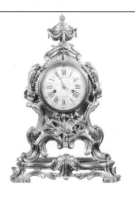
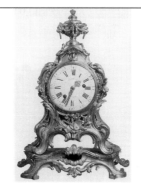

46 Ref. 21, 167
Ref. 58, I, 129

47 Ref. 58, II, 542

48 Ref. 54, 8; Ref. 66, 81

49 Ref. 3, 110

50 Ref. 3, 109; Ref. 58, I, 126; Ref. 61, I, 275 + 278; Ref. 66, 73

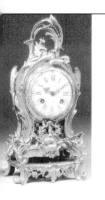
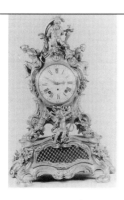
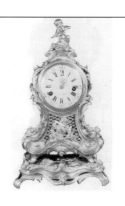
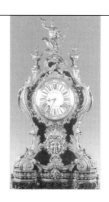
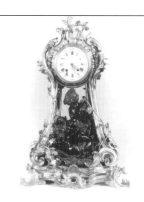

51 Ref. 3, 108

52 Ref. 58, I, 128

53 Ref. 66, 71

54 Ref. 4, 298

55 Ref. 4, 337

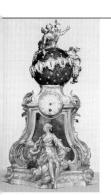

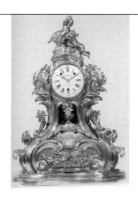

56 Ref. 7, 79;
Ref. 58, I, 132;
Ref. 61, I, 279

57 Ref. 7, I, 109

58 Ref. 8, 213; Ref. 25, 50 f.;
Ref. 58, I, 131; Ref. 61, I, 278

59 Ref. 4, 399; Ref. 25, 48f.;
Ref. 65, 33

60 Ref. 46, 21

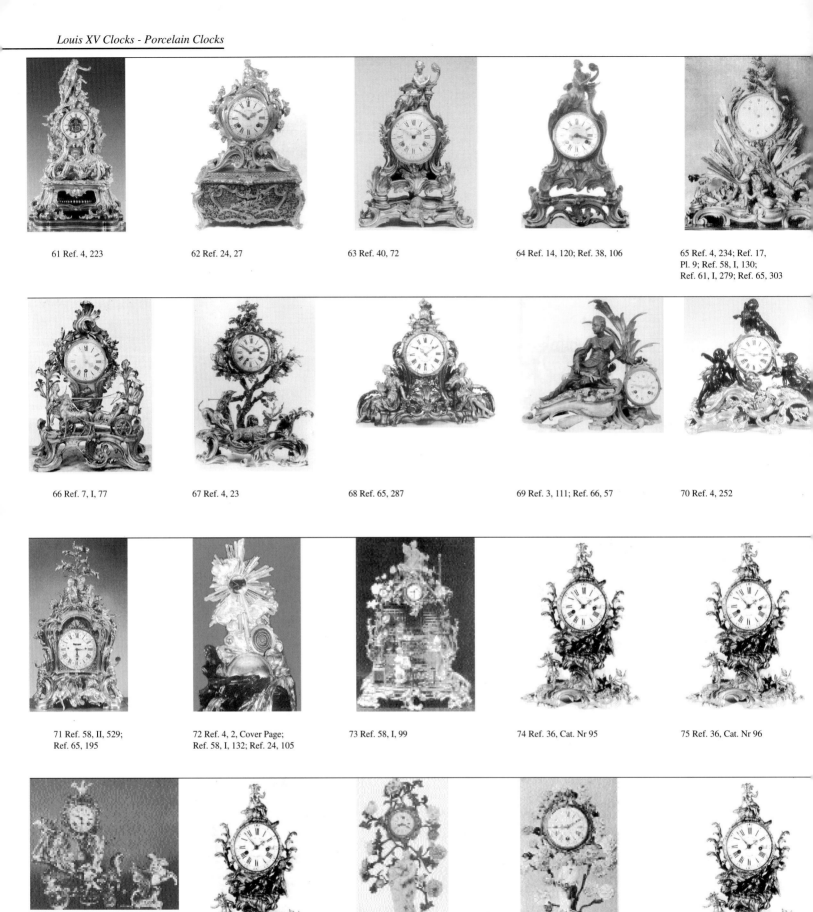

61 Ref. 4, 223

62 Ref. 24, 27

63 Ref. 40, 72

64 Ref. 14, 120; Ref. 38, 106

65 Ref. 4, 234; Ref. 17, Pl. 9; Ref. 58, I, 130; Ref. 61, I, 279; Ref. 65, 303

66 Ref. 7, I, 77

67 Ref. 4, 23

68 Ref. 65, 287

69 Ref. 3, 111; Ref. 66, 57

70 Ref. 4, 252

71 Ref. 58, II, 529; Ref. 65, 195

72 Ref. 4, 2, Cover Page; Ref. 58, I, 132; Ref. 24, 105

73 Ref. 58, I, 99

74 Ref. 36, Cat. Nr 95

75 Ref. 36, Cat. Nr 96

76 Ref. 65, 70

77 Ref. 14, 11

78 Ref. 14, 29

79 Ref. 61, I, 291

80 Ref. 7, I, 99

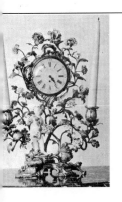
81 Ref. 61, I, 291

82 Ref. 61, I, 296

83 Ref. 61, I, 292

84 Ref. 66, 56

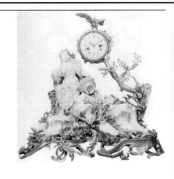
85 Ref. 3, 117;
Ref. 66, 66

86 Ref. 61, I, 294

87 Ref. 3, 116

88 Ref. 66, 58

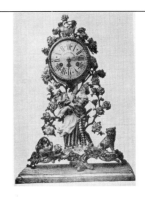
89 Ref. 61, I, 293

90 Ref. 38, 105

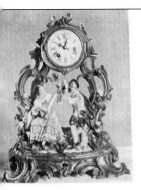
91 Ref. 61, I, 293

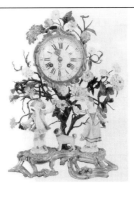
92 Ref. 66, 65

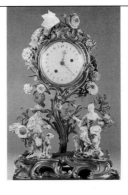
93 Ref. 9, 76; Ref. 63, 111

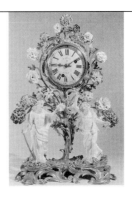
94 Ref. 61, I, 196

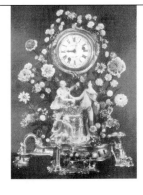
95 Ref. 8, 216

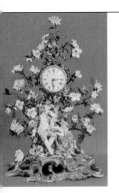
96 Ref. 61, I, 195

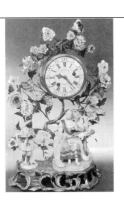
97 Ref. 11, 115
Ref. 33, II, 75;
Ref. 61, I, 295

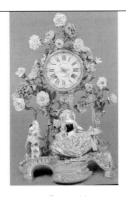
98 Ref. 49, 81;
Ref. 61, I, 194

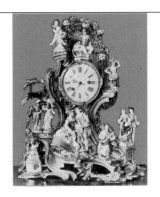
99 Ref. 26, 36 f.;
Ref. 65, 118

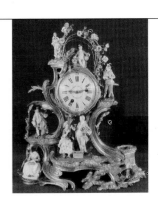
100 Ref. 12, 55

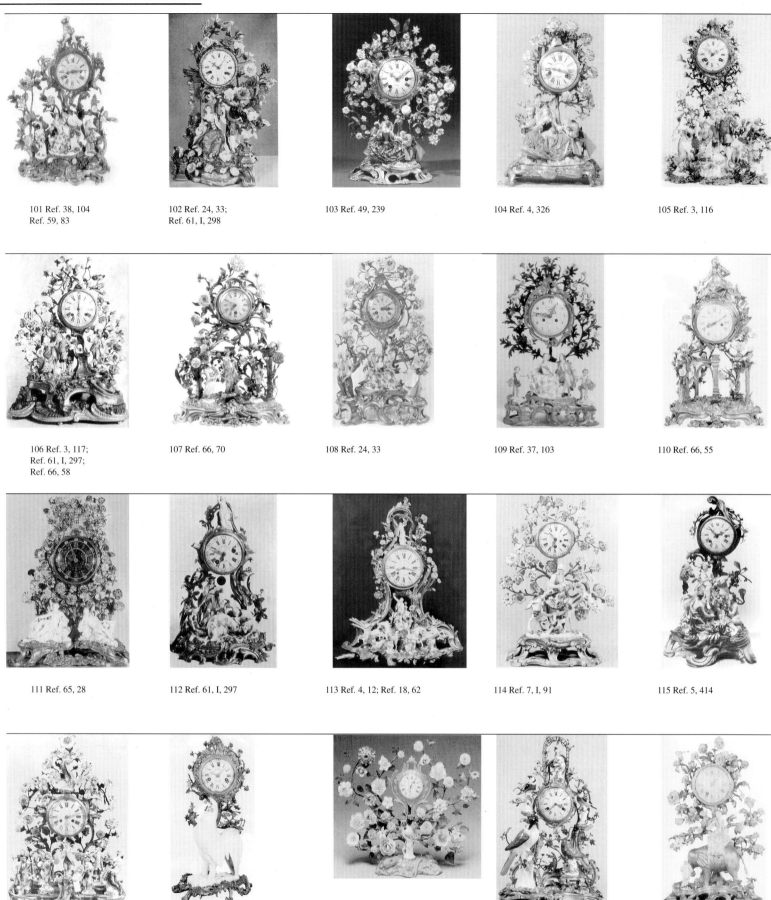

101 Ref. 38, 104
Ref. 59, 83

102 Ref. 24, 33;
Ref. 61, I, 298

103 Ref. 49, 239

104 Ref. 4, 326

105 Ref. 3, 116

106 Ref. 3, 117;
Ref. 61, I, 297;
Ref. 66, 58

107 Ref. 66, 70

108 Ref. 24, 33

109 Ref. 37, 103

110 Ref. 66, 55

111 Ref. 65, 28

112 Ref. 61, I, 297

113 Ref. 4, 12; Ref. 18, 62

114 Ref. 7, I, 91

115 Ref. 5, 414

116 Ref. 7, I, 95

117 Ref. 66, 59

118 Ref. 3, 120

119 Ref. 7, I, 93

120 Ref. 3, 119

121 Ref. 4, 325 122 Ref. 38, 102 123 Ref. 24, 11; Ref. 66, 120 124 Ref. 4, 409 125 Ref. 38, 105

126 Ref. 24, 31 127 Ref. 4, 361; Ref. 24, 31 128 Ref. 27, 135 f. 129 Ref. 66, 55 130 Ref. 66, 68

131 Ref. 61, I, 293 132 Ref. 66, 56 133 Ref. 3, 115 134 Ref. 3, 116 135 Ref. 24, 32

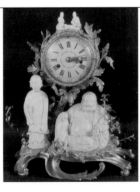
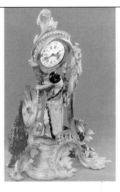
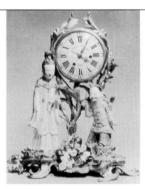
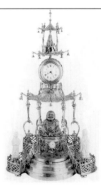

136 Ref. 12, 25 137 Ref. 12, 26 138 Ref. 33, II, Panel VI 139 Ref. 61, I, 296 140 Ref. 66, 103

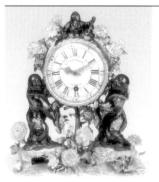

141 Ref. 4, 180

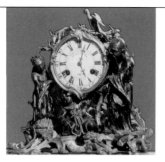

142 Ref. 24, 31;
Ref. 65, 21

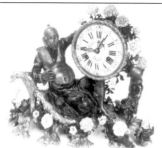

143 Ref. 24, 30

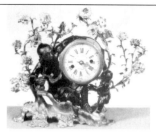

144 Ref. 18, 57;
Ref. 19, 42

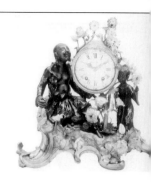

145 Ref. 66, 59

146 Ref. 65, 321

147 Ref. 27, 138

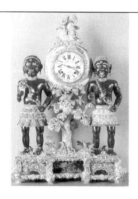

148 Ref. 4, 178;
Ref. 24, 31; Ref. 28, 98;
Ref. 58, I, 84

149 Ref. 14, 101

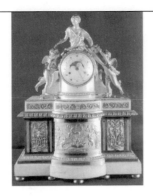
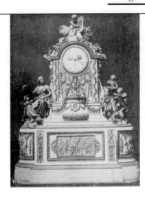

151 Ref. 4, 257;
Ref. 13, 168

152 Ref. 12, 70;
Ref. 61, II, 112

153 Ref. 12, 81

154 Ref. 12, 71;
Ref. 61, II, 112

155 Ref. 61, II, 21

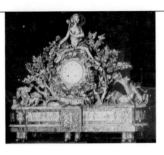

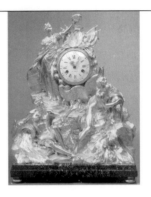

156 Ref. 13, 229;
Ref. 27, 164; Ref. 65, 111

157 Ref. 61, II, 74;
Ref. 65, 59

158 Ref. 56, 184

159 Ref. 14, 139; Ref. 25, 68 f.; Ref. 26,
39; Ref. 28, 139; Ref. 40, 2; Ref. 58, I,
235; Ref. 61, II, 24; Ref. 65, 173

160 Ref. 4, 146; Ref. 17, Pl.
31; Ref. 24, 60; Ref. 40,
vgl. S. 60; Ref. 58, I, 355;
Ref. 61, II, 275

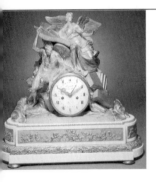

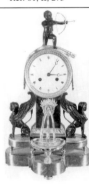

161 Ref. 4, 39; Ref. 40, 49

162 Ref. 4, 261; Ref. 13, 230;
Ref. 27, 162 f.; Ref. 65, 119

163 Ref. 12, 77; Ref. 66, 104;
Ref. 71, 82

164 Ref. 17, Pl. 15

165 Ref. 66, 155

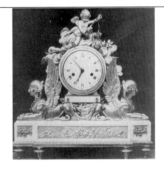
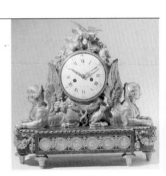

166 Ref. 56, 185

167 Ref. 17, Pl. 15; Ref. 61, II, 20

168 Ref. 27, 155

169 Ref. 61, II, 18

170 Ref. 14, 148; Ref. 18,
84; Ref. 24, 12; Ref. 25,
86f.; Ref. 58, I, 280; Ref.
61, II, 58; Ref. 65, 305

171 Ref. 17, Pl. 19

172 Ref. 4, 390

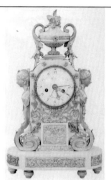

173 Ref. 66, 103

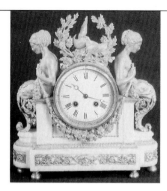

174 Ref. 27, 188

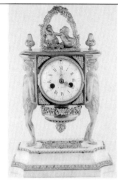

175 Ref. 68, o. S.

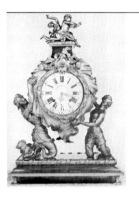

176 Ref. 7, I, 73

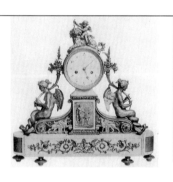

177 Ref. 17, Pl. 24

178 Ref. 12, 56

179 Ref. 17, Pl. 24; Ref. 37, 152;
Ref. 61, II, 40

180 Ref. 3, 130

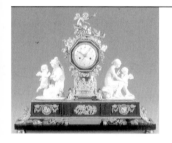

181 Ref. 4, 44

182 Ref. 66, 153

183 Ref. 4, 286; Ref. 23, Pl. 14;
Ref. 61, II, 46; Ref. 66, 93

184 Ref. 40, 182

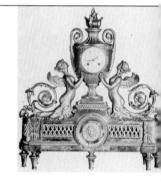

185 Ref. 58, I, 278;
Ref. 61, II, 41

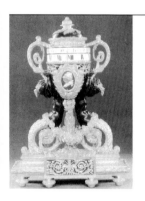

186 Ref. 3, 133

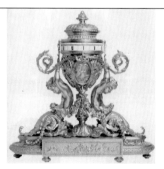

187 Ref. 37, 121; Ref. 61, II, 86

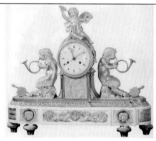

188 Ref. 17, Pl. 24; Ref. 61, II, 20;
Ref. 66, 91

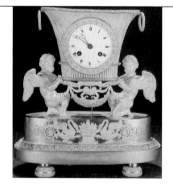

189 Ref. 12, 274

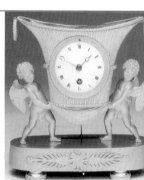

190 Ref. 40, 137

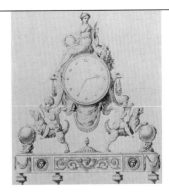

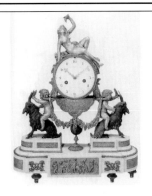

191 Ref. 61, II, 283

192 Ref. 4, 308

193 Ref. 17, Pl. 24; Ref. 52, 7 f.; Ref. 58, I, 280

194 Ref. 23, Pl. 7

195 Ref. 66, 89

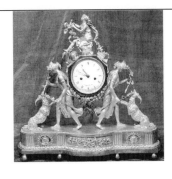

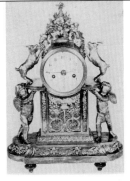

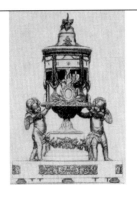

196 Ref. 13, 228; Ref. 58, I, 280; Ref. 61, II, 20; Ref. 66, 88

197 Ref. 58, I, 213

198 Ref. 18, 101; Ref. 58, I, 280; Ref. 61, II, 62; Ref. 65, 349

199 Ref. 59, 169; Ref. 66, 93

200 Ref. 61, II, 34

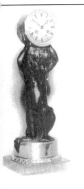

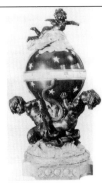

201 Ref. 61, II, 302

202 Ref. 37, 44

203 Ref. 61, II, 42

204 Ref. 44, 119

205 Ref. 61, II, 100

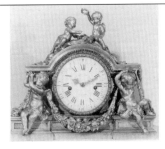

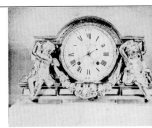

206 Ref. 19, 38; Ref. 52, 42; Ref. 61, II, 101

207 Ref. 37, 34

208 Ref. 61, II, 54

209 Ref. 65, 117

210 Ref. 58, I, 229; Ref. 61, II, 115

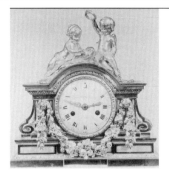

211 Ref. 58, I, 229

212 Ref. 17, Pl. 20

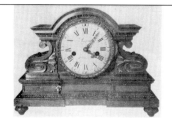

213 Ref. 61, II, 114

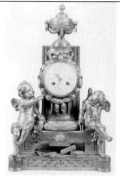

214 Ref. 3, 126; Ref. 4, 25;
Ref. 58, I, 91 + 177; Ref. 59,
191; Ref. 66, 99

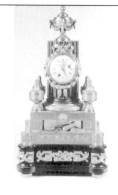

215 Ref. 58, I, 195; Ref.
58, II, 543

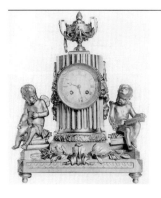

216 Ref. 17, Pl. 22; Ref. 58, I
177; Ref. 61, II, 47

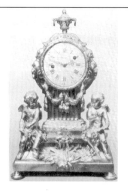

217 Ref. 17, Pl. 22;
Ref. 58, I, 195

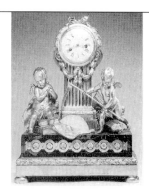

218 Ref. 3, 127; Ref. 4, 151

219 Ref. 23, Pl. 4; Ref. 36,
Cat. Nr. 230; Ref. 61, II, 32

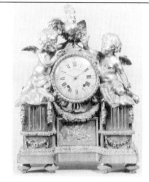

220 Ref. 58, I, 170

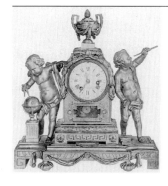

221 Ref. 17, Pl. 15; Ref. 40, 89;
Ref. 61, II, 34

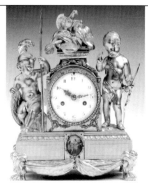

222 Ref. 5, 415; Ref. 34, 57; Ref. 40,
114 + 129; Ref. 58, I, 180; Ref. 66, 82

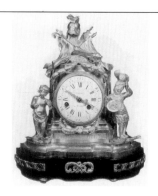

223 Ref. 66, 88

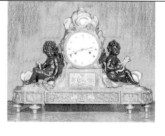

224 Ref. 45, 146

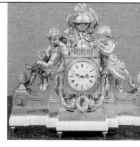

225 Ref. 3, 126; Ref. 27,
188; Ref. 61, II, 22

226 Ref. 66, 100

227 Ref. 3, 126

228 Ref. 16, 265; Ref. 18, 71;
Ref. 58, I, 171

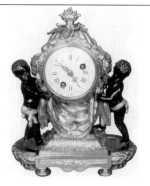

229 Ref. 66, 79

230 Ref. 61, II, 57

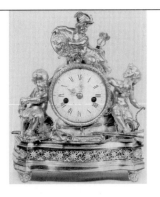
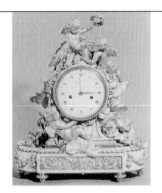
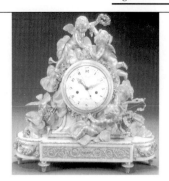
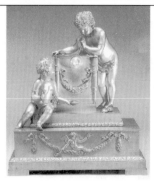

231 Ref. 40, 135 232 Ref. 4, 293 233 Ref. 58, I, 251 234 Ref. 40, 121; 235 Ref. 40, 176
Ref. 44, 268

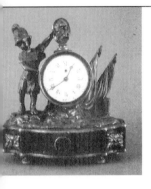
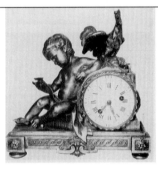

236 Ref. 61, II, 22 237 Ref. 3, 127; 238 Ref. 17, Pl. 20; Ref. 57, 46 239 Ref. 58, II, 534 240 Ref. 21, 177;
Ref. 61, II, 35 Ref. 44, 118

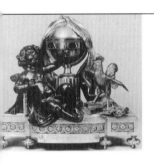

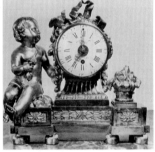
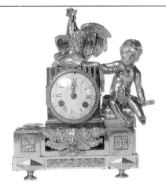
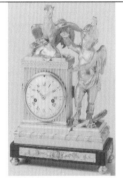

241 Ref. 58, I, 92 + 171; 242 Ref. 58, I, 176; 243 Ref. 56, 184 244 Ref. 40, 88 245 Ref. 44, 251
Ref. 65, 203 Ref. 61, II, 35

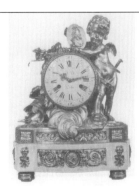
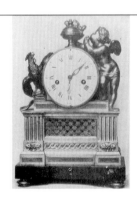
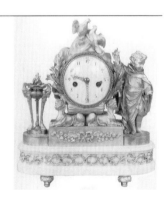

246 Ref. 40, 79; 247 Ref. 40, 88 248 Ref. 10, 36 + 67; 249 Ref. 61, II, 114 250 Ref. 66, 86
Ref. 58, I, 176 Ref. 37, 40; Ref. 38, 106

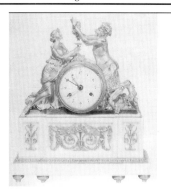
251 Ref. 66, 100

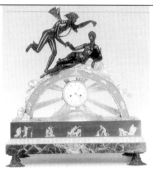
252 Ref. 4, 141

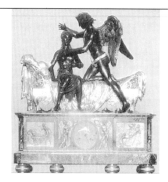
253 Ref. 58, I, 321

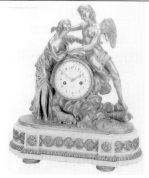
254 Ref. 66, 89

255 Ref. 58, I, 246

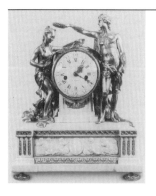
256 Ref. 4, 164

257 Ref. 17, Pl. 19

258 Ref. 3, 132

259 Ref. 24, 57;
Ref. 61, II, 28

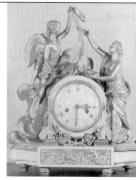
260 Ref. 24, 50; Ref. 40,
125; Ref. 58, I, 249; Ref.
65, 120

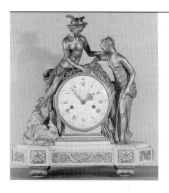
261 Ref. 40, 50; Ref. 58, I, 248

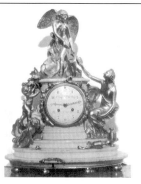
262 Ref. 24, 49;
Ref. 58, I, 250

263 Ref. 36, Cat. Nr. 198

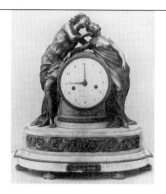
264 Ref. 61, II, 29

265 Ref. 58, I, 366

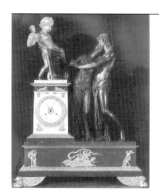
266 Ref. 4, 160 f.; Ref. 12,
123; Ref. 24, 58; Ref. 58, I, 347;
Ref. 61, II, 45

267 Ref. 17, Pl. 37; Ref. 24, 81;
Ref. 40, 66; Ref. 58, 366; Ref. 66,
167

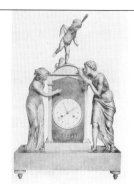
268 Ref. 61, II, 295

269 Ref. 17, Pl. 36; Ref. 55, 155;
Ref. 57, 56

270 Ref. 17, Pl. 49; Ref. 24,
78; Ref. 58, I, 350; Ref. 63,
162; Ref. 66, 178

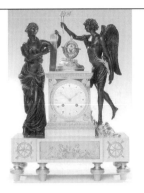

271 Ref. 6, 142;
Ref. 12, 240; Ref. 40,
119

272 Ref. 40, 42

273 Ref. 40, 119

274 Ref. 24, 73; Ref. 58, I,
395; Ref. 61, II, 329

275 Ref. 66, 90

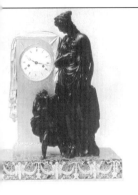

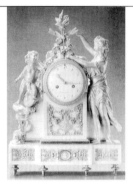

276 Ref. 17, Pl. 37;
Ref. 58, I, 366

277 Ref. 40, 83

278 Ref. 44, 118

279 Ref. 37, 59;
Ref. 61, II, 57

280 Ref. 3, 131; Ref. 40,
131; Ref. 61, II, 44

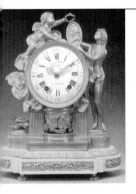
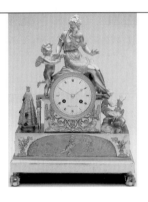
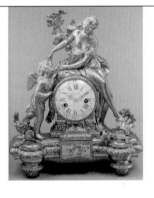
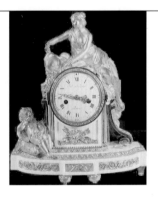
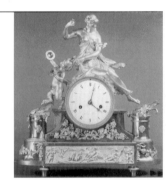

281 Ref. 3, 124 + 126

282 Ref. 6, 73; Ref. 40, 100

283 Ref. 14, 149; Ref. 24, 48; Ref. 25,
72 f.; Ref. 58, I, 246; Ref. 59, 74

284 Ref. 24, 51; Ref. 40, 58; Ref. 58,
I, 212 + 248

285 Ref. 40, 54

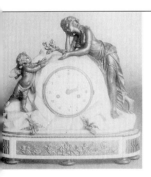

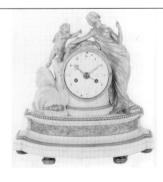
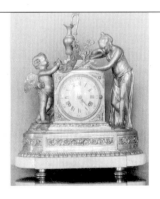
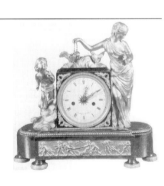

286 Ref. 3, 130; Ref. 23, Pl. 11

287 Ref. 8, 226; Ref. 27, 18;
Ref. 58, I, 247; Ref. 66, 89

288 Ref. 66, 90

289 Ref. 40, 134; Ref. 58, I, 250

290 Ref. 66, 86

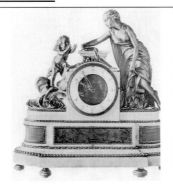

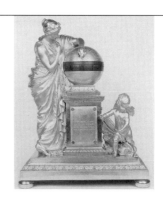

291 Ref. 40, 176

292 Ref. 17, Pl. 14

293 Ref. 61, II, 287

294 Ref. 4, 142; Ref. 17, 13;
Ref. 24, 52; Ref. 40, 37; Ref. 58, I,
93 + 164; Ref. 65, 35

295 Ref. 12, 54

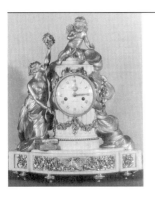

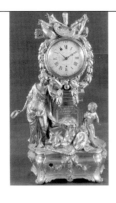

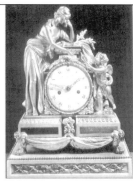

296 Ref. 24, 50; Ref. 58,
I, 249

297 Ref. 12, 31;
Ref. 65, 36

298 Ref. 66, 154

299 Ref. 63, 156

300 Ref. 4, 243; Ref. 24, 56;
Ref. 40, 97; Ref. 58, I, 247

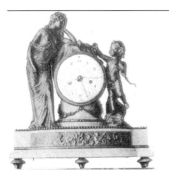

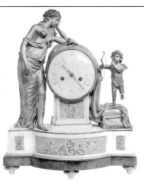

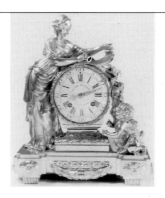

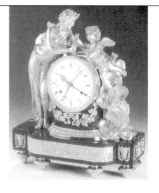

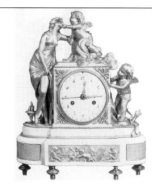

301 Ref. 59, 191

302 Ref. 17, Pl. 18

303 Ref. 4, 293

304 Ref. 34, 68

305 Ref. 66, 86

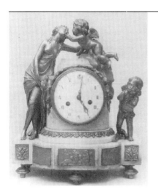

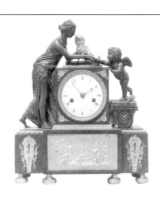

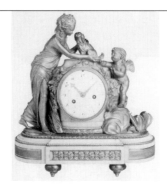

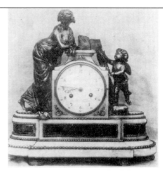

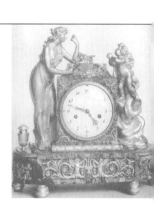

306 Ref. 23, Pl. 15;
Ref. 61, II, 29

307 Ref. 37, 99

308 Ref. 17, Pl. 20; Ref. 66, 90

309 Ref. 23, Pl. 10;
Ref. 61, II, 33

310 Ref. 2, 192

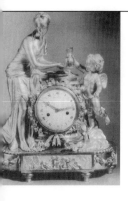
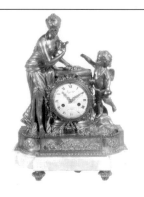

311 Ref. 58, I, 245

312 Ref. 66, 86

313 Ref. 40, 106

314 Ref. 58, I, 245
Ref. 61, II, 33

315 Ref. 61, II, 47

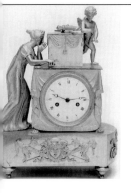

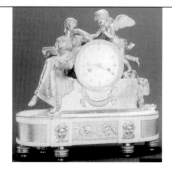

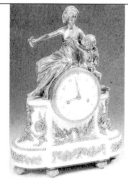

316 Ref. 42, Nr. 37

317 Ref. 66, 89

318 Ref. 40, 136

319 Ref. 17, Pl. 20; Ref. 24, 51;
Ref. 57, 50; Ref. 58, I, 248

320 Ref. 3, 153

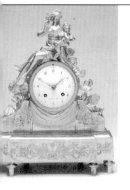
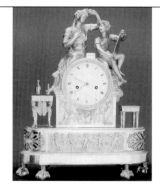
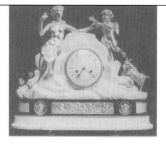

321 Ref. 34, 68;
Ref. 40, 119

322 Ref. 40, 177

323 Ref. 37, 146

324 Ref. 12, 88

325 Ref. 17, Pl. 14

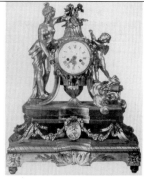
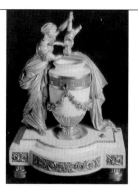
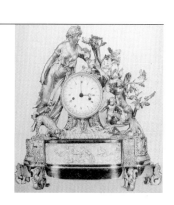

326 Ref. 17, Pl. 18

327 Ref. 17, Pl. 20

328 Ref. 61, II, 31

329 Ref. 4, 149; Ref. 12, 93

330 Ref. 17, Pl. 45;
Ref. 57, 51

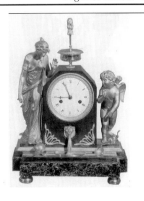

331 Ref. 66, 154 + 156

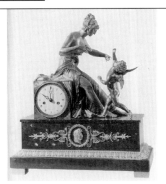

332 Ref. 37, 63; Ref. 58, I, 345

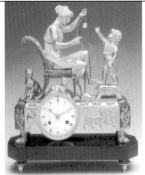

333 Ref. 40, 180

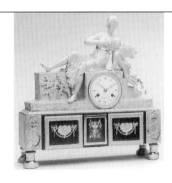

334 Ref. 40, 123

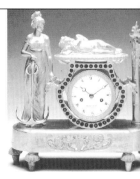

335 Ref. 40, 124

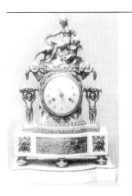

336 Ref. 23, Pl. 14

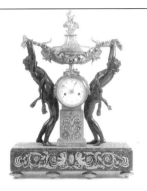

337 Ref. 24, 46; Ref. 40, 57

338 Ref. 6, 76

339 Ref. 12, 69

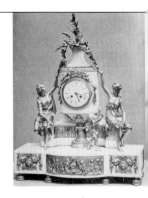

340 Ref. 3, 125; Ref. 17, Pl. 23; Ref. 58, I, 250; Ref. 61, II, 36

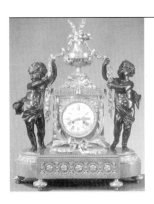

341 Ref. 58, I, 170

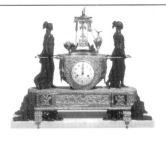

342 Ref. 4, 240; Ref. 13, 167; Ref. 18, 87; Ref. 40, 62; Ref. 58, I, 297; Ref. 61, II, 185; Ref. 65, 326; Ref. 66, 94

343 Ref. 40, 137

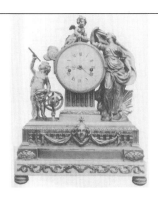

344 Ref. 3, 124; Ref. 36, Cat. Nr 88; Ref. 54, 6; Ref. 58, I, 196; Ref. 61, II, 113

345 Ref. 4, 151; Ref. 66, 100

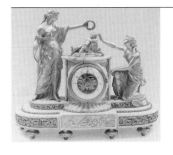

346 Ref. 4, 321

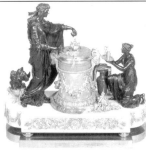

347 Ref. 48, 92; Ref. 58, I, 298 + 299 Ref. 66, 92

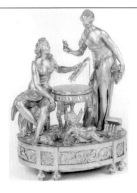

348 Ref. 1, 59; Ref. 14, 147; Ref. 24, 49; Ref. 25, 74 f.; Ref. 40, 127; Ref. 58, I, 245; Ref. 61, II, 98

349 Ref. 4, 44; Ref. 40, 63; Ref. 41, o. S.; Ref. 58, I, 299

350 Ref. 61, II, 96

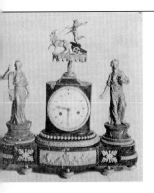
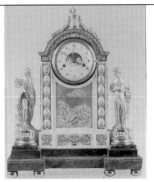
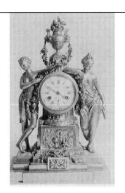
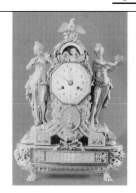

351 Ref. 61, II, 251

352 Ref. 4, 43

353 Ref. 17, Pl. 12;
Ref. 61, II, 51

354 Ref. 3, 125; Ref. 4, 342;
Ref. 61, II, 210

355 Ref. 12, 161; Ref. 17,
Pl. 50; Ref. 24, 84; Ref. 58,
I, 344; Ref. 61, II, 267; Ref.
68, o. S.

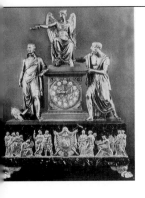
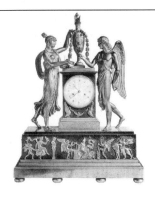

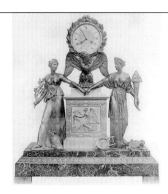
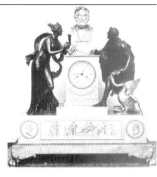

356 Ref. 52, 14, Ref. 58, I,
368; Ref. 61, II, 267

357 Ref. 17, Pl. 47

358 Ref. 17, Pl. 51

359 Ref. 17, Pl. 35

360 Ref. 17, Pl. 51; Ref. 58,
I, 352; Ref. 61, II, 266

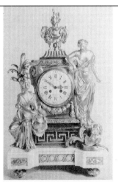

361 Ref. 4, 164

362 Ref. 61, II, 25

363 Ref. 17, Pl. 17; Ref. 61, II, 113

364 Ref. 61, II, 50

365 Ref. 24, 52; Ref. 40, 75:
Ref. 58, I, 233

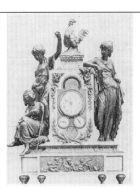
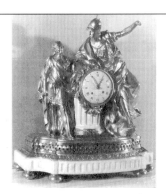
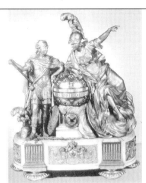

366 Ref. 4, 215; Ref.
58, I, 163; Ref. 65, 34

367 Ref. 17, Pl. 21; Ref. 58, I, 263:
Ref. 61, II, 99; Ref. 65, 61

368 Ref. 61, II, 25

369 Ref. 45, 255;
Ref. 61, II, 42 + 106

370 Ref. 58, I, 233

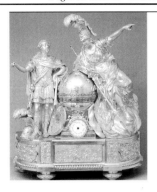
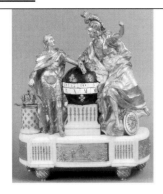
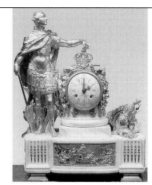
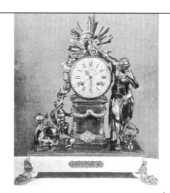
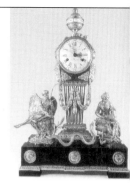

371 Ref. 58, I, 207 + 232; Ref. 65, 110

372 Ref. 24, 55; Ref. 25, 70 f.; Ref. 40, 72; Ref. 58, I, 232; Ref. 61, II, 106

373 Ref. 4, 284

374 Ref. 61, II, 62

375 Ref. 4, 271

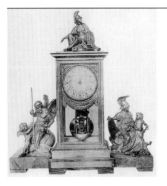
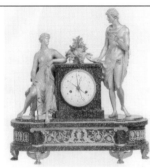
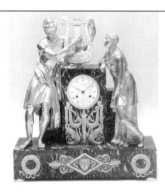
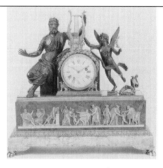
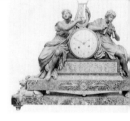

376 Ref. 17, Pl. 13

377 Ref. 37, 26

378 Ref. 24, 81

379 Ref. 58, I, 348

380 Ref. 17, Pl. 52

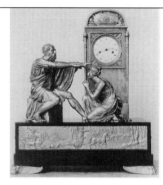

381 Ref. 4, 144

382 Ref. 38, 118; Ref. 58, I, 349

383 Ref. 27, 142; Ref. 58, I, 367

384 Ref. 17, Pl. 38; Ref. 20, 113 + 288

385 Ref. 4, 201; Ref. 58, I, 370; Ref. 70, 94

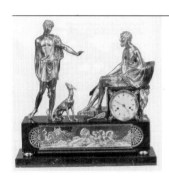
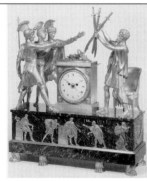
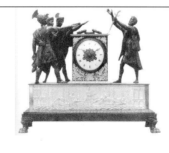

386 Ref. 58, I, 370; Ref. 61, II, 271; Ref. 66, 171

387 Ref. 17, Pl. 35, Ref. 20, 286: Ref. Ref. 27, 143; Ref. 58, I, 367

388 Ref. 24, 77; Ref. 37, 93; Ref. 40, 70; Ref. 63, 159

389 Ref. 4, 301

390 Ref. 17, Pl. 12

391 Ref. 4, 149

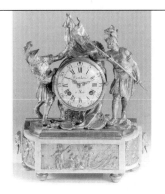

392 Ref. 40, 71

393 Ref. 17, Pl. 13; Ref. 40, 64

394 Ref. 17, Pl. 32;

395 Ref. 37, 27;
Ref. 58, I, 370

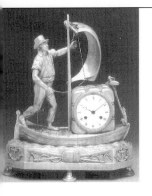

396 Ref. 40, 172;
Ref. 42, Nr. 1

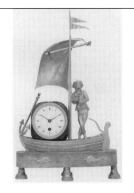

397 Ref. 64, 537

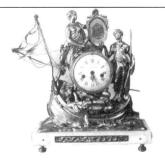

398 Ref. 4, 373; Ref. 40, 72; Ref. 54,
7; Ref. 58, I, 197; Ref. 61, II, 108 + 109

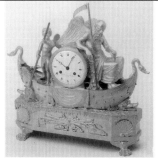

399 Ref. 39, 119;
Ref. 40, 43

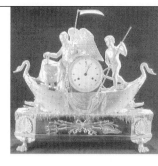

400 Ref. 12, 232; Ref. 34,
71; Ref. 40, 117

401 Ref. 61, II, 34

402 Ref. 24, 48; Ref. 58, I, 249;
Ref. 66, 96

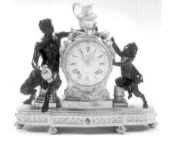

403 Ref. 4, 139

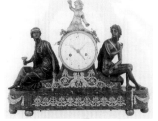

404 Ref. 66, 95

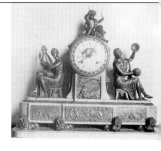

405 Ref. 59, 67; Ref. 61, II,
251

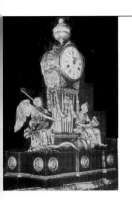

406 Ref. 61, I, 49.

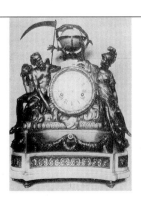

407 Ref. 58, I, 181; Ref. 61, II,
26

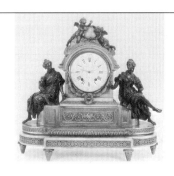

408 Ref. 58, I, 296

409 Ref. 3, 129

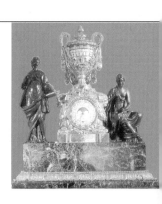

410 Ref. 4, 205

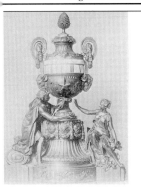
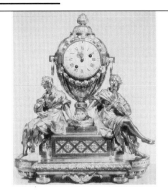
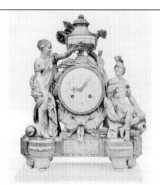
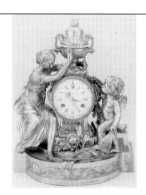
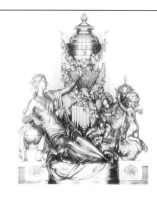

411 Ref. 4, 273;
Ref. 58, I, 178

412 Ref. 4, 238; Ref. 18, 68;
Ref. 40, 77; Ref. 44, 117; Ref. 48,
91; Ref. 58, I, 181; Ref. 69, 65

413 Ref. 4, 237; Ref. 24, 54; Ref. 40,
74; Ref. 47 Cover Page; Ref. 50, 155;
Ref. 61, II, 106; Ref. 65, 304

414 Ref. 40, 83; Ref. 59, 83

415 Ref. 58, I, 166

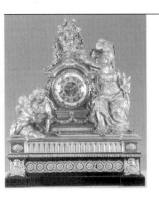

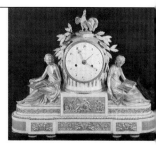

416 Ref. 4, 389

417 Ref. 56, 183

418 Ref. 56, 183

419 Ref. 27, 153; Ref. 58, I, 296;
Ref. 65, 323

420 Ref. 3, 129; Ref. 12,
73 + 76; Ref. 58, I, 297;
Ref. 63, 111

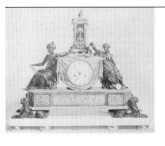

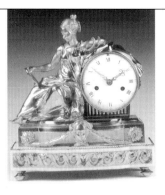
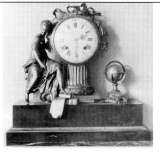
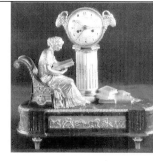

421 Ref. 61, II, 75

422 Ref. 59, 151

423 Ref. 17, Pl. 19; Ref. 40, 85;
Ref. 56, 184; Ref. 58, I, 162; Ref. 61,
II, 26

424 Ref. 38, 108; Ref. 58, I, 166;
Ref. 61, II, 43

425 Ref. 12, 124

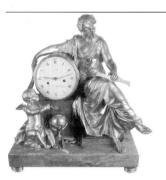
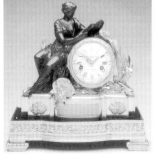
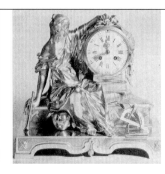
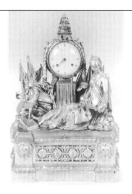

426 Ref. 60, 51

427 Ref. 40, 38

428 Ref. 4, 305; Ref. 23, Pl. 4;
Ref. 24, 56; Ref. 40, 82; Ref. 58, I,
162; Ref. 58, II, 534; Ref. 61, II, 25

429 Ref. 58, II, 532

430 Ref. 4, 315; Ref. 58, I,
161; Ref. 66, 98

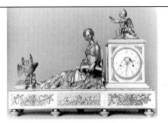
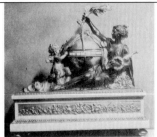
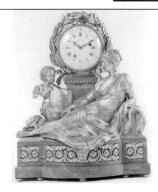
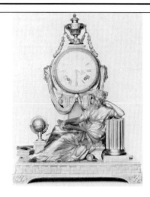

431 Ref. 58, I, 161

432 Ref. 58, II, 532

433 Ref. 61, II, 88

434 Ref. 25, 64 f.; Ref. 61, II, 36

435 Ref. 58, I, 161

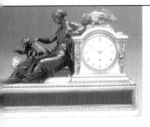
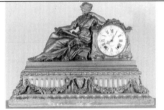
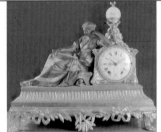
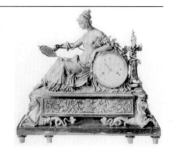

436 Ref. 4, 165; Ref. 40, 38

437 Ref. 24, 57

438 Ref. 12, 66; Ref. 65, 307

439 Ref. 4, 90; Ref. 7, 105; Ref. 11, 83; Ref. 25, 54 f.; Ref. 40, 39; Ref. 44, 117; Ref. 58, I, 160: Ref. 65, 48; Ref. 66, 95

440 Ref. 4, 143; Ref. 17, Pl. 36

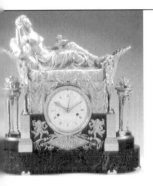
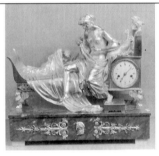
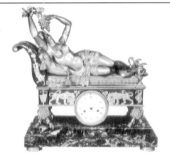
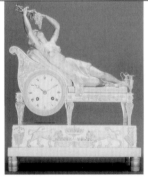
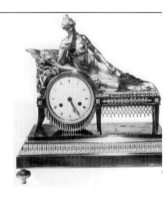

441 Ref. 3, 155

442 Ref. 24, 47

443 Ref. 58, I, 379

444 Ref. 40, 56

445 Ref. 40, 175; Ref. 58, II, 708; Ref. 61, II, 296; Ref. 66, 168

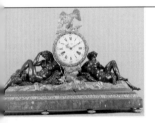
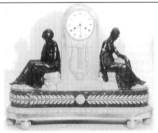
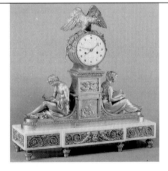
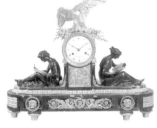
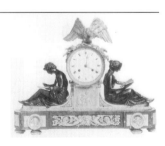

446 Ref. 25, 76 f.; Ref. 28, 140; Ref. 58, I, 296; Ref. 65, 61

447 Ref. 58, II, 709

448 Ref. 27, 154

449 Ref. 12, 64; Ref. 66, 152 + 153

450 Ref. 8, 219; Ref. 12, 62; Ref. 13, 167; Ref. 37, 54; Ref. 40, 86; Ref. 58, I, 295 Ref. 58, II, 568; Ref. 65, 322

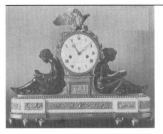

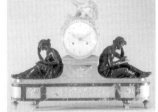

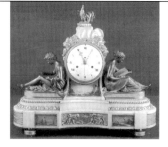

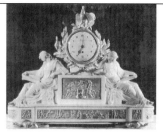

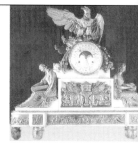

451 Ref. 4, 206; Ref. 17, Pl. 22; Ref. 27, 155; Ref. 37, 53; Ref. 61 II, 21

452 Ref. 40, 26

453 Ref. 12, 92

454 Ref. 18, 84

455 Ref. 56, 184

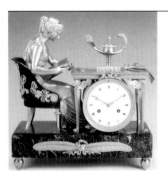

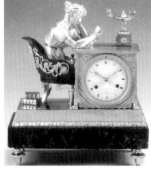

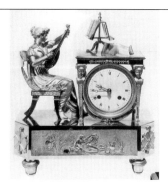

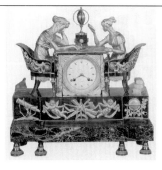

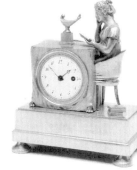

456 Ref. 34, 74; Ref. 61, II, 214 + 252

457 Ref. 17, Pl. 48; Ref. 37, 32; Ref. 40, 86; Ref. 42, Nr. 30; Ref. 57, 58; Ref. 58, I, 374; Ref. 66, 170

458 Ref. 66, 168

459 Ref. 58, I, 374; Ref. 66, 173

460 Ref. 42, Nr. 31;

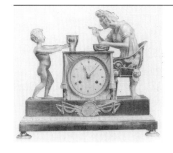

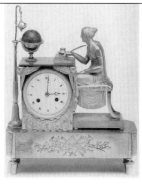

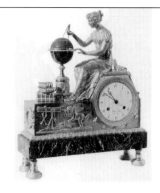

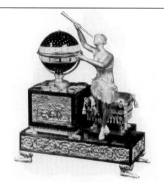

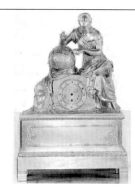

461 Ref. 37, 155

462 Ref. 42, Nr. 32

463 Ref. 37, 65; Ref. 40, 91; Ref. 58, I, 375; Ref. 61, II, 214

464 Ref. 66, 87

465 Ref. 58, I, 309

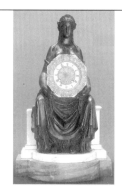

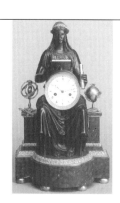

466 Ref. 12, 165; Ref. 17, Pl. 46; Ref. 57, 64; Ref. 61, II, 272

467 Ref. 17, Pl. 13, Ref. 52, 12; Ref. 61, II, 96

468 Ref. 37, 101

469 Ref. 40, 53

470 Ref. 24, 85; Ref. 56, 186

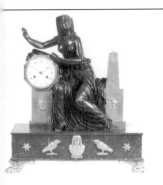
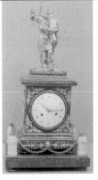
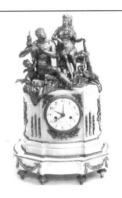
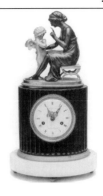

471 Ref. 58, I, 338 — 472 Ref. 61, II, 182 — 473 Ref. 65, 260 — 474 Ref. 42, Nr. 34 — 475 Ref. 61, II, 271

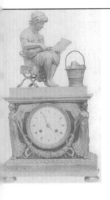

476 Ref. 17, Pl. 52 — 477 Ref. 61, II, 289 — 478 Ref. 17, Pl. 48; Ref. 57, 59 — 479 Ref. 12, 154; Ref. 37, 96 — 480 Ref. 37, 45

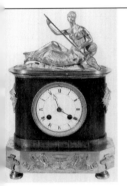
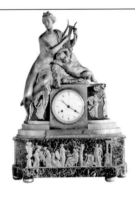
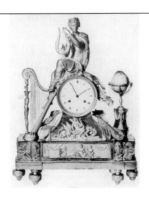
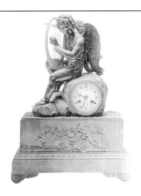
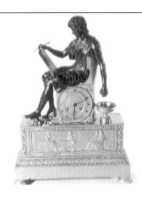

481 Ref. 66, 155 — 482 Ref. 17, Pl. 30; Ref. 57, 55 — 483 Ref. 12, 261; Ref. 17, Pl. 52; Ref. 57, 52; Ref. 66, 105 — 484 Ref. 17, Pl. 29 — 485 Ref. 58, I, 349

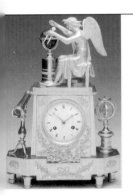
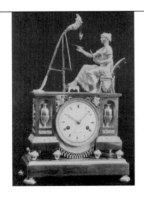
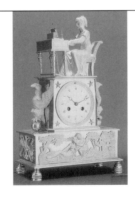
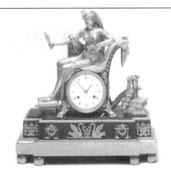
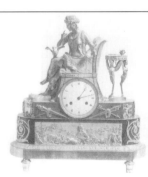

486 Ref. 40, 93 — 487 Ref. 37, 129; Ref. 61, II, 289; Ref. 66, 154 — 488 Ref. 40, 180 — 489 Ref. 24, 75; Ref. 40, 84 — 490 Ref. 37, 44

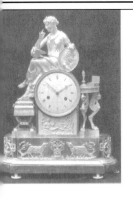

491 Ref. 37, 42;
Ref. 58, I, 377;
Ref. 66, 169

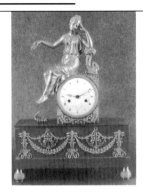

492 Ref. 61, II, 364

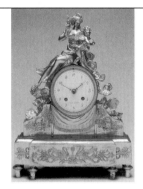

493 Ref. 34, 68

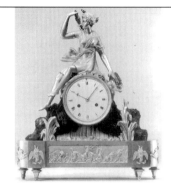

494 Ref. 55, 182

495 Ref. 37, 156

496 Ref. 3, 153

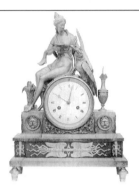

497 Ref. 17, Pl. 52

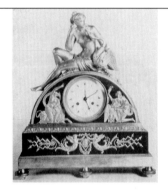

498 Ref. 61, II, 293

499 Ref. 37, 53

500 Ref. 24, 74; Ref. 39,
126; Ref. 40, 46

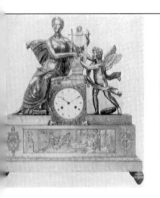

501 Ref. 58, I, 379

502 Ref. 51, 137

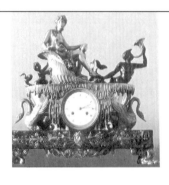

503 Ref. 58, I, 353

504 Ref. 17, Pl. 45; Ref. 32, 95

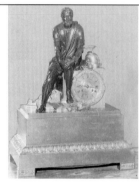

505 Ref. 52, 30

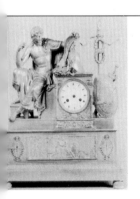

506 Ref. 3, 155

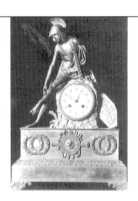

507 Ref. 61, II, 268

508 Ref. 42, Nr. 47

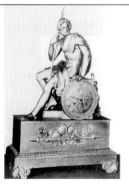

509 Ref. 19, 63;
Ref. 61, II, 269

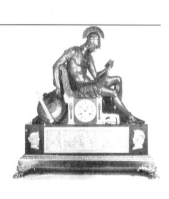

510 Ref. 12, 175;
Ref. 61, II, 268

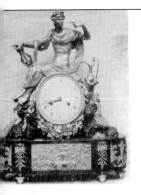 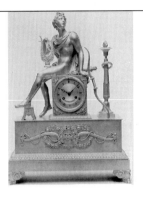 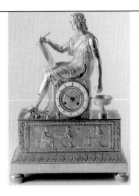 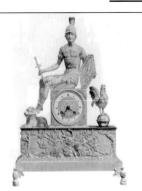 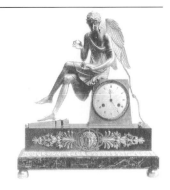

511 Ref. 61, II, 250 512 Ref. 58, I, 397 513 Ref. 3, 160; Ref. 40, 26 514 Ref. 37, 128 515 Ref. 37, 128; Ref. 58, I, 350

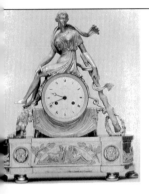 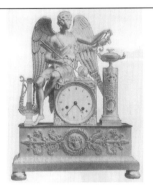 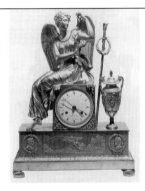 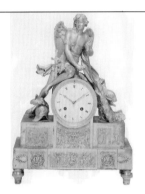 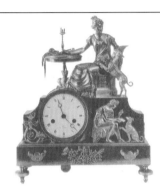

516 Ref. 24, 74, Ref. 40, 65; Ref. 58, I, 371 517 Ref. 24, 82; Ref. 37, 142; Ref. 40, 100; Ref. 56, 187; Ref. 58, I, 399 518 Ref. 66, 170 519 Ref. 3, 130; Ref. 34, 69; Ref. 55, 168; Ref. 66, 156 520 Ref. 37, 34; Ref. 66, 171

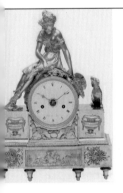 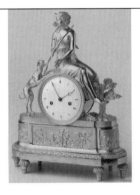 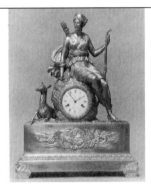 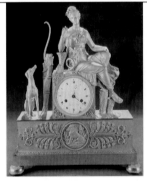

521 Ref. 20, 288; Ref. 40, 48 522 Ref. 40, 49 523 Ref. 37, 107 524 Ref. 12, 129 525 Ref. 3, 128; Ref. 61, II, 305

 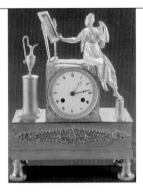 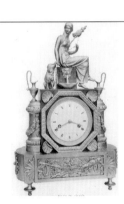

526 Ref. 42, Nr. 9 527 Ref. 24, 76; Ref. 37, 35; Ref. 39, 117; Ref. 40, 118; Ref. 66, 169 528 Ref. 17, Pl. 34; Ref. 32, 180; Ref. 40, 139 529 Ref. 12, 248 530 Ref. 17, Pl. 30

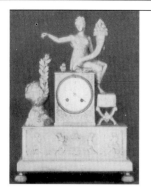

531 Ref. 61, II, 364

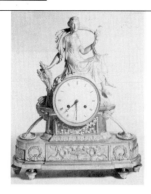

532 Ref. 40, 52; Ref. 61, II, 304

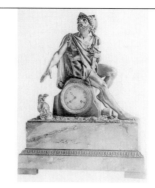

533 Ref. 17, Pl. 46

534 Ref. 61, II, 266

535 Ref. 58, I, 178;
Ref. 61, II, 51

536 Ref. 3, 160; Ref. 17, Pl. 28;
Ref. 32, 97; Ref. 55, 158 + 165;
Ref. 58, I, 352

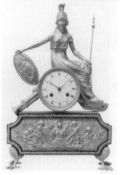

537 Ref. 37, 95; Ref. 61, II, 278

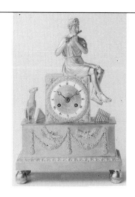

538 Ref. 40, 176

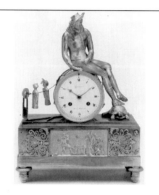

539 Ref. 42, Nr. 36

540 Ref. 12, 158

541 Ref. 61, II, 312

542 Ref. 61, II, 219

543 Ref. 39, 128

544 Ref. 4, 174; Ref. 40, 174

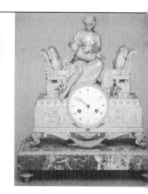

545 Ref. 3, 158;
Ref. 40, 178

546 Ref. 37, 155

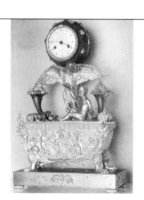

547 Ref. 52, 23

548 Ref. 24, 80

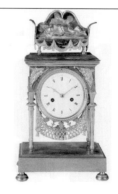

549 Ref. 66, 181

550 Ref. 17, Pl. 48; Ref. 40,
108; Ref. 57, 60; Ref. 58, I,
376; Ref. 61, II, 284

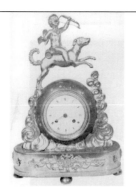
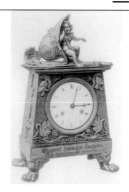
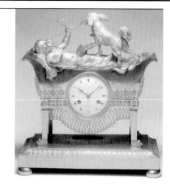

551 Ref. 40, 181

552 Ref. 40, 76

553 Ref. 61, II, 250

554 Ref. 17, Pl. 29;
Ref. 66, 172

555 Ref. 40, 182; Ref. 61,
II, 300; Ref. 66, 173

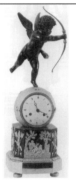
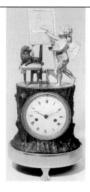
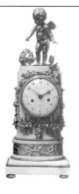
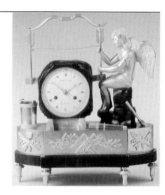

556 Ref. 37, 33

557 Ref. 37, 55;
Ref. 58, II, 708

558 Ref. 40, 179;
Ref. 61, II, 299

559 Ref. 37, 107;
Ref. 38, 109

560 Ref. 40, 135

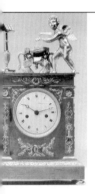

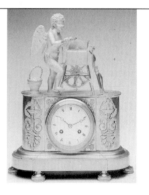
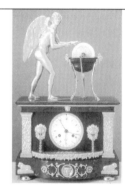

561 Ref. 55, 179

562 Ref. 42, Nr. 15;
Ref. 58, 380; Ref. 66, 151

563 Ref. 37, 106

564 Ref. 40, 101

565 Ref. 34, 76

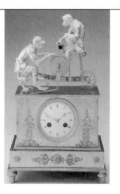
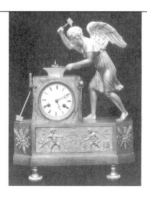
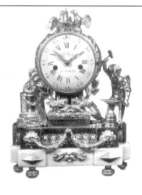

566 Ref. 66, 176

567 Ref. 40, 167

568 Ref. 37, 35

569 Ref. 66, 124

570 Ref. 39, 120;
Ref. 42, Nr. 33

571 Ref. 39, 118

572 Ref. 37, 33

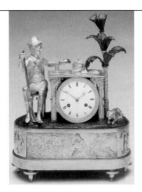

573 Ref. 40, 169

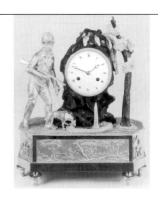

574 Ref. 40, 169

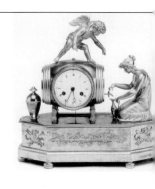

575 Ref. 42, Nr. 19

576 Ref. 40, 163;
Ref. 42, Nr. 17

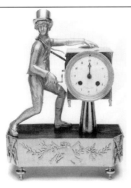

577 Ref. 42, Nr. 24

578 Ref. 40, 179

579 Ref. 34, 78

580 Ref. 12, 152

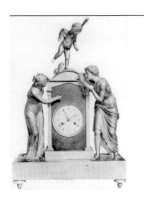

581 Ref. 17, Pl. 27;
Ref. 55, 163

582 Ref. 58, I, 353; Ref. 61, II, 252

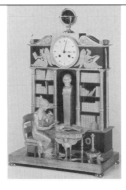

583 Ref. 24, 75; Ref. 40, 185;
Ref. 58, I, 353; Ref. 63, 131

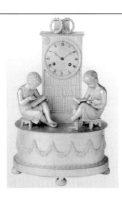

584 Ref. 3, 160; Ref. 12,
222; Ref. 24, 75; Ref. 39,
122; Ref. 40, 184; Ref. 61, II, 292

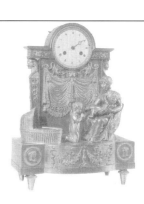

585 Ref. 37, 46; Ref. 40,
165; Ref. 58, I, 376

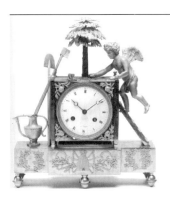

586 Ref. 42, Nr. 13

587 Ref. 42, Nr. 16

588 Ref. 42, Nr. 18

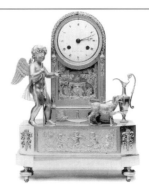

589 Ref. 42, Nr. 40

590 Ref. 52, 23;
Ref. 56, 186

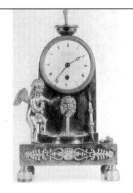
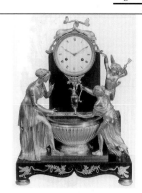

591 Ref. 12, 231;
Ref. 17, Pl. 53

592 Ref. 12, 155

593 Ref. 58, I, 378

594 Ref. 61, II, 292;
Ref. 66, 157

595 Ref. 17, Pl. 48;
Ref. 61, II, 230

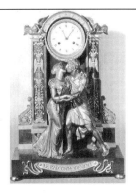
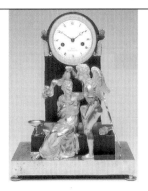
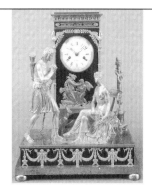
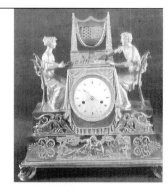

596 Ref. 58, I, 369

597 Ref. 3, 161;
Ref. 58, I, 369

598 Ref. 40, 118

599 Ref. 3, 159

600 Ref. 12, 163;
Ref. 40, 178

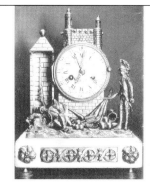

601 Ref. 12, 206

602 Ref. 58, I, 196;
Ref. 61, II, 24

603 Ref. 4, 152;
Ref. 12, 125

604 Ref. 34, 8; Ref. 40, 173;
Ref. 56, 184; Ref. 58, I, 197;
Ref. 61, II, 111; Ref. 66, 104

605 Ref. 61, II, 110

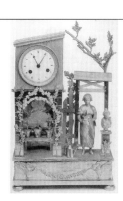

606 Ref. 42, Nr. 27

607 Ref. 42, Nr. 28

608 Ref. 42, Nr. 29

609 Ref. 61, II, 297

610 Ref. 42, Nr. 11;
Ref. 61, II, 297

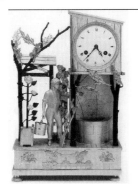

611 Ref. 42, Nr. 10;
Ref. 61, II, 297

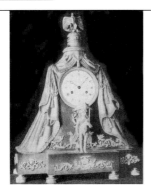

612 Ref. 61, II, 296

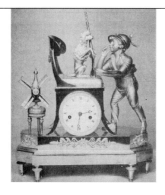

613 Ref. 42, Nr. 35;
Ref. 61, II, 300

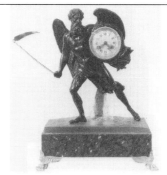

614 Ref. 3, 163; Ref. 24, 73; Ref. 37,
45; Ref. 40, 7; Ref. 58, I, 351;
Ref. 60, 51

615 Ref. 27, 144

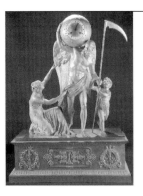

616 Ref. 12, 159;
Ref. 58, I, 345

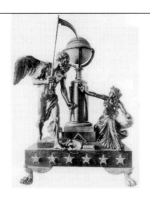

617 Ref. 17, Pl. 29; Ref. 27,
152; Ref. 61, II, 100 + 270

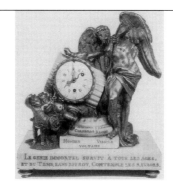

618 Ref. 4, 23; Ref. 24, 54;
Ref. 40, 44

619 Ref. 14, 141;
Ref. 24, 52; Ref. 25, 82 f.;
Ref. 40, 117; Ref. 58, I, 165;
Ref. 61, II, 96

620 Ref. 4, 136; Ref. 18, 79;
Ref. 24, 53; Ref. 40, 117;
Ref. 58, I, 244

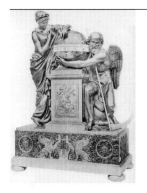

621 Ref. 17, Pl. 27;

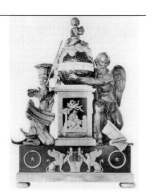

622 Ref. 17, Pl. 45;
Ref. 57, 28 + 54

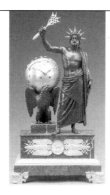

623 Ref. 40, 45

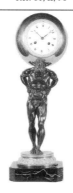

624 Ref. 66, 175

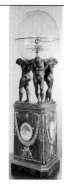

625 Ref. 22, 225;
Ref. 62, 184

626 Ref. 61, II, 204

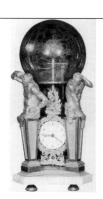

627 Ref. 66, 101

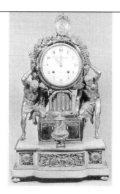

628 Ref. 58, I, 251

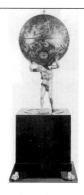

629 Ref. 12, 142 f.;
Ref. 61, II, 338

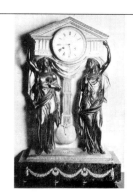

630 Ref. 58, II, 687;
Ref. 61, II, 307;
Ref. 66, 178

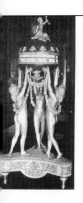

631 Ref. 24, 45;
Ref. 40, 112;
Ref. 61, II, 95

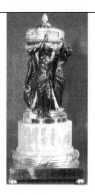

632 Ref. 4, 88;
Ref. 65, 280

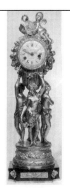

633 Ref. 24, 46

634 Ref. 18, 80; Ref. 38, 107;
Ref. 57, 47; Ref. 58, I, 179;
Ref. 61, II, 94 + 95; Ref. 65, 261 + 279

635 Ref. 37, 115;
Ref. 61, II, 94

636 Ref. 12, 135

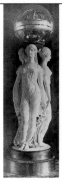

637 Ref. 21, 182;
Ref. 52, 29; Ref. 57, 62 + 63

638 Ref. 57, 56

639 Ref. 17, Pl. 54;
Ref. 57, 57

640 Ref. 4, 367

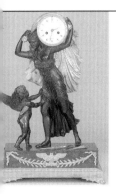

641 Ref. 24, 90

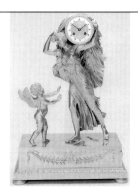

642 Ref. 40, 59 + 124

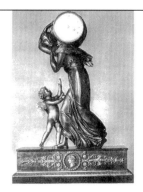

643 Ref. 58, I, 345

644 Ref. 58, I, 366;
Ref. 63, 163

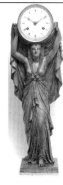

645 Ref. 17, Pl. 28;
Ref. 24, 83

646 Ref. 4, 358;
Ref. 58, I, 336

647 Ref. 37, 134;
Ref. 39, 129

648 Ref. 3, 148

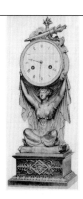

649 Ref. 17, Pl. 54

650 Ref. 6, 69; Ref. 12, 185;
Ref. 17, Pl. 49; Ref. 52, 25;
Ref. 58, I, 397; Ref. 61, II,
278; Ref. 66, 175

651 Ref. 12, 245

652 Ref. 37, 138

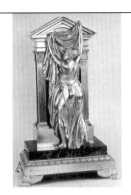

653 Ref. 58, I, 368

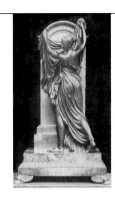

654 Ref. 24, 91;
Ref. 61, II, 295

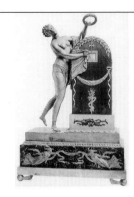

655 Ref. 6, 75; Ref. 17, Pl.
38; Ref. 52, 17; Ref. 58, I,
369; Ref. 61, II, 294; Ref.
72, 70 + 87

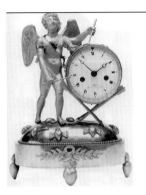

656 Ref. 42, Nr. 39

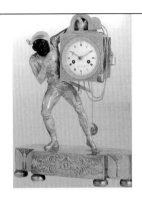

657 Ref. 3, 112; Ref. 39, 123;
Ref. 40, 169

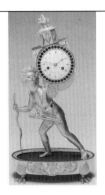

658 Ref. 40, 129;
Ref. 42, Nr. 38

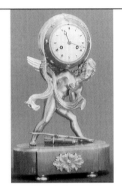

659 Ref. 40, 113;

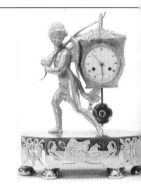

660 Ref. 24, 249;
Ref. 40, 138; Ref. 56, 187

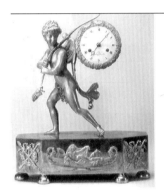

661 Ref. 24, 249

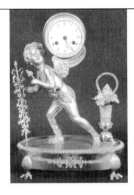

662 Ref. 37, 36;
Ref. 42, Nr. 22

663 Ref. 6, 72; Ref. 37, 63;
Ref. 40, 113; Ref. 64, 536

664 Ref. 42, Nr. 20;
Ref. 61, II, 302

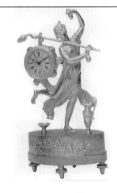

665 Ref. 20, 289; Ref. 37,
33; Ref. 61, II, 302; Ref. 64,
533

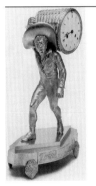

666 Ref. 42, Nr. 6

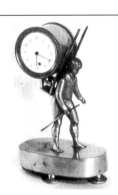

667 Ref. 42, Nr. 7;
Ref. 61, II, 303

668 Ref. 27, 147

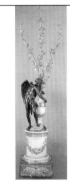

669 Ref. 25, 88 f.

670 Ref. 4, 201

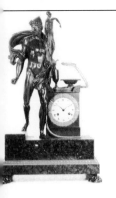

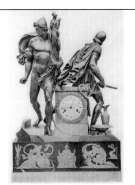

671 Ref. 58, I, 395;

672 Ref. 37, 100; Ref. 40, 64;
Ref. 58, I, 399

673 Ref. 17, Pl. 44

674 Ref. 12, 201;
Ref. 61, II, 270

675 Ref. 3, 155; Ref. 4, 140;
Ref. 58, I, 348

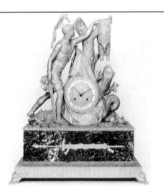
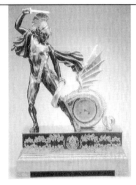
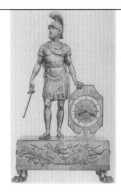
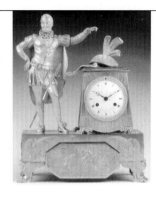

676 Ref. 12, 186 + 239;
Ref. 17, Pl. 34; Ref. 20,
288; Ref. 40, 64; Ref. 52, 26

677 Ref. 58, I, 351

678 Ref. 3, 163

679 Ref. 17, Pl. 46

680 Ref. 20, 101, Abb. 166;
Ref. 58, I, 378

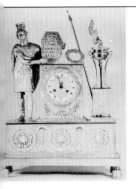
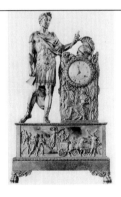
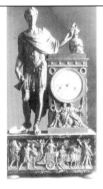

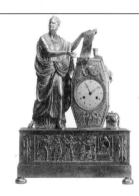

681 Ref. 33, II, 164

682 Ref. 17, Pl. 32;
Ref. 58, II, 671

683 Ref. 58, I, 348

684 Ref. 58, I, 271

685 Ref. 37, 131;
Ref. 58, I, 349

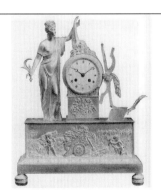
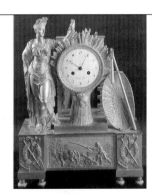

686 Ref. 37, 44

687 Ref. 37, 92;
Ref. 42, Nr. 44

688 Ref. 37, 135

689 Ref. 37, 130

690 Ref. 12, 157;
Ref. 40, 52; Ref. 42, Nr. 14

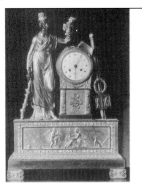

691 Ref. 61, II, 364

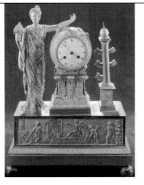

692 Ref. 12, 286

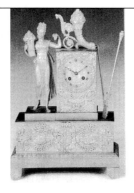

693 Ref. 3, 159

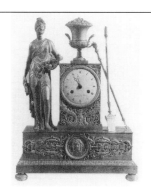

694 Ref. 37, 45 + 123

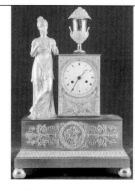

695 Ref. 12, 267

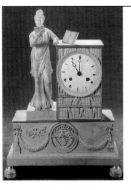

696 Ref. 12, 288

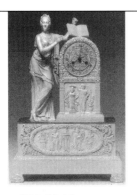

697 Ref. 3, 161

698 Ref. 34, 74;
Ref. 37, 90; Ref. 40, 92;
Ref. 58, I, 375

699 Ref. 40, 104

700 Ref. 42, Nr. 43

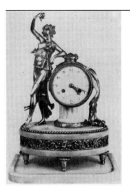

701 Ref. 61, II, 32

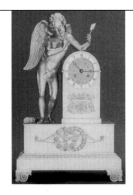

702 Ref. 40, 135

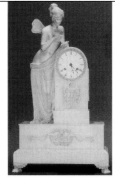

703 Ref. 40, 120

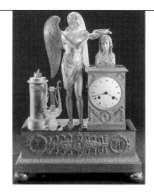

704 Ref. 12, 254;
Ref. 56, 187

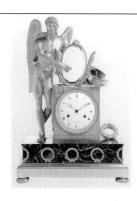

705 Ref. 39, 124

706 Ref. 37, 40

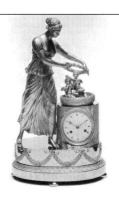

707 Ref. 40, 132;
Ref. 58, I, 368

708 Ref. 17, Pl. 51

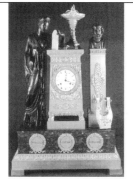

709 Ref. 12, 204 + 244

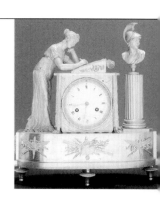

710 Ref. 40, 81

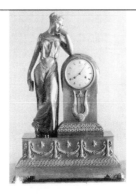
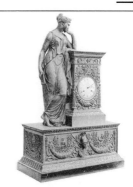
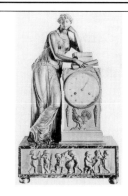

711 Ref. 57, 61 712 Ref. 31, 63; 713 Ref. 58, I, 396 714 Ref. 17, Pl. 50 715 Ref. 17, Pl. 52; Ref. 24,
 Ref. 37,150 82; Ref. 40, 77; Ref. 58, I,
 349; Ref. 61, II, 252; Ref.
 66, 173

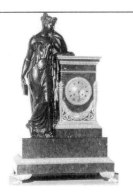
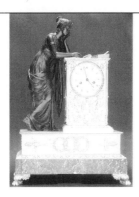

716 Ref. 61, II, 288 717 Ref. 58, I, 350 718 Ref. 40, 81 719 Ref. 3, 162; Ref. 20, 289; 720 Ref. 58, I, 343
 Ref. 24, 91; Ref. 37, 105;
 Ref. 40, 80; Ref. 55, 157; Ref. 58, I,
 343 + 352; Ref. 63, 160

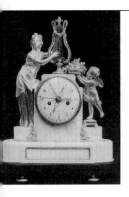
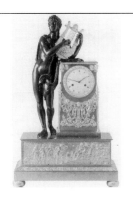
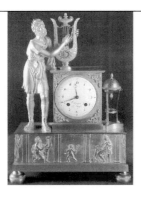
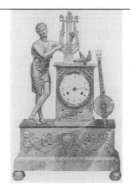
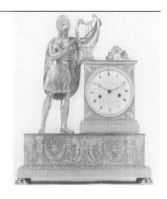

721 Ref. 37, 145; 722 Ref. 40, 31 723 Ref. 12, 162 724 Ref. 17, Pl. 46; 725 Ref. 55, 184
Ref. 61, II, 30 Ref. 38, 118; Ref. 72, 63

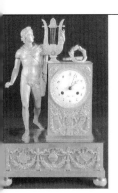

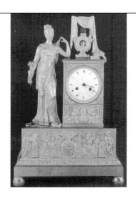
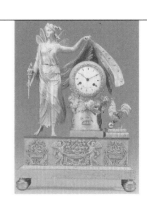

726 Ref. 12, 365 727 Ref. 17, Pl. 49 728 Ref. 12, 149 729 Ref. 12, 130 730 Ref. 4, 142

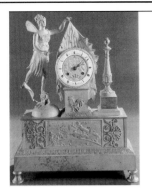

731 Ref. 12, 298

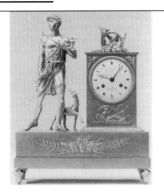

732 Ref. 55, 177

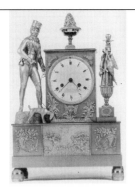

733 Ref. 55, 186 + 191

734 Ref. 37, 91

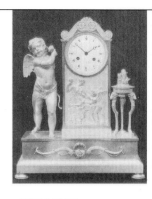

735 Ref. 37, 70

736 Ref. 58, I, 378

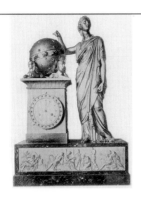

737 Ref. 5, 471; Ref. 17, Pl. 51;
Ref. 21, 181; Ref. 31, 192; Ref.
58, I, 395; Ref. 66, 177

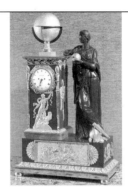

738 Ref. 27, 157

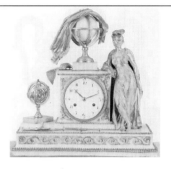

739 Ref. 66, 97

740 Ref. 4, 193

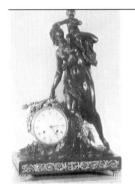

741 Ref. 58, I, 281

742 Ref. 37, 70; Ref. 58, I, 378

743 Ref. 58, I, 346

744 Ref. 17, Pl. 47

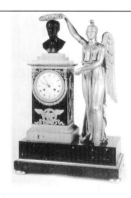

745 Ref. 58, I, 346

746 Ref. 40, 73; Ref. 61, II,
106; Ref. 66, 97

747 Ref. 20, 290

748 Ref. 12, 160; Ref. 52, 33;
Ref. 61, II, 231

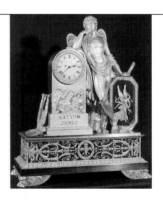

749 Ref. 27, 149; Ref. 58, I, 344

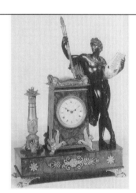

750 Ref. 27, 146; Ref. 58, I,
342; Ref. 61, II, 218

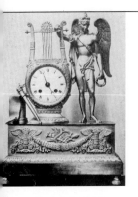
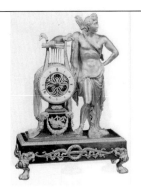
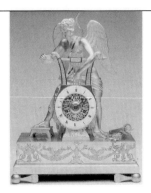

751 Ref. 61, II, 269

752 Ref. 66, 168

753 Ref. 4, 154; Ref. 40, 95

754 Ref. 40, 67; Ref. 70, 95; Ref. 72, Back Cover

755 Ref. 3, 156; Ref. 70, 94

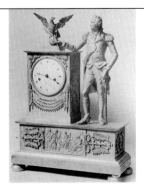
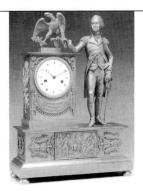
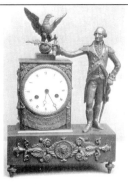

756 Ref. 61, II, 291

757 Ref. 24, 93; Ref. 40, 171; Ref. 61, II, 290

758 Ref. 3, 154

759 Ref. 61, II, 290

760 Ref. 33, II, 164

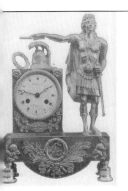
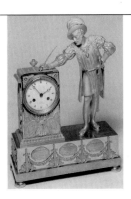
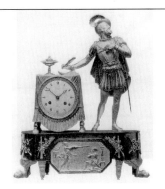
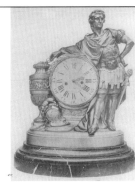
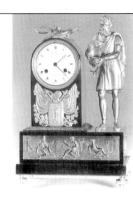

761 Ref. 37, 158

762 Ref. 40, 170

763 Ref. 37, 130

764 Ref. 4, 21; Ref. 17, Pl. 14

765 Ref. 20, 286

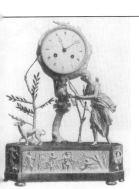

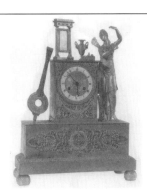

766 Ref. 37, 134

767 Ref. 42, Nr. 42

768 Ref. 37, 143

769 Ref. 37, 53

770 Ref. 37, 42

233

771 Ref. 12, 241

772 Ref. 37, 111

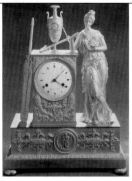

773 Ref. 12, 128

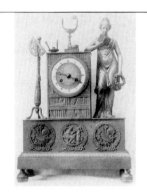

774 Ref. 61, II, 289

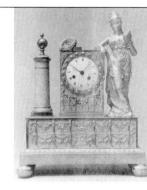

775 Ref. 37, 92

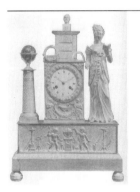

776 Ref. 37, 146

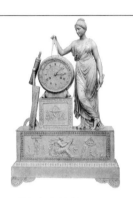

777 Ref. 17, Pl. 36

778 Ref. 6, 141

779 Ref. 12, 285

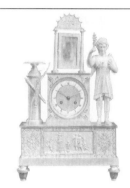

780 Ref. 37, 154

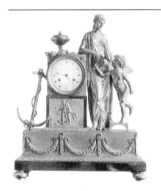

781 Ref. 17, Pl. 36

782 Ref. 37, 143

783 Ref. 12, 299

784 Ref. 3, 159; Ref. 12, 352;
Ref. 24, 76; Ref. 40, 68

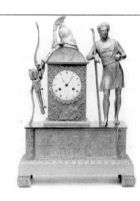

785 Ref. 42, Nr. 46

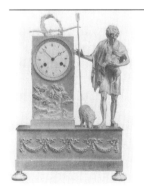

786 Ref. 37, 158

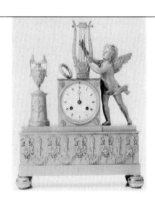

787 Ref. 58, I, 394

788 Ref. 40, 78

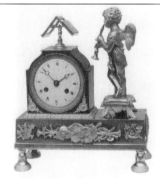

789 Ref. 37, 54

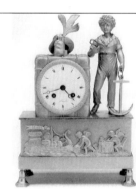

790 Ref. 42, Nr. 2

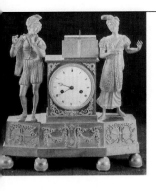

791 Ref. 12, 278; Ref. 40, 172

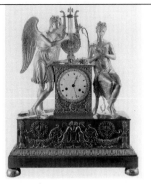

792 Ref. 12, 131 + 346; Ref. 55, 183

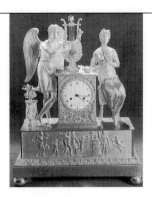

793 Ref. 12, 221

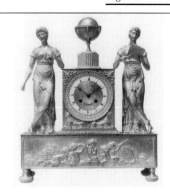

794 Ref. 24, 76; Ref. 37, 98;
Ref. 40, 90

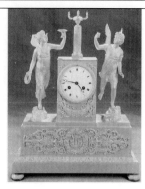

795 Ref. 12, 225

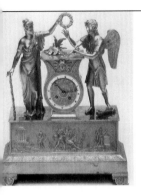

796 Ref. 24, 82

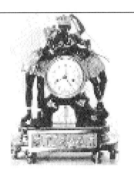

797 Ref. 3, 146 + 148; Ref. 4, 158;
Ref. 12, 120; Ref. 18, 94; Ref. 20, 289;
Ref. 40, 155; Ref. 41, o. S.; Ref. 43, 27;
Ref. 58, I, 381; Ref. 61, II, 245

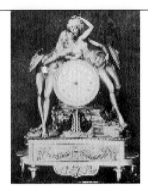

798 Ref. 61, II, 245

799 Ref. 43, 39

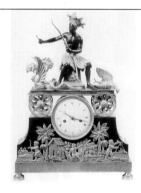

800 Ref. 43, 25;
Ref. 66, 150

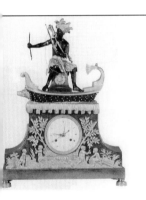

801 Ref. 40, 159; Ref. 41, o. S.;
Ref. 43, 23; Ref. 61, II, 244;
Ref. 66, 150

802 Ref. 40, 152; Ref. 41, o. S.;
Ref. 43, 33; Ref. 61, II, 245

803 Ref. 40, 152; Ref. 41, o. S.;
Ref. 61, II, 249

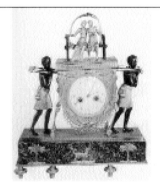

804 Ref. 66, 146

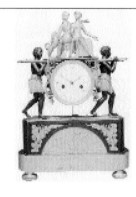

805 Ref. 34, 72; Ref. 40,
151; Ref. 41, o. S.;
Ref. 66, 149

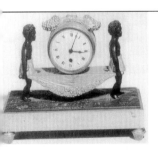

806 Ref. 43, 15

807 Ref. 40, 153; Ref. 41, o. S.

808 Ref. 3, 147; Ref. 34, 73; Ref. 36,
Cat. Nr 202; Ref, 37, 39; Ref. 38, 107;
Ref. 40, 147 f.; Ref. 41, o. S.; Ref. 43,
31; Ref. 54, 10; Ref. 58, I, 381; Ref. 61,
II, 212; Ref. 72, 62

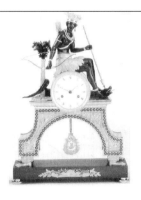

809 Ref. 40, 25

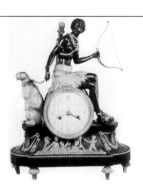

810 Ref. 3, 146; Ref. 6,
Cover; Ref, 24, 92; Ref. 40,
146; Ref. 41, o. S.; Ref. 43,
29; Ref. 58, I, 381; Ref. 61,
II, 246 + 247; Ref. 66, 148;
Ref. 71, 81

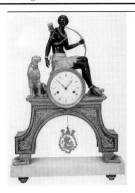

811 Ref. 66, 151

812 Ref. 43, Cover + S. 21;
Ref. 54, 13

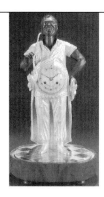

813 Ref. 12, 151

814 Ref. 43, 7

815 Ref. 3, 147;
Ref. 41, o. S.

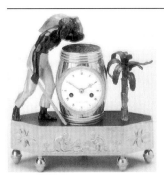

816 Ref. 40, 156; Ref. 42, Nr. 5;
Ref. 43, 7

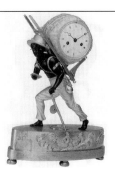

817 Ref. 3, 147; Ref. 12, 118; Ref. 34,
73; Ref. 40, 149; Ref. 41, o. S.; Ref. 42,
Nr. 3; Ref. 43, 11-13; Ref. 54, 5; Ref. 61,
II, 248; Ref. 63, 161; Ref. 64, 534 f.;
Ref. 66, 147

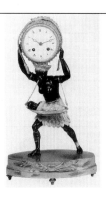

818 Ref. 12, 119; Ref. 41, o. S.;
Ref. 43, 9; Ref. 58, I, 381;
Ref. 66, 147

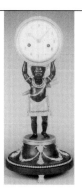

819 Ref. 41, o. S.;
Ref. 43, 35

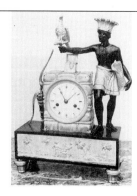

820 Ref. 40, 159; Ref. 41,
o. S.; 61, II, 243

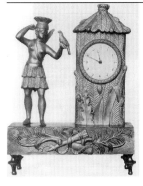

821 Ref. 61, II, 243

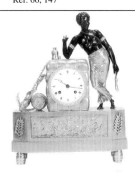

822 Ref. 3, 147; Ref. 24, 249;
Ref. 26, 42; Ref. 37, 37; Ref. 40, 142;
Ref. 41, o. S.; Ref. 42, Nr. 4; Ref. 43, 19
Ref. 58, I, 381; Ref. 61, II, 250: Ref. 66, 146

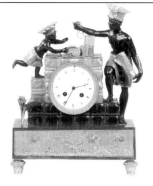

823 Ref. 66, 145

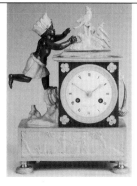

824 Ref. 40, 159

825 Ref. 43, 17

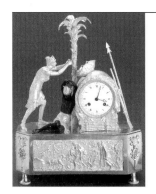

826 Ref. 24, 79; Ref. 41, o. S.;
Ref. 43, 37

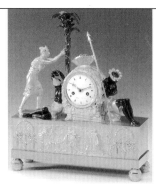

827 Ref. 6, 67; Ref. 40, 144;
Ref. 41 o. S.

828 Ref. 40, 160;
Ref. 41, o. S.

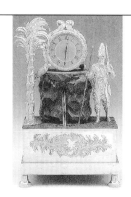

829 Ref. 3, 162

830 Ref. 40, 150

831 Ref. 40, 156

832 Ref. 43, 35

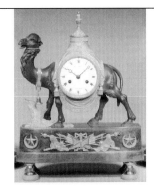

833 Ref. 41, o. S.

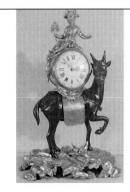

834 Ref. 61, I, 193

835 Ref. 61, I, 290

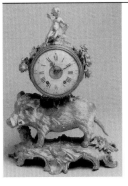

836 Ref. 58, I, 123;
Ref. 70, 69

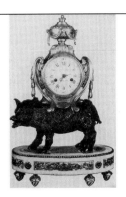

837 Ref. 54, 11;
Ref. 61, II, 15

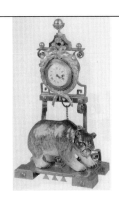

838 Ref. 66, 112

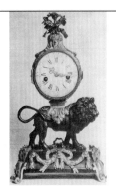

839 Ref. 61, II, 16

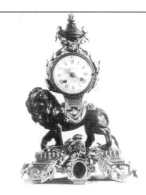

840 Ref. 4, 373; Ref. 45,
168; Ref. 58, I, 192

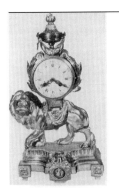

841 Ref. 61, II, 17

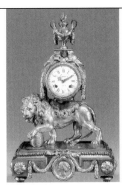

842 Ref. 4, 54

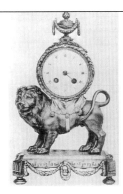

843 Ref. 17, Pl. 22;
Ref. 58, I, 193

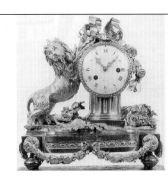

844 Ref. 4, 284; Ref. 58, I, 193;
Ref. 66, 121

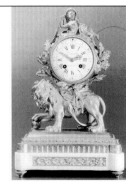

845 Ref. 4, 364

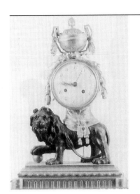

846 Ref. 66, 111

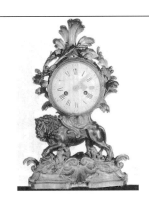

847 Ref. 58, II, 530

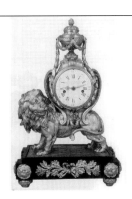

848 Ref. 6, 119; Ref. 61, II, 17;
Ref. 66, 80

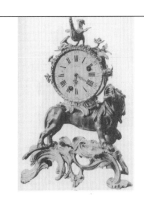

849 Ref. 36, Cat. Nr. 83;
Ref. 54, 9; Ref. 70, 68

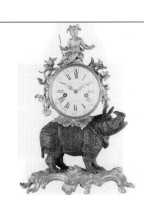

850 Ref. 3, 114; Ref. 4, 156;
Ref. 58, I, 122; Ref. 65, 120;
Ref. 66, 54

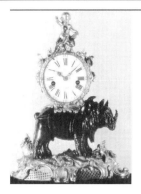

851 Ref. 24, 28;
Ref. 40, 111; Ref. 58,
II, 530

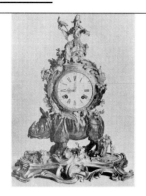

852 Ref. 61, I, 283

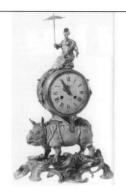

853 Ref. 37, 54

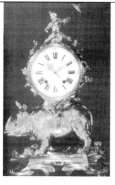

854 Ref. 58, II, 525

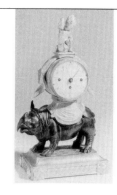

855 Ref. 70, 69

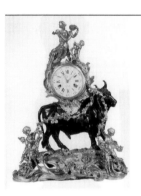

856 Ref. 66, 54

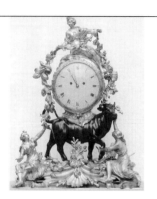

857 Ref. 27, 140 f.; Ref. 34, 70;
Ref. 65, 204

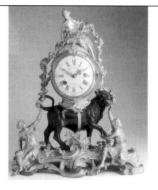

858 Ref. 40, 34; Ref. 48, 90;
Ref. 58, I, 125; Ref. 61, I, 288;
Ref. 69, 57

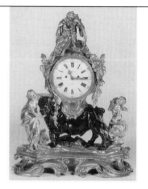

859 Ref. 27, 142; Ref. 58, I, 125

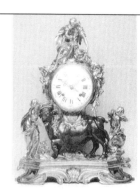

860 Ref. 3, 113

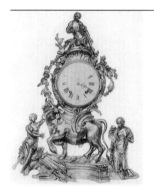

861 Ref. 17, Pl. 9; Ref. 24,
28; Ref. 26, 39; Ref. 58, I,
125; Ref. 61, I, 289

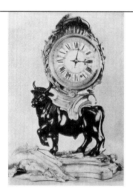

862 Ref. 61, I, 288

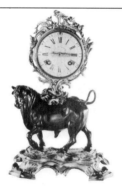

863 Ref. 14, 57

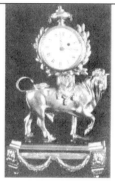

864 Ref. 61, II, 15

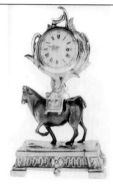

865 Ref. 36, Cat. Nr. 82

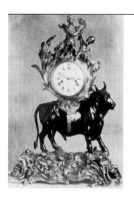

866 Ref. 61, I, 288

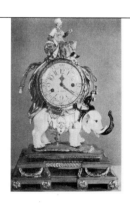

867 Ref. 4, 383;
Ref. 61, I, 292

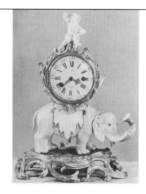

868 Ref. 7, I, 101

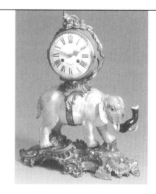

869 Ref. 4, 315

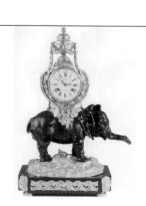

870 Ref. 66, 80

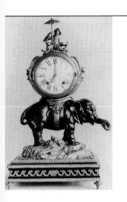
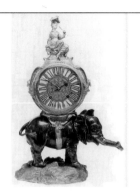
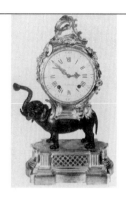
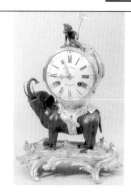
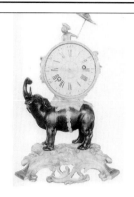

871 Ref. 19, 45;
Ref. 58, I, 124;
Ref. 65, 201; Ref. 70, 68

872 Ref. 66, 60

873 Ref. 61, II, 16

874 Ref. 40, 22 + 158;
Ref. 70, 67; Ref. 72, 62 + 86

875 Ref. 34, 57

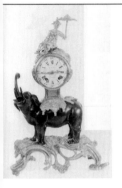
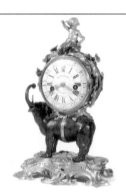
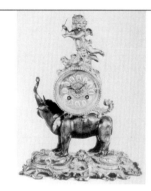
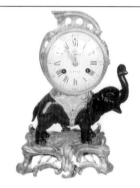
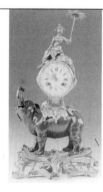

876 Ref. 66, 61

877 Ref. 70, 66

878 Ref. 33, II, 77

879 Ref. 66, 60

880 Ref. 3, 113

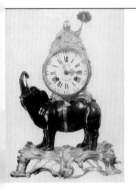
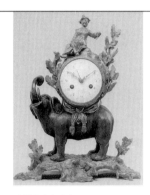
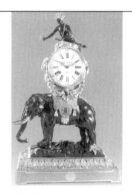
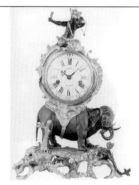
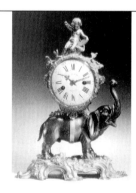

881 Ref. 24, 26;
Ref. 66, 61

882 Ref. 3, 113

883 Ref. 4, 357

884 Ref. 66, 62

885 Ref. 3, 112; Ref. 38,
107; Ref. 58, I, 123; Ref. 61,
I, 285; Ref. 65, 192

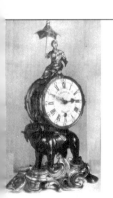

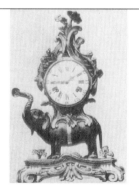
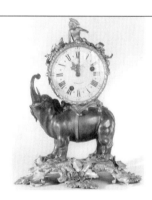

886 Ref. 61, I, 284

887 Ref. 24, 29

888 Ref. 66, 65

889 Ref. 61, I, 284

890 Ref. 12, 23; Ref. 14, 56;
Ref. 21, 160; Ref. 24, 28;
Ref. 58, I, 124; Ref. 70, 66

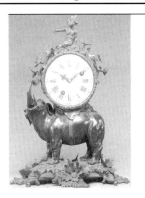

891 Ref. 3, 113;
Ref. 4, 90

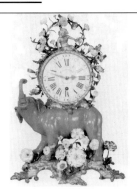

892 Ref. 3, 119; Ref. 66, 67

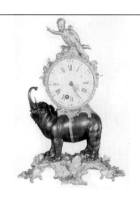

893 Ref. 8, 215; Ref. 63, 110;
Ref. 66, 63 f. + 69

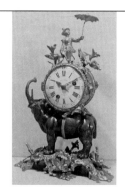

894 Ref. 61, I. 192

895 Ref. 55, 139

896 Ref. 24, 29

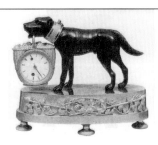

897 Ref. 37, 122; Ref. 61, II, 301

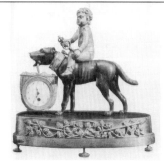

898 Ref. 37, 55; Ref. 42, Nr. 21;
Ref. 61, II, 301

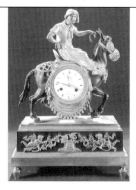

899 Ref. 12, 363 f.; Ref. 40, 154

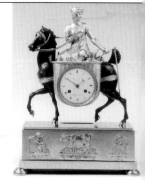

900 Ref. 12, 372; Ref. 39,
125; Ref. 54, 4; Ref. 58, I,
377; Ref. 61, II, 361

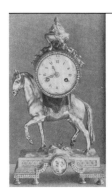

901 Ref. 19, 40;
Ref. 38, 107
Ref. 58, I, 180

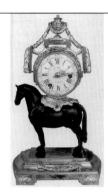

902 Ref. 66, 111

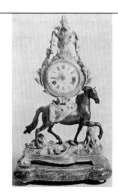

903 Ref. 61, I, 287

904 Ref. 61, I, 286

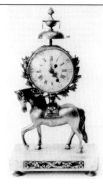

905 Ref. 33, II, 77

906 Ref. 61, I, 287

907 Ref. 61, I, 286

908 Ref. 61, II, 250

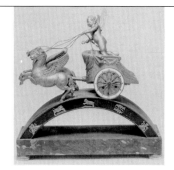

909 Ref. 58, II, 693

910 Ref. 17, Pl. 36;
Ref. 57, 29 + 58

 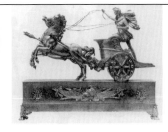 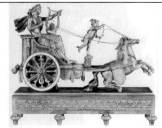 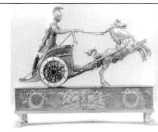

911 Ref. 3, 163

912 Ref. 6, 140; Ref. 9, 78; Ref. 12, 150; Ref. 40, 69; Ref. 52, 21; Ref. 61, II, 279; Ref. 63, 130

913 Ref. 37, 89

914 Ref. 4, 143; Ref. 66, 174

915 Ref. 55, 164

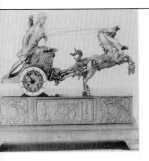 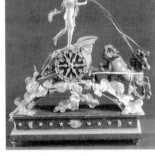 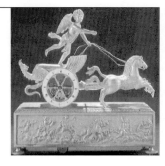

916 Ref. 58, I, 355

917 Ref. 3, 165; Ref. 12, 187

918 Ref. 12, 200; Ref. 24, 61; Ref. 27, 144; Ref. 40, 32; Ref. 58, I, 355; Ref. 61, II, 274

919 Ref. 61, II, 279

920 Ref. 12, 146; Ref. 40, 103

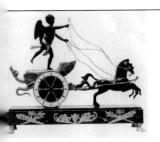 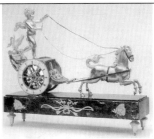 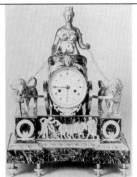 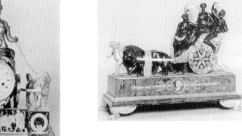 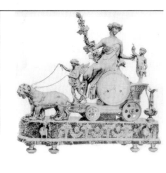

921 Ref. 37, 91; Ref. 58, I, 354

922 Ref. 40, 103

923 Ref. 58, I, 377

924 Ref. 4, 144

925 Ref. 17, Pl. 40

 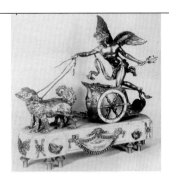 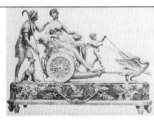

926 Ref. 30, 136; Ref. 56, 187

927 Ref. 58, II, 692

928 Ref. 17, Pl. 42; Ref. 58, I, 353; Ref. 61, II, 298

929 Ref. 4, 144; Ref. 17, Pl. 39; Ref. 21, 182; Ref. 52, 20; Ref. 58, I, 354; Ref. 61, II, 276

930 Ref. 37, 55

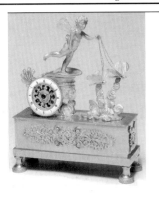

931 Ref. 40, 102

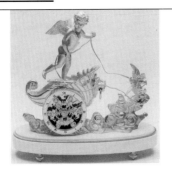

932 Ref. 40, 130

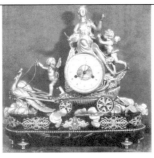

933 Ref. 61, II, 278

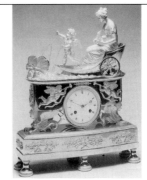

934 Ref. 40, 126

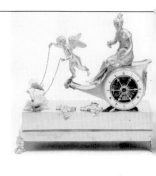

935 Ref. 42, Nr. 41

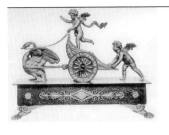

936 Ref. 17, Pl. 29

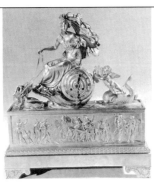

937 Ref. 58, I, 355

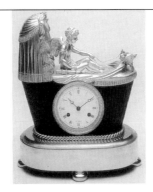

938 Ref. 34, 69; Ref. 40, 129

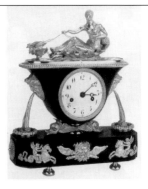

939 Ref. 33, II, 84; Ref. 38, 107;
Ref. 42, Nr. 45; Ref. 58, I, 371;
Ref. 61, II, 285; Ref. 66, 171

940 Ref. 39, 125; Ref. 40,
128; Ref. 61, II, 98 + 216;
Ref. 66, 177

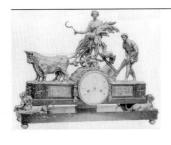

941 Ref. 12, 79; Ref. 17,
Pl. 40; Ref. 61, II, 277

942 Ref. 37, 57; Ref. 40, 53

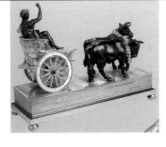

943 Ref. 39, 126

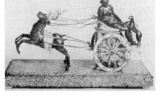

944 Ref. 61, II, 276

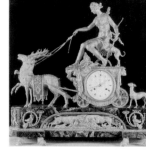

945 Ref. 12, 86; Ref. 40, 49

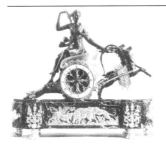

946 Ref. 37, 133

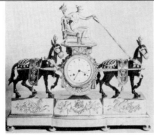

947 Ref. 61, II, 277

948 Ref. 12, 208; Ref. 61, II, 276

949 Ref. 4, 147;
Ref. 55, I, 226

950 Ref. 3, 108

951 Ref. 58, 159

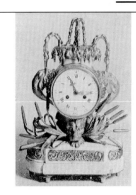

952 Ref. 61, II, 41

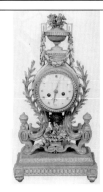

953 Ref. 66, 131

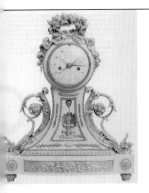

954 Ref. 66, 127

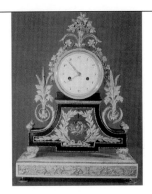

955 Ref. 61, II, 215

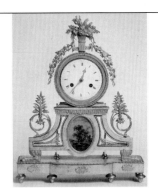

956 Ref. 37, 38; Ref. 61, II, 215;
Ref. 58, I, 380

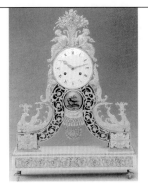

957 Ref. 34, 67

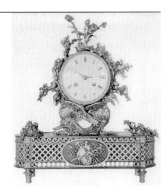

958 Ref. 11, 71; Ref. 17, Pl.
15; Ref. 32, 174; Ref. 44,
269; Ref. 58, I, 240

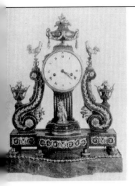

959 Ref. 61, II, 57

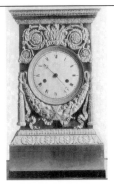

960 Ref. 24, 68; Ref. 31, 150

961 Ref. 3, 152

962 Ref. 27, 150; Ref. 58, I, 373

963 Ref. 61, II, 292

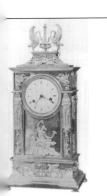

964 Ref. 37, 66

965 Ref. 3, 151; Ref. 17, Pl. 46

966 Ref. 20, Cover + 291

967 Ref. 18, 76; Ref. 68, o. S.

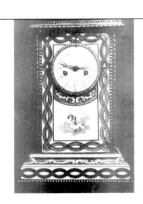

968 Ref. 61, II, 133

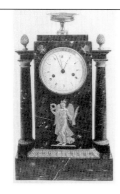

969 Ref. 14, 111;
Ref. 25, 94 f.

970 Ref. 21, 179

971 Ref. 3, 151

972 Ref. 57, 78

973 Ref. 61, II, 265

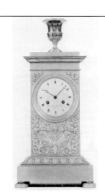

974 Ref. 31, 34;
Ref. 32, 101

975 Ref. 31, 155;
Ref. 32, 142

976 Ref. 55, 181 + 187

977 Ref. 24, 93

978 Ref. 24, 93

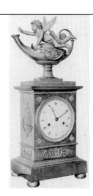

979 Ref. 58, I, 302

980 Ref. 17, Pl. 42;
Ref. 61, II, 285

981 Ref. 17, Pl. 29;
Ref. 57, 52

982 Ref. 17, Pl. 48;
Ref. 57, 60

983 Ref. 17, Pl. 48;
Ref. 61, II, 285

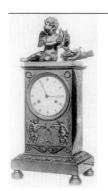
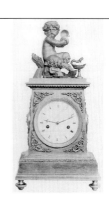

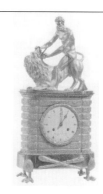

984 Ref. 17, Pl. 29

985 Ref. 17, Pl. 53

986 Ref. 3, 152

987 Ref. 61, II, 55

988 Ref. 37, 70

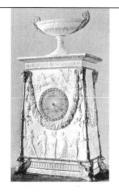

989 Ref. 66, 184

990 Ref. 37, 132

991 Ref. 58, I, 372

992 Ref. 24, 83; Ref. 61, II, 262; Ref. 66, 184

993 Ref. 57, 79

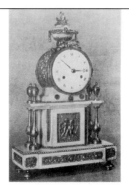
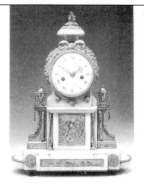
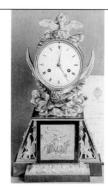

994 Ref. 17, Pl. 48; Ref. 57, 80

995 Ref. 61, II, 41

996 Ref. 61, II, 54

997 Ref. 3, 137

998 Ref. 21, 183

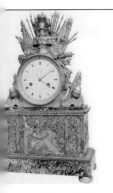
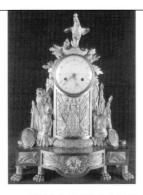
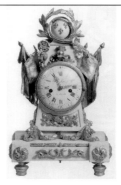
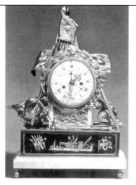
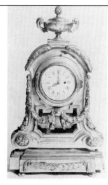

999 Ref. 17, Pl. 54; Ref. 58, I, 305

1000 Ref. 12, 153; Ref. 17, Pl. 22

1001 Ref. 66, 131

1002 Ref. 38, 108

1003 Ref. 61, II, 56

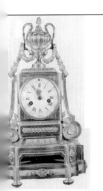
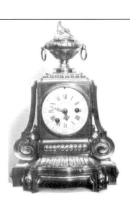
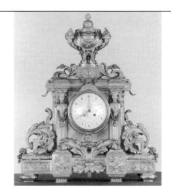
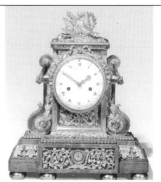
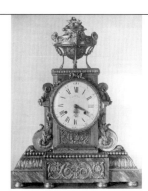

1004 Ref. 66, 135

1005 Ref. 38, 109

1006 Ref. 24, 43

1007 Ref. 4, 262

1008 Ref. 4, 262; Ref. 58, I, 226; Ref. 61, II, 48 + 178; Ref. 65, 313

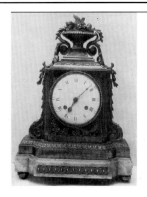

1009 Ref. 61, II, 52

1010 Ref. 12, 67

1011 Ref. 17, Pl. 15;
Ref. 58, I, 226

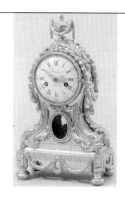

1012 Ref. 70, 79

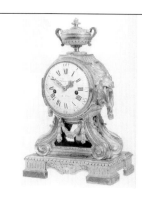

1013 Ref. 4, 387; Ref. 27,
187; Ref. 58, I, 192;
Ref. 66, 135

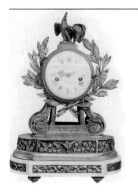

1014 Ref. 66, 126

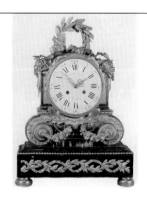

1015 Ref. 66, 126

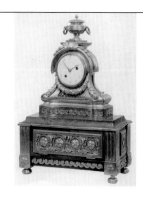

1016 Ref. 58, II, 533; Ref. 61, II, 116;
Ref. 66, 127

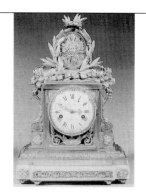

1017 Ref. 3, 127

1018 Ref. 23, Pl. 9; Ref. 55,
142; Ref. 61, II, 53

1019 Ref. 66, 126

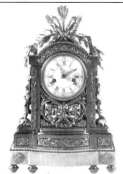

1020 Ref. 66, 124

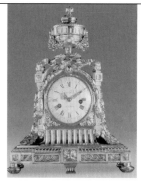

1021 Ref. 4, 43

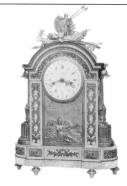

1022 Ref. 17, Pl. 26

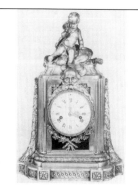

1023 Ref. 4, 139; Ref. 40,
124; Ref. 65, 259

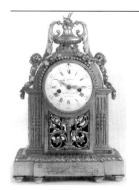

1024 Ref. 24, 42

1025 Ref. 23, Pl. 16

1026 Ref. 4, 369; Ref. 61, II, 44

1027 Ref. 7, I, 123

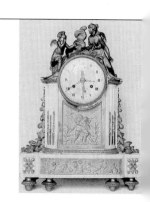

1028 Ref. 17, Pl. 23;
Ref. 57, 48

1029 Ref. 12, 80

1030 Ref. 17, Pl. 26;
Ref. 61, II, 293

1031 Ref. 61, II, 55

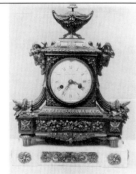

1032 Ref. 3, 129;
Ref. 61, II, 52

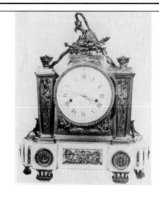

1033 Ref. 61, II, 53

1034 Ref. 3, 135

1035 Ref. 4, 251

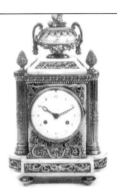

1036 Ref. 65, 253

1037 Ref. 44, 259

1038 Ref. 61, II, 54

1039 Ref. 66, 127

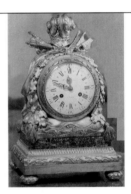

1040 Ref. 27, 156

1041 Ref. 14, 109

1042 Ref. 27, 158

1043 Ref. 37, 46;
Ref. 55, 178

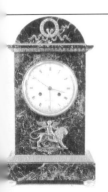

1044 Ref. 58, I, 372

1045 Ref. 31, 143;
Ref. 32, 91

1046 Ref. 57, 77;
Ref. 58, I, 373

1047 Ref. 57, 76

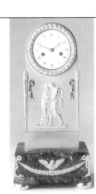

1048 Ref. 34, 70;
Ref. 40, 175

247

1049 Ref. 17, Pl. 53;
Ref. 57, 75

1050 Ref. 61, II, 294

1051 Ref. 17, Pl. 53;
Ref. 52, 16

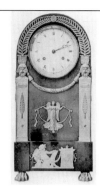

1052 Ref. 17, Pl. 53;
Ref. 31, 83;
Ref. 58, I, 373

1053 Ref. 61, II, 294

1054 Ref. 37, 104;
Ref. 58, I, 372

1055 Ref. 3, 151;
Ref. 54, 15

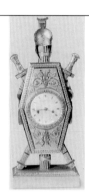

1056 Ref. 4, 154

1057 Ref. 55, 180 + 185

1058 Ref. 39, 121

1059 Ref. 4, 289

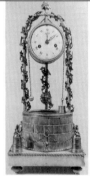

1060 Ref. 65, 280

1061 Ref. 38, 113

1062 Ref. 61, II, 293

1063 Ref. 41, o. S.

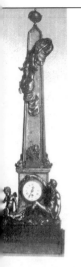
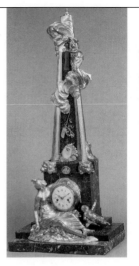
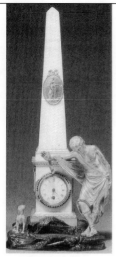
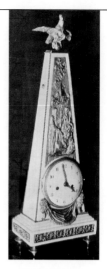
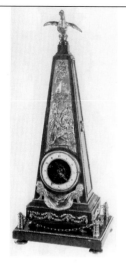
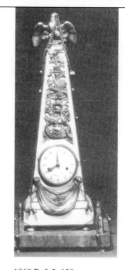

1064 Ref. 3, 140;
Ref. 61, II, 59

1065 Ref. 25, 78 f.

1066 Ref. 3, 139

1067 Ref. 61, II 59

1068 Ref. 66, 118

1069 Ref. 3, 139;
Ref. 61, II, 61

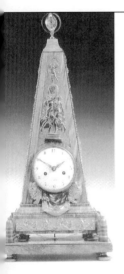
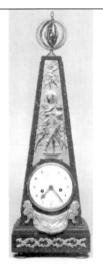
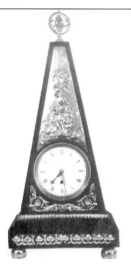

1070 Ref. 6, 77;
Ref. 13, 227;
Ref. 61, II, 60

1071 Ref. 61, II, 179

1072 Ref. 61, II, 58

1073 Ref. 4, 394

1074 Ref. 61, II, 60

1075 Ref. 61, II, 61

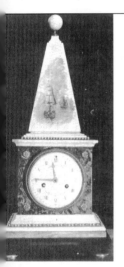
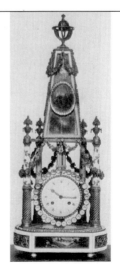
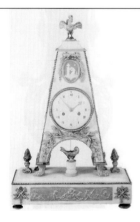
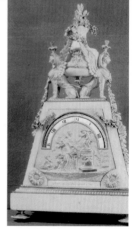
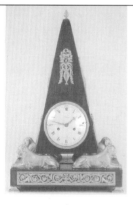
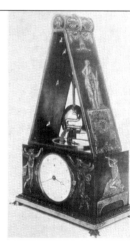

1076 Ref. 61, II, 61

1077 Ref. 61, II, 60

1078 Ref. 66, 118

1079 Ref. 61, II, 213 + 256

1080 Ref. 40, 24

1081 Ref. 61, II, 333

249

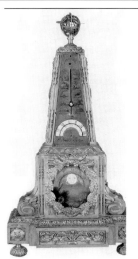

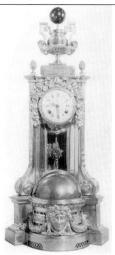

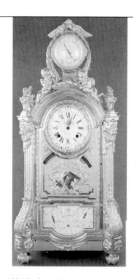

1082 Ref. 66, 129

1083 Ref. 58, II, 532;
Ref. 66, 129

1084 Ref. 4, 268;
Ref. 58, I, 204

1085 Ref. 4, 365;
Ref. 58, I, 159

1086 Ref. 14, 140;
Ref. 25, 62 f.;
Ref. 61, II, 89

1087 Ref. 17, Pl. 45;
Ref. 61, II, 272;
Ref. 58, I, 345

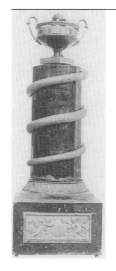

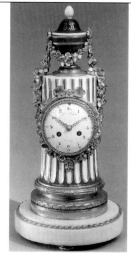

1088 Ref. 17, Pl. 46

1089 Ref. 3, 133;
Ref. 4, 26

1090 Ref. 58, II, 566

1091 Ref. 23, Pl. 19;
Ref. 58, I, 194

1092 Ref. 14, 119;
Ref. 25, 96

1093 Ref. 4, 183

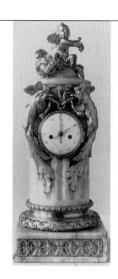

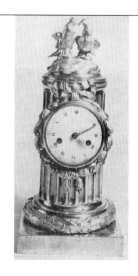

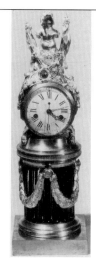

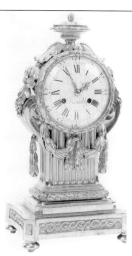

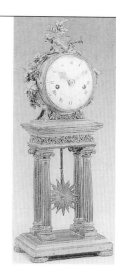

1094 Ref. 61, II, 89

1095 Ref. 61, II, 50

1096 Ref. 61, II, 52

1097 Ref. 65, 258

1098 Ref. 38, 108; Ref. 58, I,
194; Ref. 66, 130

1099 Ref. 3, 135

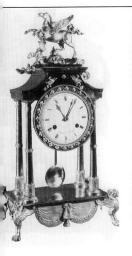

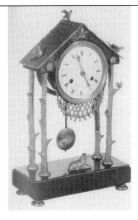

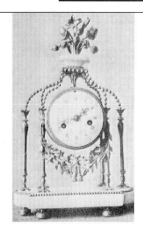

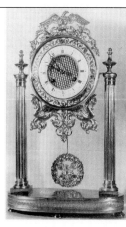

1100 Ref. 17, Pl. 46;
Ref. 21, 182;
Ref. 66, 180

1101 Ref. 4, 301;
Ref. 27, 138

1102 Ref. 37, 67

1103 Ref. 61, II, 297

1104 Ref. 61, II, 72

1105 Ref. 61, II, 306

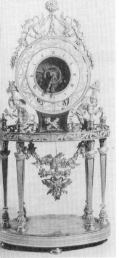

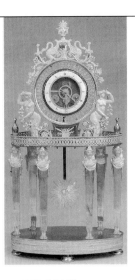

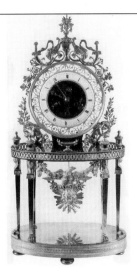

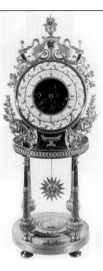

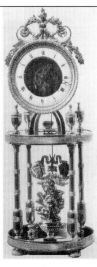

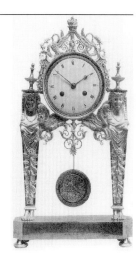

1106 Ref. 61, II, 307

1107 Ref. 24, 87

1108 Ref. 66, 158

1109 Ref. 66, 158

1110 Ref. 37, 65

1111 Ref. 37, 127;
Ref. 61, II, 265

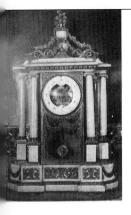

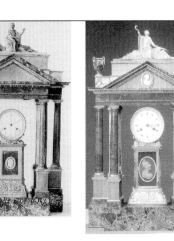

1112 Ref. 61, II, 71

1113 Ref. 61, II, 78;
Ref. 65, 37

1114 Ref. 12, 111

1115 Ref. 31, 175;
Ref. 32, 136

1116 Ref. 57, 31 + 89

1117 Obel. 3, 138;
Ref. 61, II, 262

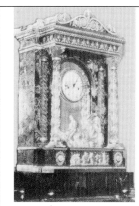

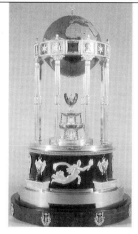
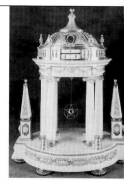

1118 Ref. 61, II, 264 1119 Ref. 12, 117 1120 Ref. 61, II, 312 1121 Ref. 61, II, 263 1122 Ref. 12, 134 1123 Ref. 12, 90

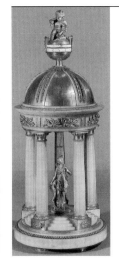

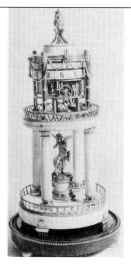
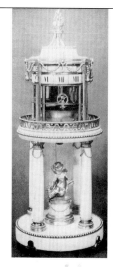

1124 Ref. 27, 150 1125 Ref. 10, 43; 1126 Ref. 40, 133 1127 Ref. 61, II, 88 1128 Ref. 61, II, 88 1129 Ref. 61, II, 87
 Ref. 61, II, 88

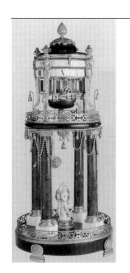
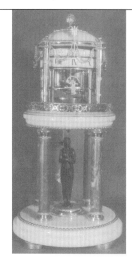
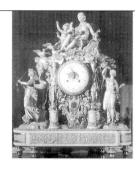

1130 Ref. 39, 116 1131 Ref. 61, II, 193 1132 Ref. 24, 60; 1133 Ref. 61, II, 70 1134 Ref. 61, II, 113 1135 Ref. 59, 131;
 Ref. 40, 115 Ref. 61, II, 98

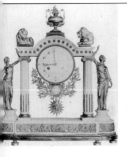 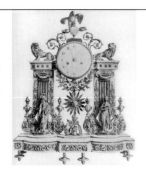 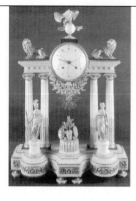 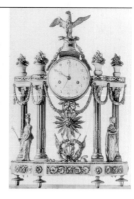

1136 Ref. 17, Pl. 17 1137 Ref. 61, II, 68 1138 Ref. 17, Pl. 16; Ref. 39, 114; Ref. 61, II, 107; Ref. 66, 105 1139 Ref. 3, 120; Ref. 66, 107 1140 Ref. 12, 78 1141 Ref. 17, Pl. 17

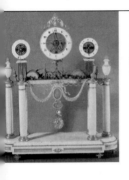 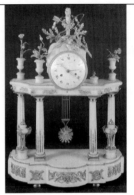 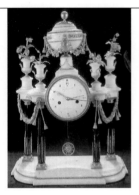

1142 Ref. 61, II, 205 1143 Ref. 12, 72 1144 Ref. 12, 63 1145 Ref. 3, 136; Ref. 12, 57 1146 Ref. 33, II, 83 1147 Ref. 56, 185

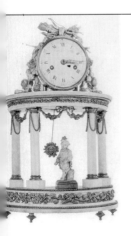 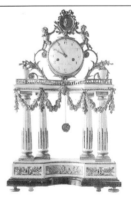 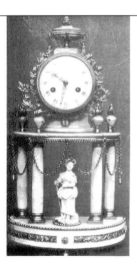 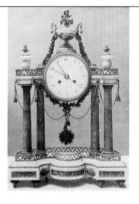 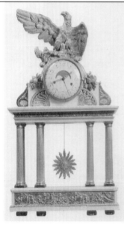 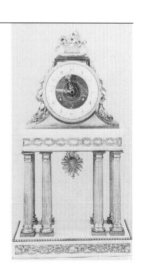

1148 Ref. 17, Pl. 17 1149 Ref. 17, Pl. 19 1150 Ref. 61, II, 70 1151 Ref.61, II, 68 1152 Ref. 56, 185 1153 Obel. 38, 112

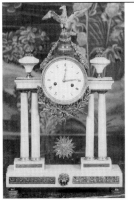

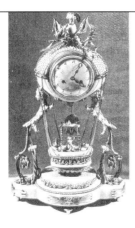
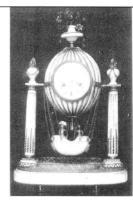

1154 Ref. 27, 159

1155 Ref. 66, 110

1156 Ref. 61, II, 105 + 197

1157 Ref. 61, II, 105;
Ref. 65, 121

1158 Ref. 61, II, 104

1159 Ref. 61, II, 103

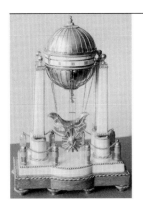
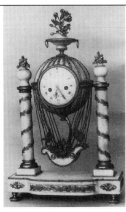

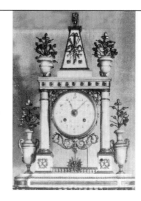

1160 Ref. 13, 166

1161 Ref.3, 157;
Ref. 61, II, 102 + 103

1162 Ref. 61, II, 255

1163 Ref. 38, 117

1164 Ref. 8, 222

1165 Ref. 4, 78

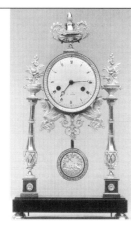

1166 Ref. 61, II, 373

1167 Ref. 3, 157

1168 Ref. 55, 144 ff.

1169 Ref. 55, 141 + 143

1170 Ref. 39, 112

1171 Ref. 6, 136

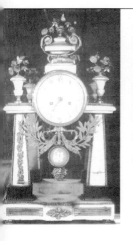

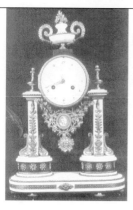
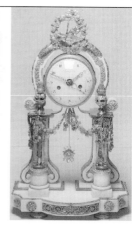

1172 Ref. 61, II, 69 1173 Ref. 61, II, 181 1174 Ref. 40, 87 1175 Ref. 66, 109 1176 Ref. 61, II, 67 1177 Ref. 40, 110

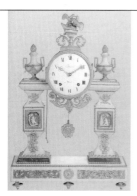

1178 Ref. 3, 136 + 137; 1179 Ref. 40, 51 1180 Ref. 39, 113 1181 Ref. 3, 136 1182 Ref. 37, 151 1183 Ref. 61, II, 69
Ref. 17, Pl. 16

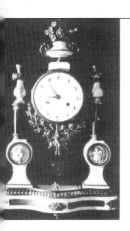
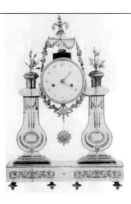
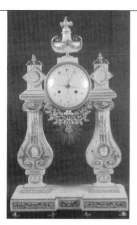
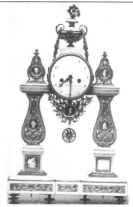

1184 Ref. 61, II, 65 1185 Ref. 66, 110 1186 Ref. 12, 74 1187 Ref.12, 75; Ref. 38, 117; 1188 Ref. 61, II, 65; 1189 Ref. 3, 137
Ref. 61, II, 63 Ref. 66, 108

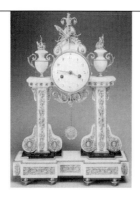
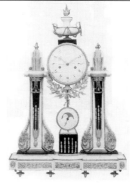

1190 Ref. 34, 76

1191 Ref. 17, Pl. 19;
Ref. 61, II, 180

1192 Ref. 56, 185

1193 Ref. 66, 109

1194 Ref. 39, 115

1195 Ref. 61, II, 72;
Ref. 66, 106

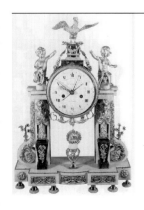

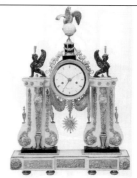

1196 Ref. 66, 106

1197 Ref. 66, 108

1198 Ref. 12, 68

1199 Ref. 12, 60; Ref. 17, Pl.
20; Ref. 30, 136; Ref. 33, II,
82; Ref. 61, II, 66 + 70 + 237;
Ref. 66, 108

1200 Ref. 66, 161;
Ref. 65, 207

1201 Ref. 37, 97;
Ref. 61, II, 68 + 183

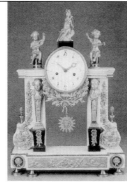

1202 Ref. 3, 23;
Ref. 55, 147 ff.

1203 Ref. 63, 129

1204 Ref. 3, 137

1205 Ref. 37, 98

1206 Ref. 61, II, 72

1207 Ref. 56, 185

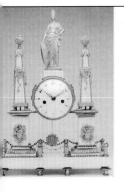

1208 Ref. 40, 47

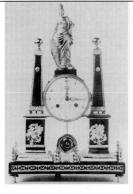

1209 Ref. 63, 147

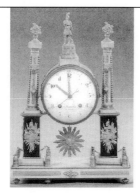

1210 Ref. 3, 139

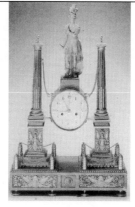

1211 Ref. 3, 136

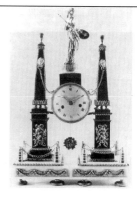

1212 Ref. 61, II, 73

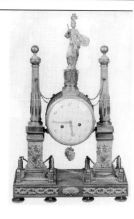

1213 Ref. 12, 59;
Ref. 37, 58; Ref. 66,
108

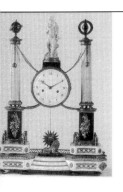

1214 Ref. 3, 138

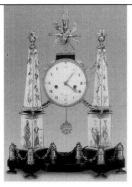

1215 Ref. 4, 394

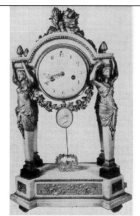

1216 Ref. 61, II, 64

1217 Ref. 61, II, 37

1218 Ref. 4, 34

1219 Ref. 61, II, 236

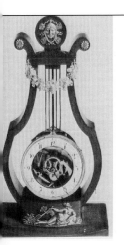

1220 Ref. 38, 116

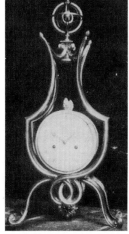

1221 Ref. 61, II, 241

1222 Ref. 61, II, 84

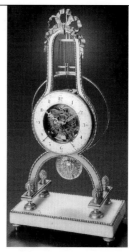

1223 Ref.53, 63

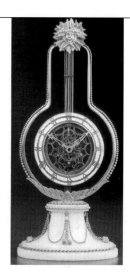

1224 Ref. 44, 263;
Ref. 62, 147

1225 Ref. 23, Pl. 15

257

1226 Ref. 17, Pl. 50

1227 Ref. 3, 134

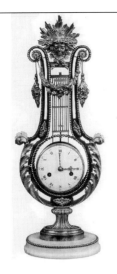

1228 Ref. 66, 116

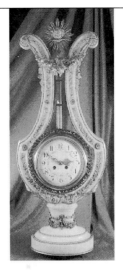

1229 Ref. 61, II, 186

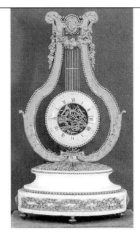

1230 Ref. 38, 109;
Ref. 61, II, 186

1231 Ref. 61, II, 187

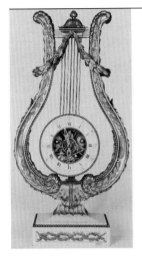

1232 Ref. 29, 105;
Ref. 61, II, 82

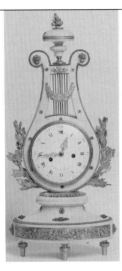

1233 Ref. 37, 102

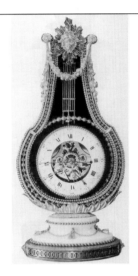

1234 Ref. 66, 115

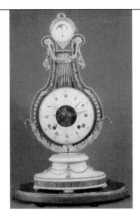

1235 Ref. 61, II, 188

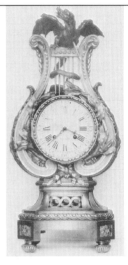

1236 Ref. 3, 114; Ref. 4, 358;
Ref. 58, I, 159

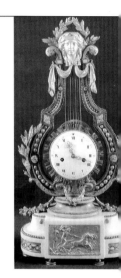

1237 Ref. 12, 94;
Ref. 40, 32; Ref. 61,
II, 82

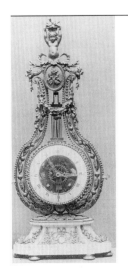

1238 Ref. 23, Pl. 13

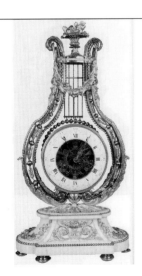

1239 Ref. 66, 112

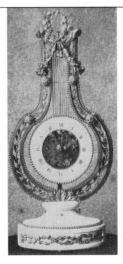

1240 Ref. 61, II, 82

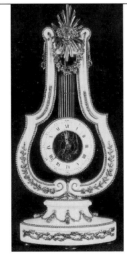

1241 Ref. 24, 62

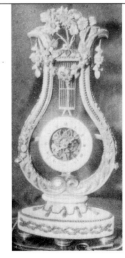

1242 Ref. 61, II, 83

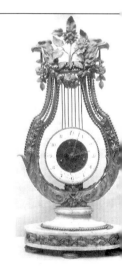

1243 Ref. 3, 134 f.;
Ref. 24, 62; Ref. 30,
136; Ref. 56, 186; Ref.
61, II, 83; Ref. 71, 80

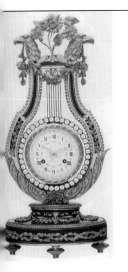

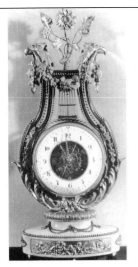

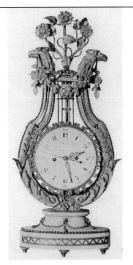

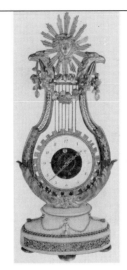

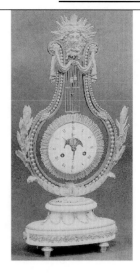

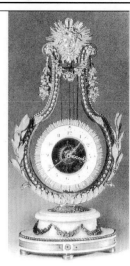

1244 Ref. 66, 116

1245 Ref. 58, I, 252

1246 Ref. 17, Pl. 22

1247 Ref. 61, II, 80

1248 Ref. 3, 134

1249 Ref. 3, 133

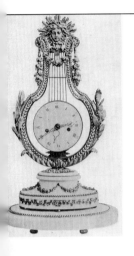

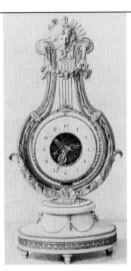

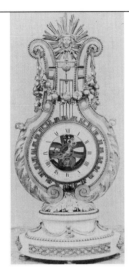

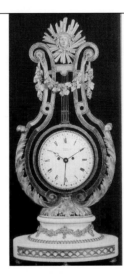

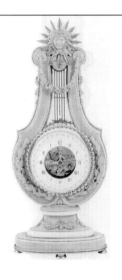

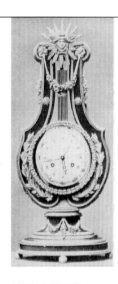

1250 Ref. 17, Pl. 23

1251 Ref. 61, II, 81

1252 Ref. 7, I, 129

1253 Ref. 27, 132; Ref. 58, I, 252

1254 Ref. 8, 223; Ref. 19, 48; Ref. 34, 65; Ref. 58, I, 252; Ref. 59, 172; Ref. 61, II, 80 + 81; Ref. 66, 115

1255 Ref. 61, II, 80

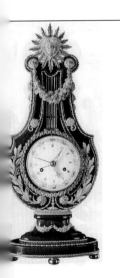

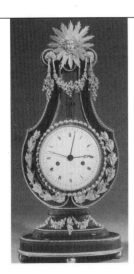

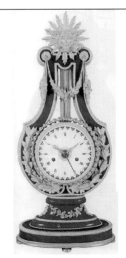

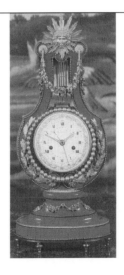

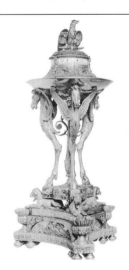

1256 Ref. 66, 114

1257 Ref. 4, 258; Ref. 27, 130; Ref. 66, 113

1258 Ref. 66, 121

1259 Ref.27, 131; Ref. 65, 41; Ref. 68, o. S.

1260 Ref. 17, Pl. 48; Ref. 58, I, 362; Ref. 61, II, 281

1261 Ref. 61, II, 284

1262 Ref. 24, 44

1263 Ref. 4, 213; Ref. 24, 44;
Ref. 72, 69

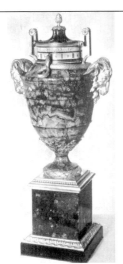

1264 Ref. 8, 224

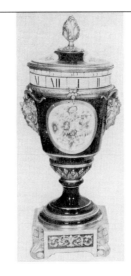

1265 Ref. 61, II, 92

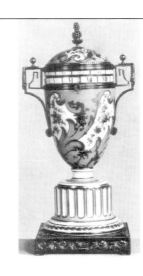

1266 Ref. 19, 47

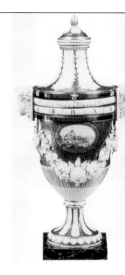

1267 Ref. 24, 44; Ref.
33, II, 76; Ref. 45, 227;
Ref. 46, 22; Ref. 61, II,
90 + 93; Ref. 66, 136

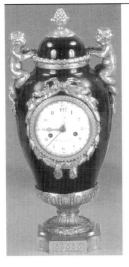

1268 Ref. 4, 198

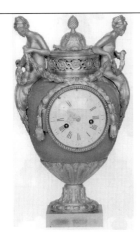

1269 Ref. 24, 43;
Ref. 66, 101

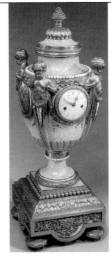

1270 Ref. 4, 379; Ref. 25, 90 f.;
Ref. 61, II, 78

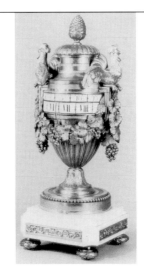

1271 Ref. 4, 187

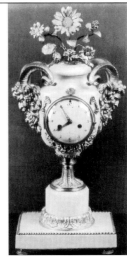

1272 Ref. 38, 118

1273 Ref. 4, 185

1274 Ref. 4, 176

1275 Ref. 38, 118;
Ref. 72, 70

1276 Ref. 7, I, 111

1277 Ref. 27, 134

1278 Ref. 63, 158

1279 Ref. 59, 269

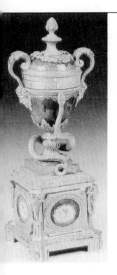
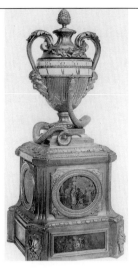
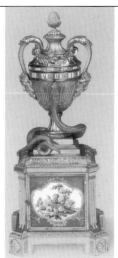
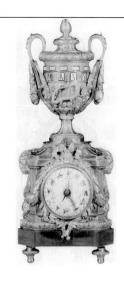
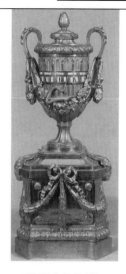

1280 Ref. 3, 133	1281 Ref. 17, Pl. 14; Ref. 30, 163; Ref. 61, II, 93; Ref. 70, 83	1282 Ref. 4, 199	1283 Ref. 66, 134	1284 Ref. 61, II, 192	1285 Ref. 61, II, 92

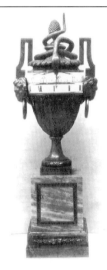

1286 Ref. 4, 377	1287 Ref. 70, 83	1288 Ref. 61, II, 91	1289 Ref. 70, 82	1290 Ref. 61, II, 90	1291 Ref. 4, 109

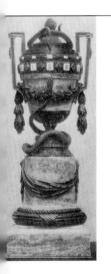
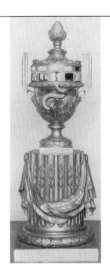
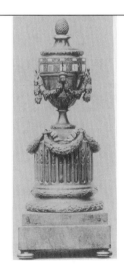
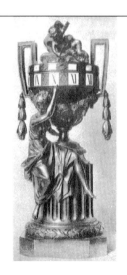
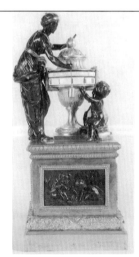

1292 Ref. 61, II, 92; Ref. 70, 81 + 82	1293 Ref. 58, I, 194; Ref. 65, 110	1294 Ref. 45, 268; Ref. 58, I, 194	1295 Ref.58, I, 167; Ref. 61, II, 91	1296 Ref. 16, 257; Ref. 18, 80	1297 Ref. 66, 123

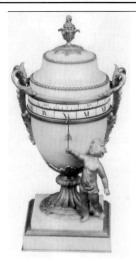
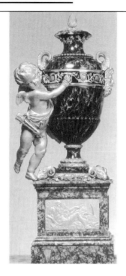
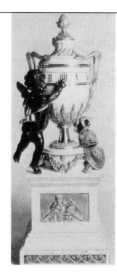

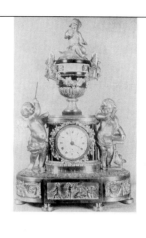

1298 Ref. 37, 160

1299 Ref. 4, 395;
Ref. 7, 115

1300 Ref. 9, 77; Ref. 18, 83;
Ref. 24, 45; Ref. 61, II, 90;
Ref. 63, 157

1301 Ref. 22, 65

1302 Ref. 8, 221; Ref. 14, 146;
Ref. 25, 92 f.

1303 Ref. 61, II, 40

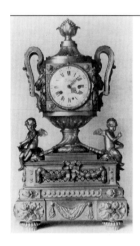
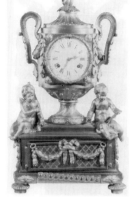
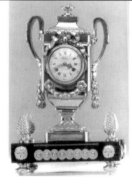
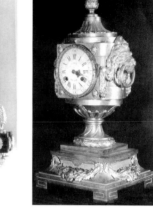
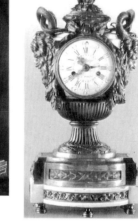
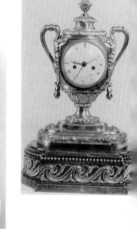

1304 Ref. 2, 190: Ref. 44,
252; Ref. 58, I, 177;
Ref. 61, II, 40

1305 Ref. 58, II, 543;
Ref. 66, 99

1306 Ref. 55, 138 + 140

1307 Ref. 4, 255; Ref. 24, 42;
Ref. 58, I, 155

1308 Ref. 3, 128; Ref. 24, 42;
Ref. 40, 55; Ref. 58, I, 196

1309 Ref. 58, I, 196

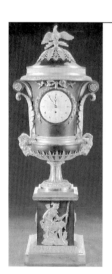
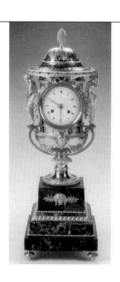
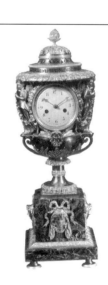
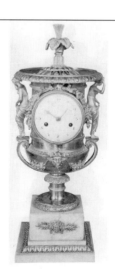
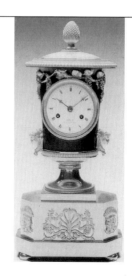
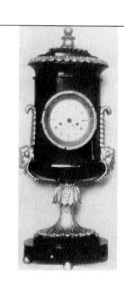

1310 Ref. 12, 89

1311 Ref. 6, 77; Ref. 17, Pl.
53; Ref. 41, o. S.; Ref. 57,
81; Ref. 66, 160

1312 Ref. 66, 160

1313 Ref. 66, 162

1314 Ref. 40, 55

1315 Ref. 61, II, 377

1316 Ref. 36, Cat.
Nr. 89

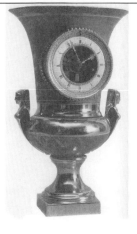

1317 Ref. 37, 142

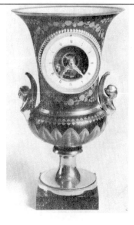

1318 Ref. 61, II, 284

1319 Ref. 4, 201

1320 Ref. 27, 133;
Ref. 61, I, 287

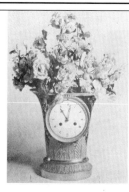

1321 Ref. 61, II, 280

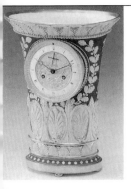

1322 Ref. 6, 69

1323 Ref. 58, II, 196

1324 Ref. 61, II, 286

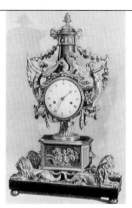

1325 Ref. 21, 178

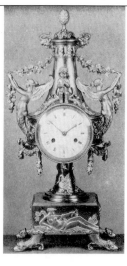

1326 Ref. 61, II, 280

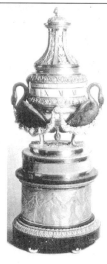

1327 Ref. 61, II, 91

1328 Ref. 24, 45

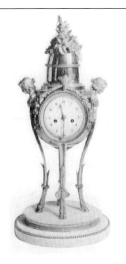

1329 Ref. 61, II, 256

1330 Ref. 62, 151

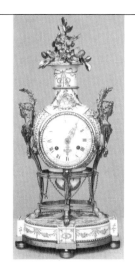

1331 Ref.19, 49

1332 Ref. 23, Pl. 12;
Ref. 59, 269

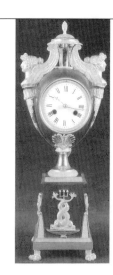

1333 Ref. 12, 223;
Ref. 40, 61

263

1334 Ref. 37, 141

1335 Ref. 37, 46

1336 Ref. 33, II, 76

1337 Ref. 61, II, 376

1338 Ref. 31, 27 + 72;
Ref. 32, 121; Ref. 58,
I, 365

1339 Ref. 61, II, 376

1340 Ref. 17, Pl. 53

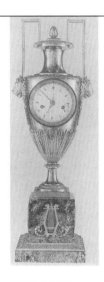

1341 Ref. 52, 13;
Ref. 57, 82

1342 Ref. 4, 303; Ref. 12, 99;
Ref. 61, II, 281

1343 Ref. 52, 10

1344 Ref. 12, 207; Ref. 36,
Cat. Nr. 90; Ref. 41, o. S.

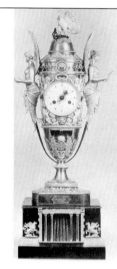

1345 Ref. 38, 116;
Ref. 58, I, 364; Ref. 61,
II, 264 + 280; Ref. 68,
o. S.

1346 Ref. 58, I, 365

1347 Ref. 12, 164

1348 Ref. 40, 134

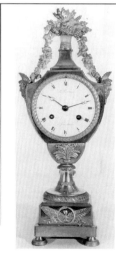

1349 Ref. 33, II, 165

1350 Ref. 66, 162

1351 Ref. 66, 182

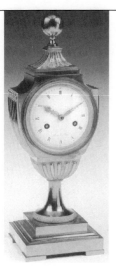
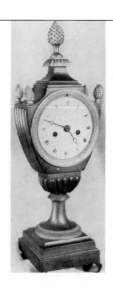
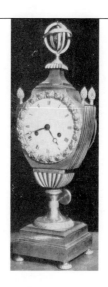
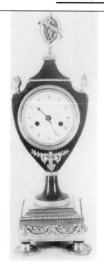
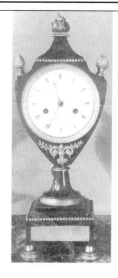

1352 Ref. 40, 55

1353 Ref. 6, 76;
Ref. 61, II, 283

1354 Ref. 61, II, 79

1355 Ref. 61, II, 377

1356 Ref. 52, 24;
Ref. 61, II, 254

1357 Ref. 61, II, 376

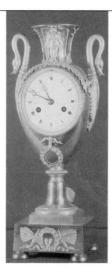

1358 Ref. 66, 182

1359 Ref. 61, II, 217

1360 Ref. 61, II, 283

1361 Ref. 61, II, 217

1362 Ref. 37, 46;
Ref. 61, II, 282

1363 Ref. 37, 144

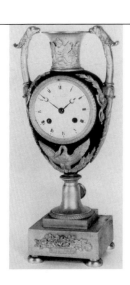

1364 Ref. 17, Pl. 42

1365 Ref. 61, II, 282

Literature Reference

1. *Abeler, J.:* Das Wuppertaler Uhrenmuseum, Berlin/ New York 1971.
2. *Abeler, J.:* Ullstein Uhrenbuch – Eine Kulturgeschichte der Zeitmessung, Berlin/Frankfurt/Vienna 1975.
3. *Agnellini, M.:* Orologi Antichi – Storia e produzione dal cinquecento all' ottocento, Mailand 1993.
4. *Augarde, J. – D.:* Les Ouvriers du Temps – La Pendule a Paris de Louis XVI a Napoleon Ier, Geneva 1996.
5. *Bassermann – Jordan, E. von:* Uhren – Ein Handbuch fuer Sammler und Liebhaber, Munich 1982.
6. *Becker, K. – E., Kueffner, H,:* Uhren , Battenberg Antiquitaeten – Katalog, Augsburg, 1994.
7. *Bellaigue de, G.:* Furniture Clocks and Gilt Bronzes – The James A. de Rothschild Collection at Waddesdon Manor, London 1974, Bk. I.
8. *Britten, F. J.:* Old Clocks and Watches and their Makers, London 1973.
9. *Bruton, E.:* The History of Clocks and Watches, London, Reprint of 1989. This book is identical with the German edition: *Bruton, E.:* Uhren – Geschichte, Schoenheit und Technik, Eltville, 1982.
10. Burckhardt, M.; Mobilier Louis XVI, Paris, n.d.
11. *Cardinal, C.:* Uhren in Geschichte, Kunst und Wissenschaft – Meisterwerke des Internationalen Uhrenmuseums in La Chaux-de-Fonds, Lausanne 1984.
12. *Carvajal, J. Ramon Colon de:* Catalogo de Relojes del Patrimonio Nacional, Madrid. 1987.
13. *Chapiro, A.:* Jean – Antoine Lepine – Uhren von 1760 bis zum Empire, Munich. 1989.
14. *Cumhaill, P. W:* Investing in clocks and watches, London, 1967.
15. *Daniels, G., Markarian, O.:* Watches and Clocks in the Sir David Salomons Collections, London/New York 1980.
16. *Dell, T.:* Furniture in the Frick Collection – VI. Furniture and Gilt Bronzes, New York 1992.
17. *Dumonthier, E.:* Les Bronzes du Mobilier National – Pendules et Cartels, Paris , n. d.
18. *Edey, W.:* French Clocks in North American Collections, Ausstellungskatalog zur gleichnamigen Ausstellung im Museum The Frick Collection vom 02. 11. 1982 – 30. 01. 1983, New York 1982.
19. *Fleet, S.:* Clocks, London/New York 1972.
20. *Groer, L.* de : Les arts decoratifs de 1790 a 1850, Fribourg/Paris 1985.
21. *Guye, S., Michel, H.:* Uhren und Messinstrumente des 15. und 19. Jahrhunderts, Zurich, 1971.
22. *Hayard, M.:* Antide Janvier 1751 – 1835 – Horloger des etoiles, Villeneuve – Tolosane 1995.
23. *Henriot, G.:* Bronzes et Bois Sculptes des Collections Privees, Paris, n. d.
24. *Heuer, P., Maurice, K..:* Europaeische Pendeluhren – Dekorative Instrumente der Zeitmessung, Munich 1988.
25. *Hughes, P.:* French Eighteenth – Century Clocks and Barometers in the Wallace Collection, London 1994.
26. *Jagger, C.:* Clocks, Orbis Connoisseur's Library, London, 1973.
27. *Jagger, C.:* Royal Clocks – The British Monarchy and its Timekeepers 1300 – 1900, London 1983.
28. *Jagger, C.:* Wunderwerk Uhr, Zollikon 1977.
29. *Kiegeland, B.:* Uhren – Die Entwicklung der Raederuhr, Munich 1976.
30. *Koenig, G.:* Die Uhr – Geschichte, Technik, Stil, Berlin/Leipzig 1991.
31. *Ledoux – Lebard, D.:* Le Grand Trianon – Meubles et objets d'art, Paris 1975.
32. *Ledoux – Lebard, D.:* Versailles – Le Petit Trianon – Le mobilier des inventaires de 1807, 1810, et 1839, Paris, 1989.
33. *Meis, R.:* Die alte Uhr – Geschichte, Technik, Stil, Braunschweig, 1978.
34. *Moeller, R.:* Uhren von der fruehen Eisenuhr bis zur Armbanduhr, Weltkunst Antiqitaetenfuehrer, Munich / Berlin 1996.
36. *Monreal y Tejada, L.:* Relojes Antiguos (1500-1850), Coleccion F. Perez de Olaguer-Feliu, Barcelona, 1955.
37. *Montanes, L.:* Catalogo del Museo de Relojes de las Bodegas – Zoilo Ruiz-Mateos S/A, La Atalaya, Jerez de la Frontera, n.d.
38. *Muehe, R., Vogel H. M. :* Alte Uhren – Ein Handbuch europaeischer Tischuhren, Wanduhren und Bodenstanduhren, Muenchen 1976.
39. *Negretti, G.: de Vecci, P.:* Faszination Uhr – Eine Geschichte der Zeitmessung, Munich 1996.
40. *Niehueser, E.:* Die franzoesische Bronzeuhr – eine Typologie der figuerlichen Darstellungen, Munich 1997.
41. *Anonym. :* De Noir et d'Or – Pendule au Bon Sauvage, Katalog zur gleichnamigen Ausstellung im Musee Bellevue, Collection M. et Mme Francois Duesberg, Hrsg. v. Musees Royaux d'Art et d'Histoire, Brussles 1993.
42. *anonym.:* La Pendule a Sujet du Directoire a Louis-Philippe, Katalog zur gleichnamigen Ausstellung im Musee Sandelin vom 26. 06. – 12. 09. 1993, Saint-Omer 1993.

43. *anonym.:* La Pendule au Negre, Katalog zur gleich-namigen Ausstellung im Musee de l'Hotel Sandelin vom 29. 04. – 12. 06. 1978, Saint-Omer 1978.

44. *anonym.:* Ferdinand Berthoud 1727–1807 – Horloger Mecanicien du Roi et de la Marine, Musee International d' Horlogerie, La Chaux-de-Fonds 1984.

45. *anonym.:* Les ebenistes du XVIIIe siecle francais, Collection Connaissance des Arts Grands Artisans d' Autrefois, l.a., 1963.

46. *anonym.:* Antike Uhren – Uhrenmuseum Beyer Zuerich – Neuerwerbungen, Callwey Verlag, Munich 1996.

47. *anonym.:* Chefs-d' Oeuvre de l' Horlogerie, Musee du Conservatoire National des Arts et Metiers, Paris n. d.

48. *anonym.:* Decorative Arts – An illustrated Summary Catalogue of the Collections of the J. Paul Getty Museum, J. Paul Getty Museum, Malibu 1993.

49. *anonym.:* Fruehes Meissener Porzellan – Kostbar-keiten aus deutschen Privatsammlungen, Katalog zur Ausstellung des Hetjens-Museums, Deutsches Keramikmuseum, Duesseldorf vom 19. 01. – 06. 04. 1997, Munich 1997.

50. *Anonym.:* Horlogerie – Catalogue du Musee, Con-servatoire National des Arts et Metiers, Paris 1949.

51. *anonym.:* Kostbare Instrumente und Uhren aus dem staatlichen Mathematisch-Physikalischen Salon Dresden, Leipzig 1994.

52. *anonym.:* La Mesure du Temps dans les collections du musee du Malmaison, Reunion des Musees Nationaux, Paris 1991.

53. *anonym.:* La Revolution dans la Mesure du Temps – calendrier republicain – heure decimale 1793-1805 sous la direction de Catherine Cardinal, Musee International d' Horlogerie, La Chaux-de-Fonds 1989.

54. *anonym.:* Museo del Reloj Antiguo – Grassy, Museumskatalog, Madrid, n.d.

55. *anonym.:* Orologi negli arredi del Palazzo Reale di Torino e delle residenze sabaude, Torino 1988.

56. *anonym.:* Pavlovsk – The Collections, publ. by Alain de Gourcuff, Paris 1993.

57. *anonym.:* Pendules et bronzes d' ameublement entres sous le mobilier, Musee national du Chateau de Fontainebleu, Ministere de la Culture…, Editions de la Reunion des Musees Nationaux, Paris 1989.

58. *Ottomeyer, H., Proeschel, P., u. a.:* Vergoldete Bronzen – Die Bronzearbeiten des Spaetbarock und Klassizismus, Muenchen 1986, Bk. I + II.

59. *Ricci, S. de:* Louis XVI Furniture, hrsg. v. Julius Hoffmann, Stuttgart n.d.

60. *Roberts, D.:* a Collector' s Guide to Clocks, The Apple Press, London 1992.

61. *Tardy:* French Clocks - The World Over, Tardy, Paris 1981, Bk. I + II.

62. *Tieger, N.:* Grandi Orologi Dal Rinascimento all' Art Deco, Mailand 1990, - This book is identical to: *Tieger, N.:* Horloges Anciennes, Flammarion, l.a. 1991.

63. *Uresova, L.:* Alte Uhren, Prague 1986.

64. *Vehmeyer, H. M.:* Antieke Uurwerken – Een Familie-verzameling, Utrecht 1994.

65. *Verlet, P.:* Les Bronzes Dores Francais du XVIIIe Siecle , Grands Manuels Picard, l. a. 1987.

66. *Wannenes, G.:* Le piu belle pendole francesi – Da Luigi XIV all' Impero, Leonardo Editore s. r. l., Mailand, 1991.

67. *Watson, F. J. B.:* Le Meuble Louis XVI, Les Beaux-Arts, Editions d' Etudes et de Documents, Paris 1963.

68. *Willsberger, J.:* Zauberhafte Gehaeuse der Zeit – Die schoensten Uhren aus sechs Jahrhunderten, Düs-seldorf/Vienna 1974.

69. *Wilson, G.:* Clocks – French eigtheenth-century clocks in the J. Paul Getty Museum, Malibu 1976.

70. *Maurice, K.:* Schoene Uhren des 17. – 19. Jahr-hunderts, Munich 1990.

71. *anonym.:* Guide Miller di Antiquariato – Orologi, A. Vallardi, l.a. 1993.

72. *Proestler, V.:* Callwey' s Handbuch der Uhrentypen – Von der Armbanduhr bis zum Zappler, Munich 1994.